US OPEN

50 YEARS OF CHAMPIONSHIP TENNIS

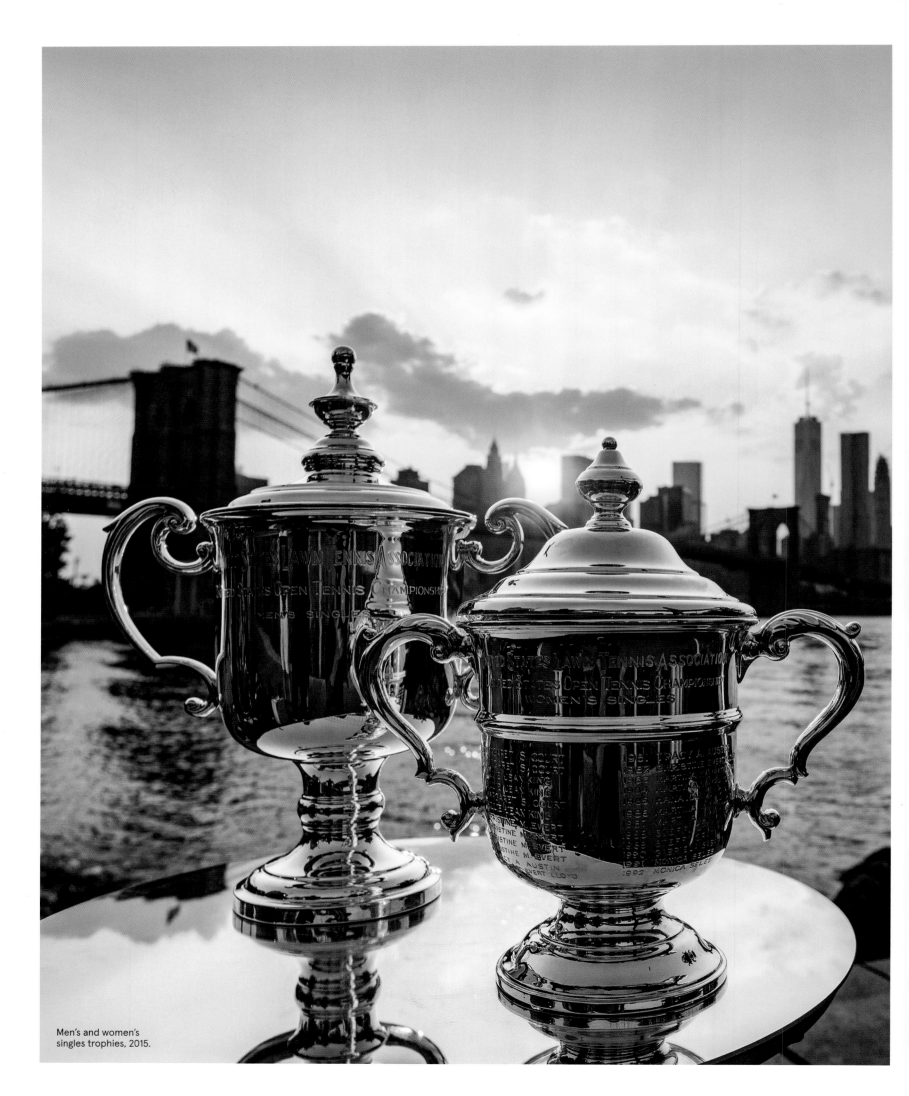

Men's and women's
singles trophies, 2015.

US OPEN

50 YEARS OF CHAMPIONSHIP TENNIS

FOREWORD BY

SERENA WILLIAMS

United States Tennis Association with Richard S. Rennert

Abrams, New York

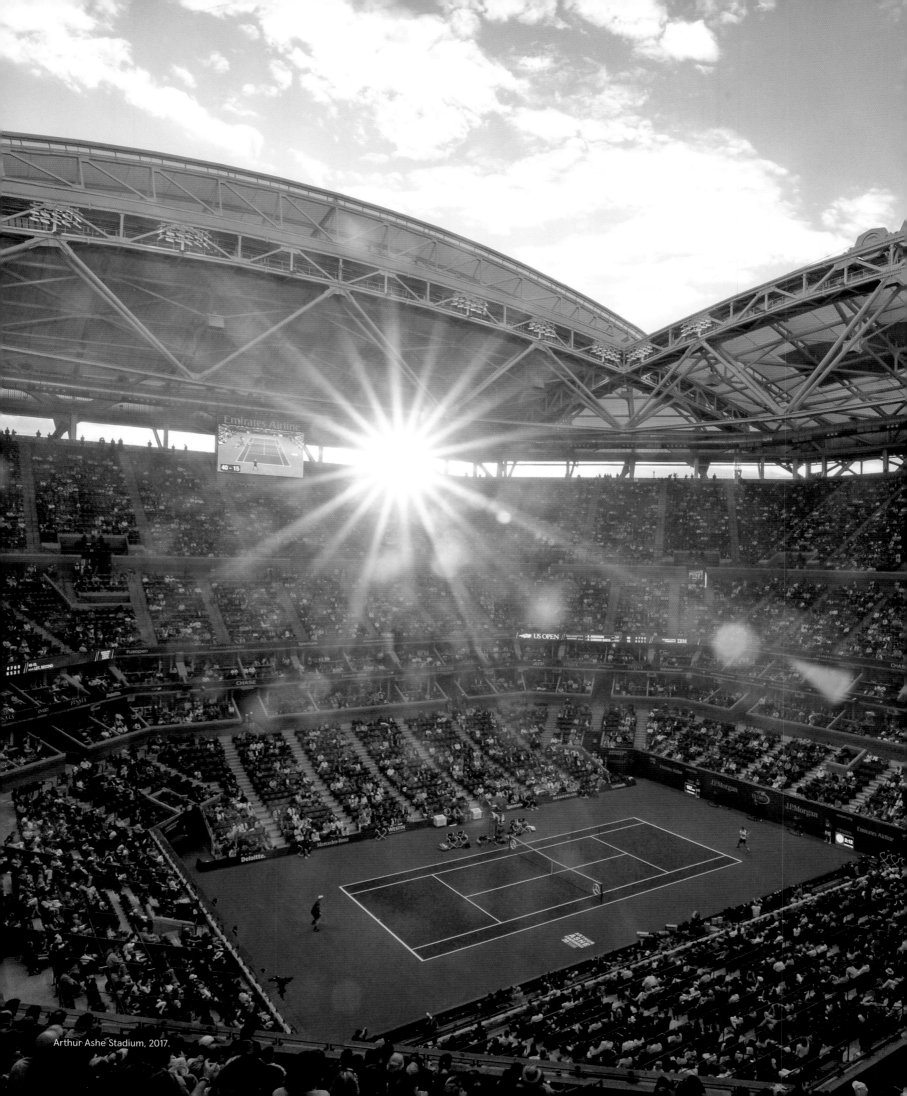

Arthur Ashe Stadium, 2017.

CONTENTS

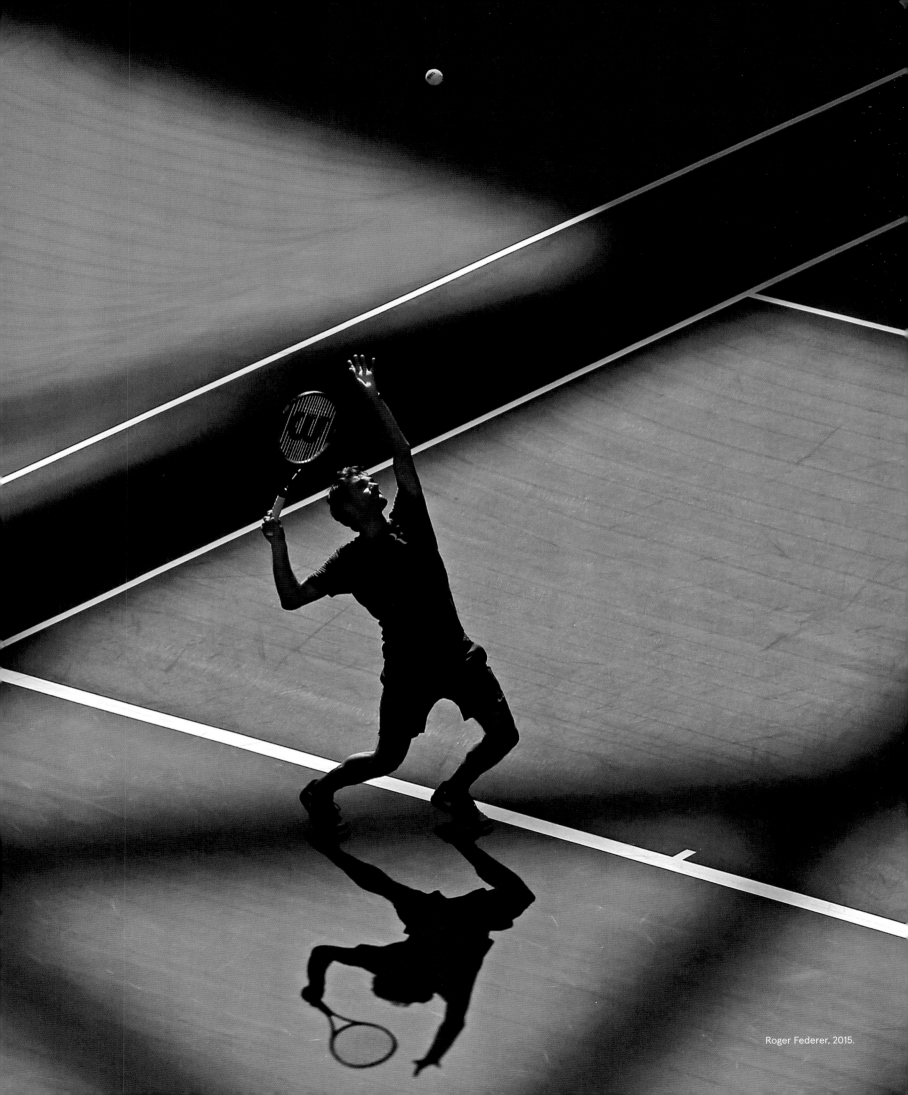

Roger Federer, 2015.

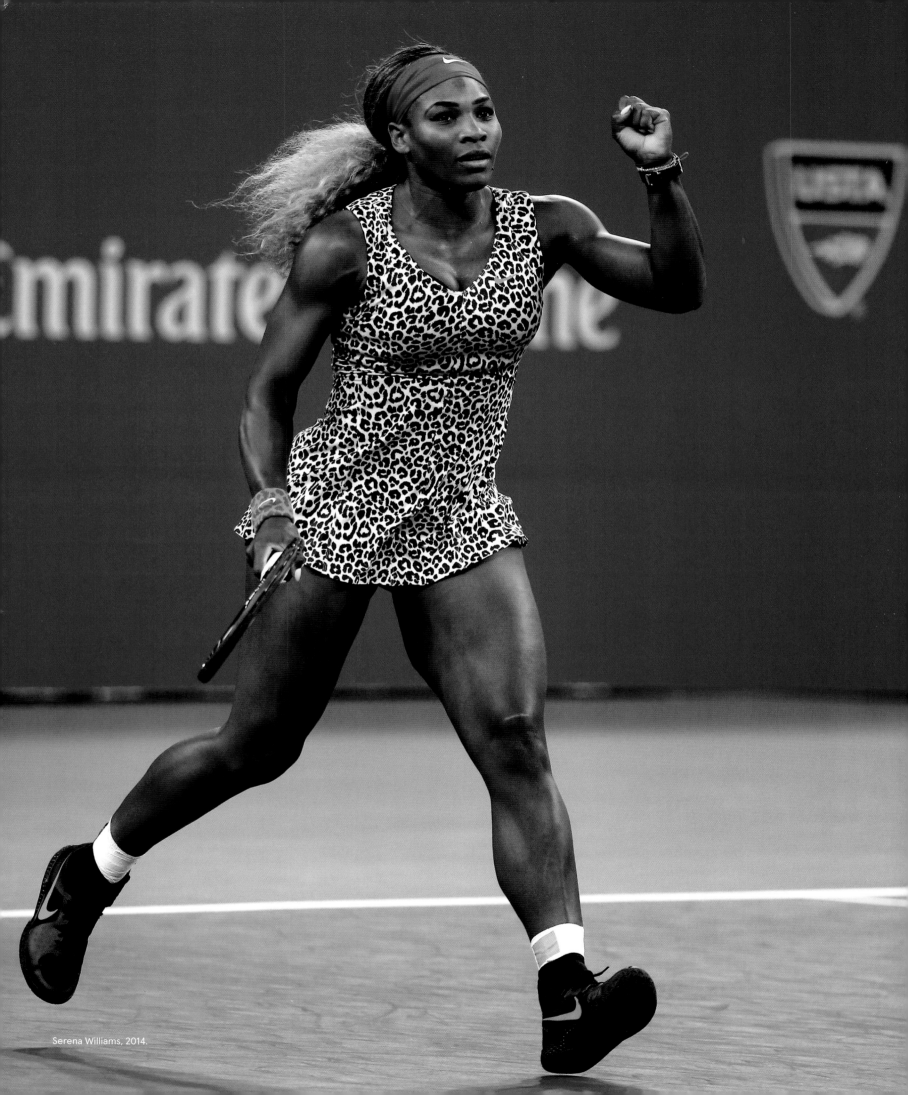

Serena Williams, 2014.

FOREWORD

By Serena Williams

TENNIS HAS ALWAYS BEEN MY ROCK. I started playing the sport at an early age with my parents and older sisters on the public courts near our home in Compton, California. We played all the time. It was our ritual. At first, we played for an hour or so a few days a week and pretty soon we were practicing for three or four hours every day. When we weren't hitting on the court, my sisters and I liked to bat a tennis ball back and forth with our hands on the sidewalk in front of our home. We made a game of it called "Grand Slam," pretending there was a major championship on the line.

It was the 1980s, and all across America tennis was riding a huge wave of popularity. When we weren't practicing, we were watching tennis on television. I studied all of the game's biggest names, especially the top women players—Monica Seles, Zina Garrison, and Steffi Graf. I was a young black girl in awe of their talent.

I played then—and still do now—simply for the love of tennis. What I love most about playing tennis is the person I've become because of it. It's the kind of sport that pushes you to find confidence from within. It teaches you to problem-solve . . . it tests your physical strength and, most importantly, your emotional endurance. Every time you step on the court, you have to bring it. You have to show up, unafraid, with one goal in mind—to win. When you win a match, there's always a next match. You have to keep working toward being better. You have to think bigger than record-breaking. You have to believe you're the best in the game, and on the court you'll find out where you stand. After countless hours of practicing and training, I look back on my child self and all the sacrifices I made with pride.

Just fifty years ago, the sport of tennis finally opened its doors to professional players—creating an economic shift that reinvigorated the game. It proved to be a renaissance that ushered in a tide of dramatic, positive change for the sport. Diversity, technology, and new audiences brought about a whole new level of competition. And that's the game that brought me my first Grand Slam title at the US Open when I was seventeen years old.

Growing up, it was always my dream to win the US Open, my home Slam. The tournament, whose showcase matches are played at Arthur Ashe Stadium in New York, is truly the world's biggest stage for tennis. And you can feel its energy more than ever with such an iconic, inspiring city around you.

As special as the US Open is, it's become more special over the years. There have been a number of game-changing initiatives and innovations, such as instant replay technology, blue tennis courts, and totally transformed grounds. I have great memories of playing in the first-ever, prime-time Grand Slam finals with my sister Venus.

But what takes me back the most is the work up to this point. From sidewalk Slams to studying every facet of what makes a great tennis player, the US Open reminds me of that dedication and drive I found in myself early on. It's where the best in tennis come to compete and set new standards of excellence, year after year. As someone who loves to play the sport as much as I do, you can't ask for more than that in a game.

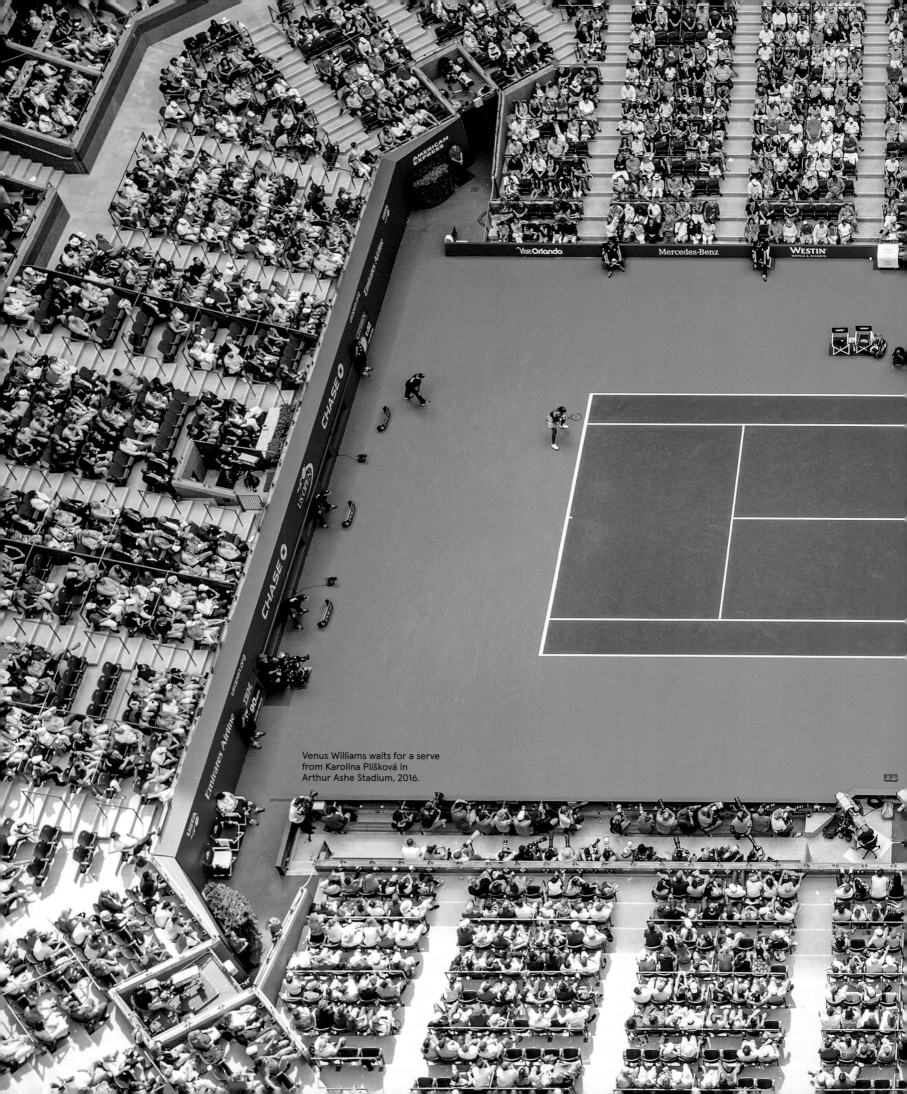

Venus Williams waits for a serve
from Karolína Plíšková in
Arthur Ashe Stadium, 2016.

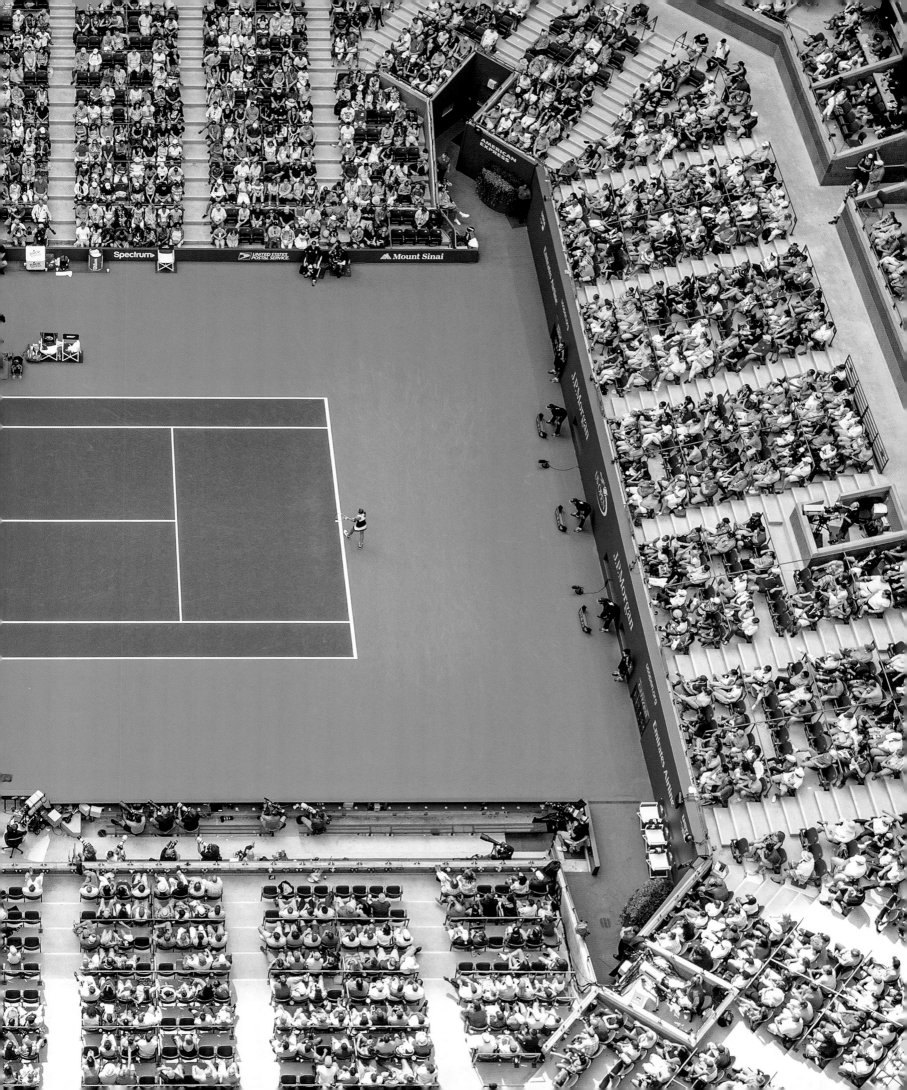

INTRODUCTION

Fifty years ago, tennis ushered in a new age, an "Open" era, that transformed the sport.

Billie Jean King (top) and
Virginia Wade play for the first
US Open championship, 1968.

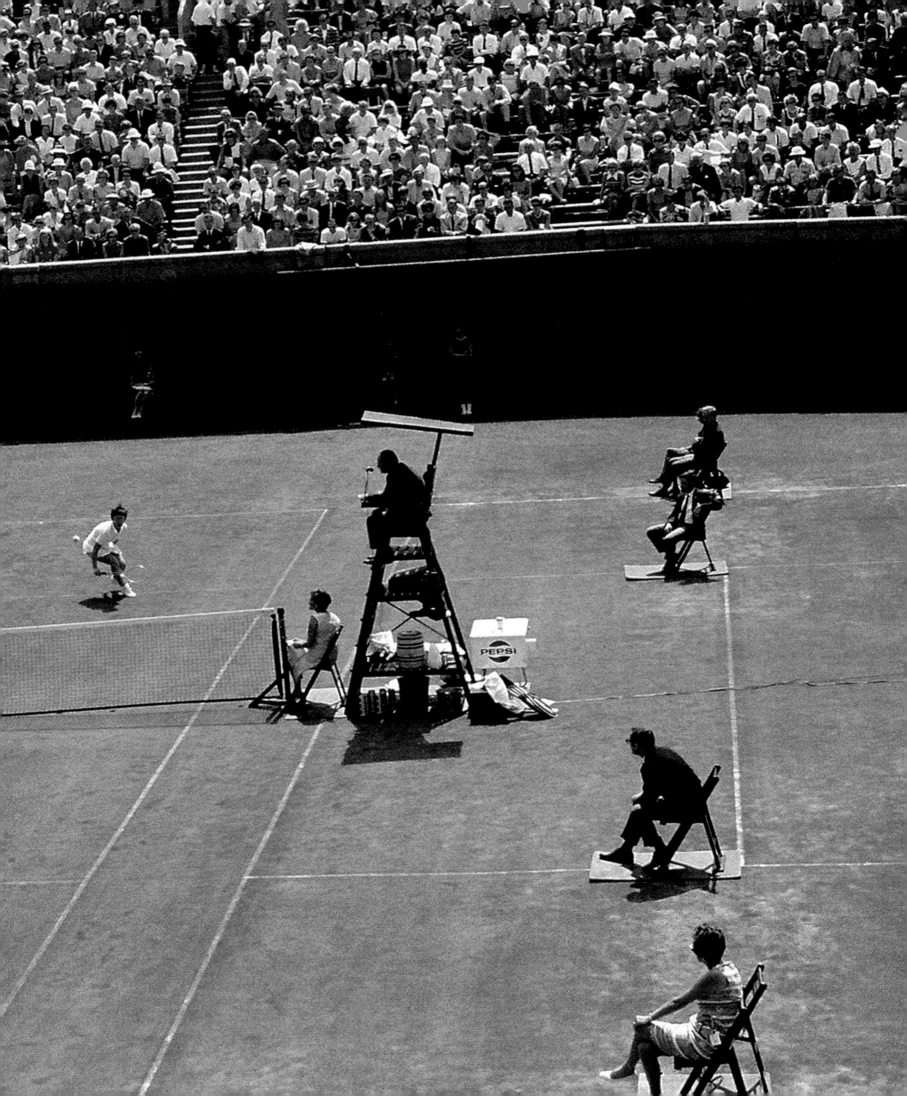

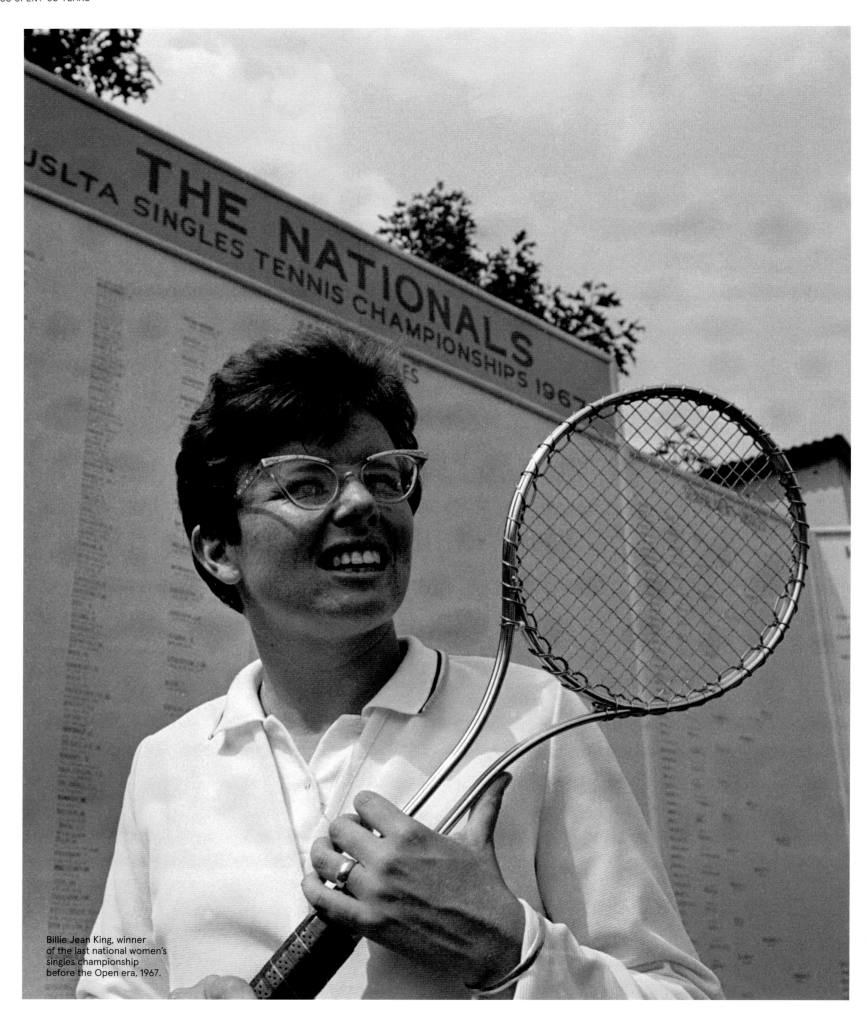

Billie Jean King, winner
of the last national women's
singles championship
before the Open era, 1967.

THE *NEW YORK TIMES* said it was the beginning of the "golden age." The *London Times* called it "a revolution on the courts." Bud Collins, who had begun covering major tennis events five years earlier and would chronicle the sport for the next five decades, described it as the "Open era," as did many of his fellow journalists and sportscasters, and that is the label that ultimately took hold.

The birth of open competition in 1968 gave the international game a tremendous boost by bringing together true amateurs and the best professional players for the first time. Often discussed but not enacted until March 30, 1968—when the concept of lifting the long-standing ban on professionals at major events was endorsed by the International Lawn Tennis Federation, the sport's international governing body—open tennis was publicly greeted with optimism and excitement (and larger purses and more spectators) but with less fanfare than a similarly radical shift in the sport would receive nowadays. It took several more years—and the arrival of several more star players—before tennis began to boom and its premier events, the Grand Slam tournaments, would be transformed into the global extravaganzas they have become a half century later.

Like the handful of open tournaments that preceded it, the inaugural US Open, which began at noon on Thursday, August 29, 1968, and was scheduled to take place over eleven days, set the tone for a historically elite sport that would rapidly become much more egalitarian. On that first morning of the first US Open, Billie Jean King coordinated a tennis clinic for 2,200 youngsters at the West Side Tennis Club in Forest Hills, New York, before making her way to its horseshoe-shaped stadium, which had been built in 1923 to serve as the permanent home of the US National Championships, the precursor of the US Open. Rising above a lush expanse of green lawns bordered by a Tudor-style clubhouse, the fourteen-thousand-seat stadium was made of steel-reinforced concrete and was wide enough to contain three grass courts. The center court would serve as the stage for King's upcoming first-round match.

The No. 1 player in America since 1965 and the defending US National champion, King had won the first open Wimbledon championship a month earlier, earning three straight singles titles at the All England Lawn Tennis and

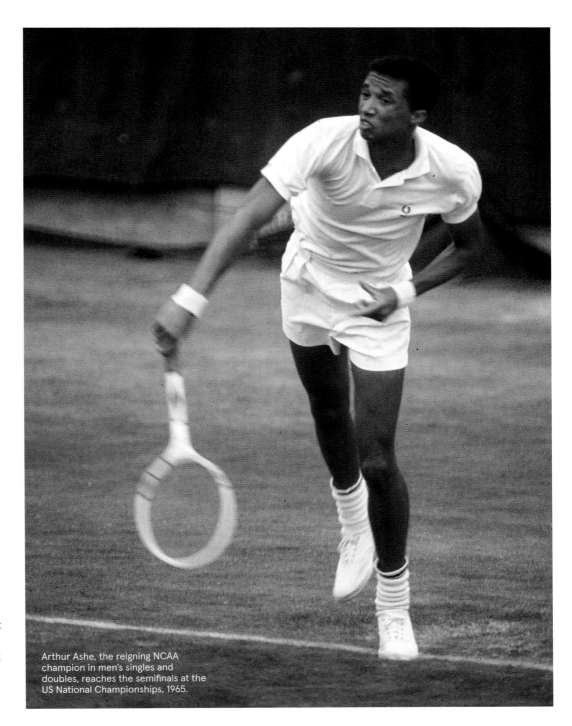

Arthur Ashe, the reigning NCAA champion in men's singles and doubles, reaches the semifinals at the US National Championships, 1965.

Croquet Club. Off the court, she had already begun making a name for herself as a champion for social change. A vocal proponent for women's sports who would campaign for equal prize money and help launch the first women's professional tennis tour, King had told a journalist who wanted to feature her on the women's page shortly before she captured the 1967 US National Championships women's singles title, "That's the trouble with this sport. We've got to get it off the society page and onto

the sports pages!" For the United States Lawn Tennis Association (now the USTA), which was formed in 1881 to serve as the governing body for tennis in America, the twenty-four-year-old King was the obvious choice to play in the inaugural stadium match in the United States' first open tennis tournament.

King's scheduled opponent for the match was twenty-year-old Helen Amos of Australia, who was preparing to make her Grand Slam tournament debut. But as the starting time

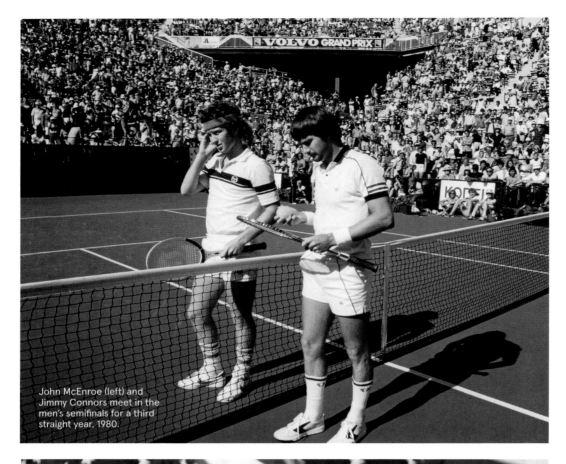

John McEnroe (left) and Jimmy Connors meet in the men's semifinals for a third straight year, 1980.

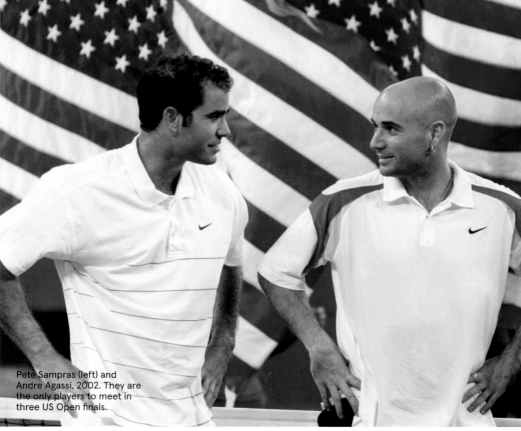

Pete Sampras (left) and Andre Agassi, 2002. They are the only players to meet in three US Open finals.

of twelve o'clock approached and the public address system repeatedly called for Amos to report to the referee's stand, she was nowhere to be found. In her stead, Vija Vuskalns entered the annals of tennis history.

A twenty-nine-year-old dentist who had attended the University of Pennsylvania and was from nearby Port Washington, New York, Vuskalns was ranked No. 8 in the Eastern section and had been accepted into the 1968 US Open as an alternate. She had played in the US National Championships in 1960 and 1961, and she was about to make her only appearance in a US Open match.

"You're in the tournament," Vuskalns was told by an official in the clubhouse lounge after Amos was defaulted. "Get into your tennis clothes."

Vuskalns changed into her tennis whites and made her way across the grass to the stadium. The cool morning had turned into a sunny and mild afternoon on the cusp of a holiday weekend, and seven thousand tennis fans had descended on the quiet Queens neighborhood to see what open tennis was all about.

After warming up with Vuskalns, King served to start the contest, thus becoming the first player to hit a match ball in US Open history.

"I was just hoping to get at least one ball back on the court," Vuskalns said later, "and I got a few." In fact, she came within a point of breaking serve in that first game but could not capitalize on her unexpected advantage, and King coasted to a 6–1, 6–0 victory, denying Vuskalns any chance of gaining a bigger place in the record books.

Although the match itself proved unexceptional, it was, in the greater scheme of things, quite extraordinary, for King was a professional tennis player and Vuskalns was an amateur. Ideological wrangling over amateur and professional standards had left the sport's international and national governing bodies—and, therefore, tennis fans—vexed for nearly half a century. Finally, the game's top players could compete at the same tournament for the first time.

The first open tournament was held in late April 1968 at the West Hants Club in Bournemouth, Dorset, England, and was followed by the French Open championships in early June. By then, it was clear that opening up the game to professional players—its biggest stars—was what the public wanted.

Over the years, the decision to permit open competition would be the sport's defining moment, as tennis's greatest champions would become household names. Chris and Martina, Jimmy and Johnny Mac, Pete and Andre, Steffi and Monica, Serena and Venus, Roger and Rafa, and, first and perhaps foremost, two of the leading figures in the inaugural US Open: Billie Jean King and Arthur Ashe, who would, after the tournament moved to a new venue in Queens, receive the ultimate recognition by having the US Open's grounds and main stadium, respectively, named after them.

"Open tennis has become a wonderful boost for the sport," Ashe said the day before the 1968 US Open began. "At Roland-Garros Stadium in Paris they had crowds such as they had not had since the days of [René] Lacoste, [Henri] Cochet, and [Jean] Borotra, the famed Musketeers. They drew more people in this year than in the three previous years combined."

For the first open Wimbledon in late June and early July, total ticket applications were four times above the usual amount. Enthusiasm for open competition continued to run high at the initial US Open, which saw attendance reach a then-record ninety-seven thousand—nearly a 15 percent rise over the 1967 tournament. Fans came to the 1968 US Open not only to watch the game's top players but also to root for the underdog amateurs—such as twenty-five-year-old US Army lieutenant Arthur Ashe—who had already begun to earn their stripes. The expectation when open tennis began was that the professionals would dominate play, but that is not what happened in the early competitions.

"When they went to England for those first few open tournaments, they just weren't in condition," said Ashe. "They'd come off playing on all kinds of surfaces and grass was still so new to them that they were disoriented. This time they'll all be ready."

Ashe was wrong about that, however. The professionals may have been regarded as tennis royalty, but the top players at Forest Hills failed to rule the courts at the 1968 US Open. Upsets involving the game's top professionals started on opening day and continued throughout the tournament, most notably when Rod Laver and Tony Roche, the men's No. 1 and No. 2 seeds, respectively, both lost in the fourth round to open up the draw.

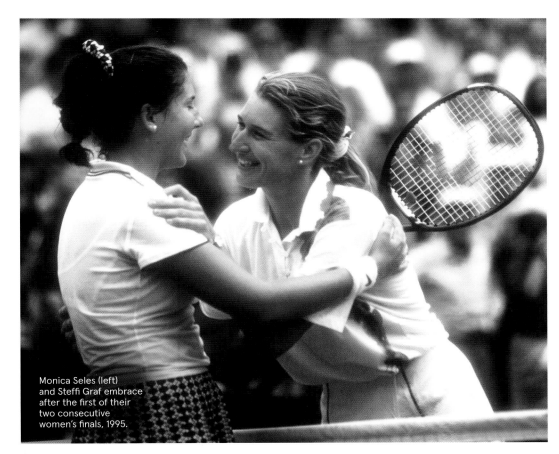

Monica Seles (left) and Steffi Graf embrace after the first of their two consecutive women's finals, 1995.

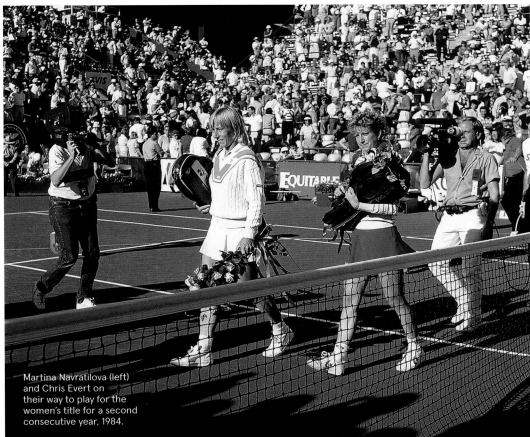

Martina Navratilova (left) and Chris Evert on their way to play for the women's title for a second consecutive year, 1984.

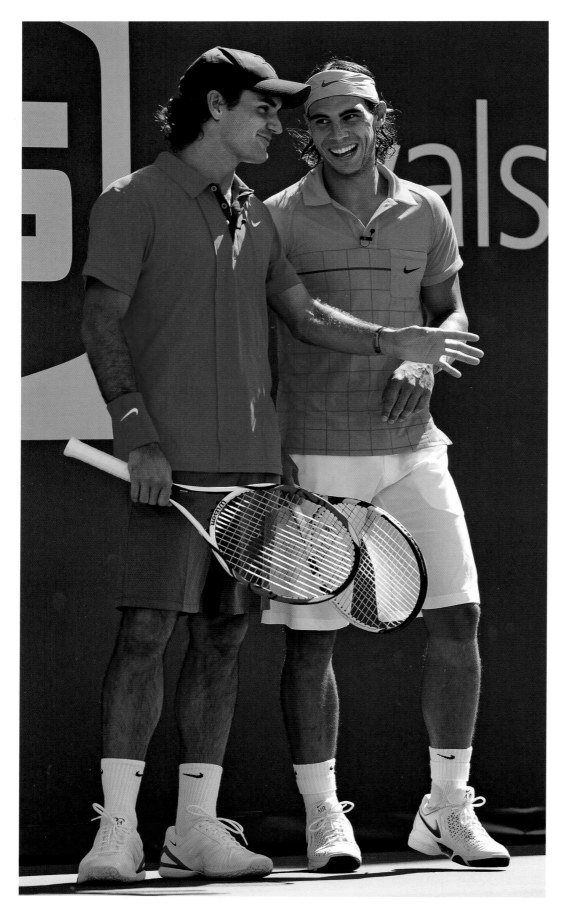

The women's singles tournament ended unexpectedly as well. A crowd of 14,106 arrived at Forest Hills on Saturday, September 7, to watch King, the world's top professional player, reach the women's singles final—the largest attendance at the West Side Tennis Club since the 1947 US National Championships. Another 14,088 fans filled the stadium the following afternoon, ready to see her claim the first-ever US Open title. Yet it was twenty-three-year-old Virginia Wade, classified as a nonprofessional under the new international rules, who stood in the late-afternoon sunlight, raising the championship trophy and receiving a check for six thousand dollars. Playing impeccable tennis, she defeated King in straight sets in forty-five minutes.

The next day, Ashe, who had retained his amateur status so he could remain on the US Davis Cup team, played for the men's singles championship against Tom Okker, whose playing status was a "registered player," which permitted him to compete as an amateur but accept prize money. The two men played a back-and-forth contest that was ultimately decided by Ashe's superior serving. Hitting twenty-six aces, he bested Okker in five sets to capture the first US Open men's singles trophy. However, due to his amateur status, he was ineligible to collect the winner's share of fourteen thousand dollars. All he received was a total of $280, which covered his tournament expenses at $20 per diem for fourteen days, including two days of practice. In a bizarre twist, the first-place prize money was handed instead to Okker, the runner-up.

Eventually, the various player classifications would disappear—and with King leading the charge, so would pay inequality. The 1973 US Open became the first Grand Slam tournament to offer equal prize money, and it has continued to do so ever since, with total compensation now topping fifty million dollars.

"The Open era of tennis unlocked a door of opportunity for all professional tennis players," said King. "Not only did we now have a chance to earn money doing what we loved, it brought us together and repositioned us as both athletes and entertainers. Beginning in 1968, the size of the crowds at tournaments increased and tennis was on an upswing. While this new era of tennis was welcomed by players and fans alike, we all wanted more, and thus began one of the greatest moments in tennis history." ●

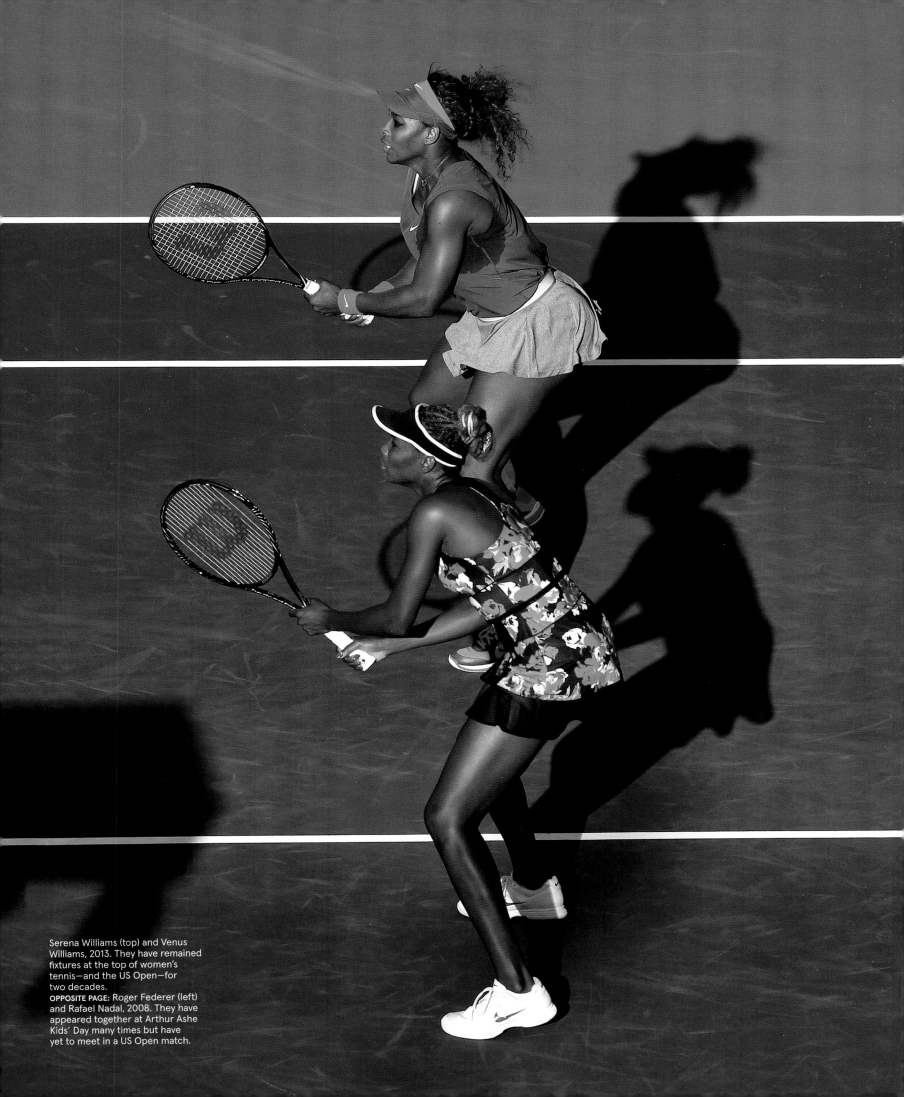

Serena Williams (top) and Venus Williams, 2013. They have remained fixtures at the top of women's tennis—and the US Open—for two decades.
OPPOSITE PAGE: Roger Federer (left) and Rafael Nadal, 2008. They have appeared together at Arthur Ashe Kids' Day many times but have yet to meet in a US Open match.

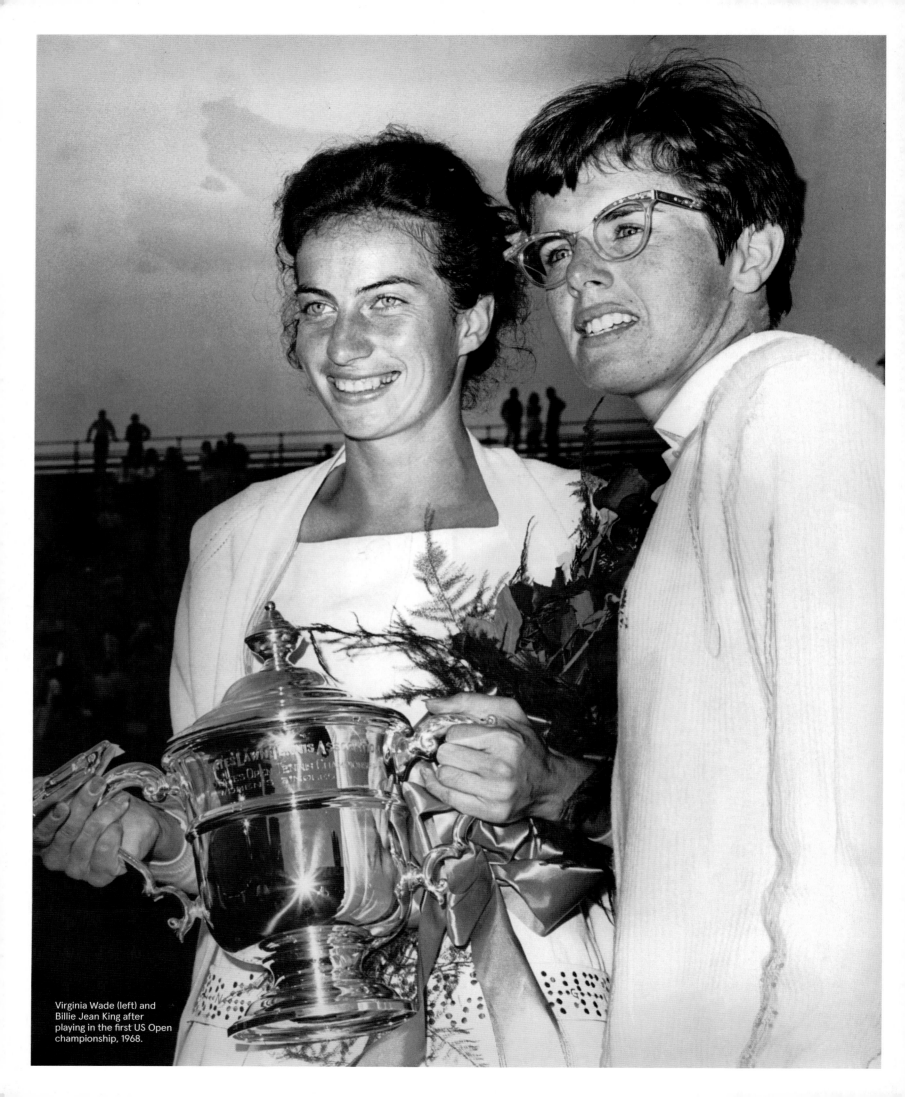

Virginia Wade (left) and Billie Jean King after playing in the first US Open championship, 1968.

19

60s

In a decade that became synonymous with change, the sport of tennis underwent the greatest transformation in its history. For the sake of the game's long-term health and growth, in 1968, the elite amateur players who had turned professional were brought back into the fold through the sanctioning of open competition.

1960

The United States Lawn Tennis Association supports a proposal for the sanctioning of open tournaments at the International Tennis Federation's annual meeting—as do the Australian, British, and French tennis associations—but the proposition fails to pass, by 107–102 votes. / Hurricane Donna disrupts play at the US National Championships as the men's and women's singles finals are delayed by six days due to rain and soggy conditions. / High crime also hits the tournament as forty thousand dollars—the tournament's receipts for the first weekend—are stolen from a safe in the West Side Tennis Club's basement. / Margaret Osborne duPont teams with Neale Fraser in mixed doubles to win her record twenty-fifth and final US Nationals title—she won three singles titles, thirteen women's doubles titles, and nine mixed-doubles titles, dating back to 1941. / Darlene Hard defeats defending champion Maria Bueno in the women's final, 6–4, 10–12, 6–4. / Neale Fraser defeats Rod Laver in the men's final, 6–4, 6–4, 9–7.

1961

Darlene Hard defeats Ann Haydon in the women's final, 6–3, 6–4. / Roy Emerson defeats Rod Laver in the men's final, 7–5, 6–3, 6–2, for the first of his twelve Grand Slam singles titles.

1962

Propositions for open tournaments are again put on the agenda at the International Tennis Federation's annual meeting but are defeated. / Thirty-five nations are represented in the US National Championships, including, for the first time, players from the Soviet Union. / Margaret Smith (later Margaret Court) becomes the first Australian woman to win the US singles title,

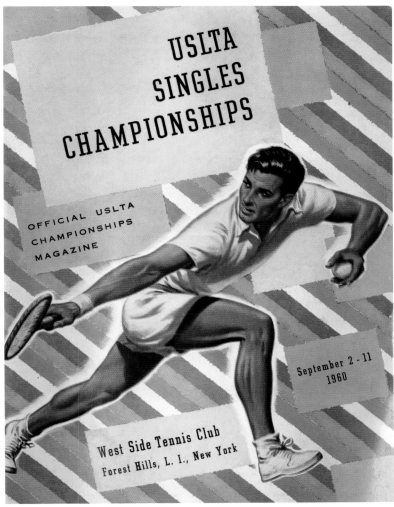

USLTA SINGLES CHAMPIONSHIPS

OFFICIAL USLTA CHAMPIONSHIPS MAGAZINE

September 2 - 11 1960

West Side Tennis Club
Forest Hills, L. I., New York

Cover of the US National Championships tournament program, 1960.

defeating Darlene Hard in the women's final, 9–7, 6–4. / Rod Laver defeats Roy Emerson in the men's final, 6–2, 6–4, 5–7, 6–4, and becomes the second man in history to complete the Grand Slam. The nine thousand fans who attend the Monday match, including Don Budge, the first man to achieve the Grand Slam, give the twenty-four-year-old Laver a standing ovation as he exits the court following his victory. He subsequently turns pro at the end of the year and does not play again in the US National Championships until the start of open tennis in 1968.

1963

Maria Bueno defeats defending champion Margaret Smith in the women's final, 7–5, 6–4. / Rafael Osuna of Mexico defeats American Frank Froehling III in the men's final, 7–5, 6–4, 6–2, to become the first Latin American man to win the US National Championships.

1964

Maria Bueno defeats Carole Caldwell Graebner in the women's final, 6–1, 6–0. / Roy Emerson defeats Fred Stolle in the men's final, 6–4, 6–2, 6–4.

1965

Billie Jean Moffitt (soon to become Billie Jean King) reaches her first US women's final. / Margaret Smith defeats Moffitt in the women's final, 8–6, 7–5, to kick off one of the greatest rivalries in women's tennis. / Manuel Santana defeats Cliff Drysdale in the men's final, 6–2, 7–9, 7–5, 6–1, to become the first Spaniard to win the US National Championships.

1966

Maria Bueno defeats Nancy Richey in the women's final, 6–3, 6–1, for the last of her four US singles crowns. / Fred Stolle defeats John Newcombe in the men's final, 4–6, 12–10, 6–3, 6–4, to join 1957 US singles champion Mal Anderson as the only unseeded men's champions.

1967

Billie Jean King defeats Ann Haydon Jones in the women's final, 11–9, 6–4. / John Newcombe defeats Clark Graebner in the men's final, 6–4, 6–4, 8–6. / The tournament marks the final time that the West Side Tennis Club hosts the amateur national singles championships. In December, the Lawn Tennis Association of Britain votes at its annual meeting to hold open tournaments in 1968, setting the wheels in motion for the advent of open tennis on an international level.

1968

The United States Lawn Tennis Association votes to open competition to professionals at its annual meeting in February and takes part in a special meeting of the International Tennis Federation in March that results in the sanctioning of open tournaments. / The first US Open is scheduled to take place at the West Side Tennis Club from August 29 to September 8, with the five major events of the US National

Championships finally coming together at the same location. / Billie Jean King plays Vija Vuskalns in the first match of the tournament in Forest Hills Stadium. / The prize money totals one hundred thousand dollars. / Total attendance is 97,294, with the largest crowd, 14,106, attending on Saturday, September 7. / Rain in the afternoon of the second Thursday and all day on the second Friday forces the tournament to be extended, concluding when the men's doubles championships are completed on September 10. / Virginia Wade defeats Billie Jean King in the women's final, 6–4, 6–2, and receives the winner's prize of six thousand dollars. / Arthur Ashe defeats Tom Okker in the men's final, 14–12, 5–7, 6–3, 3–6, 6–3, and becomes the first African American to win the men's singles title at a Grand Slam championship. Because of his amateur status, Ashe, a lieutenant in the US Army, is ineligible to receive the fourteen-thousand-dollar prize.

1969

Attendance for the tournament exceeds one hundred thousand for the first time. / Rain late in the tournament forces quarterfinal and semifinal matches to be delayed and postponed. / Margaret Court defeats Nancy Richey in the women's final, 6–2, 6–2. Court also wins the mixed-doubles title with Marty Riessen but fails to win the first US Open triple, losing in the women's doubles final with Virginia Wade to Françoise Dürr and Darlene Hard. / Rod Laver defeats Tony Roche in the men's final, 7–9, 6–1, 6–2, 6–2, to become the only man to complete the Grand Slam twice.

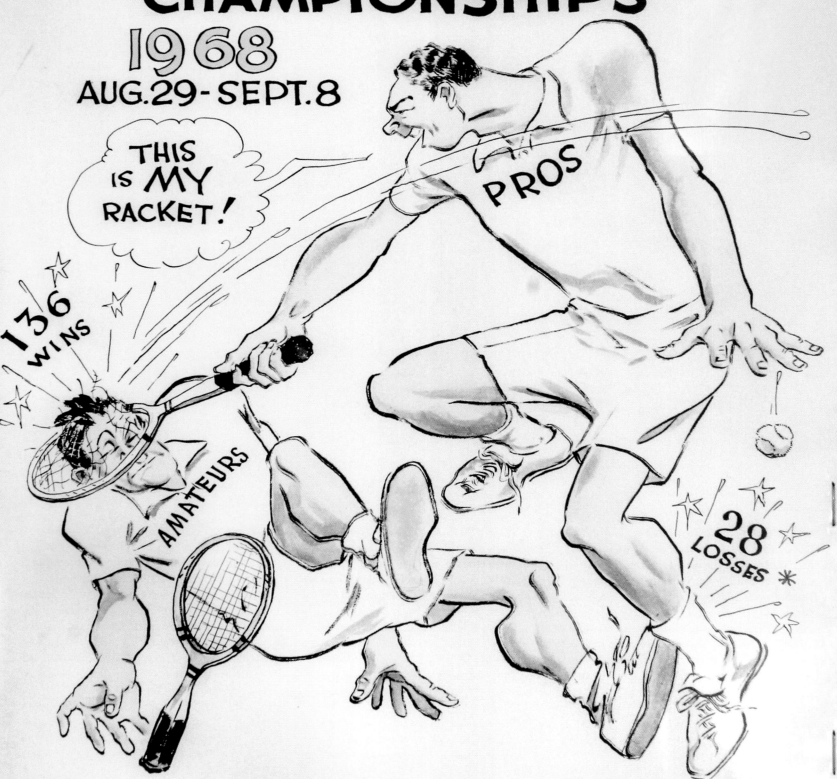

OPEN SEASON

BATTLES AND ALLIANCES CULMINATE IN AN UNPRECEDENTED VICTORY FOR THE SPORT.

•

THE CONCEPT OF OPEN TENNIS was first raised in the 1920s, as the sport's popularity increased around the world and the demand grew to see Bill Tilden, Suzanne Lenglen, Helen Wills, René Lacoste, and other top stars in action.

Well aware that many tournaments were circumventing the rules of amateurism by paying expense money to the best players, who helped attract paying customers, Julian Myrick, who had been instrumental in building the first permanent tennis stadium in the United States, at the West Side Tennis Club in Forest Hills, went so far as to tell the members of the United States Lawn Tennis Association at their 1928 annual meeting, "There is your amateur championship

and your professional championship, and eventually, as that develops, you will have your open championship."

Forty years later, Myrick's predication became a reality. "Homogenization of professionals and amateurs is here, on the grass of the West Side Tennis Club where the Nationals has been played since 1915," read the introductory piece in the 1968 US Open tournament program. "The Open is on, the money is ready, and so are the world's finest players."

To the 150 correspondents who covered the tournament, the 1968 US Open issued a press book containing the daily schedule and player listings, along with background material on the West Side Tennis Club and an uncredited

essay on open tennis, "The Open Tennis War" (reproduced on the following pages). The press book's cover illustration by noted sports cartoonist Willard Mullin (shown on the opposite page) depicts the historic coming together of amateurs and professionals, with the professionals having gained the upper hand in the first open competitions, posting 136 victories and only 28 defeats through Wimbledon. That dominance would be put to a major test at the first US Open. •

Billie Jean King (left) and John Newcombe won the singles titles at the last US National Championships without professional players, 1967.
OPPOSITE PAGE: Willard Mullin's cover illustration for the 1968 US Open press book.

The Open Tennis War

From the the 1968 US Open press book

THE WAR FOR OPEN TENNIS, waged spasmodically for 40 years with encounters ranging from minor skirmishes to international collisions, finally was crowned with success in 1968.

The victory was achieved primarily because England, the nation that had stood like Gibraltar against open tournaments when the United States was proposing them at International Lawn Tennis Federation meetings in 1930, 1933, and 1934, had the temerity in 1967 to defy the Federation in an act of open rebellion.

Going beyond the astonishing challenge to the Federation, the British gentry whose ancestors had created the line of demarcation to protect the aristocrat from sullying, contaminating contact with its sweaty social inferiors in athletic contests, not only declared that come hell or high water they would conduct Wimbledon as an Open championship, but would also end all distinc-

tion between amateurs and professionals, thus establishing a single class of competitors to be known simply as "players."

With typical British candor, the gentry declared that only in this way could tennis be rid of the shame of the "shamateur" and the secret payments of excessive "expense" money to so-called amateurs.

This British call to arms—the most revolutionary action in all the history of lawn tennis since Major Walter Clopton Wingfield, a gentleman-at-arms in Wales, gave the modern derivative of the ancient game of court tennis to the world in 1873—was destined to be victorious, thus making possible this first United States Open Tennis Championships here at the West Side Tennis Club.

But like all wars, there had to be battles, and conferences, and pacts, and defections, and unexpected triumphs and reverses.

When the Council of the British Lawn Tennis Association voted on October 5, 1967,

to recommend Wimbledon be conducted as an open event, it was the declaration of war. Previously, the International Lawn Tennis Federation had overwhelmingly rejected the British proposal by a vote of 139 to 83.

Assuming, it seemed logically, that Federation members had expressed their desires, the management committee of the Federation declared on December 2 that it would suspend the British Lawn Tennis Association if it carried through its proposal.

Immediately, panic buttons were pressed around the world. Tennis was shaken to its grass roots. A state of chaos and international anarchy was envisioned if the British, the bulwark of conservatism, stood to their guns while Federation members backed punitive action.

The suspension of the British association would mean that its players would be beyond the pale in all amateur competition outside their country and that amateurs of other nations who played in an open Wimbledon would be disqualified from any Federation-recognized tournament. The Davis Cup was in jeopardy, along with the Wightman and Federation Cups.

The British refused to abandon their collision course. On December 14, the tennis "barons" of England voted by 295 to 5 to conduct the 1968 Wimbledon tournament as an open championship and further to abolish all distinction between amateur and professional. The effective date was set for April 22, 1968, when the hard court championship at Bournemouth would be held as the first open event.

Reaction by the Federation management was swift and predictable. From Rome, on January 8, 1968, Giorgio di Stefani, Federation president, announced that the British Lawn Tennis Association would be suspended, effective April 22.

Reaction among Federation members was equally swift, but not quite as predictable. There was deep concern among tennis executives all over the world. In the hierarchy

of the U.S. Lawn Tennis Association, a deeply disturbing dilemma presented itself. It was in sympathy with the British proposal for open tennis, opposed to the English notion of eradicating all distinction between amateur and professional.

Robert J. Kelleher, USLTA president, and his aides had succeeded in leading American tennis leaders back to the position the USLTA had held on open tennis as late as 1962. In that year and also in 1961, the United States at Federation conventions had voted for home rule, permitting each nation to decide whether it wished to hold open events—and both proposals had been defeated.

A year earlier, in 1960, the USLTA along with Britain, France, and Australia, had been solidly for open tournaments. The proposition went down to defeat by the narrow margin of five votes.

The Americans then reversed themselves and went on record as adamantly opposed to various other attempts to bring about open play.

Kelleher and his forces now set out to bring the pendulum back. The USLTA president argued that open competition should be held within the framework of the International Federation, not in rebellion that would be so disruptive to amateur tennis and the program of the establishment. His thesis gained strength when it became obvious that leading players of the United States and other countries fully intended to play at Wimbledon, open or no.

A key portion of the USLTA campaign for compromise was the thinly-veiled threat to the Federation to pull the United States out of the international body, but it was a threat Kelleher hoped would never materialize.

Support for the British stand gradually grew within the USLTA as Kelleher's forces explained the problem in American terms.

On February 3, 1968, at the USLTA annual meeting in Coronado, California, America took its strongest stand in favor of open tournaments, while still resoundingly rejecting the elimination of the distinction between amateur and professional. Kelleher, as the delegate from America, was empowered to pose the threat of Federation withdrawal if the Federation did not alter its stand on open tennis and permit home rule. The USLTA did not go so far as to grant permissions for Americans to compete in a Wimbledon open held without Federation sanction, but nevertheless it was obvious that the United States would take a tough stand at a special Federation meeting.

The British, meanwhile, had acquired other allies. Australia, strongly against the open idea in 1962, now endorsed both the open game and the single class of player proposition, yet affirmed its allegiance to the Federation, seeking change through legal and not rebellious methods.

Sweden became the initial sponsor for a special Federation meeting to avert chaos. Kelleher, working with the Swedish Association, set up a conference in Paris for March 30 as a last chance for the Federation to sanction open play before the British made their move on April 22.

The conclave in the Place de la Concorde on March 30 changed tennis for all times. Without a single dissenting vote, the Federation sanctioned open tournaments, to the number of 12 for 1968.

For the British, their victory was not a total one, for the Federation refused to end distinction between amateur and pro, voting for the "retention of the notion of amateurism in the rules of the ITLF, as its removal would indisputably weaken the ideal which the ITLF has the duty to protect and develop."

However, the Federation, in the face of strong opposition from Kelleher, did make it possible for countries that wished to do so to set up a class of "registered" players who can profit by any amount they can command for competing in tournaments and still remain eligible for amateur events. Jean Borotra of France had sponsored such an idea since 1960.

The way was now clear for open tennis to become a reality, and it was at Bournemouth that the first historic confrontation took place.

Many experts had felt that in open competition, the pros would prove vastly superior to the amateurs. Yet the amateurs have served strident notice that they are not to be taken lightly. The brightest of the amateur stars have turned in stunning upsets, and at Wimbledon they were sensational, with Arthur Ashe and Clark Graebner going all the way to the semifinals.

So splendid has been the competition, that record throngs have been attracted, eager to see tennis in its new raiment. Here at Forest Hills, in the debut of open tennis in America, professionals will be seeking a share of the largest purse—$100,000— ever offered athletes who wield a racquet. The lure of that money, and the desire of the amateur to prove he is every bit as fine a player as the one who plays for pay, will assure one of the greatest of all tennis tournaments. ●

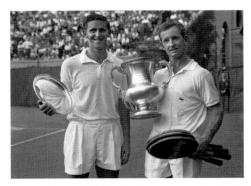 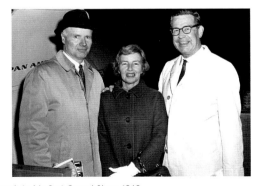

LEFT: Rod Laver (right) holds the championship trophy after defeating Roy Emerson (left) at the US Nationals to complete his first Grand Slam, 1962. CENTER: Margaret Court claims the women's title at the US Amateur Championships, a continuation of the US National Championships, a week before the initial US Open, 1968. RIGHT: USLTA President Robert Kelleher (right) travels to Paris for the landmark meeting that sanctioned open tennis, accompanied by First Vice President Alastair Martin (left) and Edith Martin, 1968. OPPOSITE PAGE: Tony Roche (left) overcomes John Newcombe to advance to the men's final, 1969. Both players belonged to a group of touring professionals known as the Handsome Eight.

WEST SIDE STORY

THE WEST SIDE TENNIS CLUB BRINGS THE
US NATIONAL CHAMPIONSHIPS TO NEW YORK CITY.

By Beatrice E. Hunt

•

NINE DIFFERENT LOCATIONS have hosted one or more of the five major events of the US National Championships/US Open since the inception of the men's singles and doubles competitions in Newport, Rhode Island, in 1881. But none can claim a longer tenure than the West Side Tennis Club. Located in a residential neighborhood in Forest Hills, New York, the Club staged the men's and/or women's championships every year from 1915 to 1967 before finally bringing all five events together for good in 1968, when the venue became the US Open's home for its first ten years.

The West Side Tennis Club was established on April 22, 1892, by thirteen young tennis players in New York City. They were tired of the long wait time to play on the municipal courts of Central Park, so they leased the nearby block front on Central Park West between 88th and 89th Streets. The grounds opened in June with three dirt courts and a pine-board shack for a clubhouse. By season's end, membership in the Club had increased to

forty-three, and two auxiliary courts had to be added. The Club held its first open tournament two years later, with an entry list of sixty-five, including many well-known players of the day. A large and enthusiastic audience was in attendance for each session. The tournament was such a success, in fact, that the United States National Lawn Tennis Association (USNLTA) awarded the prestigious Metropolitan Championship to the Club in 1897, with a handsome challenge cup given to the winner.

But changes were on the horizon. In 1902, builders sought the grounds of the West Side Tennis Club as a choice location for a high-end apartment house. A new location for the Club was found on a vacant plot on 117th Street between Morningside Drive and Amsterdam Avenue, across from Columbia University and close to the new Cathedral of St. John the Divine, on property owned by the Drexel banking family of Philadelphia. For twenty dollars a year per court, the Club settled into its new home. Four good dirt courts were constructed, with room for four more. A house

on the grounds was remodeled, and modern plumbing, showers, and lockers were installed. Membership quickly reached the limit of 110, and there was a large waiting list.

The growth of Manhattan caught up with the West Side Tennis Club again in 1908, and a second move was required, this time to a remote spot that seemed as though it might become a permanent location. The facility covered two city blocks at 238th Street and Broadway and was leased with the privilege to purchase. A fine two-story clubhouse was erected in the center, surrounded by twelve grass courts—the Club's first experience with this surface—with fifteen clay courts around them. By this time, the West Side Tennis Club had become recognized as the most important tennis club in the metropolitan area and continued to hold the Metropolitan Championship annually. The evolution from a limited, quality place for a few New Yorkers to play tennis to an expanding forum for competitive events was well under way.

In 1911, a further step forward was taken

when the final round of the Davis Cup was held on the 238th Street courts. The United States beat the British team, and about three thousand spectators crowded the wooden stands around the courts. This evidence of popular interest led the West Side Tennis Club's Board of Governors to seek a larger area where the Club could expand and establish itself as the premier tennis club in the United States. The Club laid aside $13,000 to assist in the purchase of a permanent site. For a time, the possibility of buying the grounds at 238th Street was considered. But the Club also looked at larger, alternate locations in the five boroughs, as well as in Nassau County and in New Jersey along the Hudson River. The Club received fifty-three offers, and in December 1912, the decision was made to purchase more than ten acres in Forest Hills, New York, for $77,000, with a clubhouse to be built for $30,000. Forest Hills was only fifteen minutes by rail from Pennsylvania Station in Manhat-

tan, with subway transportation in prospect.

The West Side Tennis Club opened its first tennis courts in Forest Hills in the fall of 1913 while continuing to maintain court facilities at 238th Street and 117th Street. In 1913, another Davis Cup tie was held on the 238th Street grounds. Still, having taken the bold step of building a new facility in Forest Hills, with a handsome clubhouse and a magnificent group of fifty-three clay and grass courts, it became necessary to justify the new location. The property was heavily mortgaged, and there was little cash in the bank. Fortunately, the new Club was an unrivaled tennis facility, putting it in an excellent position to bid for the top events of the upcoming tennis season. The most important of these was the 1914 Davis Cup Challenge Round Final. An arrangement was made with the USNLTA to hold the Challenge Round in August 1914 on the new courts. Twelve thousand people overflowed the wooden stands erected for the match, then

the largest crowd to watch a tennis event. Although the United States, the defending champion, lost to Australasia, 3–2, the tie was fiercely fought and remains one of the highlights in Davis Cup history.

The great outpouring of spectators revived the debate to move the US Championships from the Casino in Newport, Rhode Island, where they originated in 1881. Such a move had been contemplated for many years. The attendance in Newport was largely confined to the summer residents who made it more a social than a sporting event. In 1911, a proposal to remove the championships from Newport was made at the USNLTA annual meeting but lost by a vote of 90 to 65. At that time, there was no bidder against Newport, and only one club, the Merion Cricket Club in Haverford, Pennsylvania, said it would submit an entry if the USNLTA decided to move the tournament.

In February 1915, a proposal to move the men's singles championship to New York was

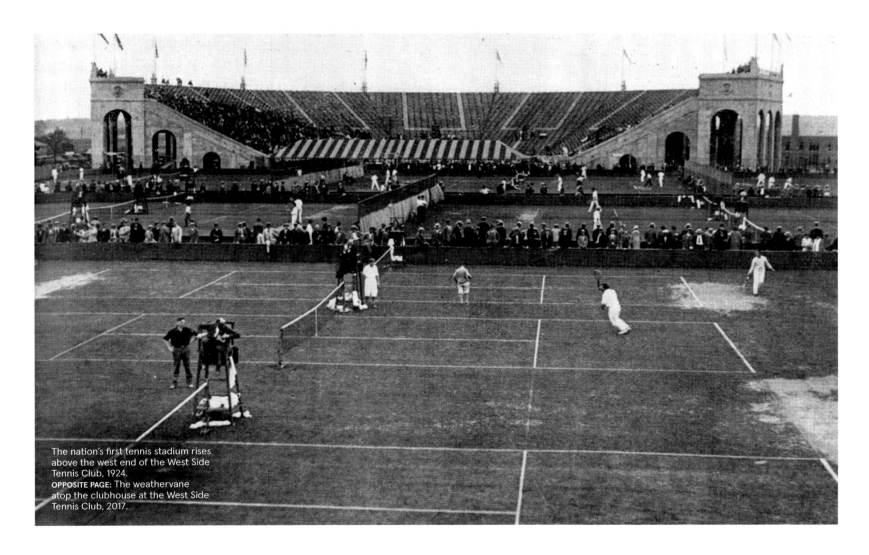

The nation's first tennis stadium rises above the west end of the West Side Tennis Club, 1924.
OPPOSITE PAGE: The weathervane atop the clubhouse at the West Side Tennis Club, 2017.

brought before the USNLTA annual meeting by a committee of 125 players led by Karl Behr. To support their argument, the committee members prepared circulars outlining the reasons to make a change. Among the points was that tennis was a national sport, and New York was the playing center of the country; the West Side Tennis Club had superior court conditions, facilities, and transportation; and the location would help attract the greatest number of players and fans.

A West Side Committee, headed by Club president Julian Myrick, Lyle Mahan, and Behr also campaigned to persuade the USNLTA to transfer the US National Championships to Forest Hills. The Club's membership now included nine hundred players, with thirty ranked in the Top 100 in the United States. But they faced opposition. A document by those who wanted to keep the championships in Newport was signed by twenty-nine players, including eighteen former singles champions, and was circulated as well. The campaigns conducted by both sides resulted in the largest, the liveliest, and the longest meeting ever held by the USNLTA. The vote was very close, 129 for New York and 119 for Newport.

Even after New York was chosen as the tournament's new site, the USNLTA announced it would accept bids from other cities wanting to host the US Nationals the following year, in 1916. West Side Tennis Club officers vowed to host the 1915 US Nationals so impressively that no other site would be considered. Careful planning, heavy and friendly media coverage, good crowds, and a sizable profit kept the championships in Forest Hills until 1920. Starting the next year, the USNLTA decided to spread things around, holding the Davis Cup Challenge Round at the West Side Tennis Club and the singles championships at the Germantown Cricket Club in Philadelphia, Pennsylvania. Although the United States successfully defended the Davis Cup against Japan in 1921 and Australasia in 1922 and 1923, the superiority of the American team, led by "Big Bill" and "Little Bill"—Bill Tilden and William Johnston—was so great that the matches did not attract the hoped-for attendance. Commencing in 1921, the women's singles championships were held at Forest Hills, but they also failed to draw larger crowds. It was evident that measures had to be taken to bring the more lucrative

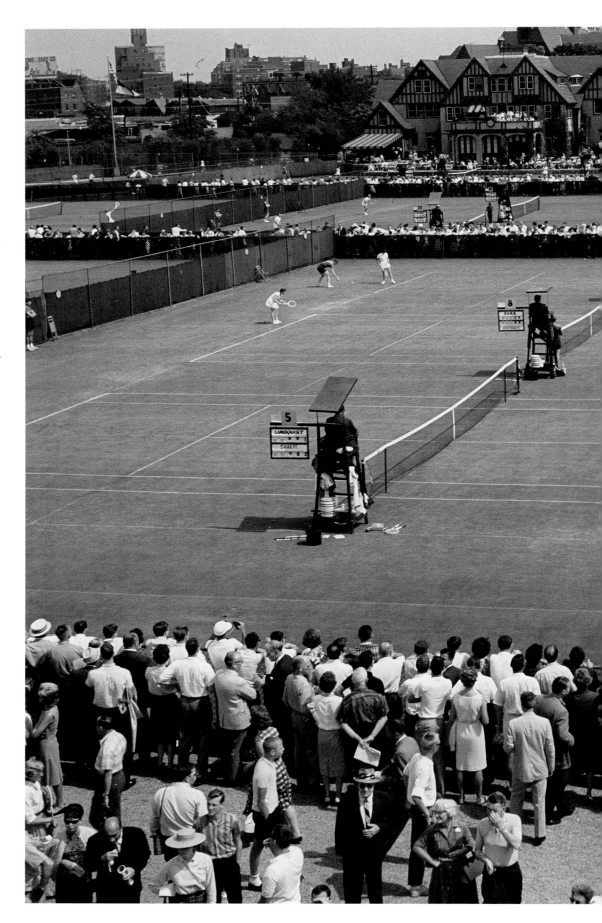

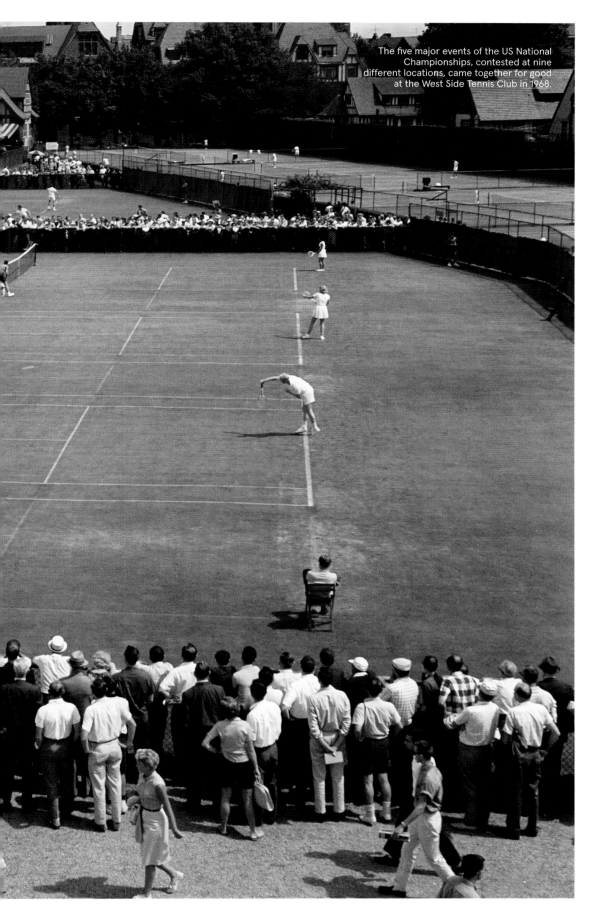

The five major events of the US National Championships, contested at nine different locations, came together for good at the West Side Tennis Club in 1968.

men's championships back to Forest Hills.

Once more, a bold move was undertaken by the West Side Tennis Club. Not only was it expensive to demolish and re-erect the wooden stands each year, it deprived the members of about eight of the best grass and clay courts at the time of year when they were most playable. Early in 1923, West Side's Board of Governors appointed a committee to prepare plans for the building of a stadium on the grounds. The inspiration to build a new stadium came in part from the All England tennis club, which in 1922 had built the world's first tennis stadium for the Wimbledon Championships and succeeded in attracting large crowds.

Charles S. Landers, an engineer and a past president of the West Side Tennis Club, and Kenneth M. Murchison, an architect and Club member, prepared plans for a stadium seating approximately thirteen thousand persons. In order to finance the construction of the stadium, which was expected to cost at least $150,000, a contract was signed with the USNLTA whereby the West Side Tennis Club would have the right to hold the Davis Cup Challenge Round in 1923, the US National men's singles championship from 1924 to 1928, and either the singles, doubles, or Davis Cup, from 1929 to 1931, thus covering a ten-year period. With this contract in hand, the Club, in order to finance the construction, voted to allot not fewer than 1,500 choice seats in the stadium on ten-year subscriptions at a cost of $100 each plus $10 federal admission tax. The available seats were quickly subscribed to, and the construction of the stadium started in April 1923. America's first tennis stadium was able to host its first matches four months later. Although not entirely completed, the stadium was used for the first time for the initial competition of the Wightman Cup, which was held to generate interest in women's tennis similar to the Davis Cup. A few weeks later, the Davis Cup Challenge Round was played in the stadium, followed by the US National women's championships. According to the agreement, the men's singles championships returned to Forest Hills in 1924.

The stage was set. The West Side Tennis Club would serve as the main home of the US National Championships and play host to the world's best men's and women's players for the next half century. ●

MARATHON MAN

ARTHUR ASHE GOES THE DISTANCE AT
THE INAUGURAL US OPEN, REACHING THE TITLE MATCH
IN BOTH SINGLES AND DOUBLES.

•

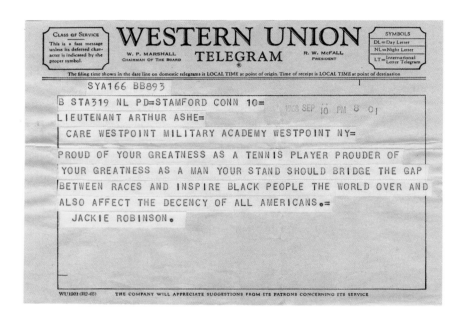

FOUR DAYS BEFORE the start of the 1968 US Open, Arthur Ashe captured the men's singles title at the US Amateur Championships. The tournament, held at the Longwood Cricket Club in Brookline, Massachusetts, was the result of 1968 being a transitional year for tennis. Because the arrival of open competition meant the 1968 US Open, formerly known as the US National Championships, was admitting professionals as well as amateurs, the United States Lawn Tennis Association decided to create a separate national championship for amateurs and start the event a week before the US Open began.

For nonprofessional players, the new tournament was more or less a continuation of the US National Championships, and so it drew all the top American amateur players,

including twenty-five-year-old Ashe. The US Amateur Championships were televised nationally on PBS, and winning it elevated Ashe's popularity as he became the first American man to win the national championship title since 1955. Facing Bob Lutz in the final, Ashe was trailing two sets to one, but he took the fourth and fifth sets to capture the tournament. The victory also ensured him of the No. 1 amateur singles ranking for the first time. Following the final, he took a short break from tennis before heading to New York later in the week to begin his march into history at the 1968 US Open.

The inaugural US Open featured a men's singles draw of ninety-six players, with thirty-two players granted a first-round bye. Among the men receiving byes was Ashe, the No. 5 seed. Making his US Open debut on

the second day of the second round, Sunday, September 1, 1968, on a drizzly afternoon, he defeated fifty-two-year-old Frank Parker—who had been ranked among the top ten players in the United States for seventeen consecutive years—in straight sets. In the days that followed, he also defeated Paul Hutchins of England and No. 14 seed Roy Emerson of Australia without dropping a straight set to reach the quarterfinals. There he lost his first set of the tournament, to No. 16 seed Cliff Drysdale of South Africa, but won the next three sets to advance to the semifinals, which were moved back a day, to Sunday, September 8, after persistent showers caused Friday's schedule to be canceled. His Davis Cup teammate, No. 7 seed Clark Graebner, awaited him.

Ashe was technically part of three matches that Sunday: the singles semifinal, in which

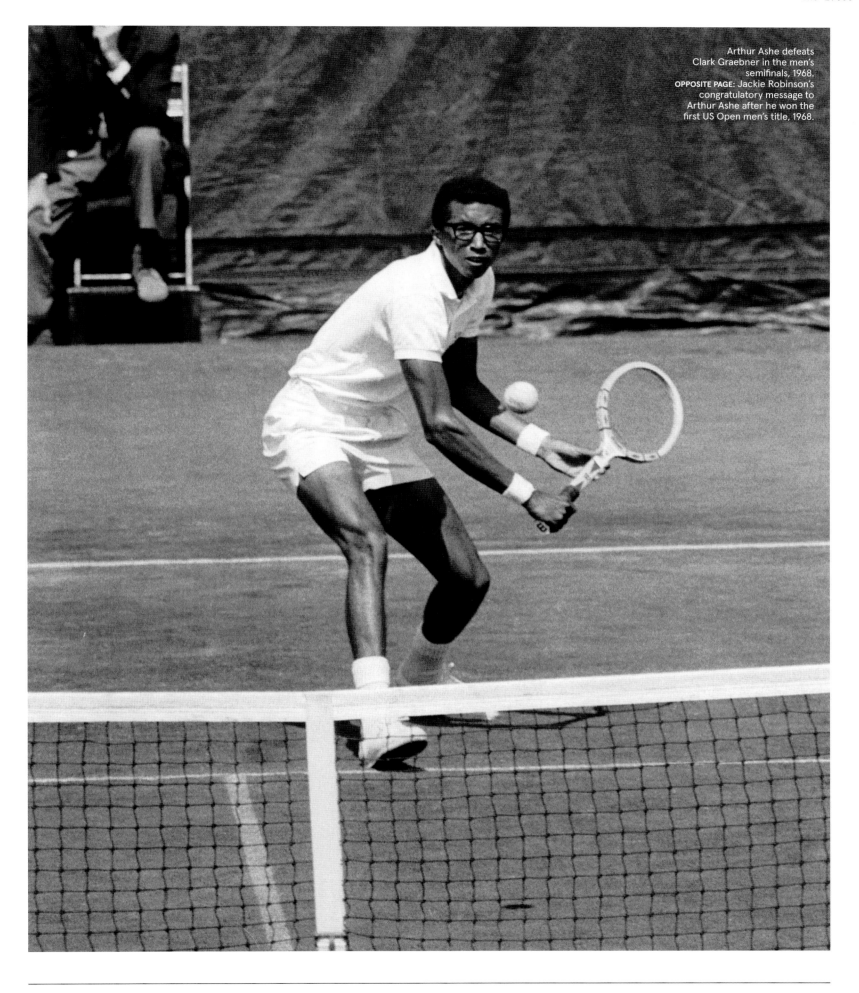

Arthur Ashe defeats
Clark Graebner in the men's
semifinals, 1968.
OPPOSITE PAGE: Jackie Robinson's
congratulatory message to
Arthur Ashe after he won the
first US Open men's title, 1968.

he defeated Graebner in four sets (a match recounted by John McPhee in his classic book *Levels of the Game*); a doubles quarterfinal, which Ashe and his first-time partner, Andrés Gimeno, won by default; and a doubles semifinal, which was called because of darkness, with Graebner and Charlie Pasarell leading Ashe and Gimeno, 4–6, 6–3, 6–4, and 4–4 in the fourth set.

Although the first US Open was a huge success, drawing significantly more fans than the 1967 US National Championships, the attendance for the men's singles final suffered from the rescheduling. Moved to a three o'clock start on a Monday afternoon, the match attracted 7,100 fans, just over half the capacity of the 14,000-seat Forest Hills Stadium.

Those on hand were treated to a contrast in styles between the hard-serving Ashe and the fleet-footed Tom Okker. Ashe's powerful serve ultimately decided the contest, as he unleashed twenty-six aces and consistently undermined Okker's strength—his return game—in their back-and-forth battle, which went five sets and lasted two hours and forty minutes. Near six o'clock, as Ashe approached the baseline to serve for the championship, the spectators stood and clapped for what proved to be the sixty-fifth and final game of the match—and still the most games played in a US Open final. Ashe responded by winning the game at love, driving a forehand volley past Okker to secure a 14–12, 5–7, 6–3, 3–6, 6–3 victory and become the first man to win a US Open championship and the first black man to win a Grand Slam men's title.

And yet Ashe still had more tennis to play. An hour after he walked across the stadium grass to accept the singles championship trophy—his amateur status made him ineligible to receive the top prize of fourteen thousand dollars—he returned to center court to complete the men's doubles semifinals. Ashe and Gimeno split sixteen games with Graebner and Pasarell before darkness fell that evening and halted the match for the second consecutive day, with the fourth set knotted at 12-all. It would be two years before the drama and excitement of the tiebreak would be introduced at the US Open and seven years before lights were installed at the West Side Tennis Club, enabling night matches to make their US Open debut.

When the men's doubles semifinal resumed at 10:30 the next morning, Ashe and Gimeno staved off defeat by taking the fourth-set marathon, 20–18. Both teams tried to gain the upper hand in the decisive fifth set, knowing a berth in the final was at stake, but neither duo was able to do so, until Ashe and Gimeno pulled ahead at last, 15–13, to win the semifinal. The match took three days to complete and ninety-five games—by far the most games that have been played at the US Open in doubles.

That same Tuesday, Ashe and Gimeno were granted a brief rest period and then returned to the court to play Bob Lutz and Stan Smith for the men's doubles championship. A tight first set went to Lutz and Smith, 11–9, and they made sure Ashe and Gimeno did not fashion a comeback by taking the next two sets, 6–1 and 7–5, for the title. The match ended at 2:33 p.m. on September 10, with Ashe walking off the court having played 81 games each day for three straight days. Major League Baseball teams play 162 games during a full season. Ashe played that many games in less than twenty-four hours. He remains the only player in history to win the US Amateur Championships and the US Open in the same year. ●

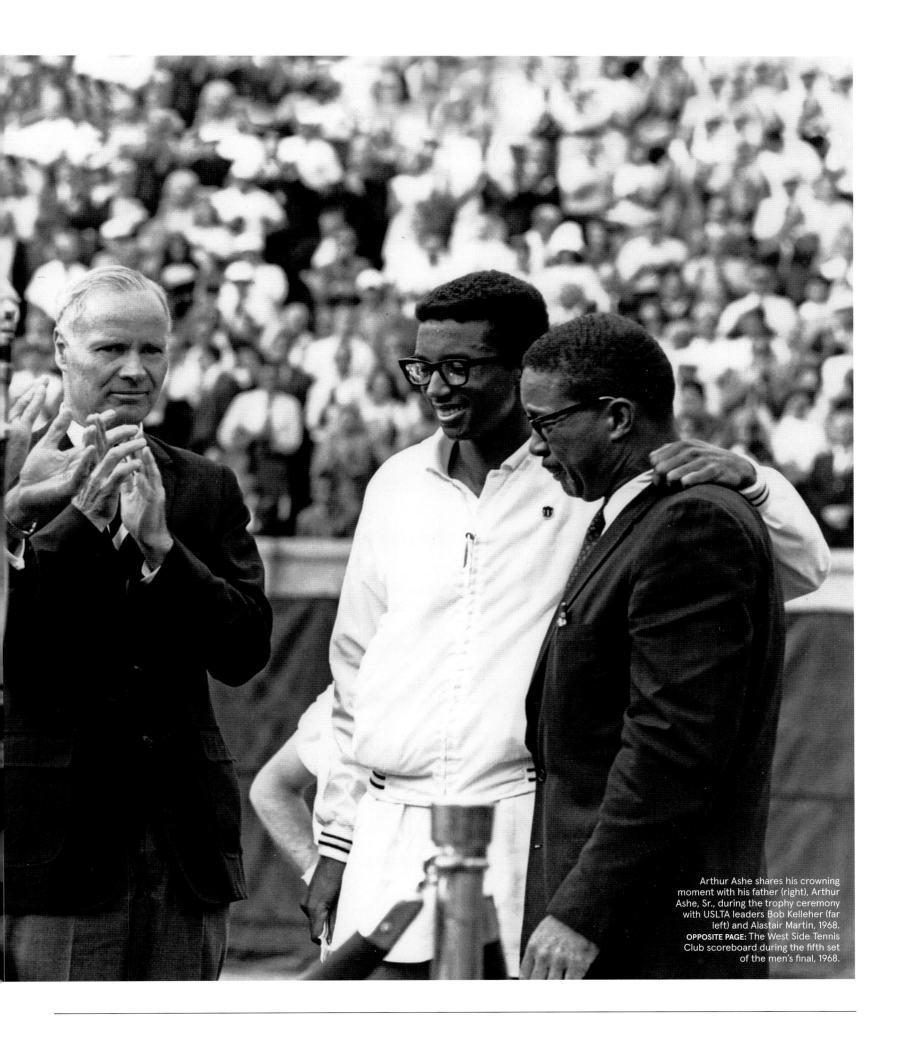

Arthur Ashe shares his crowning moment with his father (right), Arthur Ashe, Sr., during the trophy ceremony with USLTA leaders Bob Kelleher (far left) and Alastair Martin, 1968. **OPPOSITE PAGE:** The West Side Tennis Club scoreboard during the fifth set of the men's final, 1968.

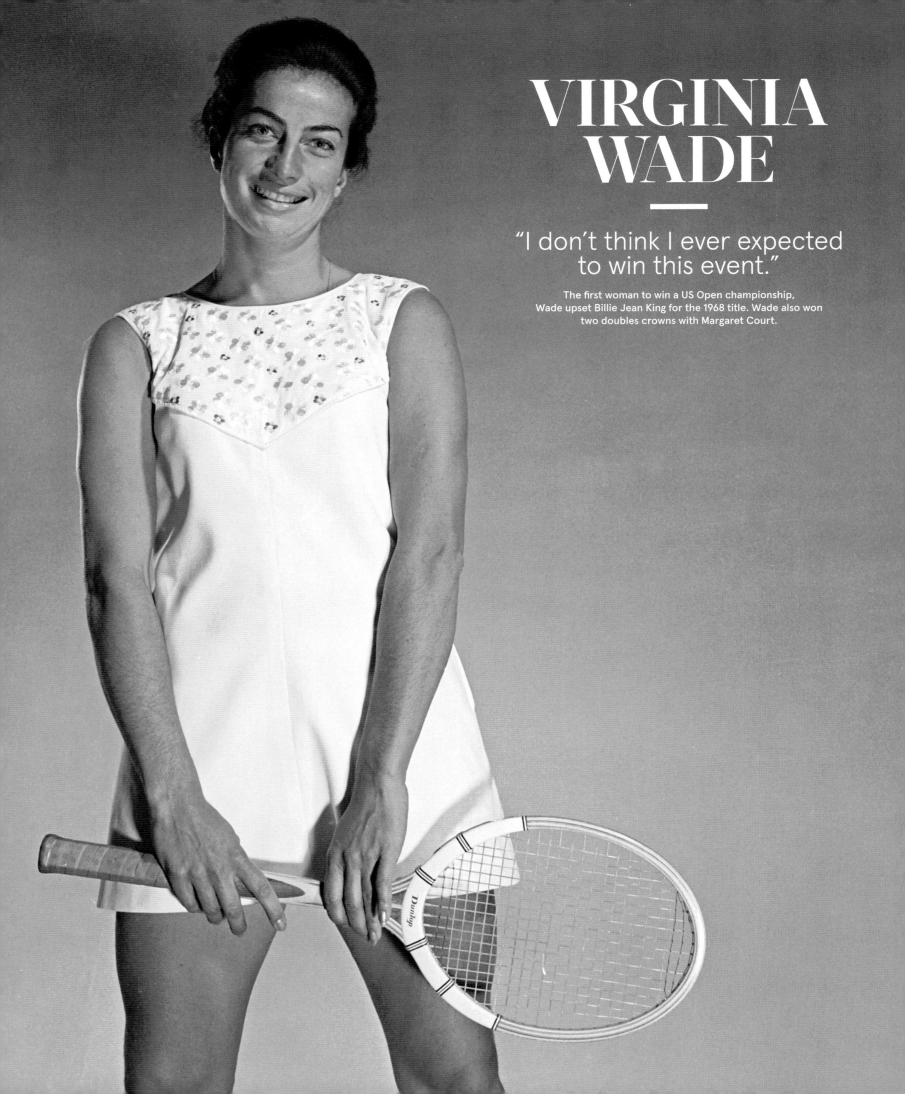

VIRGINIA WADE

—

"I don't think I ever expected to win this event."

The first woman to win a US Open championship, Wade upset Billie Jean King for the 1968 title. Wade also won two doubles crowns with Margaret Court.

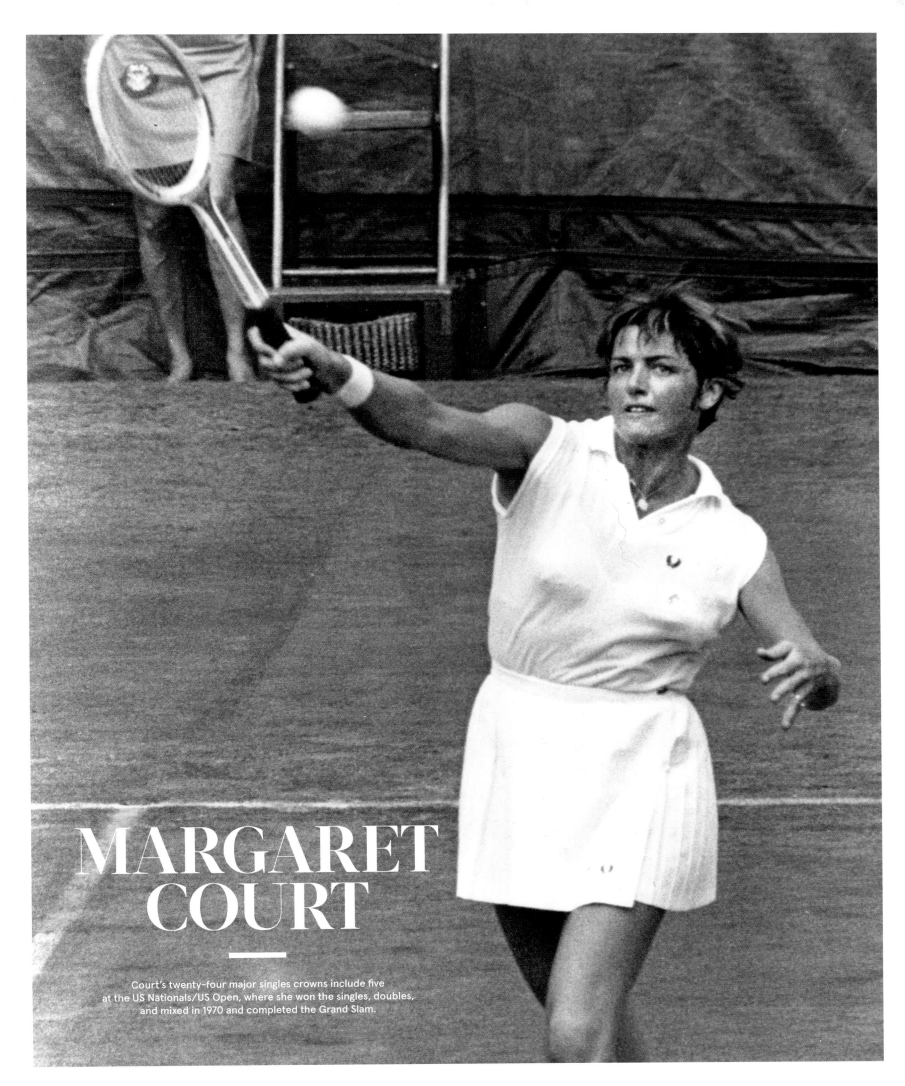

MARGARET COURT

Court's twenty-four major singles crowns include five
at the US Nationals/US Open, where she won the singles, doubles,
and mixed in 1970 and completed the Grand Slam.

DYNAMIC DUOS

Each decade of the US Open has produced a men's doubles team that has stood above the rest.

BOB LUTZ AND STAN SMITH were already familiar faces at Forest Hills by the time the 1968 US Open began. The two Californians made their first trip to the US National Championships to play in the men's doubles tournament in 1964, when Lutz was sixteen years old and Smith was seventeen. Although their debut effort ended in disappointment, with a five-set loss in the first round, they fared much better on their next two visits, advancing to the quarterfinals in 1965 and 1966. The pair returned to the US Nationals in 1967 as the NCAA men's doubles national champions— Lutz had claimed the national collegiate singles title as well—but took a small step backward by falling in the third round. In 1968, the University of Southern California teammates again won the NCAA men's doubles national championship—with Smith following in his partner's footsteps by claiming the national collegiate singles title—and during that year's visit to Forest Hills, there were no missteps.

Losing only one set in five matches, Lutz and Smith captured the inaugural US Open men's doubles championship with an 11–9, 6–1, 7–5 victory over Arthur Ashe and Andrés Gimeno in the final. Fifty years later, Lutz and Smith remain the only reigning national collegiate champions to win the US Open men's doubles title. All told, they played in six US Open men's doubles finals and won the championship four times in a thirteen-year span, with titles in 1968, 1974, 1978, and 1980.

Claiming their last crown was the toughest test of all. Whereas they won their first three finals in straight sets, it took five tightly contested sets for Lutz and Smith to defeat defending champions Peter Fleming and John McEnroe in the 1980 final. Fleming and McEnroe would later take up Lutz and Smith's mantle as the premier US Open men's doubles team, winning three titles, in 1979, 1981, and 1983. During that period, McEnroe was widely regarded as the best doubles player of his—and perhaps of any—generation, a notion supported by his doubles partner of nine years. When asked who the greatest doubles team in history was, Fleming famously quipped, "John McEnroe and anyone." After their partnership ended, McEnroe won a fourth US Open men's doubles title in 1989 with Mark Woodforde, who appeared in three consecutive finals with Todd Woodbridge, coming out on top in 1995 and 1996.

Among the other leading doubles duos to command the hard courts of Flushing Meadows in the 1980s and 1990s were Ken Flach and Robert Seguso, who reached three finals in five years, winning the 1985 title.

As the century turned, a set of twin stars emerged in the doubles firmament, shining more brightly than any other men's duo ever has. In 1998, Bob Bryan and Mike Bryan, attending Stanford University, won the NCAA men's doubles national championship and received a wild card to play in their first US Open.

It took a while for them to climb to the US Open summit, but finally, seven years later, they became the first NCAA men's doubles champions since Lutz and Smith to win a US Open men's doubles title. Since then, they have become the winningest men's doubles team in tournament history— capturing the title every even year from 2008 to 2014, amassing five crowns to surpass Lutz and Smith's US Open total. They have also become the winningest men's doubles team, period.

"It's always sweet winning a Grand Slam," Mike Bryan said after he and his twin brother clinched the 2014 US Open final for their record fifth title. "This just adds some extra whip cream and cherries and nuts on top." A landmark victory, it made the Bryan brothers the first men's doubles team to win one hundred career titles.

(For more on the Bryan brothers, see page 250–253.) ●

CLOCKWISE FROM TOP RIGHT: Stan Smith (left) and Bob Lutz, 1978; Mike Bryan (left) and Bob Bryan, 2005; Todd Woodbridge (left) and Mark Woodforde, 1996; Peter Fleming (left) and John McEnroe, 1983; Smith and Lutz (top) play McEnroe and Fleming, 1979.

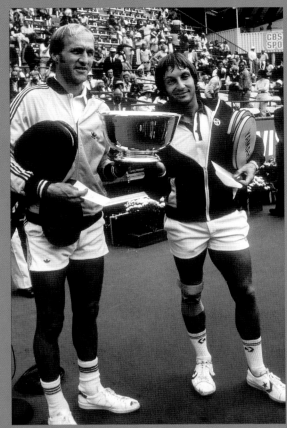

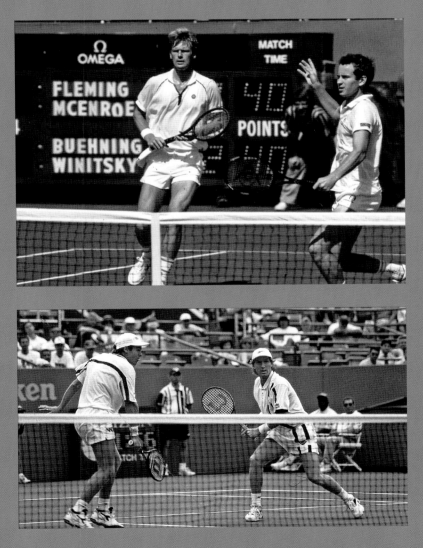

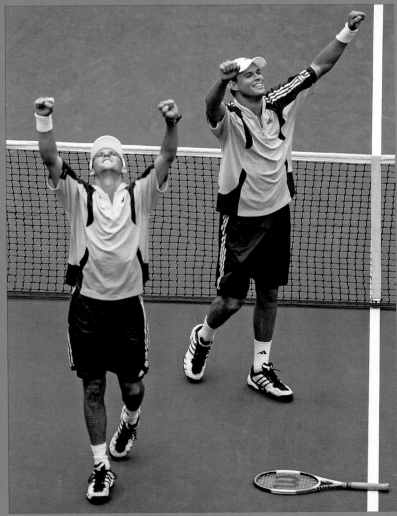

ARTHUR ASHE

By George Vecsey

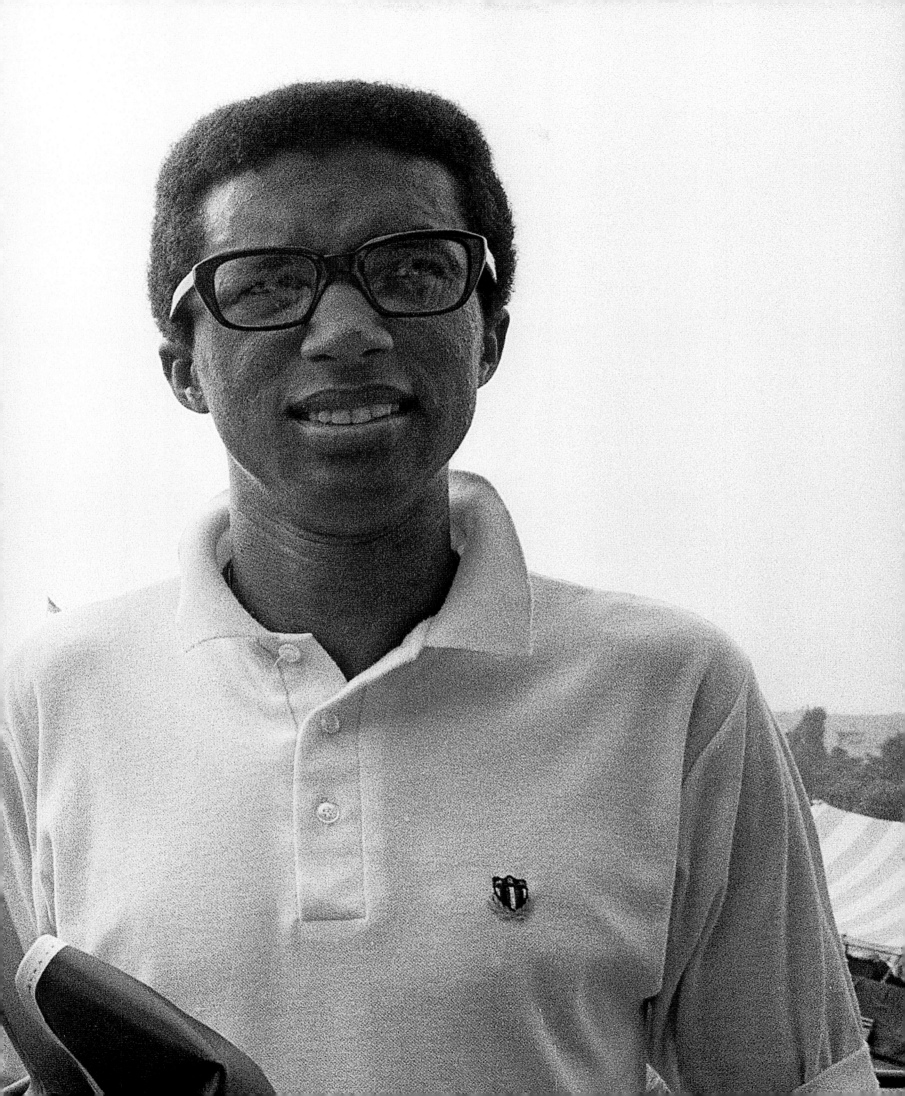

The stadium is named for him, but Arthur Ashe never played there or even saw it.

Arthur Ashe Stadium has a retractable roof and luxury boxes and giant message boards providing microscopic evidence for challenged calls, plus glimpses of visiting celebrities.

The new place is a far cry from the quaint little club where US Army Lieutenant Arthur Ashe won the very first US Open in 1968, but could not keep the prize money because

he was still—an absurd concept these days—an amateur.

Arthur Ashe—the wise human, not the rocking stadium—was a throwback to a different time of clunky racquets and white outfits and skidding on grass courts. He was understated and polite, and he never lost those traits, even when beset by controversy and tragedy.

He seemed to belong in the old place, the West Side Tennis Club, tucked into a leafy corner of Forest Hills, Queens. I first saw him when I was in my mid-twenties and he was four years younger, easy to pick out among the white tennis crowd of the time. I stopped him on the narrow lanes between grass courts and asked if he had a few minutes for an interview, and he shifted the racquets and equipment

bag he was lugging and said he would like to talk, but at the moment, he was heading out to play a match. Oh. He said it politely. I deserved an athlete's loud and profane scorn, but that was not Arthur.

In that same low-key way, he became the first black male to reach the top level of tennis, coming out of Richmond, Virginia, to attend UCLA and serve his obligatory hitch as an army officer. In 1968, after years of politicking had brought down the indentured servitude and phony amateurism in tennis, Ashe was competing in the first openly professional national tournament in his homeland.

There were giants in those days. At least, the names seem gigantic in print half a century later. Look at the quarterfinalists in that first

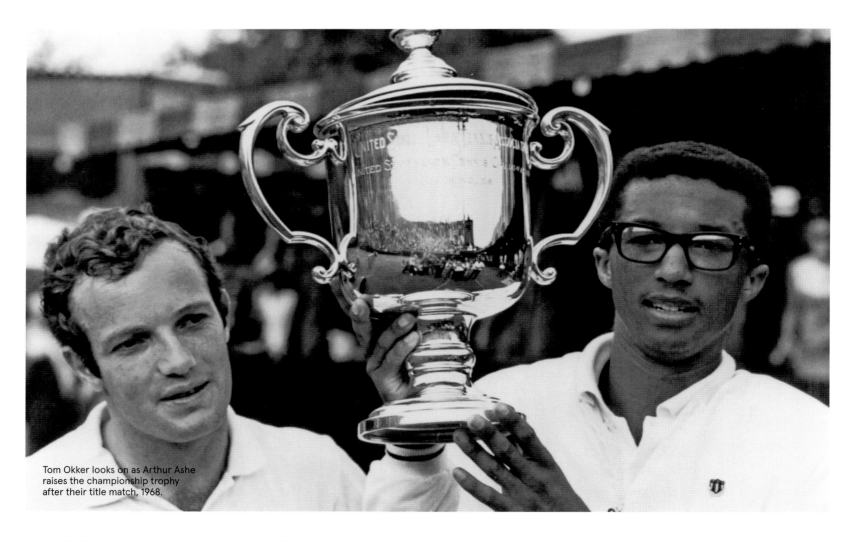

Tom Okker looks on as Arthur Ashe raises the championship trophy after their title match, 1968.

Washington, D. C.
February 7, 1968

Lt. Arthur Ashe
USMA
West Point
New York

Dear Mr. Ashe,

I would like to express my personal appreciation and that of my co-
workers in SCLC for your expression of support and solidarity in the
fight for justice, freedom and dignity for all people in this country.

Rev. Jefferson Rogers, a long-time and staunch freedom fighter, has
spoken to us several times of your basic devotion and dedication to
the movement. Your eminence in the world of sports and athletics
gives you an added measure of authority and responsibility. It is
heartening indeed when you bring these attributes to the movement.

If we can ever be of assistance to you, do not hesitate to call upon
us. I look forward to the pleasure of meeting you in person when the
opportunity presents itself.

Yours for freedom,

Martin Luther King, Jr.

A letter from Martin Luther King, Jr.,
to Arthur Ashe, then a US Army lieutenant
based in West Point, New York, 1968.

"You've got to get to the stage in life where going for it is more important than winning or losing."

— ARTHUR ASHE —

Forest Hills in 1965. "But I was not far from my best in '68."

Even traditionally starchy tennis reflected the turmoil all over the world in 1968. "Everybody was feeling their oats," recalled Drysdale, who had joined a rogue band of professionals, known as the Handsome Eight, in going out on their own. "We had a taste of professionalism, and there was no turning back."

In 1968, the worlds were joined. In the quarters, Drysdale played his pal, Arthur Ashe, twenty-five years old and reaching his prime. "He had a great style," Drysdale said. "He was a flat-ball hitter, not much spin or finesse. In a way, he played more like the later players."

Drysdale does not remember the shot-by-shot flow of that match between friends, but he does say, "I know I gave him a very tough set." Drysdale won the first set, 10–8, but then succumbed, 6–3, 9–7, 6–4. He does not recall what the two friends said to each other at the net, but it is quite likely they changed nearby in the minimal locker room at West Side.

"That's what made those years such fun," Drysdale said, recalling the camaraderie of the time. "If anybody had come around with a coach, everybody would have said, 'What are you doing?' We'd go out for a beer or dinner. That's how we traveled."

Ashe then defeated his fellow American Clark Graebner in the semis, 4–6, 8–6, 7–5, 6–2, in a sociological pairing recorded for posterity by the great John McPhee in a *New Yorker* article and the classic book *Levels of the Game.*

In the final, Ashe defeated a friend, Tom Okker of the Netherlands, 14–12, 5–7, 6–3,

pro Open: Clark Graebner defeated John Newcombe; Ken Rosewall defeated Dennis Ralston; Tom Okker defeated the aging matinee idol, Pancho Gonzales. And Arthur Ashe played twenty-seven-year-old Cliff Drysdale, a regular on the tour.

Stereotypes do not apply here. Drysdale was born in Nelspruit, South Africa, but opposed his homeland's apartheid laws and would apply for American citizenship in 1974. Drysdale surely wanted to beat the young American, whom he knew and liked.

"I felt like I won the Open for Arthur," Drysdale said recently. He is a tennis commen-

tator and entrepreneur, living in Austin, Texas. Over the years, he often reminded Ashe of the gigantic favor he performed in the round of 16: "I took out the Rocket. Arthur could never beat the Rocket."

"The Rocket" is Rod Laver, still regarded as perhaps the greatest male player, pound for pound, era for era, in tennis history. Naturally ambidextrous, Drysdale played right-handed but used a two-handed backhand to throw the lefty Laver off his game—and beat him in five sets.

"I was slightly over the hill," recalled Drysdale, a finalist to Manuel Santana at

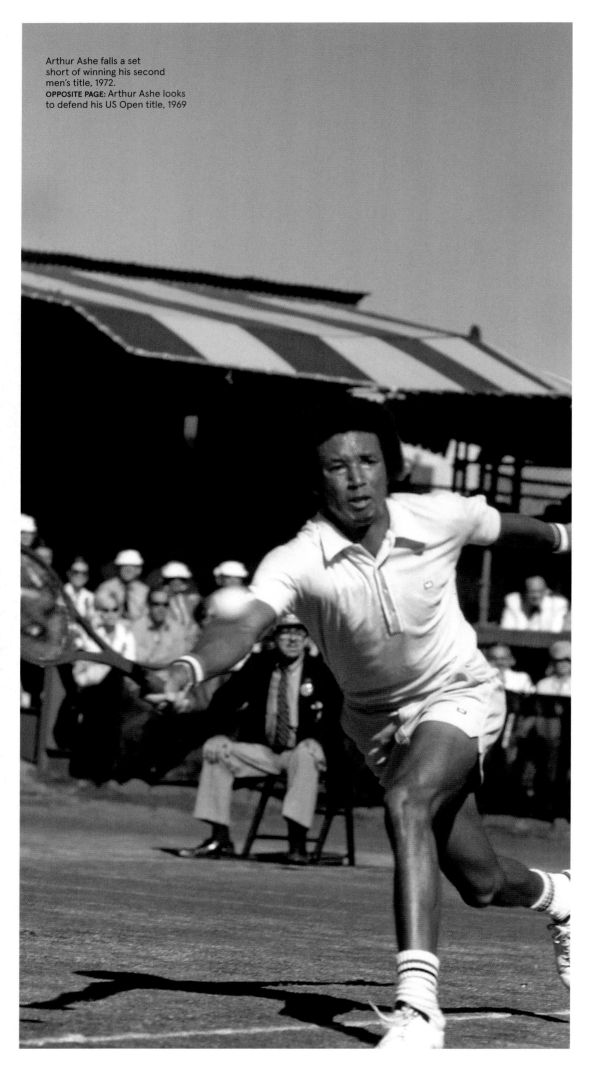

3–6, 6–3, but was ineligible for the cash prize because of his amateur status.

"The triumph was the most notable achievement made in the sport by a Negro male athlete," Dave Anderson noted in the *New York Times*, concluding that in the new age of professionalism, Ashe was "the only tennis player to have won an open at $20 per diem and with a free hotel room."

The victory would be one peak of Ashe's playing career. In 1975, there was another; he would beat brash young Jimmy Connors in four sets at Wimbledon.

Later, Ashe was Davis Cup captain for both Connors and John McEnroe, which should have qualified him for a Nobel Peace Prize, and led the US to the 1981 and 1982 titles. He had retired as a player by then, having suffered a heart attack in 1979 which required quadruple bypass surgery. A faulty blood transfusion during a second surgery in 1983 undoubtedly transmitted the AIDS virus to him.

Even so, Ashe stayed close to the game. He commentated for ABC and HBO and wrote about tennis for several publications. He was invited to teach a college course on black athletes in contemporary society, from which grew *A Hard Road to Glory*, his groundbreaking, three-volume history of black Americans in sports. He continued to work tirelessly to bring tennis to children who may not have otherwise had the opportunity to play, most notably through what is now known as the National Junior Tennis & Learning network, which he founded in 1969 with Charlie Pasarell and Sheridan Snyder. Above all, he remained an outspoken champion for social causes, believing in the need to "speak globally, be heard globally, act globally."

At the 1992 US Open, four months after announcing he had contracted AIDS, Ashe staged the Arthur Ashe AIDS Tennis Challenge to raise money for AIDS research. He died in February 1993, and the US Open has begun with an Arthur Ashe event ever since.

The new stadium was dedicated in his name on August 25, 1997. If Arthur were still with us, he might be watching a current US Open from a private box or perhaps in the press section, schmoozing with reporters about tennis and politics and race and anything else, wearing a vaguely naval cap with a gold braid.

For two weeks in late summer, Arthur Ashe Stadium rumbles and quivers, a gaudy reminder of the first US Open in 1968 and the understated pioneer who won it. ●

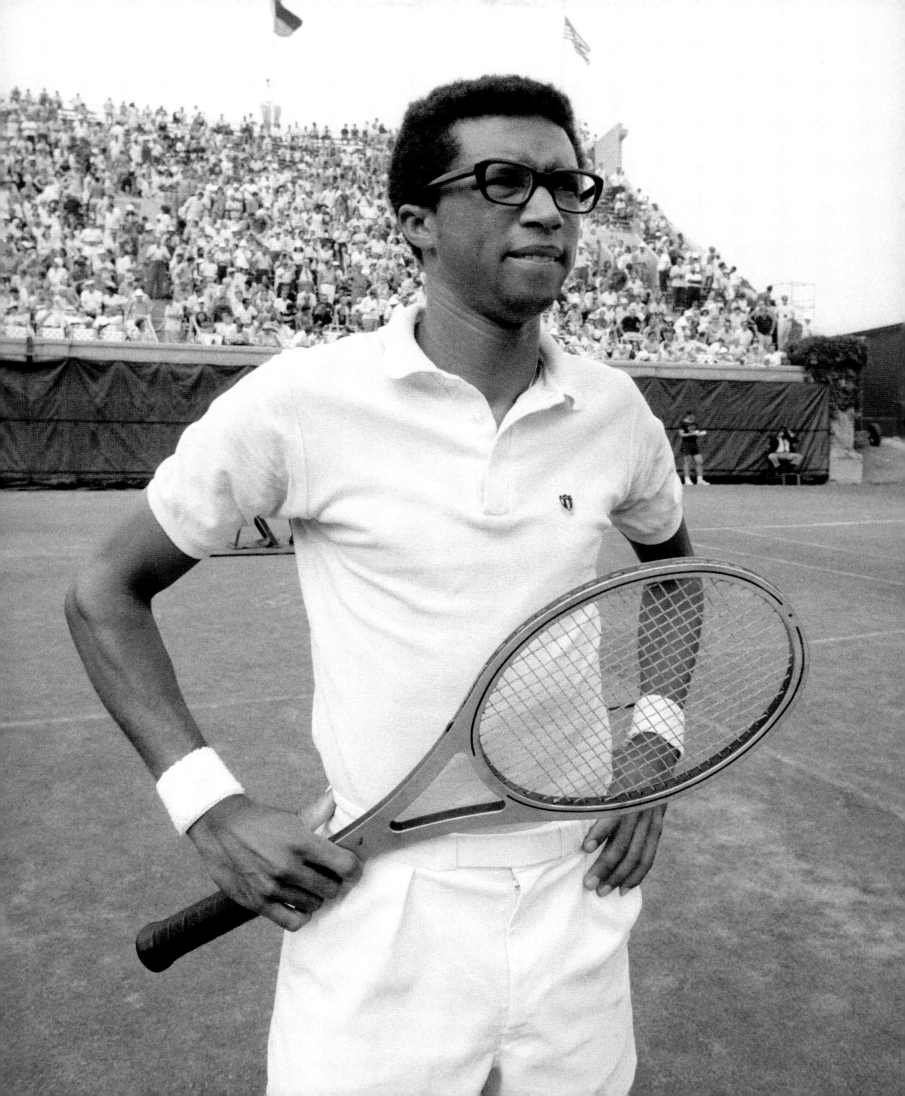

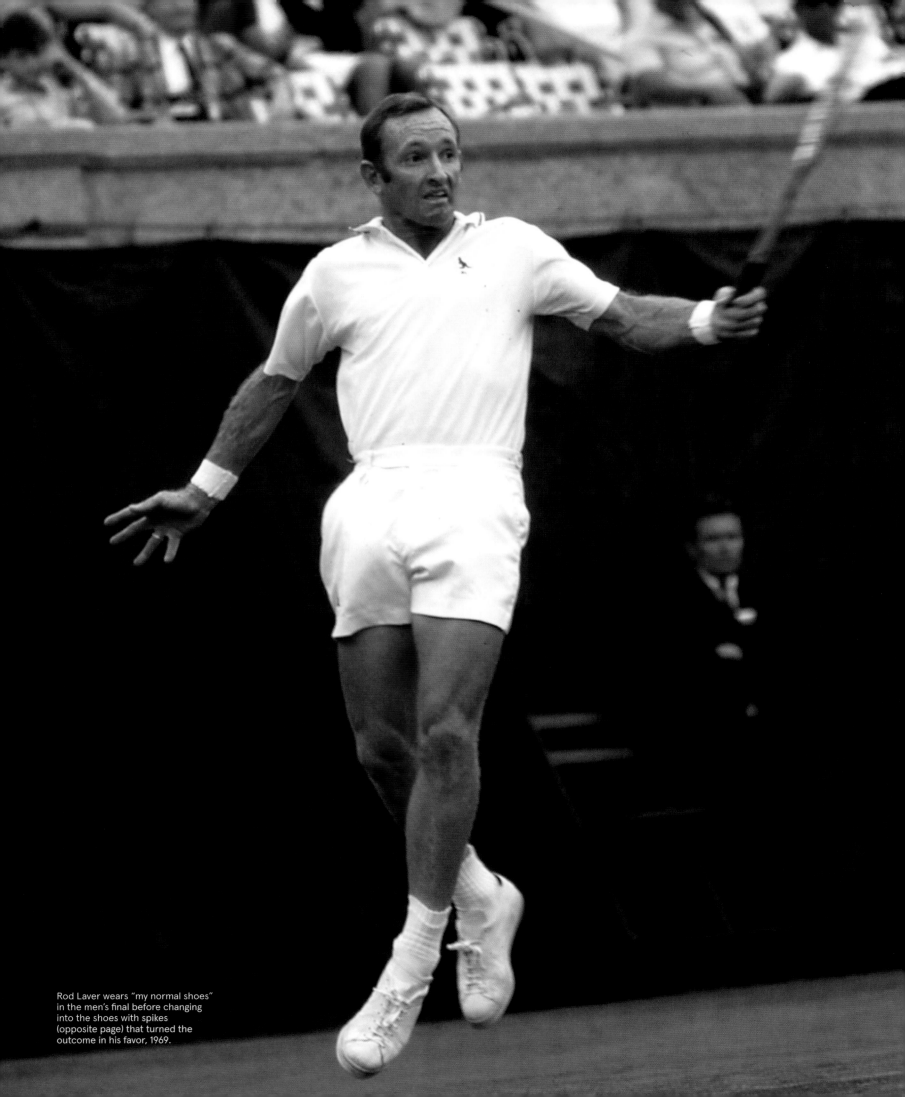

Rod Laver wears "my normal shoes" in the men's final before changing into the shoes with spikes (opposite page) that turned the outcome in his favor, 1969.

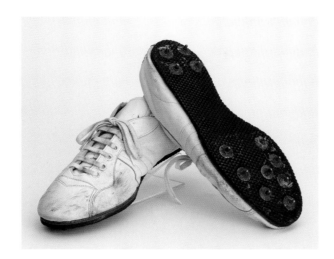

GRAND SLAM II

ROD LAVER CAPTURES HIS SECOND GRAND SLAM, WITH THE HELP OF A HELICOPTER AND A PAIR OF SPIKES, AT THE 1969 US OPEN.

By Rod Laver
from *Rod Laver: An Autobiography*

•

IN 1962, ROD LAVER *became the second man in tennis history to claim all four majors in the same year. He began the second-ever US Open with a chance to repeat the feat, having won the 1969 Australian Open, French Open, and Wimbledon in succession. He was also riding a twenty-three-match winning streak, though he feared his luck would run out at the US Open. It almost did. Down two sets to one against Dennis Ralston in round four, he came back to win in five sets. In the semifinals,*

Laver, the No. 1 seed, needed two days to defeat Arthur Ashe, the defending champion and No. 4 seed, sewing up the victory with a 14–12 third set. The title match against his Australian countryman Tony Roche, the No. 3 seed, posed its own problems. Pushed back a day due to rain, the 1969 US Open men's singles final got off to a late start on Monday, September 8, as more rain fell. Once the morning rain ended, the two men had to wait another hour and a half for a helicopter to be brought in to help dry the

grass court. Here is Laver's account of how he wrapped up what he called "Grand Slam II" in Rod Laver: An Autobiography, *published by Triumph Books in 2016.*

It was mid-afternoon before Rochey and I were able to go onto the court, which was wet, slippery and slow. Since early morning, there had been a helicopter hovering over the court in a bid to dry it off, but all the chopper blades did was suck up more water to the surface and make it even soggier.

An important match wouldn't proceed under those conditions today. Yet I was confident that I'd handle the sludgy surface better than Tony because I had played on much worse surfaces time and again as a pro—mud-heaps and waterlogged bullrings where to take a step would be to lift a chunk from the surface—while Rochey was only a recent arrival in the pro ranks and had spent most of his career playing on pristine, perfectly maintained courts. As a precaution, however, before we hit up I fronted match referee Billy Talbert and said, "If I find myself sliding, can I wear spikes?" He said, "Be my guest. This is the last match of the tournament so it doesn't matter if you tear up the court." The spikes were three-eighths of an inch (9.5 millimeters) long but, unlike sharp running shoe spikes, the ends had been cut off and were blunt, so if it became necessary to wear them they would definitely churn up the court. I started the match wearing my normal shoes, thinking I'd wait to see how I went in the mud.

I should have won the first set, but deserved to lose it. And lose it I did. After sliding all over the court, I was serving for the set at 5–3. Tony broke me with a magnificent backhand return,

which I couldn't reach on the slippery surface. I asked the referee, "Can I put on my spikes?" Seeing that the conditions were hampering my game, Talbert gave his approval. Tony chose not to don spikes because he had strained his thigh muscle in the semifinal against Newk [John Newcombe] and worried that he might exacerbate the injury and cramp up with the quick and juddering stops you make when you've got spikes on. Although, because of the spikes, I was moving around the court well, it was so drenched and torn up that my feet were still going in directions I didn't want them to. Rochey won that first set 9–7. I had served five double faults, and I'd not been guilty of serving that badly for a long, long time. At that stage, Tony was looking invincible. . . .

Tony began the second set as he'd finished the first. On fire. He held his serve in the first game. Then he led me 30–40 on my serve in the second game and found himself in an excellent position to go on and win the set, which would put him in the box seat for the match. As I readied to serve again, Tony stalled to set himself to return. I settled myself, too. I *had* to hold serve. The entire match and the Grand Slam, which I confess was now top of my mind, could hinge

on it. Usually, I try to serve at medium pace with spin, making sure the ball goes in and putting the onus on my opponent to handle it. This time I did the opposite, the unexpected, and I belted down a boomer, slicing it wide to Tony's forehand. He scarcely got his racquet on it. He had blown his chance to break me. Such chances are rare, and I made sure he didn't get another. The match did turn on that point. I won that game, and as I became more sure of my balance, I began to hit the ball as hard as I ever hit it. Tony couldn't handle the pressure I was able to exert. I won the second set 6–1.

A half-hour rain delay held up the third set. When play resumed, I won it 6–2. I felt in total control. . . . There was a tiny blip when I was serving for the [fourth] set and match at 5–2; I made the old mistake of trying to smash away for a winner a sitter of a forehand volley return from Tony when a workmanlike, no-risk response would have done the trick, and I blew it. My second serve was slower and placed perfectly and Rochey's forehand return went long. I had won the US Open final 7–9, 6–1, 6–2, 6–2 in 113 minutes. . . .

I had won a second Grand Slam. I was the only player ever to do so. ●

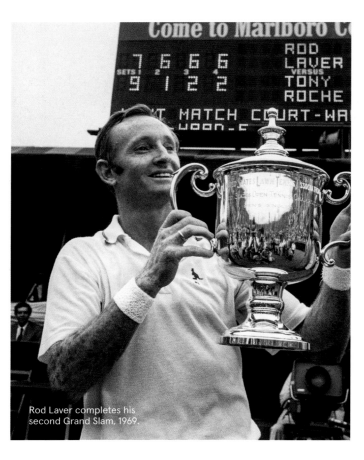

Rod Laver completes his second Grand Slam, 1969.

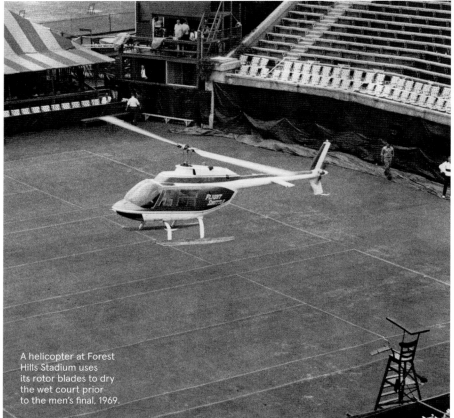

A helicopter at Forest Hills Stadium uses its rotor blades to dry the wet court prior to the men's final, 1969.

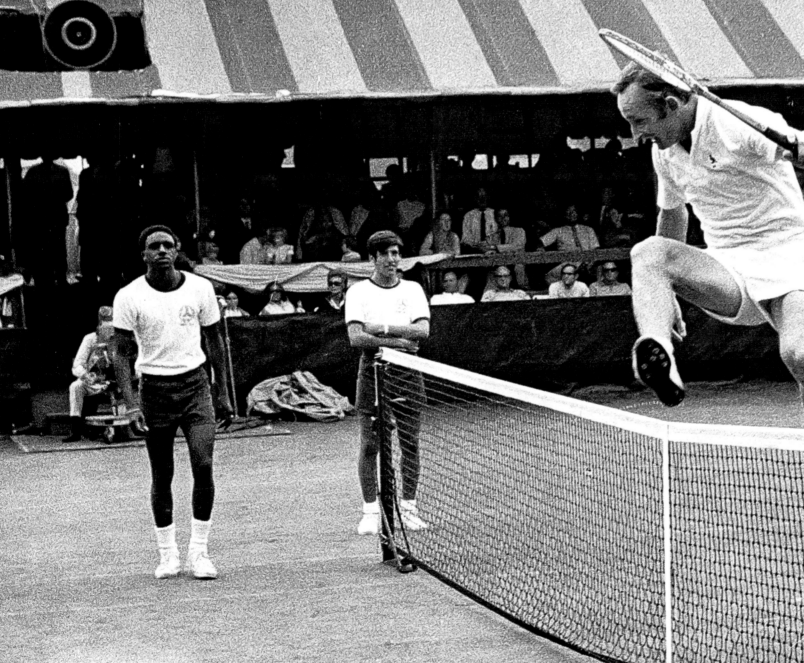

ROD
LAVER
VERSUS
TONY
ROCHE

SERVER	SETS	GAMES	POINTS
2	5	40	
1	2	15	

"I ran to the net to greet Tony [Roche] as the crowd stood and cheered," said Rod Laver, who in 1969 became the first player to win the Grand Slam twice. "In my euphoria I forgot my dignity and leapt over the net."

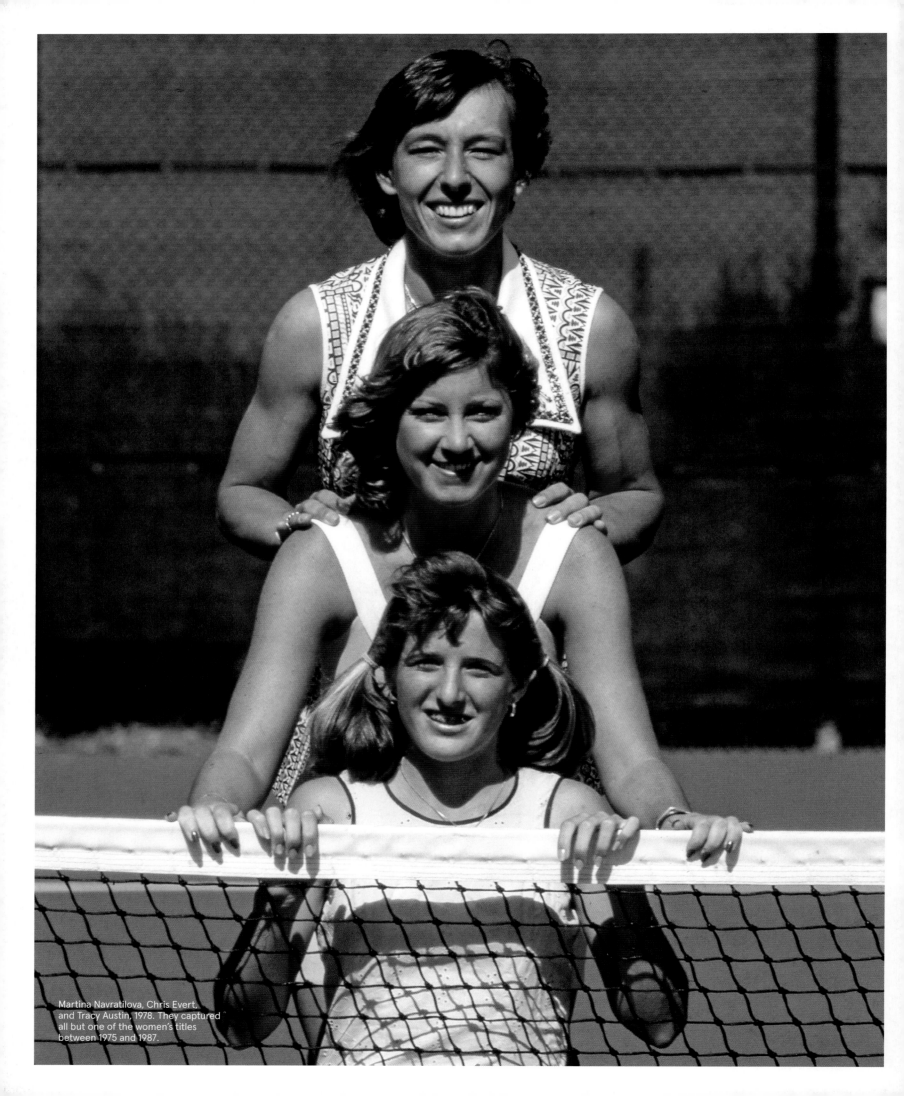

Martina Navratilova, Chris Evert, and Tracy Austin, 1978. They captured all but one of the women's titles between 1975 and 1987.

19

THE

70s

Open tennis was still in its infancy as the 1970s began. But by the time the decade came to an end, the sport had matured significantly through the arrival of notable new stars, the introduction of game–changing innovations, and a major move to a more spacious and public facility.

1970

The field court walkways and grandstand at Forest Hills are reconfigured to provide for more spectators. / Jimmy Connors plays his first match at the US Open on his eighteenth birthday, losing to Mark Cox, 6–2, 6–4, 6–2. / Margaret Court defeats Rosie Casals in the women's final, 6–2, 2–6, 6–1, to complete the Grand Slam and wins the US Open triple crown by teaming with Judy Tegart Dalton to win the women's doubles and Marty Riessen to capture the mixed doubles. / Ken Rosewall defeats Tony Roche in the men's final, 2–6, 6–4, 7–6, 6–3, and becomes the oldest US Open men's champion at thirty-five years, ten months, and eleven days.

1971

Qualifying for the tournament begins as approximately sixty-four players not accepted directly into the US Open draw compete on New York City public parks courts for four places in the opening round at Forest Hills. / John Newcombe becomes the first No. 1 seed to lose in the opening round of the US Championships/US Open since 1928. / Chris Evert makes her US Open debut at age sixteen and reaches the semifinals. / Billie Jean King defeats Rosie Casals in the women's final, 6–4, 7–6. / Stan Smith defeats Jan Kodeš in the men's final, 3–6, 6–3, 6–2, 7–6.

1972

Traditional attire of "tennis whites" is no longer required as the tournament approves pastel colors to be worn by players. / Billie Jean King becomes the first player to repeat as US Open singles champion, defeating Kerry Melville in the women's final, 6–3, 7–5. / Ilie Năstase defeats Arthur Ashe in the men's final, 3–6, 6–3, 6–7, 6–4, 6–3.

Cover of the tournament program for the first US Open held in Flushing, New York, 1978.

weather, the courts are switched to a claylike Har-Tru surface. / Lights are installed for night matches. / Onny Parun defeats Stan Smith on August 27 in the first-ever US Open night match, 6-4, 6-2, in front of 4,949 fans. Chris Evert tops Lesley Hunt, 6-1, 6-0, the next evening in the first women's night match. / Eighteen-year-old Martina Navratilova of Czechoslovakia announces her defection to the United States after losing to Evert in the semifinals. / Evert defeats Goolagong in the women's final, 5-7, 6-4, 6-2. / Manuel Orantes defeats Jimmy Connors in the men's final, 6-4, 6-3, 6-4.

1976

Sixteen seeds are used for the first time in the women's draw. / Chris Evert defeats Evonne Goolagong in the women's final, 6-3, 6-0. The loss is Goolagong's fourth consecutive runner-up finish. / Jimmy Connors defeats Björn Borg in the men's final, 6-4, 3-6, 7-6, 6-4.

1977

The last US Open is played at the West Side Tennis Club in Forest Hills. / Ground is broken on the USTA National Tennis Center. / Tracy Austin and John McEnroe make their US Open debuts. / Mike Fishbach uses his controversial—and eventually outlawed—"spaghetti strings" racquet in a second-round upset of Stan Smith. / Forty-two-year-old transsexual Renée Richards loses in the first round to Virginia Wade but reaches the doubles final with Betty Ann Stuart. / Martina Navratilova wins the first of her record sixteen US Open titles, teaming with Betty Stöve to win the women's doubles. / Chris Evert defeats Wendy Turnbull in the women's final, 7-6, 6-2. / Guillermo Vilas defeats Jimmy Connors in the men's final, 2-6, 6-3, 7-6, 6-0.

1978

The US Open moves to the USTA National Tennis Center. / Björn Borg and Bob Hewitt play the first match in Louis Armstrong Stadium on the night of August 29, with Borg winning, 6-0, 6-2. / Chris Evert defeats sixteen-year-old Pam Shriver in the women's singles final, 7-5, 6-4. / Jimmy Connors defeats Borg in the men's final, 6-4, 6-2, 6-2, giving him US Open victories on grass, clay, and hard courts.

1979

Five days past her fourteenth birthday, Kathy Horvath becomes the youngest woman to play in the US Open. / In one of the US Open's wildest matches, John McEnroe defeats Ilie Năstase, 6-4, 4-6, 6-3, 6-2, in a night match that features Năstase being defaulted by chair umpire Frank Hammond; an eighteen-minute free for all ensues in which fans become uncontrollable, and Năstase is reinstated by tournament referee Mike Blanchard, who replaces Hammond on the chair for the rest of the match. / Four Americans— Jimmy Connors, John McEnroe, Vitas Gerulaitis, and Roscoe Tanner— reach the men's semifinals for the first time since 1950. / Tracy Austin becomes the youngest US Open champion at the age of sixteen years, eight months, and twenty-eight days, defeating Chris Evert Lloyd in the women's final, 6-4, 6-3. / John McEnroe defeats Vitas Gerulaitis in the men's final, 7-5, 6-3, 6-3.

1973

The US Open becomes the first Grand Slam tournament to offer equal prize money to both men and women. / Yellow tennis balls are introduced for the benefit of the players, spectators, and television viewers. / Forty-five-year-old Pancho Gonzales makes his final appearance at Forest Hills. / Junior tennis comes of age as Billy Martin wins the inaugural boys' singles title. / Margaret Court defeats Evonne Goolagong in the women's final, 7-6, 5-7, 6-2. / John Newcombe defeats Jan Kodeš in the men's final, 6-4, 1-6, 4-6, 6-2, 6-3.

1974

Grass makes its final appearance as the court surface of the US Open. / Ilana Kloss claims the inaugural girls' singles title. / Evonne Goolagong ends Chris Evert's fifty-six–match winning streak in the semifinals. / Billie Jean King defeats Goolagong in the women's final, 3-6, 6-3, 7-5. / Jimmy Connors defeats Ken Rosewall in the men's final, 6-1, 6-0, 6-1; their twenty games played are the fewest in a men's final in the Open era.

1975

To insure quick drying and help eliminate delays due to inclement

BILLIE JEAN KING

By Chris Evert

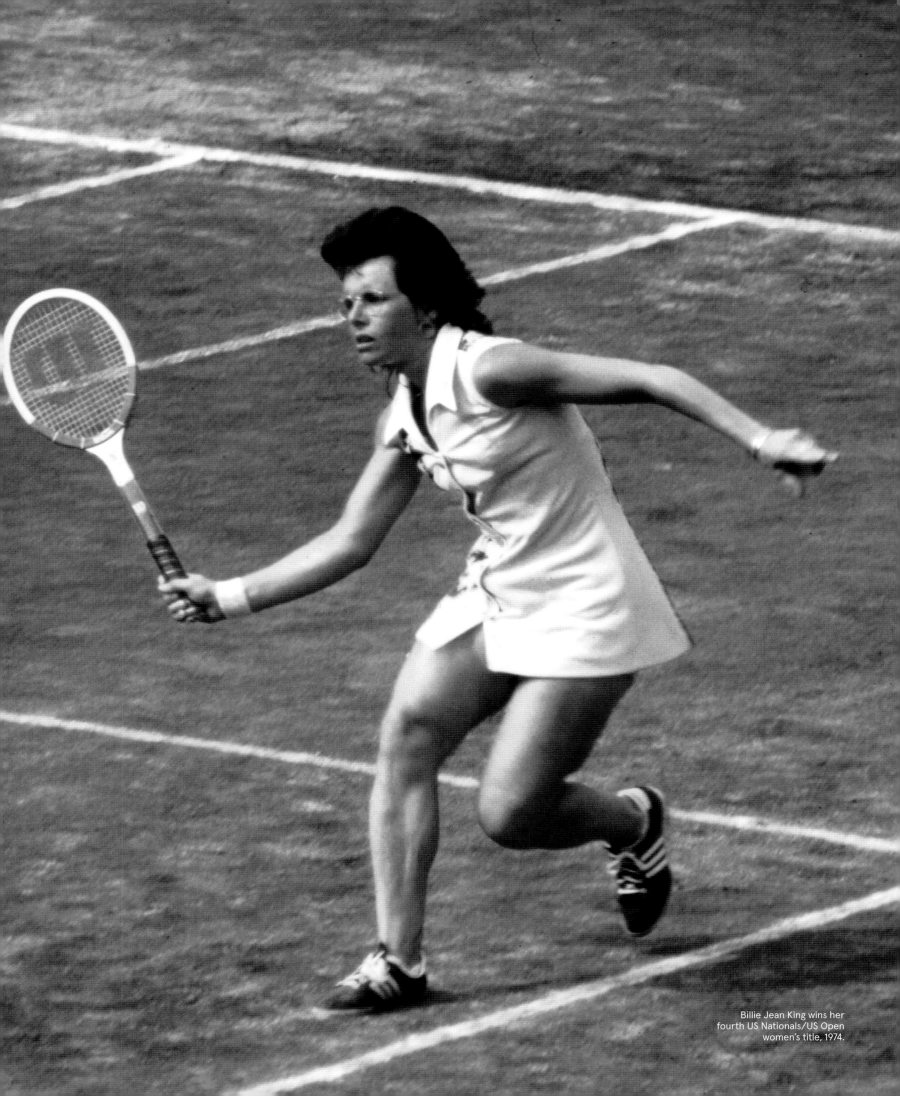

Billie Jean King wins her
fourth US Nationals/US Open
women's title, 1974.

There were people everywhere. That's what I remember about the walk to play the 1971 US Open semifinal against my idol, Billie Jean King. Back then, when the Open was played at Forest Hills, players had a long walk from the locker room to the stadium court on a roped-off sidewalk. Given that I was just sixteen and the level of talk about the tournament, fans had amassed to get a closer look at the "upstart from Florida." Such commotion might rattle some players, but it didn't bother Billie Jean in the slightest. In the juniors, I was accustomed to not saying a word to my opponent on the way to court. It was all business. But was Billie Jean ever chatty. She noted the hordes of people and all the excitement and said, "You're riding on the crest of a wave. Enjoy it."

Then she dismantled me, 6–3, 6–2.

I approached that semifinal as though playing with house money. I had survived six match points in my second-round win over Mary-Ann Eisel and followed that with two more three-set victories in which I dropped the opening set. Plus, the tournament was on grass, my weakest surface. In a sense, I felt lucky to be there, and Billie Jean took every advantage. She fed me a steady diet of junk balls and drop shots, trying to suck the pace out of most rallies. She mixed up her spins and disguised her net rushes, making sure I couldn't develop any rhythm. I came into the match with little strategy, and she had devised the perfect game plan to beat me.

We would meet two more times at the US Open, both in the late stages of the tournament—the 1977 quarterfinals and 1979 semifinals—and both went my way. The surfaces had changed first to clay and then to hard courts, which certainly suited me better. I had also matured and hit my prime while Billie Jean's best days were behind her. I don't remember many details about these encounters, except that in one, Billie Jean had a sore neck and wore a turtleneck throughout the match to keep it warm. I also couldn't help but admire that well into her mid-thirties, in an era when most women her age had long since retired, King was still vying for titles.

It's easy to focus on her off-court and social accomplishments while minimizing what a terrific player she was. Helping to establish a thriving women's tour and working toward gender equality throughout sports and society are meaty, generational issues that deserve recognition. It's no accident that she was named one of the one hundred most influential people of the twentieth century by *Life*. When she was just twelve years old, Billie Jean had an epiphany that she wanted to change the sport. Change the world, really. But she

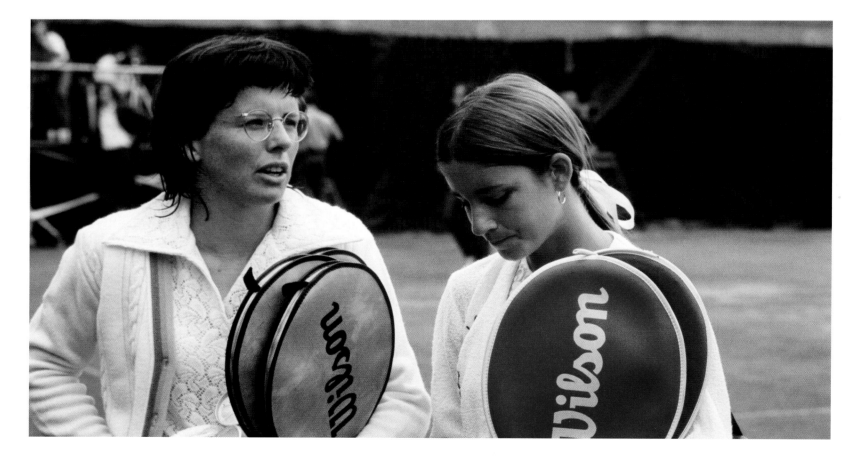

wouldn't have had the platform to make such an impact if she hadn't been the best tennis player in the world.

When she competed, Billie Jean wore her heart, tears, and everything else on her sleeve. While I couldn't win in such a manner, I envied her passion and combativeness. Her game was built around superior athleticism, some of the greatest volleys ever, a nasty slice backhand, and a whole lot of grit. Her all-court prowess made her a threat on any surface and a superb doubles partner.

Beyond those physical gifts, she loved the intricacies of tennis and the technical aspects of the game: how racquet head positioning affected contact and the influence spins had on different shots. She had a love of the process rather than just the results. To feel how each ball uniquely came off the strings was a thing of beauty to her. That made her joyful. As did seeing and helping her peers succeed. It's what made her a great coach and an even better person.

When I got on tour she was the dominant player, but her bigger concern was for the viability of future careers, not her own. Leading up to that first match at the Open, I had been receiving a lot of publicity in the press. I already had a win over Margaret Court and was riding a twenty-plus match streak. Many of the top players felt it was premature notoriety that was dimming their spotlight. Several even chose never to talk to me. Billie Jean wouldn't have it. She told them they were being ridiculous and the added fan interest I was attracting was great for the game; that ultimately, if I put more people in the stands, it would put more money in their pockets. I was always extremely grateful to her for that support.

Billie Jean finished her career with thirty-nine Grand Slam singles, doubles, and mixed-doubles titles. An astounding total to be sure, yet I maintain that her selfless off-court leadership cost her another handful more. Here's what I mean: Early in my career (January 1974), I played King in the final of a tournament in San Francisco. It was on a fast indoor court, which favored her aggressive style, and she beat me in straight sets. The following week, we had a rematch in Palm Springs on a hard surface, and I won rather easily. It was like she was two entirely different players. Later that day, I learned that while I was preparing for the match, Billie Jean had spent the morning in New York City in meetings with potential tour sponsors and flew back that afternoon for the match. No other player would have made that kind of sacrifice. But that's what heroes like Billie Jean do—they lead by example even at the cost of their own glory.

When Billie Jean was president of the WTA, she lured me into becoming vice president because she knew someone would have to take over when she retired—which I did, serving as president for nine years after her departure. I feel like she has been giving me advice my whole life—joining the Virginia Slims tour, serving and volleying in doubles, my love life, and even kids (even though she has none). But that's Billie Jean King. I love it—and her— and wouldn't want it any other way. ●

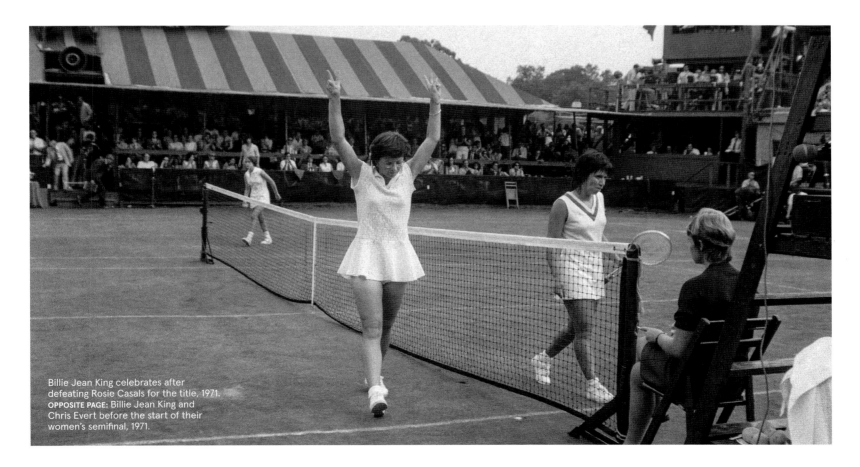

Billie Jean King celebrates after defeating Rosie Casals for the title, 1971.
OPPOSITE PAGE: Billie Jean King and Chris Evert before the start of their women's semifinal, 1971.

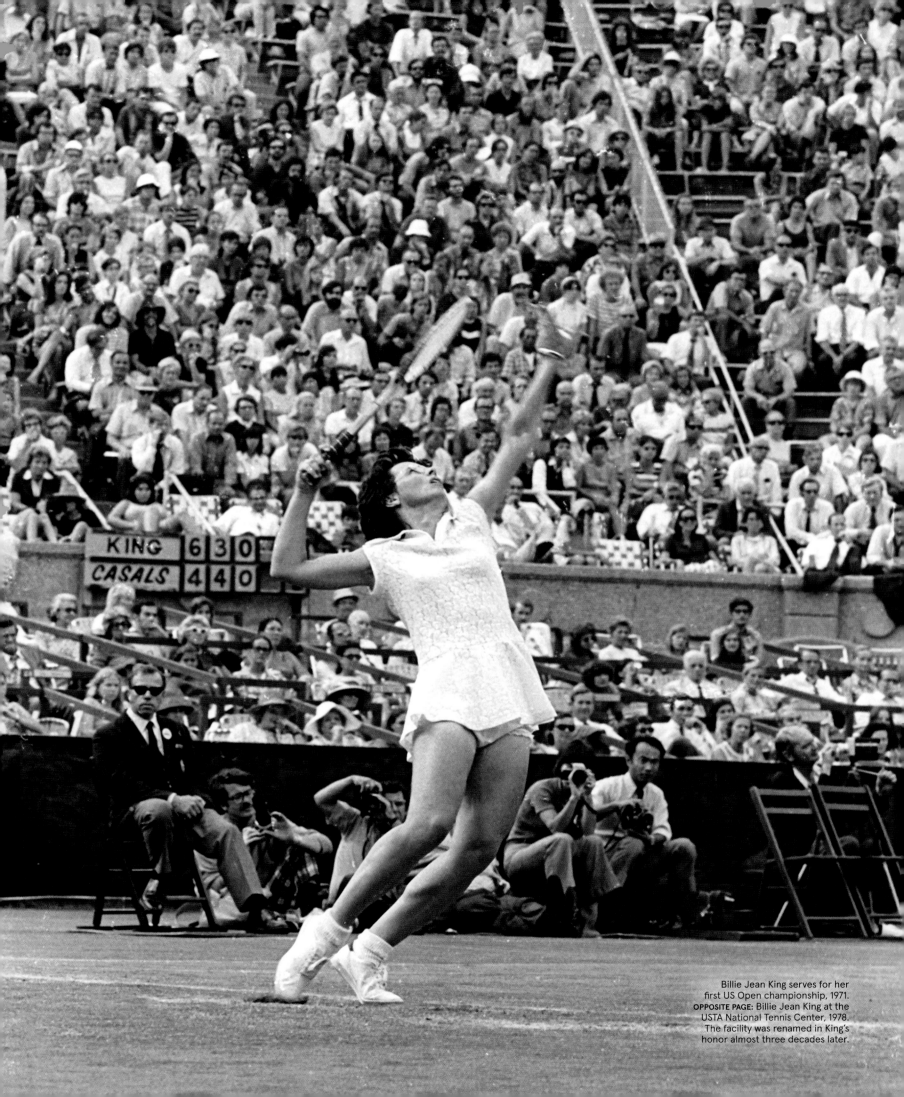

KING 6 3 0

CASALS 4 4 0

Billie Jean King serves for her
first US Open championship, 1971.
OPPOSITE PAGE: Billie Jean King at the
USTA National Tennis Center, 1978.
The facility was renamed in King's
honor almost three decades later.

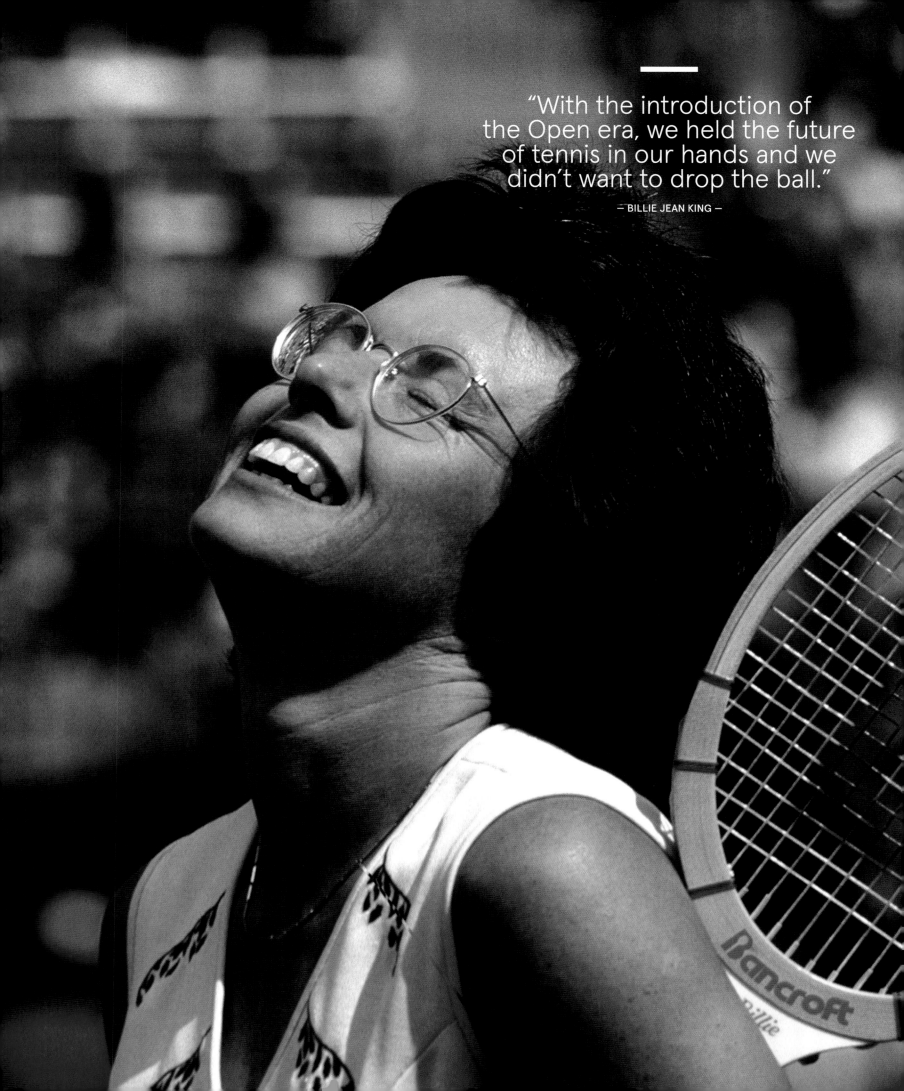

"With the introduction of the Open era, we held the future of tennis in our hands and we didn't want to drop the ball."

— BILLIE JEAN KING —

KEN ROSEWALL

—

"It's such a long time between wins."

Rosewall won the men's title in 1970, at age thirty-five, fourteen years after winning his first US singles crown.

STAN SMITH

Smith won the 1971 men's singles championship along with four doubles crowns (with Bob Lutz) in three different decades.

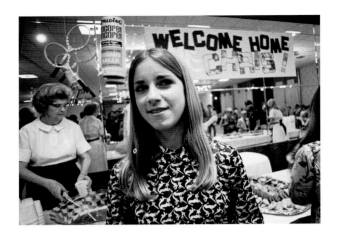

STEALING THE SHOW

A PROMISING SIXTEEN-YEAR-OLD WHO WILL PLAY A STARRING ROLE AT THE US OPEN FOR NEARLY TWO DECADES MAKES HER TOURNAMENT DEBUT IN 1971.

•

"IT WAS LIKE A FAIRY TALE," Chris Evert said of her storybook run in her 1971 US Open debut. Her arrival at the grand ball of the late-summer tennis season wasn't entirely unexpected. She came to the tennis palace in Forest Hills as a highly regarded teenage player who had been turning heads for some time, and Evert's celebrity would grow incrementally as her first US Open unfolded. All of her singles matches were scheduled for center court because once tennis fans—both in the stadium and watching on national television—got a glimpse of the unseeded high school student with the unwavering game, there was no going back.

In her first US Open match, Evert produced an improbably dramatic, come-from-behind victory that was the stuff of dreams, endearing her to the American public. She would follow that victory with another one hundred match wins during her nineteen consecutive US Open appearances, becoming the only player in tournament history to top the century mark in victories. At the 1971 tournament,

Evert would also begin her remarkable string of sixteen consecutive appearances in the US Open semifinals. She would not advance to her first US Open final until four years later; but when she did, she would proceed to win the 1975 US Open and the next three as well, ending her US Open career with six championships in all. No one has won more.

A student at St. Thomas Aquinas High School in Fort Lauderdale, Florida, Evert had already strung together an impressive year on the tennis courts by the time the 1971 US Open began. She showed up at the West Side Tennis Club in Forest Hills having won twenty-seven of her twenty-eight matches and seven titles at tournaments ranging from the USTA Girls' 18 National Championship to the Virginia Slims Circuit, where in one tournament she had defeated Billie Jean King (who defaulted mid-match because of cramps) and Julie Heldman in the event's final rounds, to the Wightman Cup, where she led the US team to a 4–3 victory in August with a 6–1, 6–1 deciding win over Virginia Wade. A year

earlier, in the semifinals at the Carolinas International Tennis Classic in Charlotte, North Carolina, Evert, at age fifteen, had beaten the world's No. 1 player, Margaret Court, 7–6, 7–6, just a week after the twenty-eight-year-old Australian had completed an epic sweep at the 1970 US Open, winning all three possible titles—singles, doubles (with Judy Tegart Dalton), and mixed doubles (with Marty Riessen)—and becoming the first woman to complete the Grand Slam in the Open era.

Accompanied by her mother, Colette, Evert traveled to Forest Hills on the morning of September 2, 1971, to make her US Open debut against Edda Buding, a thirty-five-year-old German who had won the gold medal in doubles at the 1968 Olympic Games. But before the teenager could enter the stately clubhouse to get ready for the match, she and her mother had trouble getting onto the grounds. They had arrived at the West Side Tennis Club without her player's credentials.

"Nobody recognized me," Evert recalled, "and we were turned away at three gates.

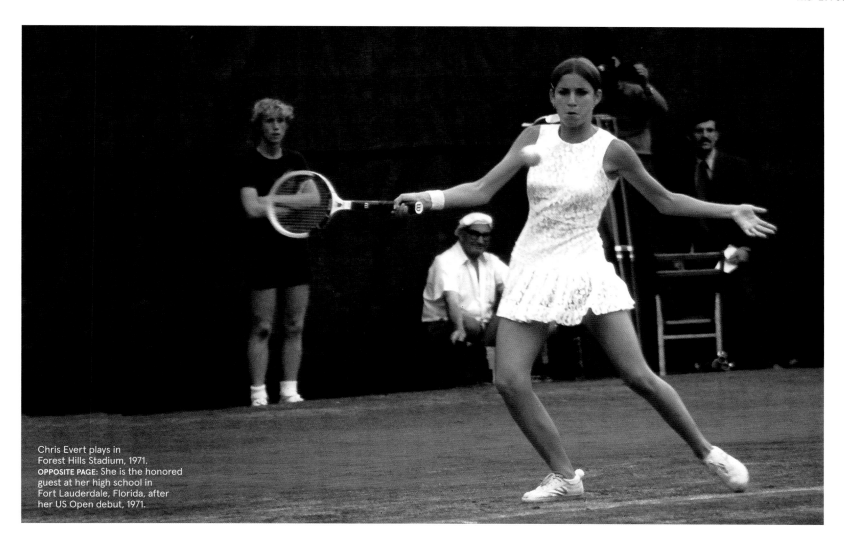

Chris Evert plays in Forest Hills Stadium, 1971.
OPPOSITE PAGE: She is the honored guest at her high school in Fort Lauderdale, Florida, after her US Open debut, 1971.

Then, my mother was finally able to talk our way in."

Despite the difficulty in gaining admittance, tournament officials were counting on Evert's arrival. They had decided to schedule her opening match on center court—normally reserved for seeded players—in the absence of several top women. Court, the two-time defending champion, had skipped the tournament because she was pregnant. Wade, the first US Open champion, was out with an injury. Evonne Goolagong, who had won the 1971 French Open and Wimbledon titles in succession, had chosen not to make the trip to New York from Australia; she would make her US Open debut the following year.

"When I found out that I was playing my first match in the stadium," Evert said, "I was petrified."

Yet it was Buding who left the court in tears, a 6–1, 6–0 victim in forty-five minutes. Next up was Mary-Ann Eisel, ranked No. 4 among American women, who held six match points in the second set. Coolly and methodically,

Evert erased all six match points and never looked back, running away with the third set to defeat a distraught Eisel, 4–6, 7–6, 6–1. Two more three-set victories followed, over the No. 5 seed, Françoise Dürr, and Lesley Hunt in the quarterfinals. They, too, departed teary-eyed over losing a Grand Slam match to a demure-looking high school student who wore her hair in a ponytail tied up in a ribbon with a bow.

Right from the start, the Forest Hills crowds established a home-team atmosphere as Evert entered the main stadium. Match after match, she stole the show—just as the tournament organizers had hoped she would—and fans eagerly came out in droves, filling the seats to see the game's newest sensation. She played all five of her 1971 US Open matches in the stadium—and, in the years that followed at Forest Hills, she would receive the honor of playing every one of her matches on center court.

The largest crowd of the 1971 tournament—13,647 fans, including US Vice President Spiro

Agnew—packed the stadium on September 10 to watch Evert, the youngest semifinalist since 1927, and three of the top four seeds—Billie Jean King, Rosie Casals, and Kerry Melville—seek a berth in the title match. Evert's classmates sent her a well-wishing telegram signed by more than seven hundred people before her semifinal with King began. But good wishes were not enough. King was the superior player and dispatched Evert convincingly, 6–3, 6–2, nullifying her ground strokes with a barrage of deep volleys. King did the same to Casals the next day in the final to close out the women's tournament, 6–4, 7–6, with her first US Open championship.

When it was all over—before she returned home to Fort Lauderdale, where her fellow students would hold a "welcome home" celebration for her—Evert reflected on what she had accomplished.

"I had a really good summer," she said, "and I hate to see it end."

There would be others. ●

HOME IMPROVEMENTS

THE US OPEN INTRODUCES GAME-CHANGING INITIATIVES AND INNOVATIONS IN THE 1970s TO IMPROVE THE TOURNAMENT FOR PLAYERS AND FANS ALIKE.

By Barry Lorge

•

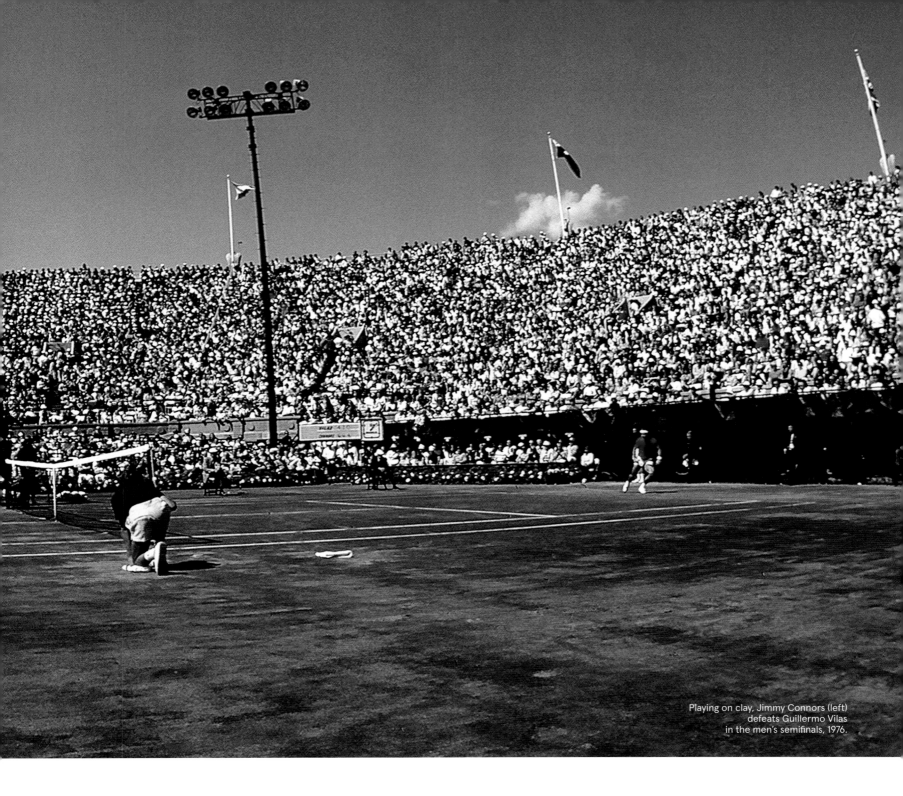

Playing on clay, Jimmy Connors (left) defeats Guillermo Vilas in the men's semifinals, 1976.

MAJOR WALTER CLOPTON WINGFIELD, *a British Army officer who created the first set of written rules for Sphairistiké, or lawn tennis, in 1873, received a patent, signed by Queen Victoria, for "a new and improved portable court for playing the ancient game of tennis" and then set about introducing the modern version of lawn tennis to British society. As the new sport took hold, a number of improvements were soon adopted, including*

changing the hourglass shape of Wingfield's court to a rectangle, lowering the height of the net from seven to three feet, and using an oval racquet instead of one that was fan-shaped. Alterations to the rules were rare, however, and would remain so for nearly a hundred years.

For an organization focused on a game long-steeped in tradition, the United States Lawn Tennis Association wasted little time in making significant changes to promote the

sport's growth. In 1969, a year after the Open era began, the US Open held a consolation event that made use of a new style of scoring to shorten long sets. The following year, the experiment became practice as the 1970 US Open broke with the other Grand Slam tournaments and instituted the drama and excitement of the tiebreak. The brainchild of Jimmy Van Alen, founder of the National Lawn Tennis Hall of Fame, the tiebreak eliminated marathon matches by

Jimmy Van Alen, inventor of the tiebreak, 1970. The US Open that year became the first Grand Slam tournament to use the tiebreak. RIGHT: A "Sudden Death" flag signaled to fans that a tiebreak was being played.

giving every set a clear-cut conclusion when the score reached 6-all. Consisting of nine points, with the set going to the player who wins the most points—which might not be determined until the ninth and final point—the Van Alen Simplified Scoring System (VASSS) was a form of sudden death. Indeed, the West Side Tennis Club signaled to fans around the grounds that a tiebreak was under way by raising a red flag above the court bearing the letters S and D. Although popularly received, the nine-point tiebreak, alternating serves at 2-2-2-3, had its detractors, because the format favored the player who served an extra time for the ninth point. In 1975, the sudden-death tiebreak was replaced by the twelve-point tiebreak, which requires a player to win by two or more points and is still in use today.

The 1975 US Open unveiled other significant changes as well. Over the winter, bulldozers had removed the sod from all but eight courts at the West Side Tennis Club so the grass could be replaced by Har-Tru green clay. The quick-drying courts, built with drain pipes underneath, were designed to get players back in action more quickly after rain delays and facilitated the building of temporary grandstands on the grounds that could hold more fans. With the disappearance of grass from the US Open, the United States Lawn

Tennis Association officially dropped the word Lawn from its name.

The 1975 US Open also brought lights to Forest Hills Stadium, which enabled the tournament to add a separate-admission night session to the daily schedule. Tennis under the lights has since become one of the signature US Open experiences—for players and fans alike—yet the embracing of night tennis was hardly immediate. In this excerpt from the official US Open tournament magazine on the occasion of the twenty-fifth anniversary of night tennis, Barry Lorge recounts the early lore and lure of tennis under the lights.

Nighttime tennis didn't take in the City of Lights, but for a quarter century, it has been an increasingly popular fixture in the City That Never Sleeps.

The French Open experimented one year in the 1970s with play under the floodlights, but it did not suit the Parisian lifestyle. Spring evenings there are made for leisurely dinners by candlelight, not clay-court rallies by "candlepower." It fell to the US Open to establish night sessions as a part of the Grand Slam scene. The restless energy about which Sinatra sang so memorably in "New York, New York" made the city the place for a championship with days that begin at 11 a.m. and evenings that extend past midnight.

As corporate America outgrew the nine-to-five workday and joined the global economy, the US Open's corporate clientele grew. Dinner-cum-tennis became a favored way to entertain. Folks who worked during the day also found the night sessions appealing and fun. In the era of insatiable cable programming, tennis on TV became a supper companion or an insomniac's dream, depending on your time zone, and daytime TV in other parts of the world. The result has been huge increases in attendance, viewership, revenues, and global exposure.

It stood to reason that the Grand Slam tournaments would be daylight affairs until 1975 because three of the Big Four—the Australian, Wimbledon, and US championships—were contested on grass courts. Night play was unthinkable because turf gets slick and slippery when the sun goes down. Only the French Open was played on a surface— slow, red clay—on which footing would be suitable for night play, but that notion went over in Paris like a fallen soufflé.

The introduction of night sessions at the US Open coincided with the 1975 switch from grass to Har-Tru, an artificial clay, as the tournament surface at the West Side Tennis Club in Forest Hills, Queens. There were eight night episodes that first year. The first nocturnal match was August 27, 1975. Former champion Stan Smith was eliminated in the first round, 6–4, 6–2, by Onny Parun, a convivial journeyman from New Zealand. The historic occasion drew only 4,949 spectators. Nightcap tennis was off to a sleepy start.

A succession of straight-set slaughters did little to enhance the sparsely attended evening sessions until the first episode of Monday Night Tennis. Chris Evert routed Wendy Overton, but then Jimmy Connors livened things up. The defending champion, who always loved the prime-time spotlight, outslugged baseliner Harold Solomon, 6–4, 6–2, 5–7, 6–3, in a match that began at 9:17 p.m. on Monday, September 1, and ended at 12:14 a.m. Tuesday, September 2—Connors's twenty-third birthday. Many in the audience of 8,187 stayed through the long night's journey into morning. This could work after all.

The most memorable night match of the 1975 US Open was not scheduled that way, however. It was the finale of what would, in subsequent years through 1996,

come to be known as Super Saturday. Because of the floodlights, it was possible to sandwich two best-of-five-sets men's semifinal matches around the women's final. On this day—September 6, 1975—Connors hammered Björn Borg and Evert completed her US Open ascension over Evonne Goolagong Cawley. Then, Spaniard Manuel Orantes authored one of the most startling comebacks in major-tournament history, reviving himself from 0–5 in the fourth set and fighting off five match points to beat Guillermo Vilas, 4–6, 1–6, 6–2, 7–5, 6–4.

The match that would really cement the popularity of night sessions came on the second Tuesday of 1976. Actually, it ended at 1 a.m. on Wednesday, climaxing a marathon of marvelous fourth-round matches in the stadium. The evening program was delayed forty minutes to allow day-session patrons to exit and night-session ticket holders to enter. But the wait was worth it for a then-record 14,418 who attended the night session.

Evert made a quick appetizer of Sue Barker, but the main course was a five-set feast. Ilie Năstase, the 1972 champion, was acrobatic, athletic, and uncommonly self-controlled under duress, out-stroking Roscoe Tanner in a 7–5, 6–7, 1–6, 7–6, 6–4 spellbinder. Total attendance for both sessions for one of the most dramatic days in US Open history was 30,702—the first time the 30,000 mark was exceeded. Night sessions were here to stay. ●

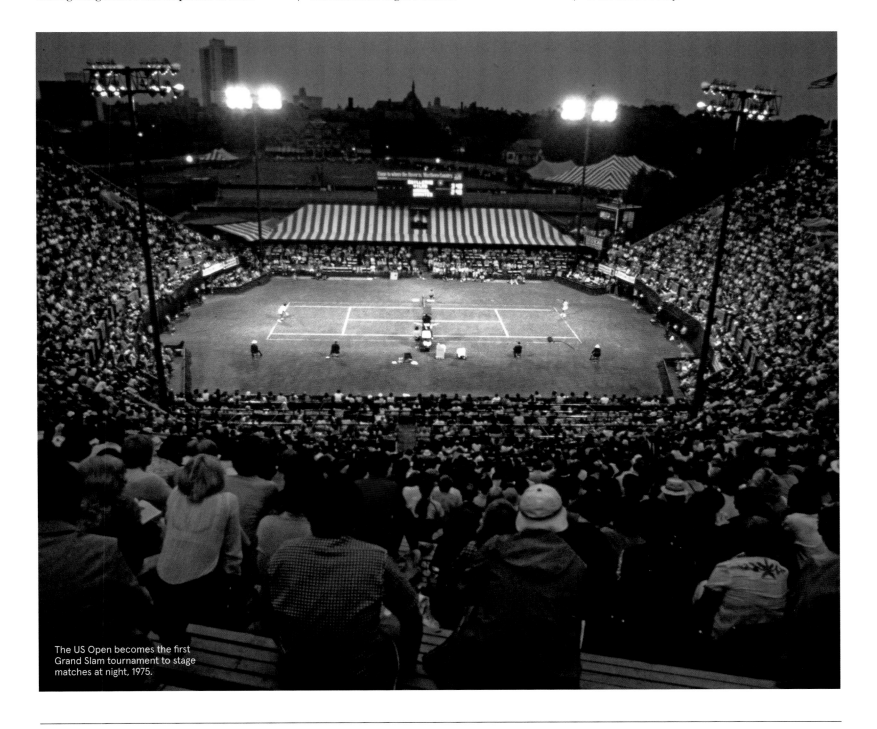

The US Open becomes the first Grand Slam tournament to stage matches at night, 1975.

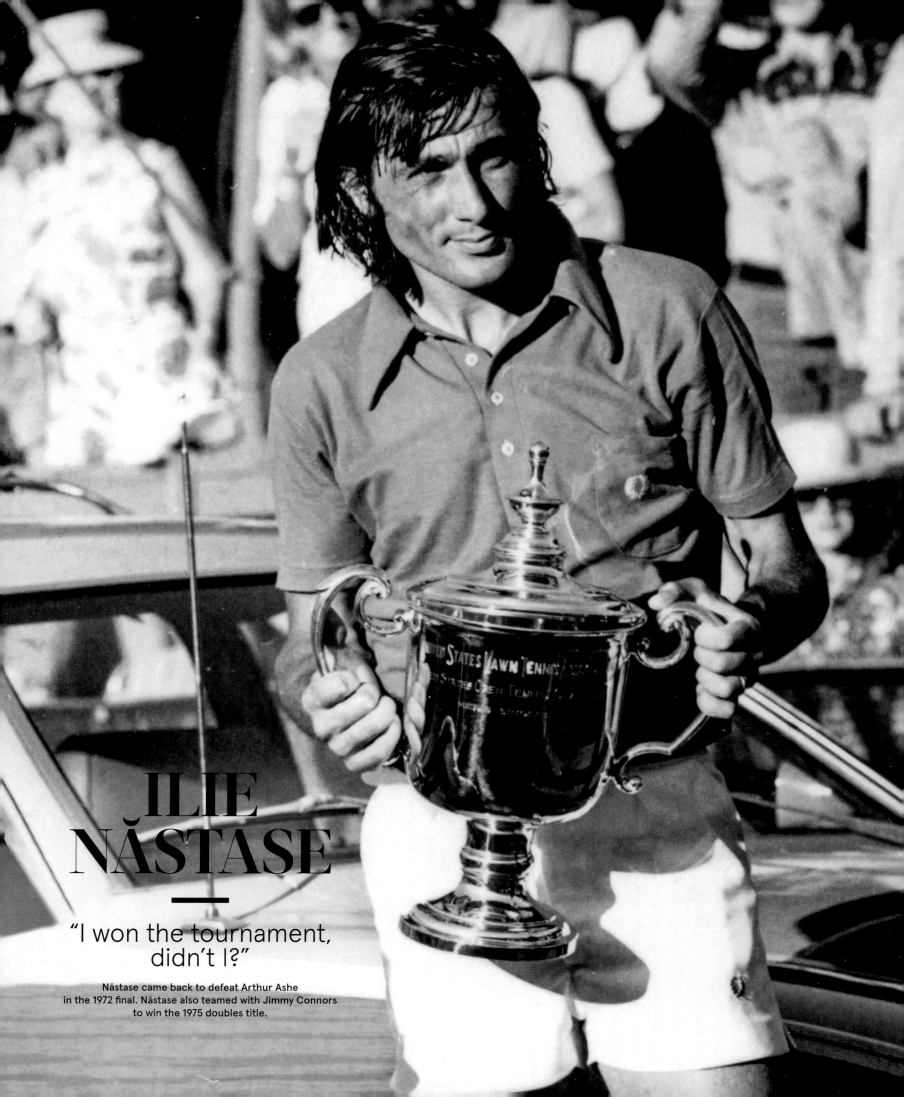

ILIE NĂSTASE

—

"I won the tournament, didn't I?"

Năstase came back to defeat Arthur Ashe
in the 1972 final. Năstase also teamed with Jimmy Connors
to win the 1975 doubles title.

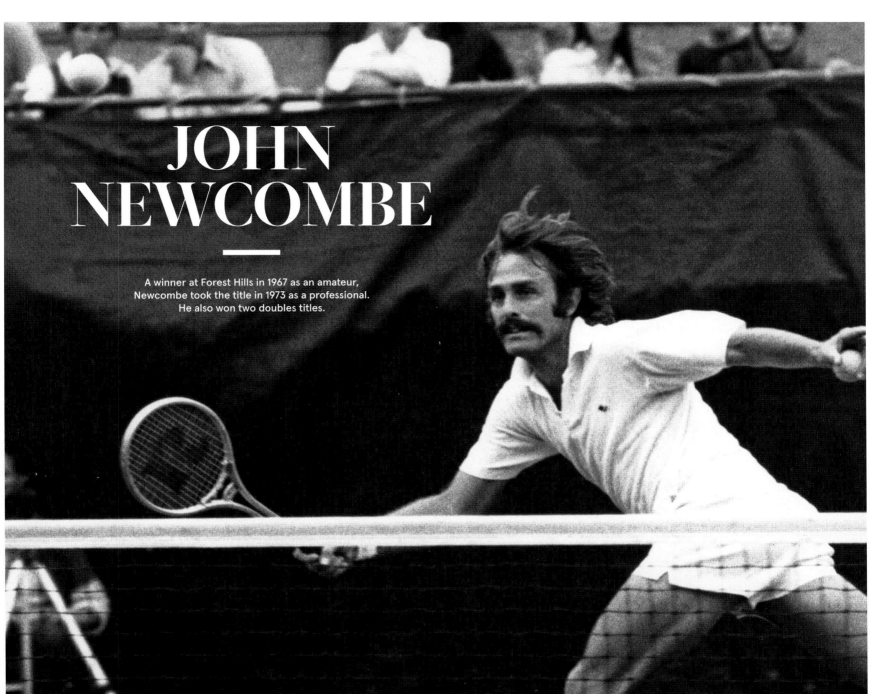

JOHN NEWCOMBE

—

A winner at Forest Hills in 1967 as an amateur,
Newcombe took the title in 1973 as a professional.
He also won two doubles titles.

FINALLY

THE WINNER IS CELEBRATED, THE RUNNER-UP LEFT TO RUE AN OPPORTUNITY MISSED. BUT AT THE US OPEN, FINALISTS OFTEN END UP CHAMPIONS, TOO.

By E. J. Crawford

•

THE INAUGURAL US OPEN runner-up was none other than Billie Jean King, now the namesake of the tournament's Flushing Meadows facility, who fell to Virginia Wade in the 1968 women's singles final. Since then, the very best players in the world have not only won a US Open title; most of them have lost one, too. The list includes Open-era leaders in singles titles for both the men—Jimmy Connors, Roger Federer, and Pete Sampras— and the women—Chris Evert and Serena Williams. And some champions have left New York empty-handed altogether, including two of the very best players of the 1970s, four-time finalists Björn Borg and Evonne Goolagong, neither of whom ever conquered the US Open. Some of the tournament's greatest players sometimes were just not quite great enough.

It's a familiar scene, occurring twice each fortnight: The newly minted US Open champion crumbling to the court in disbelief, raising arms to the heavens in triumph or clambering up to the players' box to celebrate. Forgotten in these moments are the ones on the other side of the nets: the finalists, the runners-up left to lament their chances at Grand Slam glory now gone.

But these players are not also-rans. Those who have lost the most US Open finals also count among the greatest names in the history of tennis—and often are some of the finest Open champs as well. The two men tied for the most losses in a US Open singles final in the Open era are Novak Djokovic and Ivan Lendl, each the bridesmaid on five occasions in Flushing Meadows but also the winners of five combined men's

singles titles and twenty total major crowns.

The men's record holder for most trips to the final without a victory is the inimitable Borg, an eleven-time Grand Slam singles champion who won all six of his French Open finals and five of the six title matches he played at Wimbledon but repeatedly left the Big Apple empty-handed. He was defeated in the US Open final four times in a six-year span, falling twice to Connors (1976 and 1978) and twice to John McEnroe (1980 and 1981). His 1980 loss in the title match to McEnroe is widely considered one of the greatest matches in US Open history, as Borg lost the first two sets but mounted a rousing comeback to force a fifth set, only to fall short, 6–7, 1–6, 7–6, 7–5, 4–6. His 1981 defeat to McEnroe chased Borg from Grand Slam tennis at the young age of twenty-five.

The standard-bearer for unrecognized US Open excellence on the women's side remains seven-time Grand Slam champion Goolagong, who lost four successive women's singles finals from 1973 to 1976. Her defeats came at the hands of three of the sport's all-time greats—Margaret Court, Billie Jean King, and twice to Evert, including a narrow defeat in their first meeting—a register that provides much context but little comfort.

In that 1975 loss, Goolagong outdueled Evert from the baseline in the first set and seemed poised to take the match—and her first US Open title—in straight sets. But after she suffered the only service break in the second set, she lost steam and never recovered. "I felt sort of tennised out," Goolagong said after the match. "She was getting too much back, and I wasn't patient enough to play that type of game and keep going."

Their meeting in the US Open final the following year was far more one-sided. Feeling "very nervous" in her first US Open title defense, Evert dropped the opening two games. But after that, Goolagong's impatience again got the better of her, and she managed to win only one more game that afternoon. "Maybe she realized she wasn't willing to stay out there all day to beat me," said Evert.

In the Open-era annals, only one other woman has lost four US Open singles finals, and she just happens to be on the short list of greatest players ever. Despite her four women's singles crowns, Martina Navratilova lost on Flushing's final Saturday in 1981, 1985, 1989, and 1991—with her first two setbacks serving as the only matches in Grand Slam tournament history to end in a final-set tiebreak. And right behind Navratilova and Goolagong are two other all-timers: three-time US Open runners-up Evert and Steffi Graf. Even the greatest finisher in tennis history, Serena Williams, she of the six Open crowns, has lost twice in a US Open final, including a stunner to Samantha Stosur in 2011.

The list of multiple-time runners-up at America's Grand Slam is indeed long and impressive. In addition to those already mentioned, it includes four-time second-fiddler Andre Agassi, three-time second-bester Pete Sampras, and the distinguished roll of two-time fallen that includes current or future Hall of Famers Victoria Azarenka, Rosie Casals, Jimmy Connors, Roger Federer,

Martina Hingis, Jan Kodeš, Tony Roche, Monica Seles, Venus Williams, Helena Suková, and Caroline Wozniacki.

And so it seems, these losers are hardly losers at all. In fact, thirty of the fifty players who have wistfully watched another hoist the hardware on Finals Weekend have also claimed an Open crown for themselves, and an additional ten—Azarenka, Goolagong, Kodeš, and Roche, along with Michael Chang, Jim Courier, Juan Carlos Ferrero, Nancy Richey,

Michael Stich, and Wozniacki—went on to win Grand Slam singles titles elsewhere.

So, take heart, 2017 finalists Madison Keys and Kevin Anderson. If history is any indication, your time will come. One day, you will not have to cede the stage to another but will hold a trophy of your very own, joining a long list of vanquished who one day experienced both sides of the wonderful trip through the final act of the toughest two weeks in tennis. ●

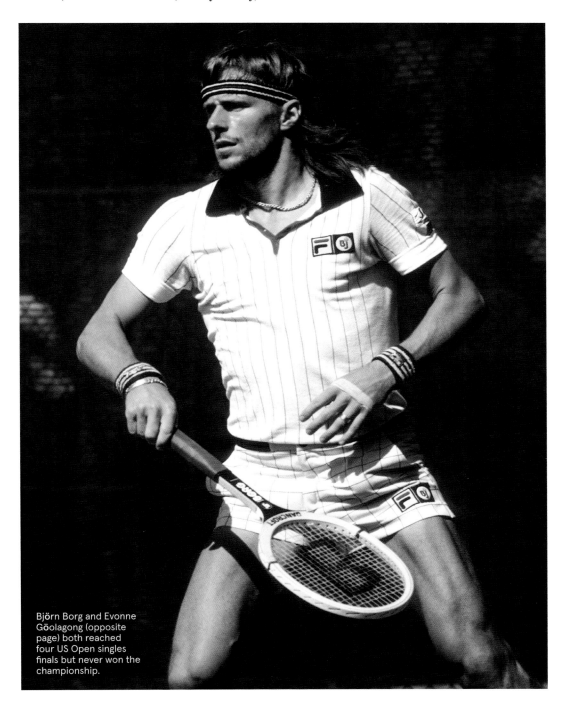

Björn Borg and Evonne Göolagong (opposite page) both reached four US Open singles finals but never won the championship.

MIXED RESULTS

For the game's top men and women, teaming up to win a title often proves to be a major challenge.

MIXED DOUBLES was a very popular draw during the US Open's early years, fielding as many as fifty-one teams through 1972, after which the event settled into its current size of thirty-two. Since then, the field for mixed doubles has remained smaller than those of the US Open's four other major events, making the men and women who have paired up to win a championship an exclusive group of players in their own right. Among them are several of the most notable names in tournament history, starting with the two biggest stars in women's tennis in the 1960s and early 1970s, Margaret Court and Billie Jean King.

In 1969, Court became the tournament's first singles champion in the Open era to also win a US Open mixed-doubles title. When she returned to the US Open in 1970 to defend her titles, she was the winningest player in Grand Slam tournament history by a wide margin. Her forty-eight major championships—nineteen in singles, thirteen in doubles, and sixteen in mixed doubles—far outpaced Billie Jean King, second among active players with twenty-one major titles, five in singles. King, however, did not enter the 1970 US Open. She underwent knee surgery several weeks before the tournament began, making Court a clear-cut favorite to win in singles, doubles, and mixed doubles. Indeed, Court had already swept the year's first three Grand Slam singles tournaments, making her the first woman since Maureen Connolly in 1953 with an opportunity to win all four majors in a single season. Court had won three of the year's four majors twice before, in 1962 and 1969, but had fallen short of the Grand Slam at Wimbledon both times.

At the 1970 US Open, Court played second fiddle to no one. Not in singles, not in doubles, and not in mixed doubles. She defeated Rosie Casals to win the singles final, teamed with Judy Tegart Dalton to get past Casals and Virginia Wade in the doubles final, and joined with Marty Riessen to successfully defend their mixed-doubles title. Court stands as the only player in US Open history to achieve a Grand Slam in singles while winning three titles at the same tournament.

Martina Navratilova, who won her first mixed-doubles title in 1985, is the only other player besides Court to win all three possible titles in the same year at the US Open, capturing the triple crown in 1987, when she partnered with Pam Shriver in women's doubles and with Emilio Sánchez in mixed doubles. Nineteen years later, Navratilova won the third mixed-doubles title of her career by joining forces with another leading champion in mixed doubles, Bob Bryan.

"The mixed I think is more difficult to win than the doubles," Navratilova said after her 2006 win, "because there's so many more teams that can win the whole thing. If you look at the overall history of mixed doubles, there are some teams that you would never think had a chance in the beginning of the tournament and they win the whole thing."

It is, in fact, a rare occurrence for the game's top players in singles and doubles to also take the top prize in mixed doubles. Only four other women besides Court and Navratilova have succeeded in winning US Open titles in singles, doubles, and mixed doubles over the course of their careers. Billie Jean King completed the set in 1974. Serena Williams, who is the youngest woman to win a mixed-doubles title—she was sixteen years and eleven months old when she teamed with Max Mirnyi in 1998—did it in 1999. Arantxa Sánchez-Vicario joined the group in 2000, and so did Martina Hingis in 2015.

No man has succeeded in winning all three US Open titles—although Jimmy Connors and Ilie Năstase came close in the 1970s. Năstase won his lone US Open singles title in 1972, and Connors won the first of his five US Open singles championships in 1974. A year later, in 1975, Connors and Năstase teamed to win the men's doubles title—which left both players one match short of the distinction of winning all three championships: Năstase had advanced to the 1972 mixed-doubles final with Rosie Casals, while Connors, partnering with Chris Evert, had reached the 1974 mixed doubles title match.

Court and Riessen rank as the top mixed-doubles team in US Open history, with three titles, while Riessen stands along with Bryan atop the men's list for most mixed-doubles championships with four. Court, King, and Navratilova share the women's mark for most mixed-doubles championships, with three titles apiece. Navratilova holds one other noteworthy mixed-doubles record. She was forty-nine years and ten months old when she won the mixed doubles title with Bryan in 2006—not only making her seven years older than the oldest man to win the title, Leander Paes in 2015, but establishing her as the oldest US Open champion in any event. ●

CLOCKWISE FROM TOP LEFT: Ilie Năstase and Renée Richards, 1978; Martina Navratilova and Mike Bryan, 2006; Martina Hingis and Jamie Murray, 2017; Max Mirnyi and Serena Williams, 1998; Emilio Sánchez and Navratilova, 1987; Jimmy Connors and Chris Evert, 1974; Navratilova and Bryan, 2006.

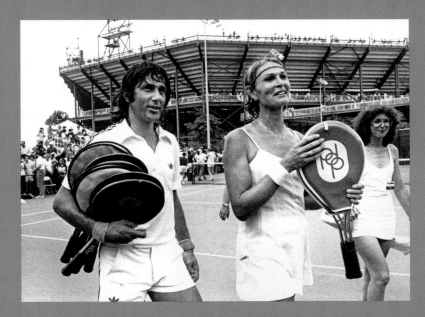

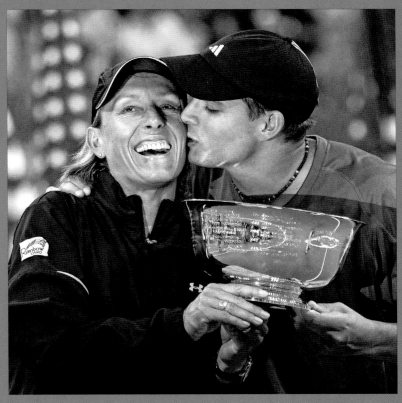

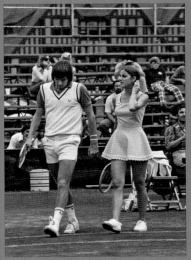

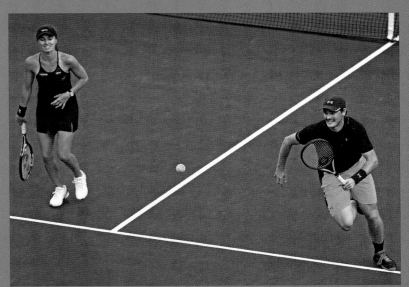

JIMMY CONNORS

By Joel Drucker

Jimmy Connors raises
the championship trophy
after defeating Björn Borg
in the men's final, 1976.

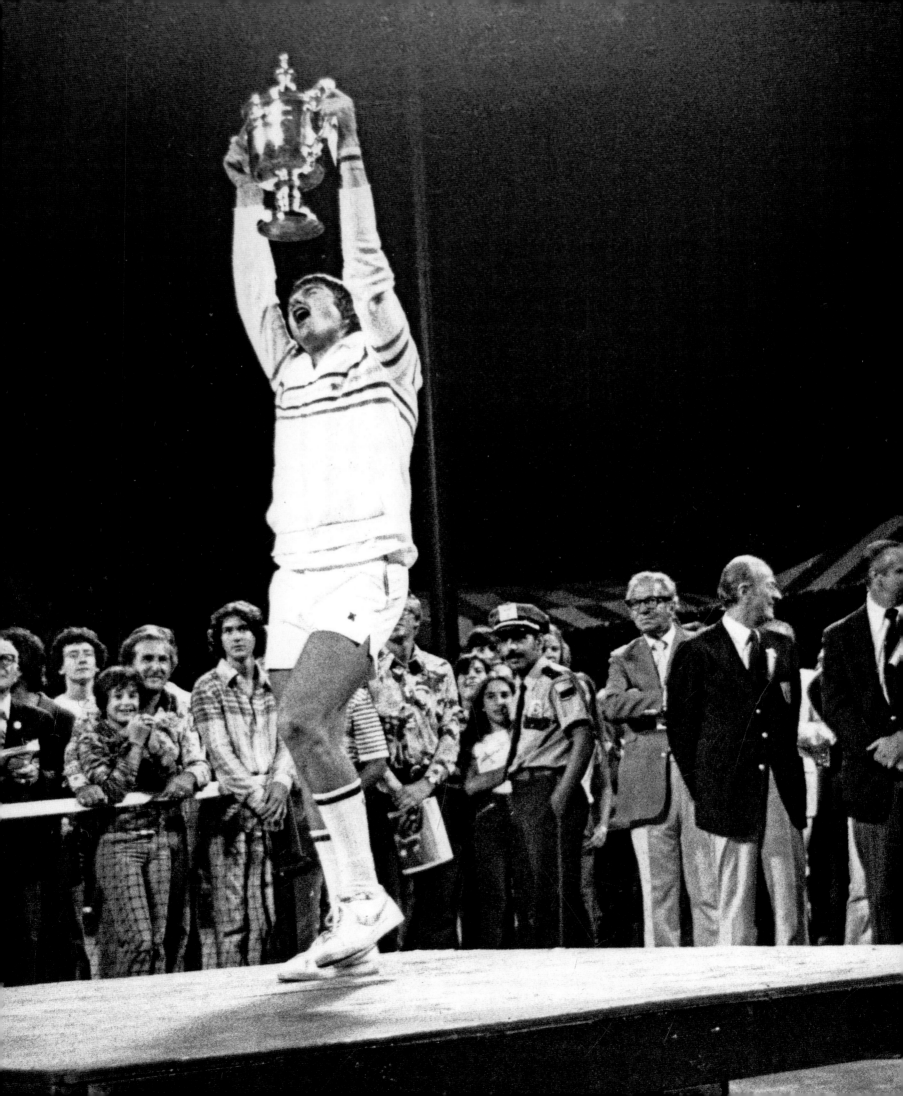

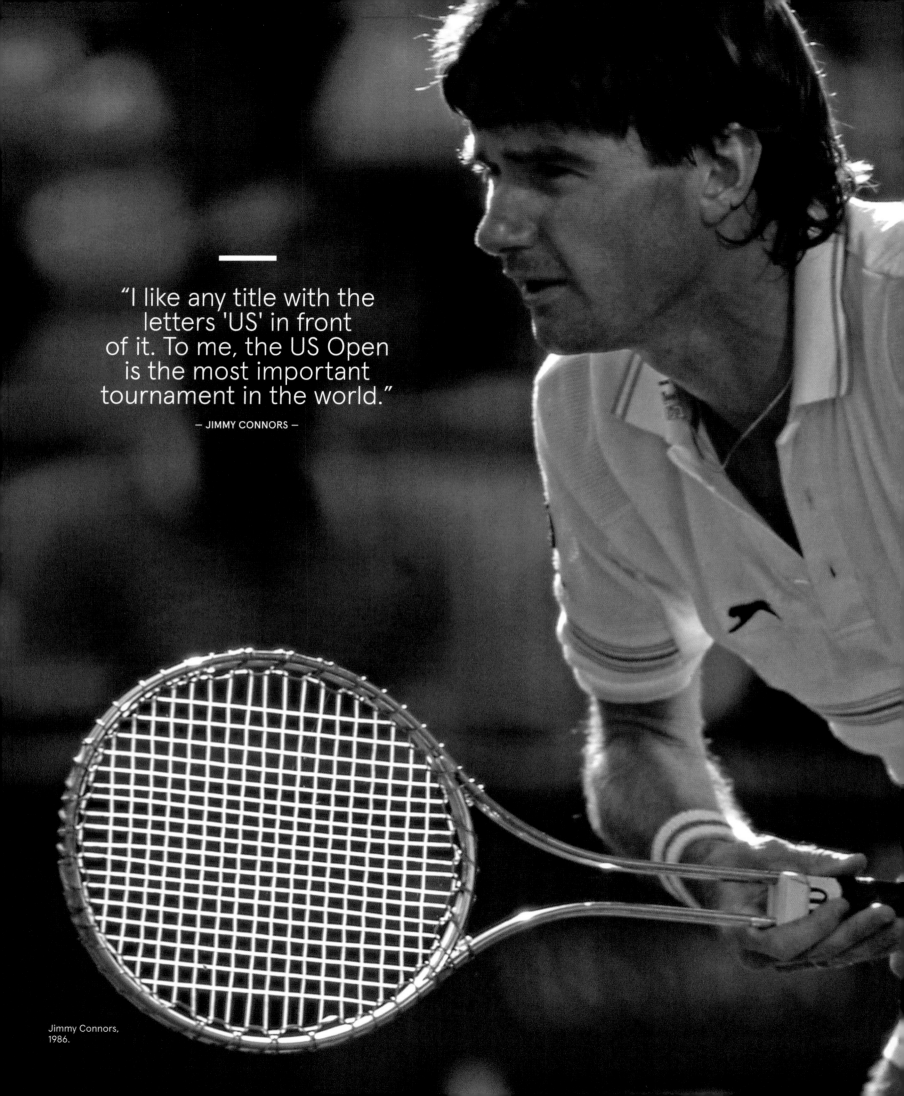

"I like any title with the letters 'US' in front of it. To me, the US Open is the most important tournament in the world."

— JIMMY CONNORS —

Jimmy Connors, 1986.

The romance between Jimmy Connors and the US Open has long been recognized. But it was not love at first sight. True to the spirit of Connors and the tournament's host city, it was a love hard-fought. Connors knew this, never more than on September 10, 1978. That evening, he'd won the US Open for the third time, beating his greatest rival, Björn Borg, to close out a run that was arguably the most significant of Connors's five US Open victories.

A year earlier, he had lost in the final to Guillermo Vilas. That match had ended more like a soccer game. As fans stormed the court to raise Vilas on their shoulders, Connors, miffed at a late call on match point, nearly punched a photographer and stormed off the court, skipping the post-match awards ceremony. This had also been the last match played at the West Side Tennis Club in Forest Hills, the venue rendered obsolete by a decade of unprecedented growth. Connors's 1978 triumph had come in the debut year of a new public facility, what would be known as the USTA Billie Jean King National Tennis Center.

In the early 1970s, Connors was front and center for the transformation of tennis from a sport for the classes to one for the masses. Prior US Open champions were cool crooners, tranquil gentlemen such as Stan Smith, Arthur Ashe, Rod Laver, Ken Rosewall, and John Newcombe. But the red-hot "Jimbo" was tennis's first rock star. From his glistening steel racquet to his scuffling footwork to his off-the-charts intensity to his Prince Valiant haircut, everything about Connors signaled a new tennis paradigm. "People don't understand," he said, "that it's a goddamned war

out there." The implication that Connors carried this mind-set beyond the lines only heightened the drama.

The US Open was once an acoustic garden party; Connors made it an electric jungle, a carnival of commotion and sizzling ambition.

At first, not everyone took to this confident man from the Midwest. In the 1974 final, thirty-nine-year-old Rosewall was clearly the crowd favorite. But popularity meant nothing in the wake of Connors's all-out assault, a 6–1, 6–0, 6–1 obliteration that lasted just

sixty-eight minutes. "Not everybody was for Rosewall," Connors said afterward. "There were eight for me." Two years later in the final, this time following a win over Borg, Connors said, "The New York crowd is a tough one to play in front of. They come to see blood. I didn't want to give them any of mine."

Who could blame New York for its demands? Crime, financial woe, and political turmoil had brought the Big Apple to the brink. New York and Jimbo joined together as feisty counterpunchers. So it was that Connors was a man on a mission at the 1978 US Open. Earlier that summer, Borg trounced him in the Wimbledon final, a loss that triggered Connors to say he'd follow the Swede "to the ends of the earth," a battle cry besieged New Yorkers could relate to. There was also the matter of an ascending teen, a feisty American left-hander named John McEnroe. In 1978, inside the new Louis Armstrong Stadium, Connors routed each in straight sets on consecutive days.

Like New York City, Connors was tenacious. Having earned a redemptive win—and at a venue far different from the patrician club he'd bolted out of a year earlier—Connors now cast the blood he'd spilled on-court in a different light. Addressing the crowd after receiving his trophy, Connors said, "It seems every time I come to New York, I play my best tennis. Whether you like me or not, I like you."

Never again would a New York crowd root against Connors. The '78 win had made him the only player in tennis history to win the US Open on three different surfaces. There would follow more than a decade of gripping matches, highlighted by Connors's ongoing rivalries with Borg, McEnroe, Ivan Lendl, Andre Agassi, and Stefan Edberg. There would be two more title runs, Connors even regaining the world No. 1 ranking at the age of thirty.

Then, the requiem. Connors would call his 1991 run to the semis at the age of thirty-nine, "the best eleven days of my life." It began as a small fire: a comeback from two sets to love down versus Patrick McEnroe. By Labor Day—Connors's birthday—it was a blaze, Jimbo's epic showdown versus Aaron Krickstein capturing hearts and minds across the world. Be it in love or hate, victory or defeat, no one had made the US Open a place not just for spectators but for participants more than Connors. ●

Jimmy Connors in his record fourteenth men's semifinal, 1991.

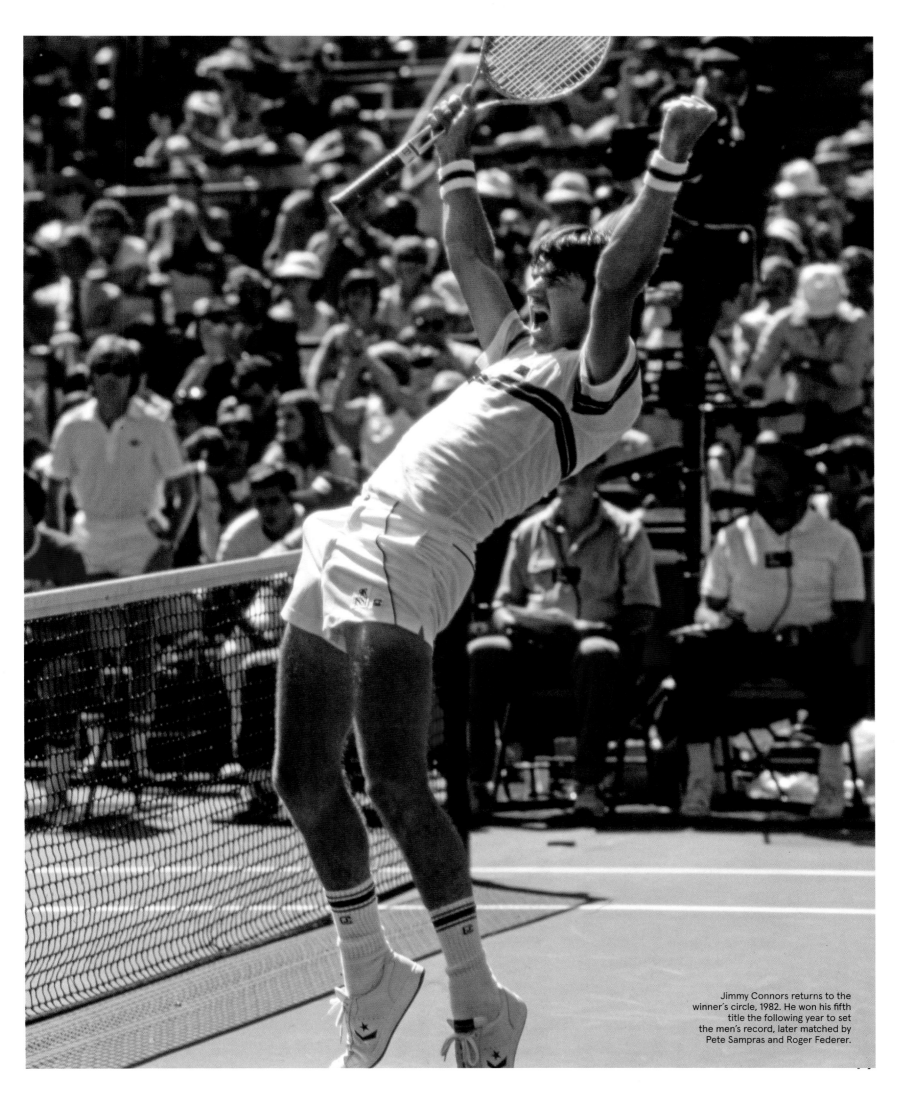

Jimmy Connors returns to the winner's circle, 1982. He won his fifth title the following year to set the men's record, later matched by Pete Sampras and Roger Federer.

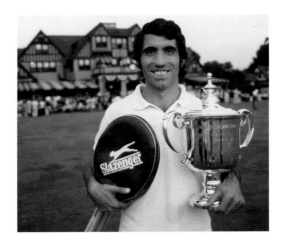

IMPOSSIBLE DREAMS

MANUEL ORANTES BECOMES THE FIRST PLAYER TO WIN A CHAMPIONSHIP AT THE US OPEN AFTER TRAILING BY MATCH POINT.

•

THERE IS NO MENTION of the term *match point* in the official rules of tennis. Nevertheless, all matches being played to a conclusion reach a juncture wherein the leading player can win the match by securing the next point to be played. Sometimes, it takes more than one match point for the leading player to earn the victory.

In the Open era, only seven players have achieved the improbable—claiming a US Open crown after being just one point from elimination—and Manuel Orantes, the first player to face a match point and still win the title, realized the greatest comeback of all.

Orantes arrived at the 1975 US Open never having experienced a great deal of success at the tournament. In five appearances, he had advanced past the third round only once—in 1971, when he reached the quarterfinals before being dispatched by Arthur Ashe in straight sets. The grass courts at the West Side Tennis Club in Forest Hills had a lot to do with it. At age twenty-six, Orantes had established himself as one of the game's premier players, rising as high as No. 2 in the world, with eighteen singles crowns to his credit. All but one of the titles had come on clay, as did his

best result in a Grand Slam tournament to that point—an appearance in the 1974 French Open final, which he lost to Björn Borg in five sets.

To Orantes's good fortune, the 1975 US Open introduced a major change that suited the Spaniard's fluid ground strokes perfectly. The US Open changed its court surface to Har-Tru green clay for the 1975 tournament in response to growing player criticism of the bounce of the ball on the grass courts. Playing on his favorite surface as the No. 3 seed, Orantes breezed through his first five matches—including the quarterfinals against Ilie Năstase—before nearly meeting his match in Guillermo Vilas, the No. 2 seed, in their semifinal contest.

Down two sets to one and 0–5 in the fourth set against Vilas, Orantes mounted an extraordinary comeback, with his supporters cheering him on with cries of "Viva Orantes!" He saved five match points and rattled off seven straight games to force a fifth set—and then emerged triumphant in the three-hour-forty-four-minute battle of attrition that marked the tournament's longest match, outlasting an exhausted Vilas, 4–6, 1–6, 6–2,

7–5, 6–4. The semifinal ended at 10:28 p.m., the late finish made possible by the introduction of night tennis at the 1975 US Open.

Orantes did not eat after the match; nor did he sleep much, either. Due to a plumbing problem in his hotel room, he did not go to bed until 3:00 a.m. "It was a very hard night," he said.

Eighteen hours after leaving the court, Orantes was back at the West Side Tennis Club, ready to play the biggest match of his life.

"I can win on all of them. I've proved that," Jimmy Connors, the defending champion, top seed, and Orantes's opponent in the final, had said of the clay surface earlier. Indeed, Connors would win the US Open on clay . . . the following year.

The 1975 US Open belonged to Orantes. Feeding "soft balls" to Connors to "let him do everything," the left-handed Orantes dictated the tempo and demonstrated his mastery of the clay court with slices and topspin.

"I didn't believe that it would be possible for him to hit passing shots and play like he did all the way through," Connor said. "But unfortunately for me, he did."

Barely making an error, Orantes dismantled Connors, 6–4, 6–3, 6–3, to claim the 1975 US Open championship, the biggest prize of his career.

The only woman to win a US Open singles title after trailing by match point is Martina Navratilova, who in 1986 saved three match points in her 6–1, 6–7(3), 7–6(8) semifinal victory over Steffi Graf. Navratilova erased two match points on her serve at 4–5 in the third set and held a match point of her own at 6–5 in the decisive tiebreak, only to see Graf win the point and then serve for the match at 8–7. A netted backhand by Graf evened the score at 8–8, and Navratilova won the next two points to book a date with Helena Suková in the final.

Three years later, Boris Becker saved two match points against Derrick Rostagno in the second round. Ahead two sets to one and 6–4 in the fourth-set tiebreak, Rostagno hit a volley long on his first match point. On the second match point, Becker's passing shot hit the top of the net and fell beyond Rostagno's reach. "The guardian angel helped me, but he came a bit late," said Becker, who won, 1–6, 6–7(1), 6–3, 7–6(7), 6–3, and went on to defeat Ivan Lendl in the 1979 final.

Pete Sampras saved only one match point in his 1996 quarterfinal against Àlex Corretja, but his escape was no less miraculous. Depleted and dehydrated by the time their fifth-set tiebreak began, Sampras repeatedly leaned over his racquet between points in an attempt to gather his strength and reached match point on Corretja's serve at 5–6, only to lose the next two points. Down match point, Sampras hit a lunging forehand drop volley to even the score and went ahead with a second serve ace. Seemingly stunned by the shift in fortunes, Corretja double faulted to give the victory to Sampras, 7–6(5), 5–7, 5–7, 6–4, 7–6(7), who won the title with a straight-sets victory over Michael Chang.

In his march to the 2003 title, Andy Roddick also saved one match point. Trailing two sets to love and 5–6 in a third-set tiebreak against David Nalbandian in the semifinals, Roddick saved his match point with a service winner before rolling to a 6–7(4), 3–6, 7–6(7), 6–1, 6–3 victory and advancing to the final, where he defeated Juan Carlos Ferrero in straight sets.

Novak Djokovic saved a pair of match points on Roger Federer's serve in the fifth

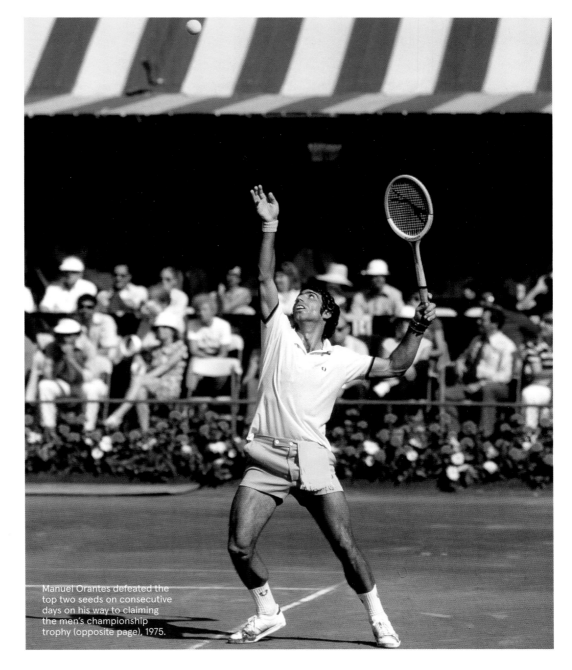

Manuel Orantes defeated the top two seeds on consecutive days on his way to claiming the men's championship trophy (opposite page), 1975.

set to knock off the five-time champion, 6–7(7), 4–6, 6–3, 6–2, 7–5, in the 2011 semifinals. Trailing 5–3, 40–15, Djokovic salvaged the first match point with a crosscourt forehand return that landed on the sideline. On the second match point, Federer made an unforced error on a forehand, and Djokovic wound up taking the last four games of the match to earn the victory. He then won his first US Open title by defeating Rafael Nadal in the final.

The last player to win a US Open championship after trailing by match point was Stan Wawrinka, who saved one match point

in a fourth-set tiebreak against Daniel Evans in the third round at the 2016 US Open. With Evans leading two sets to one and ahead 6–5 in the tiebreak, Wawrinka fought off the match point on his serve with a forehand volley winner at the net. He went on to take the tiebreak, 10–8, and the match, 4–6, 6–3, 6–7(6), 7–6(8), 6–2. Eight days later, he won his first US Open championship by defeating Djokovic in the title match. Following the final, Wawrinka reflected on his good fortune after someone asked for the secret of his success.

"For sure you get a little bit lucky when you save match point," he said. "But that's tennis." ●

CHRIS EVERT

By Steve Flink

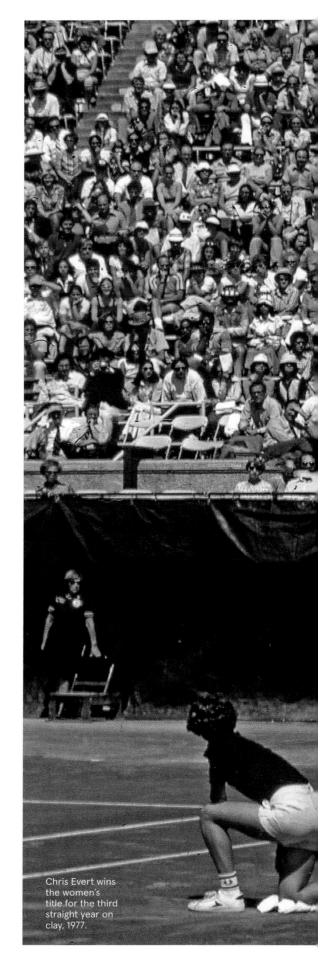

Chris Evert wins
the women's
title for the third
straight year on
clay, 1977.

A^s we celebrate the golden anniversary of the US Open, a cavalcade of champions spring swiftly to mind in defining this half century of soaring and riveting competition. They have hailed from virtually every corner of the globe. They comprise an extraordinary breed of competitors who have raised the bar immeasurably for tennis, individuals who have made the game more vibrant, standouts who have captured the public's imagination enduringly and irrevocably.

But no player—male or female—has connected with the New York fans for a longer period of uninterrupted excellence and unassailable consistency than did Chris Evert. This implacable American came out of Fort Lauderdale, Florida, as a teenager; turned the US Open upside down as a sixteen-year-old making an incomparable debut in 1971; and played on indomitably through the eighties. For nineteen consecutive years, she was never less than a quarterfinalist, capturing a record six singles titles on two different surfaces, amassing the most match victories ever (101) against only twelve defeats, and achieving the finest winning percentage of any major Open-era figure in New York. Through it all, she was the ultimate sportswoman, a model of decorum, and an exemplary professional. Meanwhile, with her unerring precision from the backcourt and a transformational two-handed backhand, she sweepingly influenced the next generation with her dignity, unwavering determination, and playing style.

Evert fondly recollects her entire US Open career, starting with her stunning run to the semifinals in her 1971 debut. She vividly recalls her string of three-set comeback triumphs over Mary-Ann Eisel (against whom she sedulously rescued herself from the brink of defeat and saved six match points), Françoise Dürr, and Lesley Hunt. That stirring run carried her to the penultimate round, where she was beaten by the craftiness and match-playing acumen of Billie Jean King. Evert was the central figure in that tournament, and it altered her life forever.

"Whatever they wrote at the time about it being a Cinderella story," she reflects, "it really was. I remember somebody told me afterward, 'You were interviewed by Howard Cosell!' He was the most renowned sportscaster in the country, but I didn't know who the heck he was. I was oblivious to all the attention I was getting. I just went home after my matches with my mother, to my aunt and uncle's house in Larchmont, and emptied the dishwasher. I was lucky to have the two greatest tennis parents ever, and they kept me grounded. I came into that tournament like a nobody, and I left feeling like a star."

That 1971 Open did indeed turn Chris Evert into a household name, not simply in tennis

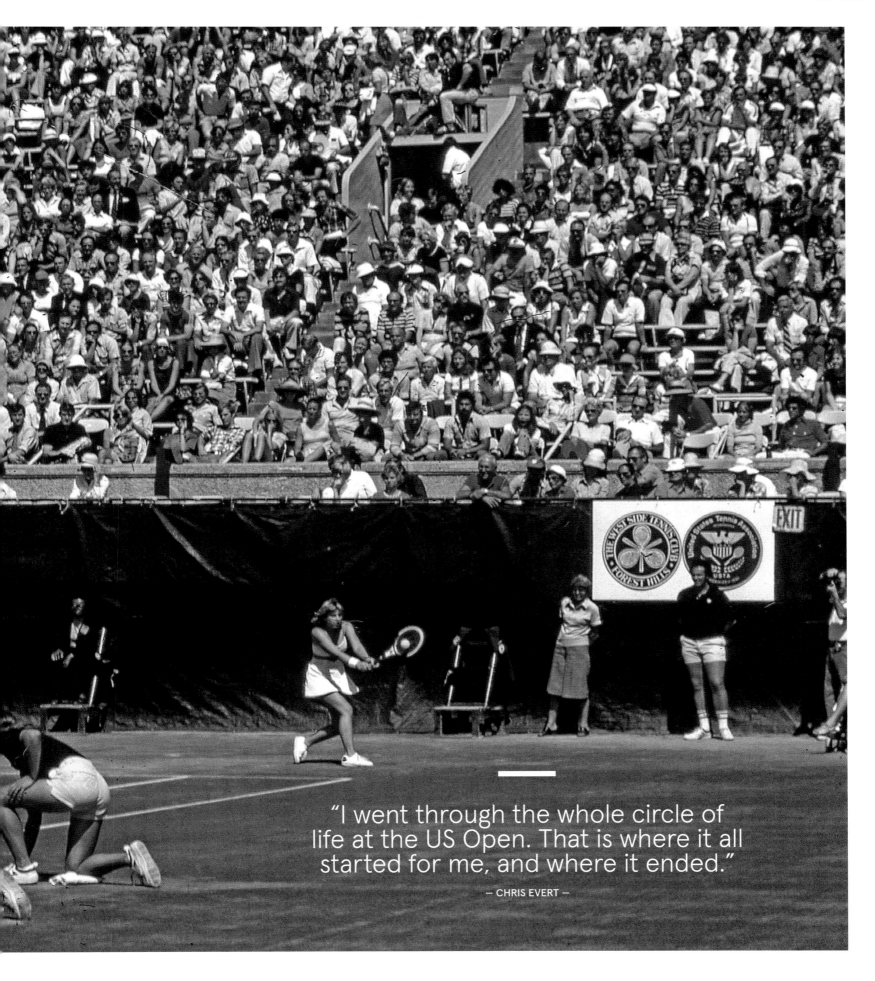

"I went through the whole circle of life at the US Open. That is where it all started for me, and where it ended."

— CHRIS EVERT —

but across the entire world of sports. After reaching three more semifinals in a row on the grass at Forest Hills, she secured her first US Open title on Har-Tru when the tournament shifted to that claylike surface in 1975, fighting with quiet ferocity to upend Evonne Goolagong, 5–7, 6–4, 6–2, in a hard-fought final. Recalling the exhilaration of that experience, Evert told me recently, "When it ended, the first thing I saw was my mother sobbing in the stands. She was more emotional than I was. But to win the championships of my country for the first time in that manner, in a tough three-set match, definitely meant a lot to me. I thought Evonne played great tennis."

Evert took the title the next two years at Forest Hills and then came through on the hard courts of Flushing Meadows in 1978 to make it four US Open title runs in a row. After losing to her virtual mirror image, Tracy Austin, in the 1979 final, Chris stymied the Californian upstart in the semifinals, 4–6, 6–1, 6–1, on the same court in 1980, ending a perturbing five-match losing streak against the tenacious

Austin, claiming her fifth US Open crown by upending Hana Mandlíková a day later.

"I would have lost to Tracy again," says Evert, "if it had not been for Don Candy, who was Pam Shriver's coach. He told me if I was going to play the same way I normally did, I was going to lose. He said I had to play outside the box and take the initiative. I did that. I changed a losing game, and it changed my perspective on how to play the game after that. I knew I could step up and be more aggressive. Before I won that match against Tracy, I had thought she would dominate tennis for the next ten years, but, after beating her, it definitely gave me a second lease on life in my career at twenty-five."

After collecting her sixth and last title in 1982, Evert was ousted in the 1983 final by a top-of-the-line Martina Navratilova. When they collided again the following year in the final on a magnificent Super Saturday, it seemed entirely possible that Evert would prevail. But, despite unbridled crowd encouragement, notwithstanding a stouthearted

performance, she suffered a thirteenth consecutive defeat against her most formidable rival, bowing out gallantly, 6–4, 4–6, 4–6.

"That was devastating," recollects Evert. "For those two years [1983–84], honestly, every time I walked on the court with Martina, I felt like I had lost the match already with my attitude. This time I gave myself a pep talk and I walked out there giving myself a chance. I stayed with her the whole time, playing aggressive tennis, but I should have taken more chances in the third set when I had opportunities. I got tentative with the thought of beating her, and then I lost. I was disappointed in myself that I couldn't rise to the occasion and close it."

And yet, Evert eclipsed Navratilova the next time they met in Key Biscayne, Florida, and went on to oust her in the finals of the 1985 and 1986 French Open, as well as the semifinals of the 1988 Australian Open. But when Evert came to New York for the 1989 US Open, she knew it would be her last appearance. At thirty-four, she realized that

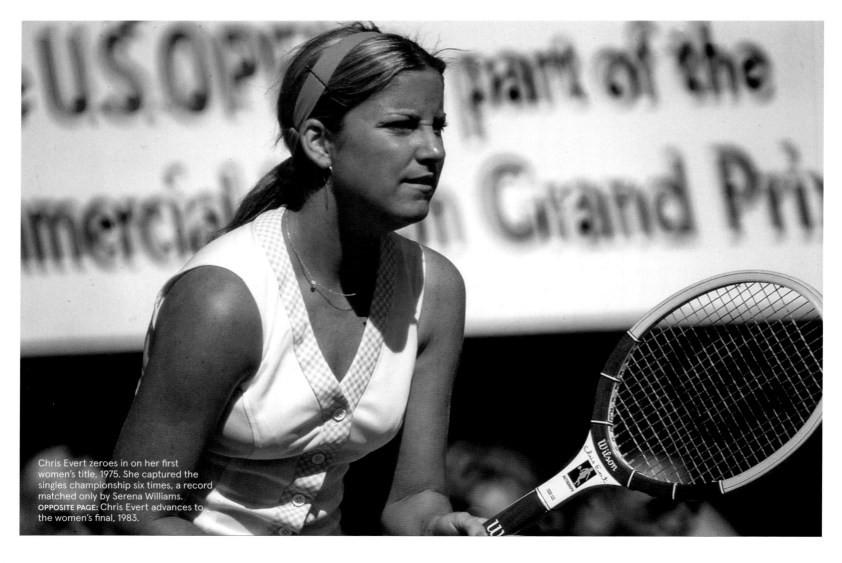

Chris Evert zeroes in on her first women's title, 1975. She captured the singles championship six times, a record matched only by Serena Williams.
OPPOSITE PAGE: Chris Evert advances to the women's final, 1983.

in many ways she had run out of resources. Evert turned back the clock several years in crushing fifteen-year-old Monica Seles, 6–0, 6–2, but then squandered a 5–2 first-set lead against Zina Garrison and lost 7–6(1), 6–2 in the quarterfinals.

"That win against Monica was my match of my year," says Evert. "I polished her off, and that made me feel good. I was on a real high, but losing to Zina was a reminder of why I was retiring. I just didn't have the hunger or intensity. It was almost like I didn't care if I won or lost. It was appropriate that I would end my US Open career on a match like that, because the mental part of my game was declining, and I wasn't getting psyched up for every single match the way I did for my whole career. I knew it was time to go."

Although Evert would lead the United States to victory in the Fed Cup in Tokyo the next month, the US Open was the last tournament she would ever play. She concluded her career by being the victor in 90 percent of her matches, surpassing every other modern male or female champion with that astonishing efficiency. She collected eighteen major singles titles and missed the semifinal cut in only four of her fifty-six Grand Slam championships. She was a singularly reliable and steely competitor, a perennially popular champion, and arguably one of the five best female tennis players of all time.

Summing up her feelings on competing at the US Open across the seventies and through the eighties, Evert says, "Your antenna goes up when you play in your country's championships. The alertness level and the intensity and all the intangibles are magnified when you are playing on home turf. Every time I walked on the court, no matter who I played, I felt the New York crowd cheering for me. I put everything I had into the US Open every year, and afterward, I was spent. After the US Open, where I always had that natural inspiration, it was almost like I shut it down."

The fact remains that Evert seldom let her guard down at the US Open—or, for that matter, anywhere else. She was the quintessential competitor, a champion through and through, and a woman who settled only for the loftiest professional standards. In the final analysis, it is inconceivable that any player will ever replicate Evert's enduring eminence and capacity to steadfastly conduct herself graciously, elegantly, and honorably under the glare of the public spotlight. ●

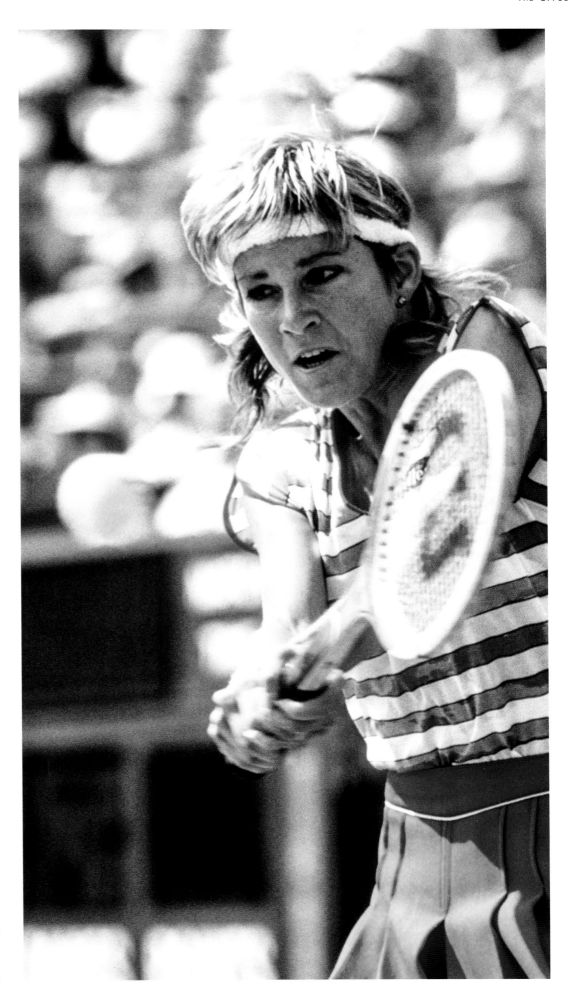

GUILLERMO VILAS

—

"Once you win one, you want
to win another one. If you win two,
you want to win a third one.
Then you want them to build a statue
in the middle of Buenos Aires."

Vilas's surprise win over defending champion Jimmy Connors in the
1977 final was the last US Open match played at Forest Hills.

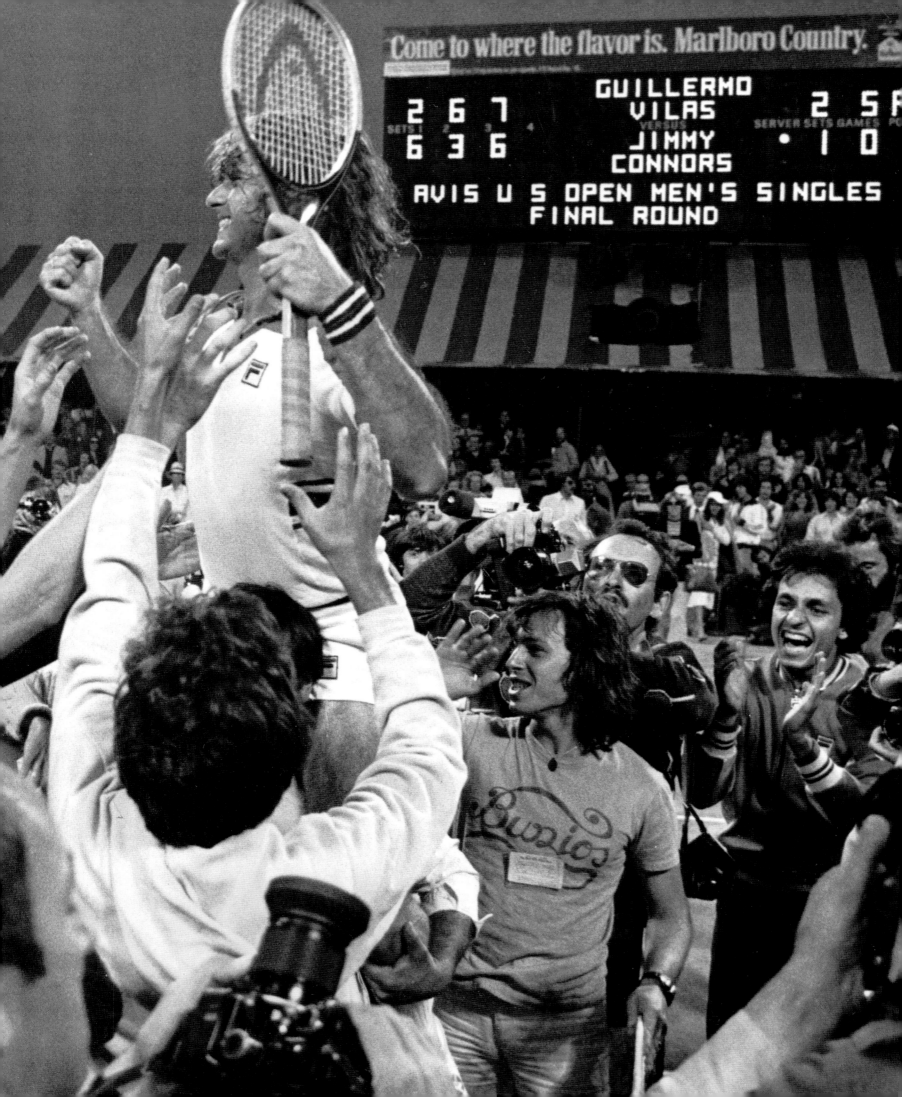

PUBLIC ACCESS

RELOCATING IN 1978 TO THE LARGEST PARK IN QUEENS
PROVIDES THE US OPEN WITH A MORE SPACIOUS VENUE TO
ACCOMMODATE ITS GROWING POPULARITY.

·

Fans gather in every direction to watch Ilie Năstase and Ion Țiriac team up in men's doubles, 1979.

THE US OPEN has been based in New York City ever since its precursor, the US National Championships, outgrew its birthplace in Newport, Rhode Island, and moved to the borough of Queens, taking up residence in 1915 at the newly constructed West Side Tennis Club in Forest Hills. The tournament's eventual migration across Queens to its present home in Flushing Meadows grew out of a similar desire to make the US Open

more accommodating for tennis fans. Happenstance, hard bargaining, and a pair of world's fairs also contributed to the 1978 move to Flushing Meadows.

New York City Park Commissioner and master builder Robert Moses was the first person to get the ball rolling in Flushing Meadows by converting marshland and a mountainous garbage dump—memorialized by F. Scott Fitzgerald as "the valley of the

ashes" in his 1925 novel *The Great Gatsby*— into a 1,225-acre site for the 1939–40 New York World's Fair. Commemorating the 150th anniversary of George Washington's inauguration in New York City as the nation's first president, which marked the formal beginning of the US government, the 1939–40 New York World's Fair was the city's first international exposition in eighty-five years. Unlike the previous world's fairs, where cities such as London,

Paris, Chicago, St. Louis, and San Francisco celebrated mankind's technological advancements and achievements, the 1939-40 New York World's Fair, having been formulated in 1935, at the height of the Great Depression, employed "Building the World of Tomorrow" as its theme and was the first world's fair to look toward the future. A visionary builder himself, Moses planned to turn the reclaimed wasteland, which was located in the geographical center of New York City, into a vast park for all New Yorkers to enjoy at the conclusion of the Fair. However, a lack of funds stalled the park's development.

A quarter of a century later, Moses capitalized on a second opportunity to realize his grand plans for the park when he was hired to organize the 1964–65 New York World's Fair. Once again, he selected Flushing Meadows for the fairgrounds. Symbolized by the 900,000-pound, twelve-story-high stainless steel Unisphere, the New York World's Fair would become the largest world's fair ever held in the United States, occupying nearly a square mile of land.

In the midst of the fair's construction, Moses realized an arena was needed for hosting the opening ceremonies and other special events—including US Olympic trials, judo and karate exhibitions, and cultural festivals—and he sought to have the structure built and paid for by an outside corporation. In exchange, the company would be entitled to sponsor an exhibit in the arena's main hall and have its name adorn the building—a highly uncommon practice at the time. The Singer Company, a client of the ad agency employed by the fair, gamely agreed to pay for the stadium's construction and facility operations during "this Olympics of Progress," which is how Moses summed up the international exposition in his opening ceremony speech. The Singer Exhibit Center, located in the arcade under the stands, showed off the latest in fashions and fabrics, do-it-yourself sewing projects, and a slew of Singer products—not only sewing machines but also typewriters, vacuum cleaners, television sets, phonographs, and computing devices. The stadium, a seventeen-thousand-seat oval situated close to the fair's main entrance, was named the Singer Bowl.

In the years immediately after the fair, the Singer Bowl was used occasionally for rock concerts—Jimi Hendrix, the Doors, and the Who performed there—professional boxing

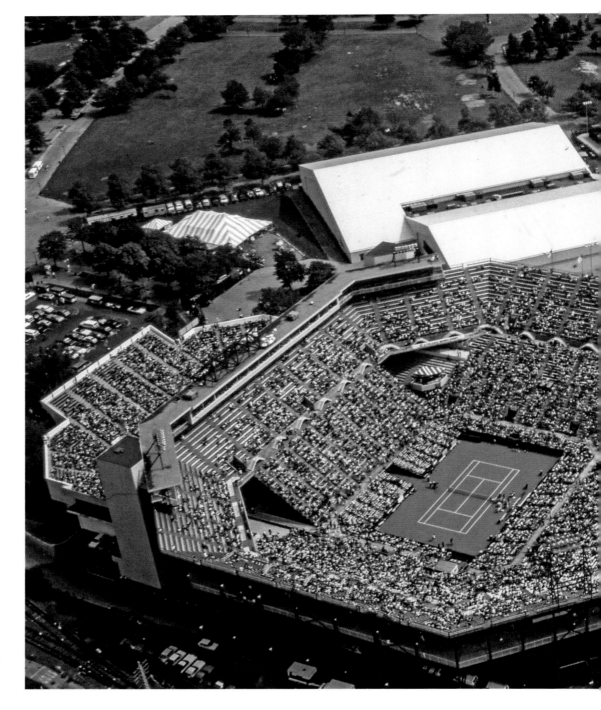

matches, and an assortment of other proceedings, including an NBA all-star game for charity in 1968 and a fireworks celebration after the neighboring New York Mets won the 1969 World Series. On the Fourth of July in 1973, during a jazz jamboree featuring the likes of Ella Fitzgerald, Eubie Blake, and Gene Krupa, the arena was renamed Louis Armstrong Memorial Stadium in honor of the jazz giant who had lived nearby, in the Corona section of Queens. But the stadium soon fell

into disrepair—a victim of New York City's fiscal crisis—and was closed in 1974, unable to meet the standards for a permanent certificate of occupancy.

It would soon be reborn.

William "Slew" Hester, a cigar-chomping oil wildcatter who was about to assume the presidency of the USTA, noticed the dilapidated remains of Louis Armstrong Stadium rising above the two feet of snow that covered the grounds of Flushing Meadows–Corona Park

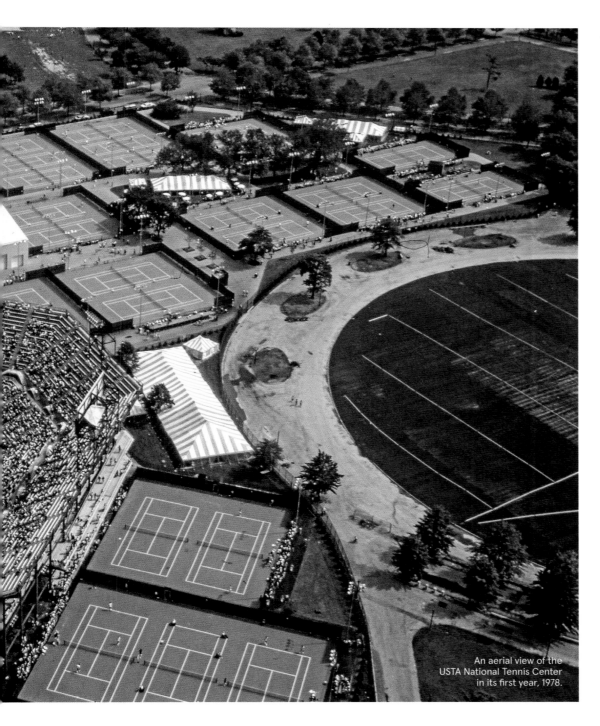

An aerial view of the USTA National Tennis Center in its first year, 1978.

Armstrong's hometown of New Orleans; and comedian Alan King, one of the first celebrities to attend the US Open on a regular basis. By then, architect David Specter had come up with a masterstroke to make the long and narrow Louis Armstrong Memorial Stadium more suitable for viewing tennis matches. If the existing configuration had been used, most of the spectators would have been seated too far away from the court. Alternatives included tearing down the stadium altogether and building a new one. After discussing the problem with his friend Ysrael Seinuk, who was a structural engineer, Specter recommended to Hester that they convert the western half of the arena's giant oval into an octagonal bowl, creating two adjoining structures for tennis: Louis Armstrong Stadium and the Grandstand.

"The architectural gods were smiling. There was just enough space between the existing steel and concrete walkways to fit the length of the tournament court," said Specter, who identified the project as "The USTA National Tennis Center" on his architectural drawings. The name would stick.

Throughout the construction process, problems kept arising. A tidal water table was discovered beneath a landfill. Old pilings from demolished World's Fair buildings were unearthed and needed to be removed. Seven New York City unions went on strike. In May 1978, a representative from Consolidated Edison called Hester to say a test conducted by the electric and gas utility indicated the new facility's power requirements were so immense that every transformer in the surrounding area would blow out. A daylong search located two huge transformers in Louisiana that were shipped to Queens to bring electricity to the facility from the Long Island Railroad station next door. Two weeks before the tournament began, camera crews discovered more light was needed for television broadcasts, so additional floodlights had to be manufactured and installed.

In the midst of the various delays, Hester liked to try to hurry things along by asking, "Whatcha think you're doin', building the Taj Mahal?"

Remarkably, ten months after the ground-breaking, the new palace was ready, just in time for the first ball to be struck at the 1978 US Open. ●

as he flew into LaGuardia Airport at Christmastime in 1976. Negotiations to renew the expiring ten-year contract with the West Side Tennis Club for the US Open had reached an impasse, and Hester, who strongly believed the time had come to find a new home for the tournament, now knew where to build it. Much like Moses, who had envisioned creating an idyllic park out of a heap of ashes, Hester was a man of determination, and he wasted little time in getting in touch with city officials.

Within a matter of days, he had an agreement in principle with New York City to build a public tennis center with twenty-seven outdoor courts, nine indoor courts, locker rooms, klieg lights, and food concessions— all anchored by Louis Armstrong Stadium, which the USTA promised to rehabilitate.

Ground was broken, on October 6, 1977, during a rainy ceremony that included Hester; Lucille Armstrong, widow of the great jazz musician; a group of dancers from

JOHN McENROE

By Peter Bodo

John McEnroe after defeating
Jimmy Connors to advance to
the men's final, 1984.

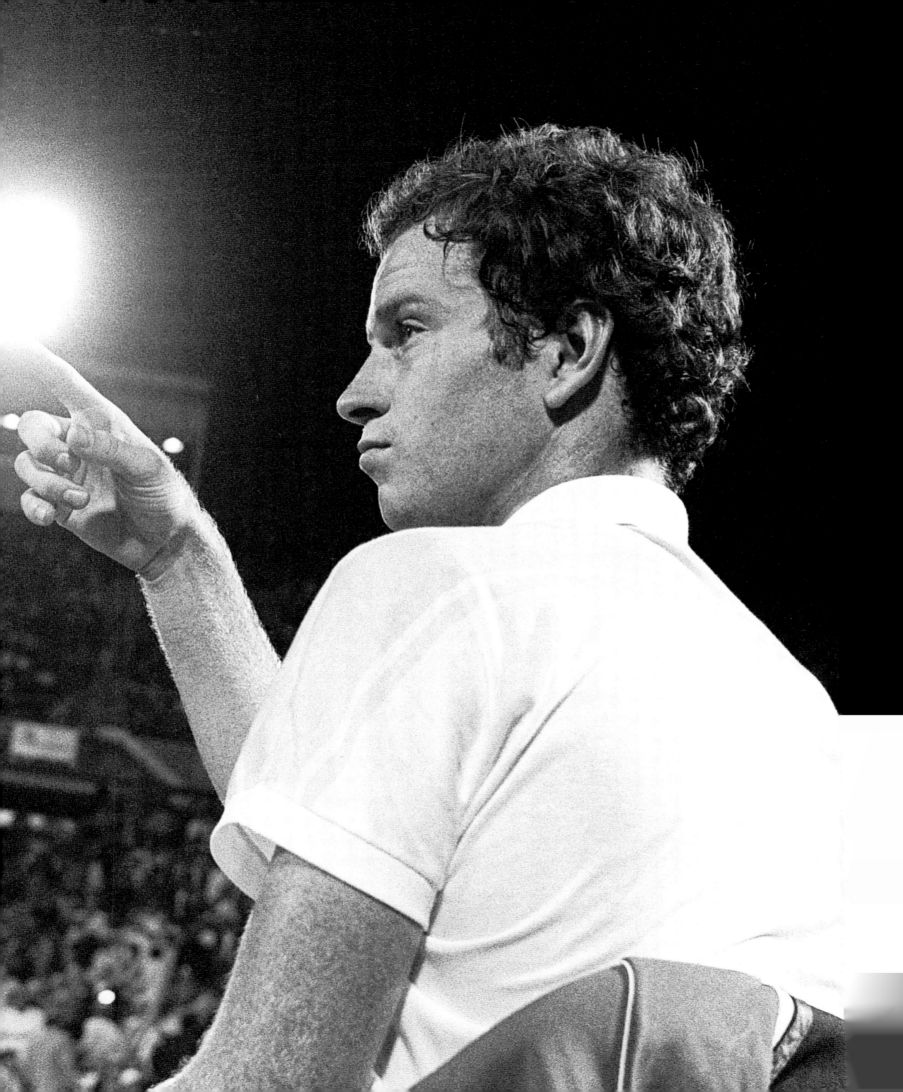

John McEnroe wasn't the most successful player in US Open history. He wasn't even the most prolific winner of his generation, one in which stony-visaged Ivan Lendl appeared in eight consecutive singles finals (winning three), and five-time champion Jimmy Connors did all in his power to woo and ingratiate himself to the notoriously fickle New York fans. But no player represents the US Open more accurately and faithfully than this four-time singles champion.

Despite having grown up and lived his entire adolescent life in the same New York borough that hosts the US Open, McEnroe was never the flavor of the month at the USTA's National Tennis Center. He never swept New Yorkers off their feet. Throughout his entire career, he was denied the adulation showered on other hometown heroes. The reasons were obvious—and valid. He was too much the brat. Too boorish. Too pushy. Too edgy.

What he was, of course, was too New York.

McEnroe was a mirror in which the city didn't see only what it wanted to but also a true, raw reflection of itself. And who wants that?

Now that his playing days are over, certain truths emerge and stay with us. McEnroe has become beloved in Gotham. He's a genuine New York personage with a high public profile in the only city he has ever called home. It's the same place where he never felt he had to kowtow to anyone, including tennis officials, opponents, and fans (how very New York!). New York is the city McEnroe could never view the way Connors saw it, with the wide-eyed awe of a rube who just hit town

and bought into all that "If you can make it here, you'll make it anywhere" malarkey. Having to ride the subway train and a bus back and forth to school in Manhattan, the way McEnroe did for so long, can dim that kind of luster.

One of the great ironies of McEnroe's career is that the public never fully appreciated the nature of his style of play. It was an inexplicable disregard, considering that matters of style, artistry, and originality loom so large in the minds of so many New Yorkers. McEnroe's style—from that "can-opener" lefty serve to his cramped but effective forehand—was unique. His catlike quickness was delightful to behold. The first commandment of tennis is arguably "bend your knees." It's just one of the countless injunctions, not all tennis related, that McEnroe appeared to flout.

McEnroe emerged at a time when the game was firmly in the hands of Connors and Björn Borg. Connors played an exciting but fundamentally bread-and-butter baseline game. Borg, whose athleticism was unparalleled, reduced the game to table tennis. Neither Connors nor Borg had what anyone would call an "artistic" game. But then McEnroe didn't either, at least not the way we might apply the word to the game of, say, Roger Federer.

The thing that made it difficult to recognize McEnroe's artistry was a certain lack of fluidity in his style. While fleet and nimble,

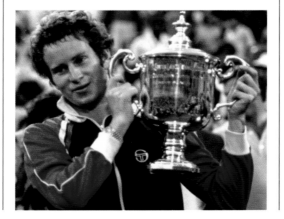

McEnroe's game was all angles and slices and chops. Yet his touch was exquisite, his shot selection inventive, his use of the court profoundly creative. McEnroe's tennis was like Brazilian soccer. He played radical, improvisational jazz for an audience expecting something along more classical lines.

Aficionados and tennis aesthetes appreciated McEnroe from the get-go, but they never constituted the majority of fans who attend the US Open. From early in his career, McEnroe was defined not by his many-hued game but by his churlish antics. "I want to be remembered as a great player," he once said in a moment of sober self-analysis. "But I guess it will be as a player who gets angry on the court."

Clearly, McEnroe is remembered as both. His greatness as a player rests on two pillars: the US Open and Wimbledon. They account for all seven of the Grand Slam singles titles he won. His life-span at the top was surprisingly short, considering his record and reputation. McEnroe won all of his singles majors in the span of five years. It's a tribute to his intensity, the quality that enabled him to record the highest annual winning percentage in 1984, the year his match record was a dazzling 82–3.

McEnroe offended many and incurred the wrath of legions at the peak of his powers, but often in ways that were comical as well as memorable. His famous "You cannot be serious!" accusation at Wimbledon has become a catchphrase known to all; McEnroe himself has become a cultural touchstone. He's not only a ubiquitous US Open broadcast analyst, he also pops up here, there, and everywhere. *The Meyerowitz Stories* is a 2017 movie in which the delusional main character played by Dustin Hoffman frequently issues protests over one thing or another, always punctuating them with the exclamation, "McEnroe!"

Over time, truth asserts itself. McEnroe is now the face of tennis in New York, the person who best represents the US Open and what it means to Gotham and beyond. It's about time, too. ●

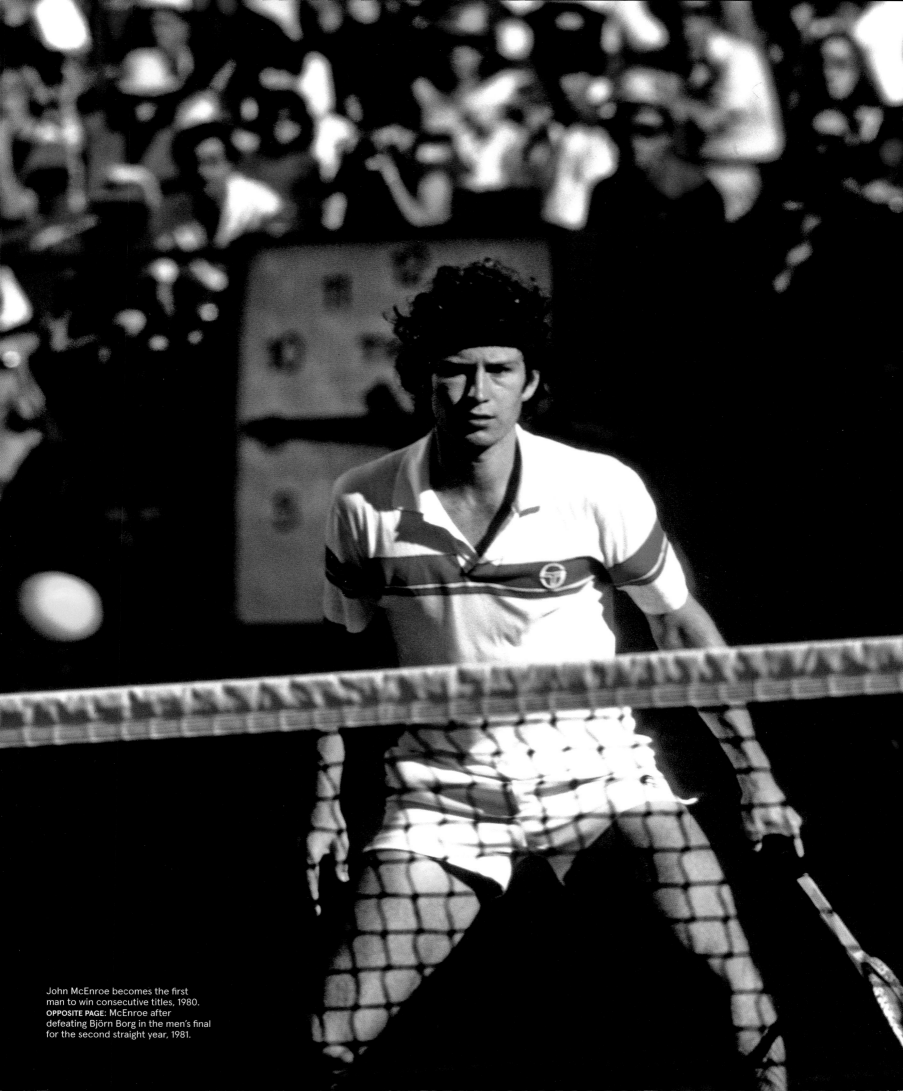

John McEnroe becomes the first
man to win consecutive titles, 1980.
OPPOSITE PAGE: McEnroe after
defeating Björn Borg in the men's final
for the second straight year, 1981.

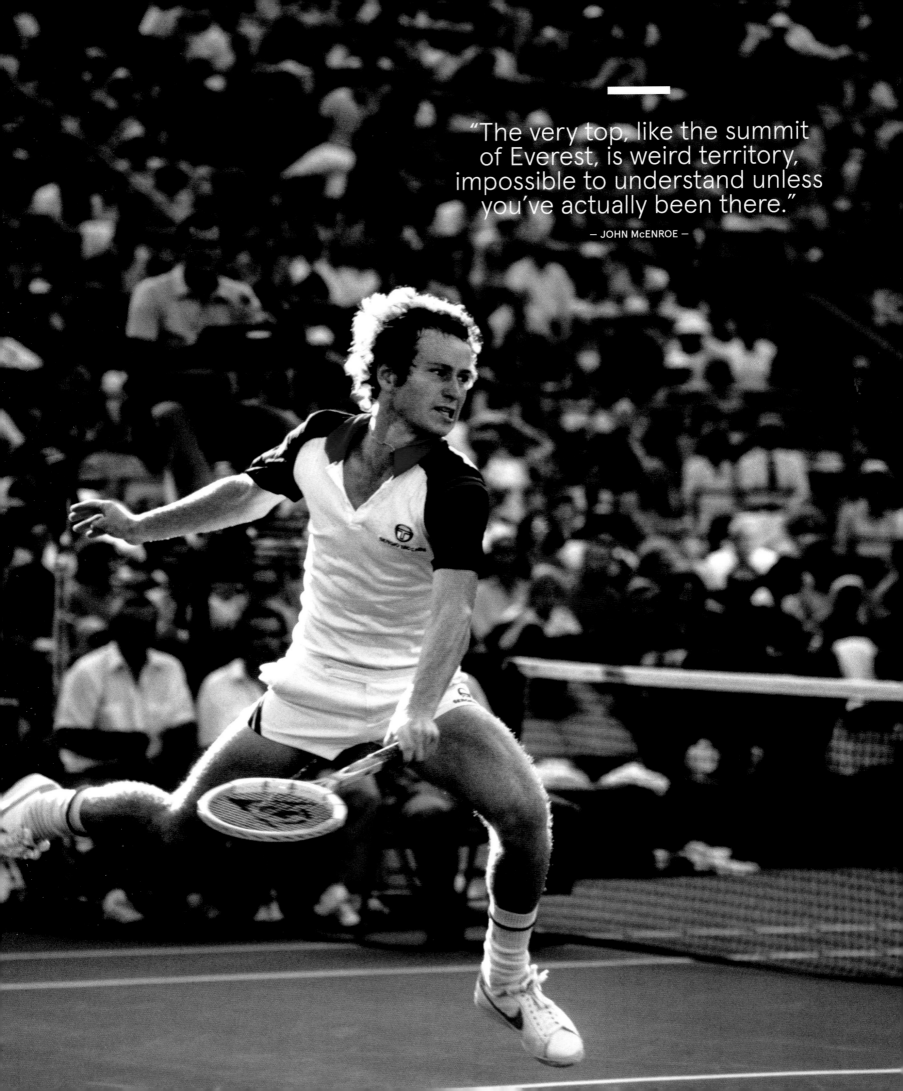

"The very top, like the summit of Everest, is weird territory, impossible to understand unless you've actually been there."

— JOHN McENROE —

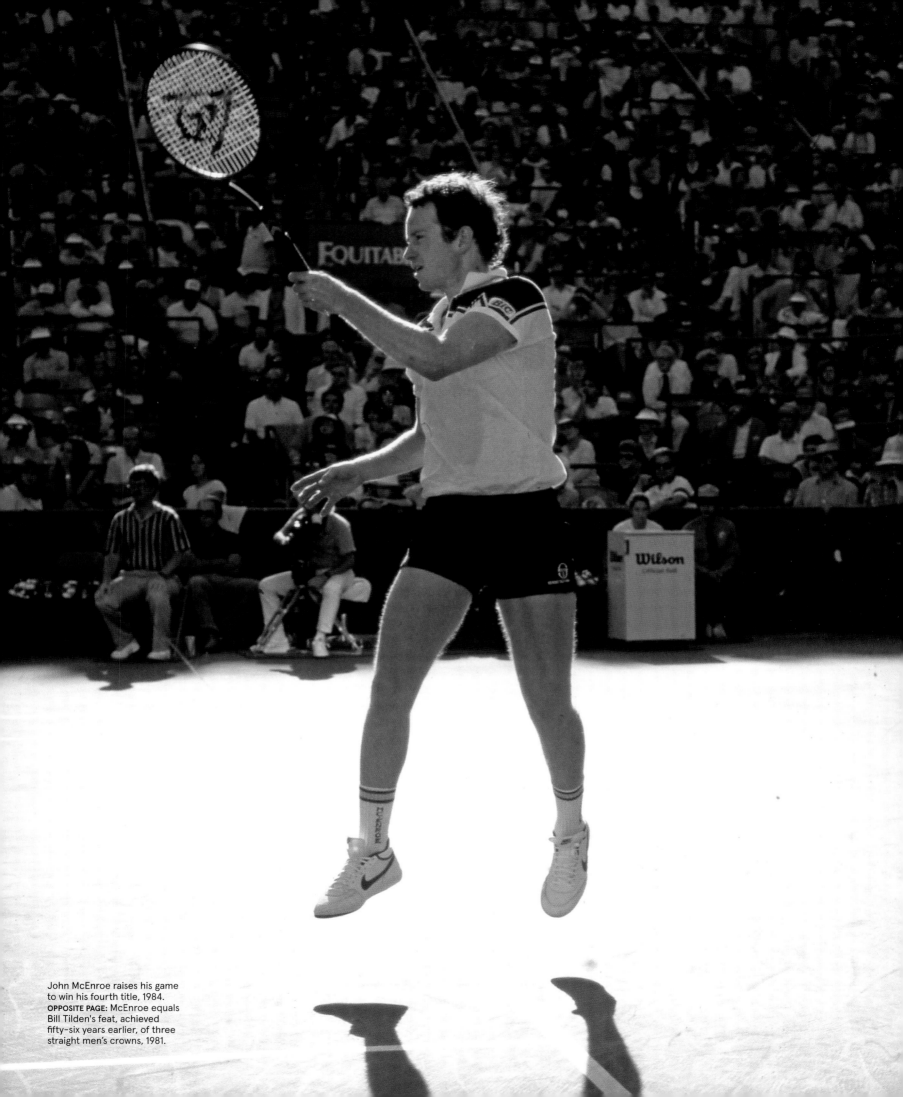

John McEnroe raises his game to win his fourth title, 1984.
OPPOSITE PAGE: McEnroe equals Bill Tilden's feat, achieved fifty-six years earlier, of three straight men's crowns, 1981.

TRACY AUSTIN

By Neil Amdur

Tracy Austin becomes
the youngest women's singles
champion, 1979.

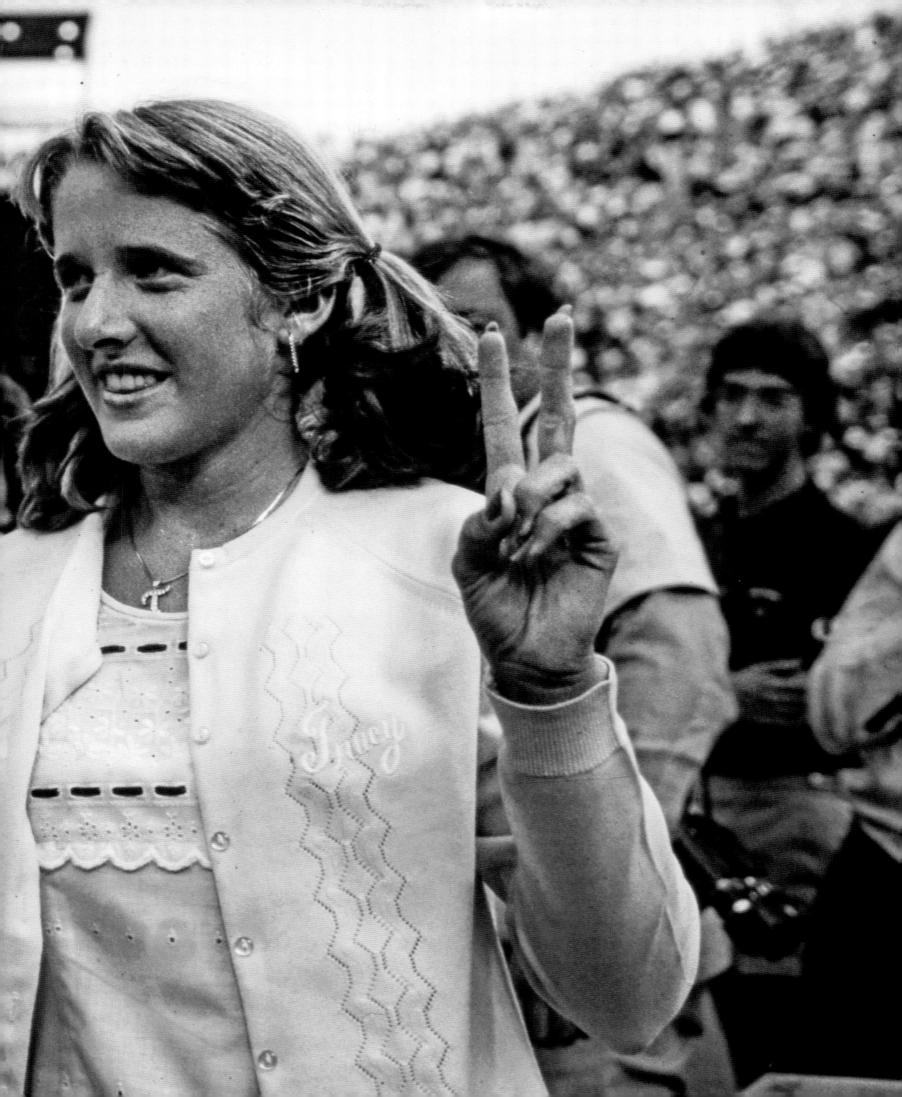

For Tracy Austin, the US Open remained "a very special place." And not simply because it was the scene of her two Grand Slam singles titles, a love affair with prime-time night matches, or an unexpected phone call in the clubhouse from the president of the United States.

New York, and the Open, became a virtual home away from home for a modest California teenager whose mental toughness and laser-like focus were as compelling and threatening to rivals as her steady ground strokes.

From the time she first arrived as a fourteen-year-old amateur in 1977, complete with braces, pigtails, and made-for-play pinafore dresses, Austin's unassuming five-foot, ninety-pound frame had already staked out roots. At ten years old, she had won a national 12-and-under crown and claimed a pro title earlier that year in Portland, Oregon.

But the US Open created unexpected pressures and pleasures. At the West Side Tennis Club in Forest Hills, site of the '77 Open, the traditional pre-match walk through the crowds from clubhouse to courts ("involved and vocal," Austin would later recall) was exhilarating. One year later, with the move to Flushing Meadows, the darkened underground bowels of the stadium produced a heightened sense of mystery and drama for Austin in the pre-match trek. "It was just a long process of noise and interaction," she said.

The US Open crowds also provided a "vibe" and "certain electricity" that differed from her matches at Wimbledon and Paris, especially at night. After working out on a private court at a home on Long Island where she and her mother regularly stayed during the Open, Austin treated night matches as more "honor" than disruption to the daily tournament schedule.

Her "breakout moment" at the '77 Open was a 6–1, 6–4 upset over No. 4 seed Sue Barker followed by a 6–3, 7–5 win over Romanian Virginia Ruzici, who would capture Paris one year later. A loss to the rangy thirty-two-year-old power hitter Betty Stöve of the Netherlands in the quarterfinals was reversed a year later, after Austin turned pro, in a final in West Germany that served as a preview of her march to the 1979 US Open singles title.

Rewriting Maureen Connolly's 1951 achievement by three months in becoming the youngest US Open champion at sixteen years, nine months was no routine feat. In the second round, Austin was confronted by another talented fourteen-year-old baseline peer, Andrea Jaeger, then escaped a third-set tiebreak scare against Kathy Jordan in the fourth round.

The fact that Austin defeated Martina Navratilova (7–5, 7–5) and Chris Evert (6–4, 6–3) in successive straight-set matches for the title, a feat few others would achieve on the circuit, left her to observe years later, "That was a lot to compartmentalize for a sixteen-year-old." Besides ending Evert's bid for a fifth consecutive title, Austin had also snapped her opponent's 125-match winning streak on clay earlier that year in a three-set semifinal at the Italian Open.

"I loved our matches," Austin would say of their sixteen-match rivalry, which included nine victories for Austin (one of only three players who held a career advantage on Evert in singles). "You knew it was hard, you had long rallies, and you had to outmaneuver and put groups of shots together."

The 1981 US Open proved even more satisfying for Austin on many levels. After rising to No. 1 during 1980, a sciatic nerve injury sidelined her for four months in early '81, a harbinger of medical issues that would ultimately shorten her career. Navratilova stormed through the first set of their US Open final, 6–1, on a windy, unsettled day when Austin could easily have succumbed to the serve-and-volley southpaw power that had ousted Evert in the semifinal.

"I tried to stay calm and cool," Austin recalls now, even after she won the second set in a tense tiebreak but squandered three match points in the twelfth game of the third set that extended the match to a decisive tiebreak for the first time in an Open final.

Trying to find the emotional balance between "intensity and moderation," Austin borrowed wisdom from her grandmother, who had lived to 103 and often preached "a little bit of everything, but everything in moderation." By pinning Navratilova to the corners of her more vulnerable backhand, Austin surprised her opponent with forehand winners down the line for the early lead en route to a decisive 7–1 victory and the title.

Austin's repeat success against Evert and Navratilova in the season-ending Toyota Series earned her Female Athlete of the Year from the Associated Press. But by the summer of 1983, well before her twenty-first birthday and struggling with a variety of injuries, Austin was forced to withdraw from the US Open. Future comeback attempts were also sidetracked by recurring injuries and an auto accident in 1989.

Her legacy remains, however, as a youthful champion and the youngest inductee into the International Tennis Hall of Fame (at age twenty-nine in the summer of 1992), who could playfully engage in verbal tongue twisters with one of her older tennis-playing brothers in the car en route to the Open, lock in match-wise on the court, and then engage President Jimmy Carter on the phone after one of her matches.

"I was so intimidated that I can't even remember what I said," Austin recalls decades later, now married with three sons. "It was overwhelming. Just imagine someone says to you, 'Oh, the president's on the line for you.' It was surreal." ●

"I don't think about [being] the youngest [US Open champion]. I just think about the champion's part."

— TRACY AUSTIN —

Tracy Austin wins her second title, 1981.

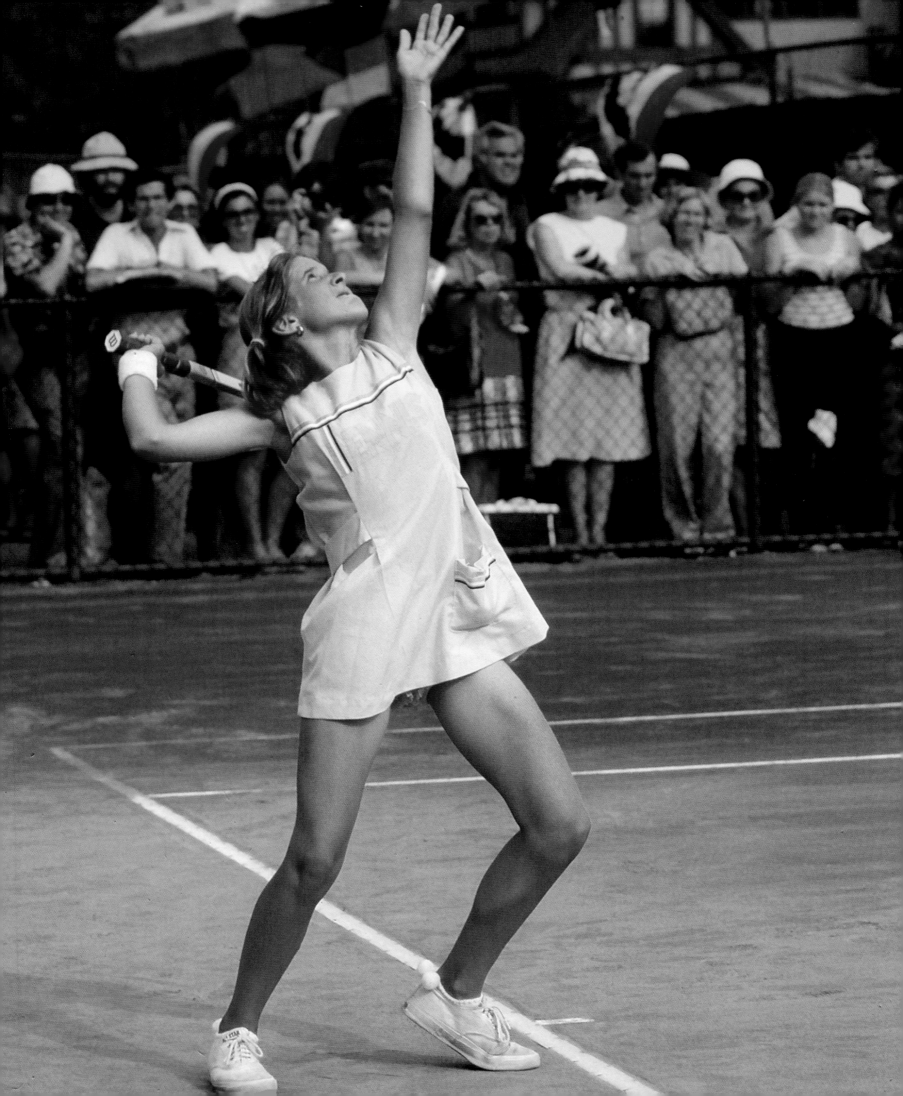

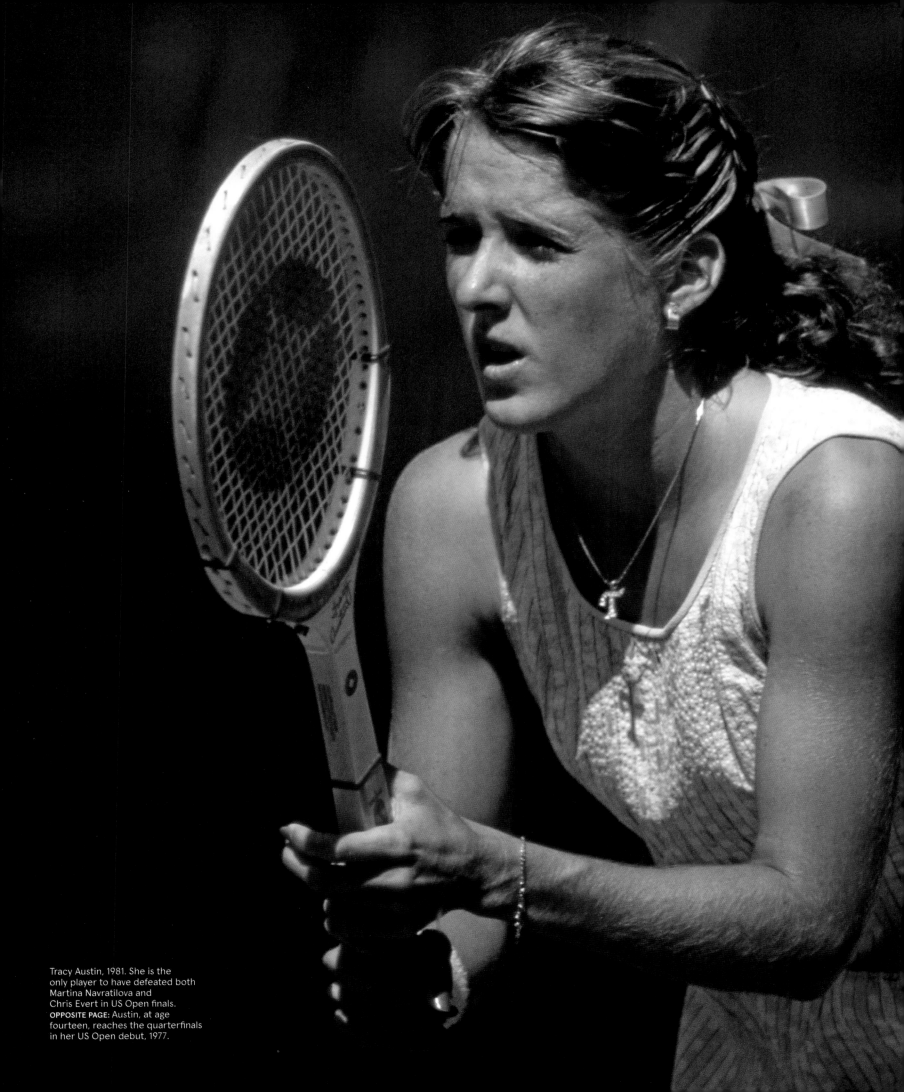

Tracy Austin, 1981. She is the
only player to have defeated both
Martina Navratilova and
Chris Evert in US Open finals.
OPPOSITE PAGE: Austin, at age
fourteen, reaches the quarterfinals
in her US Open debut, 1977.

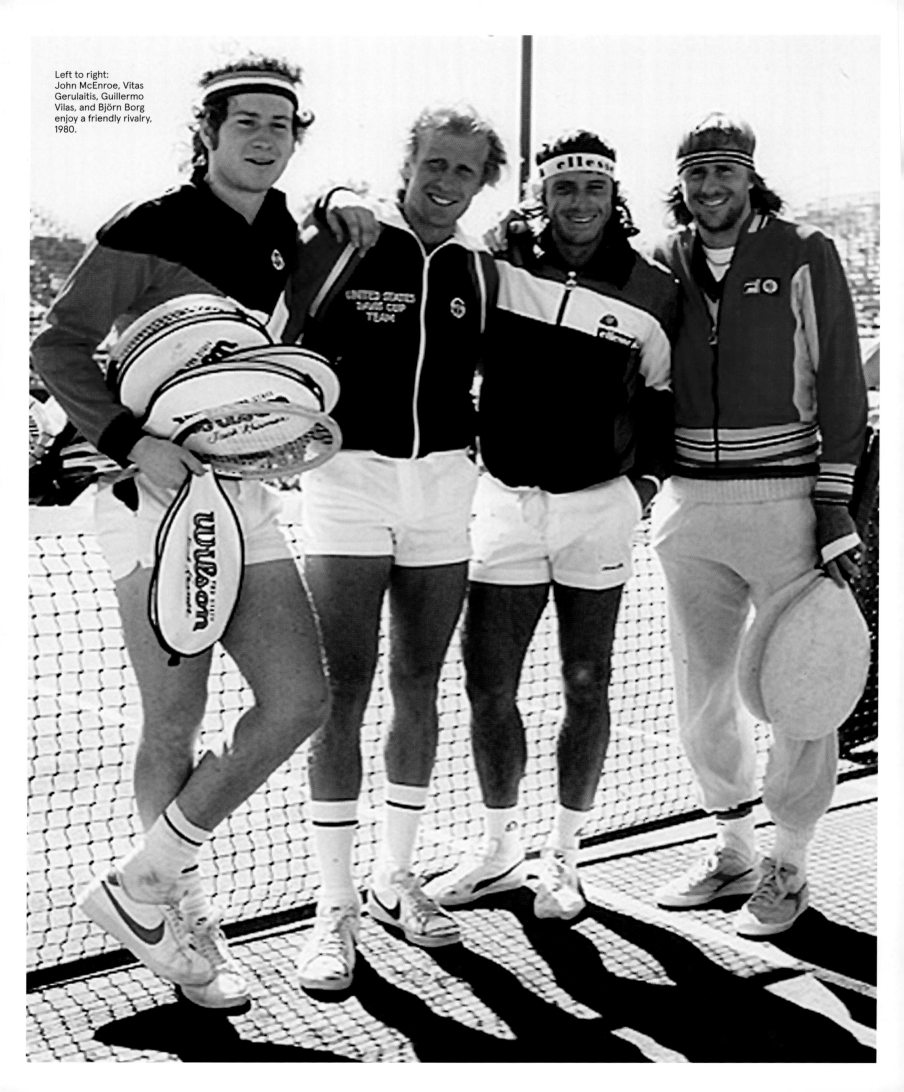

Left to right:
John McEnroe, Vitas
Gerulaitis, Guillermo
Vilas, and Björn Borg
enjoy a friendly rivalry,
1980.

19

THE

80s

The US Open raised its game to new heights in the 1980s. Showcasing some of the greatest and most colorful talents the sport has ever known, this was the decade when the hard courts of the USTA National Tennis Center became tennis's ultimate proving grounds, where only the strong survived.

1980

Andrea Jaeger, at the age of fifteen years and three months, becomes the youngest US Open semifinalist. / Billie Jean King wins her thirteenth and last US Nationals/US Open title, teaming with Martina Navratilova in women's doubles. / Chris Evert defeats Hana Mandlíková in the women's final, 5–7, 6–1, 6–1. / John McEnroe defeats Björn Borg in the men's final, 7–6, 6–1, 6–7, 5–7, 6–4. Their fifty-five games played are the most in a final in the tiebreak era.

1981

The women's draw is increased to 128 players. / Barbara Gerken becomes the first women's qualifier in tournament history to reach the quarterfinals. / At the one-hundredth anniversary of the US Championships, Americans claim the men's and women's singles and doubles titles. / Tracy Austin defeats Martina Navratilova in the women's final, 1–6, 7–6, 7–6. / John McEnroe becomes the first man since Bill Tilden in the 1920s to win three straight US titles, defeating Björn Borg in the men's final, 4–6, 6–2, 6–4, 6–3. The loss is Borg's fourth US Open runner-up finish and his final Grand Slam appearance.

1982

Total tournament prize money exceeds $1 million for the first time. / Billie Jean King makes her final US Open singles appearance. / Ivan Lendl ends John McEnroe's twenty-six-match US Open win streak in the semifinals. / Chris Evert defeats Hana Mandlíková in the women's final 6–3, 6–1, for her record sixth title. / Jimmy Connors defeats Ivan Lendl in the men's final, 6–3, 6–2, 4–6, 6–4.

1983

Aaron Krickstein, the reigning USTA National Boys' 18 champion, advances to the round of 16 before

Cover of the US Open tournament program, 1983.

August 30, causing serious damage to the grounds, including downed power lines, major flooding, and uprooted trees. There is no delay, however, and the tournament resumes in full the next day. / Hana Mandlíková defeats Martina Navratilova in the women's final, 7–6, 1–6, 7–6. / Ivan Lendl defeats John McEnroe in the men's final, 7–6, 6–3, 6–4.

1986
John McEnroe suffers his earliest US Open exit, losing in the first round to Paul Annacone. / Andre Agassi makes his US Open debut at age sixteen and will not miss a US Open through his retirement in 2006. / Jimmy Connors's streak of twelve straight semifinal berths is ended in the third round by Todd Witsken, who becomes the lone American man to reach the quarterfinals. / All four singles finalists are Czechoslovakian-born. / Martina Navratilova defeats Helena Suková in the women's final, 6–3, 6–2. / Ivan Lendl defeats Miloslav Mečíř in the men's final, 6–4, 6–2, 6–0.

1987
A long-range planning study is initiated that will ultimately result in the building of Arthur Ashe Stadium and the expansion of the US Open grounds. / Gabriela Sabatini and Beverly Bowes take the court exactly at midnight, in the latest start of a US Open day-session match. / Michael Chang, at the age of fifteen years, six months, and ten days, becomes the youngest man to win a match at the US Open. / Chris Evert's streak of sixteen straight US Open semifinal appearances is ended by Lori McNeil in the quarterfinals. / On the one-hundredth anniversary of the first women's championships, Martina Navratilova wins the triple crown, defeating Steffi Graf in the women's singles final, 7–6, 6–1, and teaming with Pam Shriver to win the women's doubles and Emilio Sánchez to win the mixed doubles. / Ivan Lendl defeats Mats Wilander in the men's final, 6–7, 6–0, 7–6, 6–4.

1988
Pete Sampras makes his US Open debut at age seventeen. / A stomach flu nearly wipes out a full day's schedule in Arthur Ashe Stadium as Chris Evert and Rick Leach are forced to default their women's singles semifinal and men's doubles final matches, respectively. / Steffi Graf defeats Gabriela Sabatini in the final, 6–3, 3–6, 6–1, to complete the Grand Slam, and she goes on to win the gold medal in women's singles at the Olympics in Seoul, Korea, for a "Golden Slam." / Mats Wilander defeats Ivan Lendl, 6–4, 4–6, 6–3, 5–7, 6–4, in four hours and fifty-five minutes—the longest men's final in US Open history.

1989
Chris Evert, playing in her last US Open, defeats fifteen-year-old Monica Seles for her 101st and final US Open singles victory before losing to Zina Garrison in the quarterfinals. / Steffi Graf defeats Martina Navratilova in the women's final, 3–6, 7–5, 6–1. / Ivan Lendl advances to his record eighth consecutive US Open men's final but is defeated by Boris Becker, 7–6, 1–6, 6–3, 7–6.

losing to Yannick Noah. / Martina Navratilova defeats Chris Evert in the women's final, 6–1, 6–3. / Jimmy Connors defeats Ivan Lendl in the men's final, 6–3, 6–7, 7–5, 6–0, for his record fifth title. / The winner's purse exceeds $100,000 for the first time, as Navratilova and Connors each receive a check for $120,000.

1984
Martina Navratilova and Pam Shriver become the first women's doubles team to complete a Grand Slam. / "Super Saturday" is born on September 8 as all four matches played in Louis Armstrong Stadium—a senior men's semifinal, two men's semifinals, and the women's final—reach the maximum number of sets. / Martina Navratilova defeats Chris Evert in the women's final, 4–6, 6–4, 6–4. / John McEnroe defeats Ivan Lendl in the men's final, 6–3, 6–4, 6–1.

1985
Mary Joe Fernández, at the age of fourteen years and eight days, becomes the youngest player to win a match at the US Open. / A tornado strikes the USTA National Tennis Center in the late afternoon of

MARTINA NAVRATILOVA

By Pam Shriver

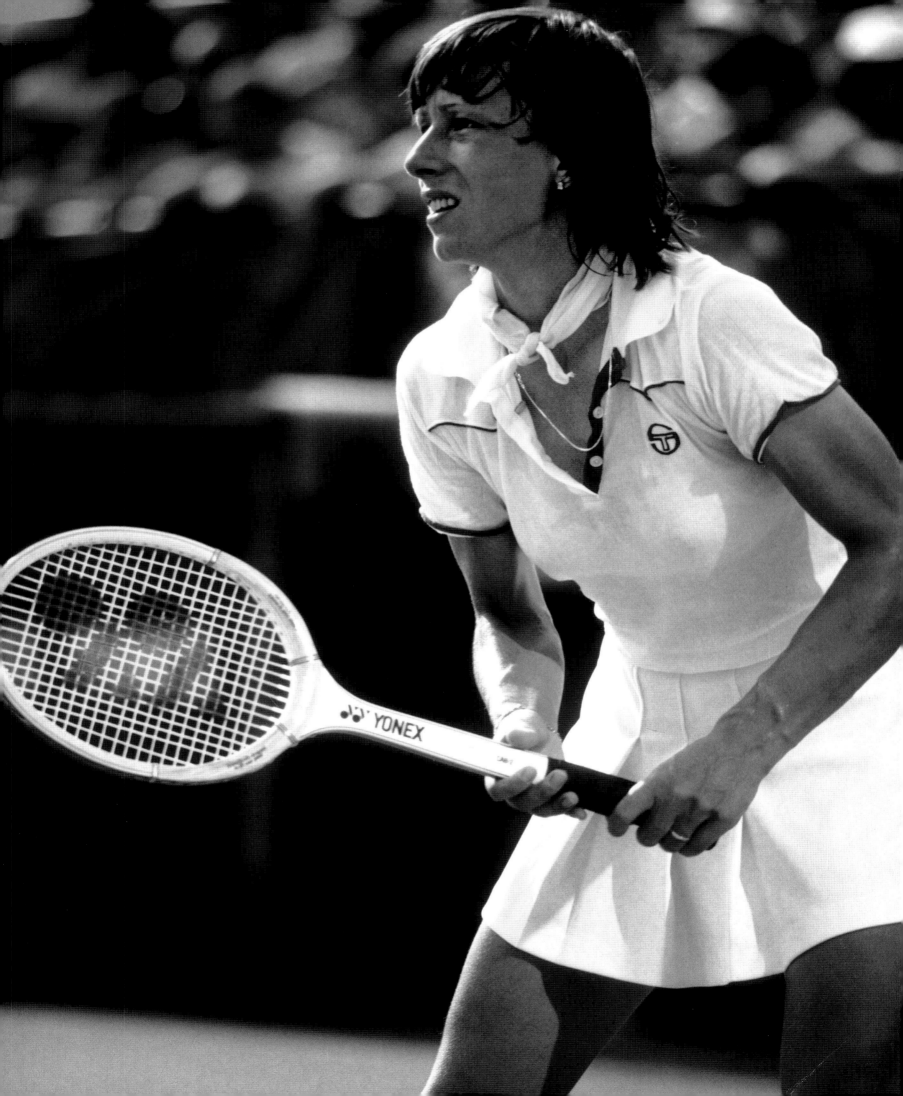

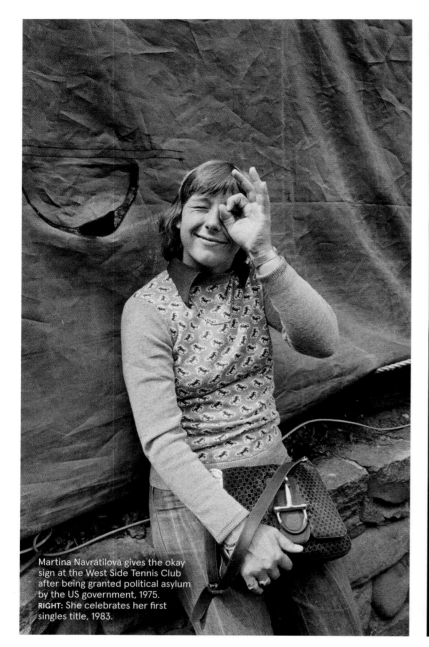

Martina Navratilova gives the okay sign at the West Side Tennis Club after being granted political asylum by the US government, 1975.
RIGHT: She celebrates her first singles title, 1983.

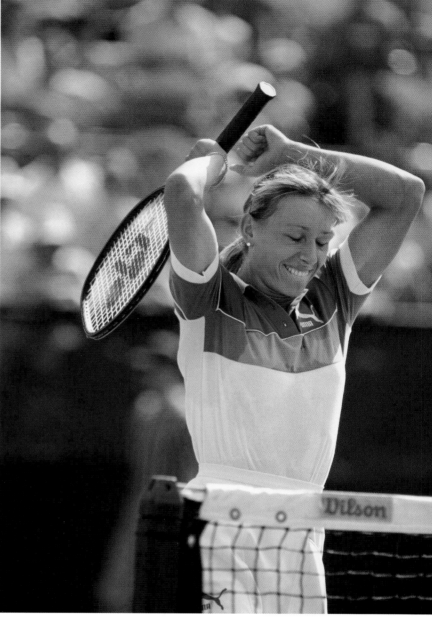

I t took time for Martina Navratilova to come to terms with all that is the US Open. It was a process that evolved as she evolved—both as a player and as a person. It was a journey, one that was measured in so much more than just the miles from Prague, where she was born, to Flushing Meadows, where in so many ways, she was born again. But once the athlete and the event connected, it became a very special relationship, an unbreakable bond between a singular champion and a sensational event.

The US Open was not the place where Martina won her first Grand Slam singles title; that came at Wimbledon in 1978. Nor was it the place where she won the majority of her eighteen Grand Slam singles crowns; her record nine titles at the All England Club set that mark. And as is often the case with so many foreign-born players, the US Open was at first intimidating to Martina; the noise and the crowds, the bustle and the outright nutti-ness all proved more than a bit overwhelming.

But that said, the initials *US* always were attractive to her; the things that they represented were the things that she desired in her life and career. It was freedom, mostly; a freedom that was not readily available to her in communist Czechoslovakia. Despite her obvious talents, there were always obvious restrictions.

And so, in 1975, the day after she lost in the US Open semis to Chris Evert—the woman who would become the other half of one of our sport's greatest rivalries— Martina chose this tournament to announce her defection to the US, beginning a new chapter of her life in a packed press tent on the second Saturday afternoon of the US Open.

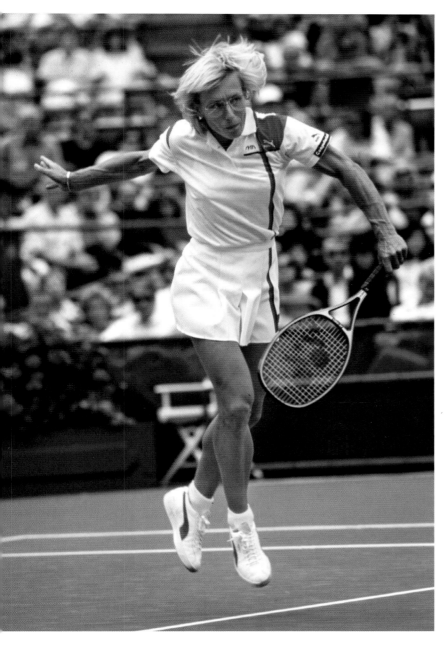

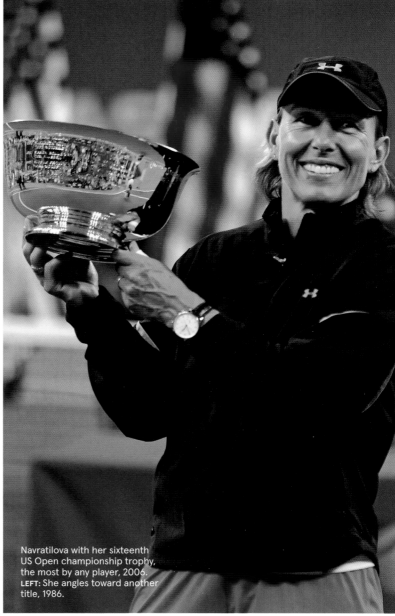

Navratilova with her sixteenth US Open championship trophy, the most by any player, 2006.
LEFT: She angles toward another title, 1986.

While it might be more poetic if Martina had gone from there to rattling off year after year of US Open championships, it didn't happen that way. But although the title eluded her for years, she played in some of the Open's most remarkable and memorable matches, and even in losing, her connection to the event and to its fans was slowly forged. From 1977–1979, she reached the semis three consecutive times, losing tightly contested matches each time—first to Wendy Turnbull, then to me, and then to Tracy Austin. Through that stretch, the New York fans slowly began to appreciate Martina; I think they came to see that she wanted this title, that she wanted

their support, and that she was willing to work hard for both.

To me, the defining moment in Martina's relationship with the US Open and its fans came in 1981. That was our first US Open playing doubles together, so I was sitting courtside for her final against Austin. By this time, Martina already had proven her mettle at the majors, having won Wimbledon twice. But after winning the first set of the final easily, 6–1, she lost two consecutive tiebreaks, and Tracy took the title with a 1–6, 7–6, 7–6 win.

As she stood on court and started her address as runner-up, the crowd burst into

> "The ball doesn't know how old I am."
>
> — MARTINA NAVRATILOVA —

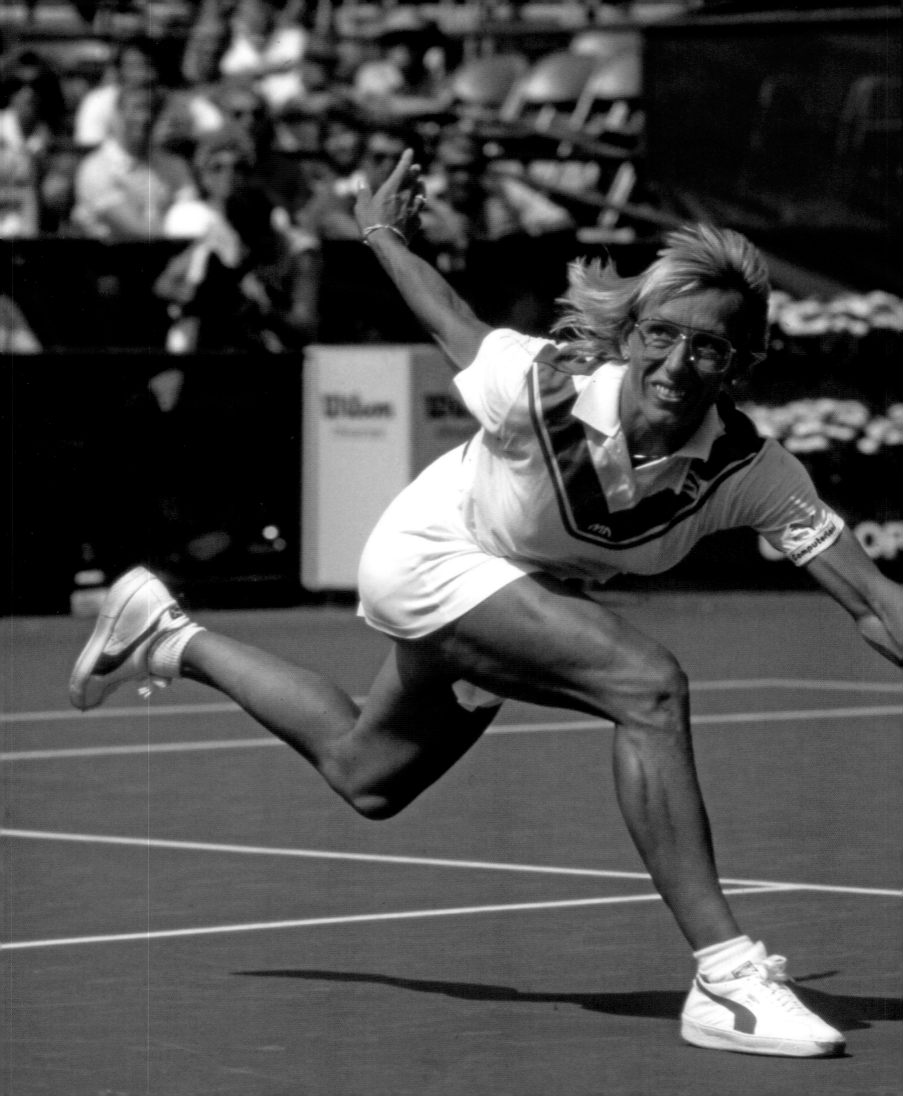

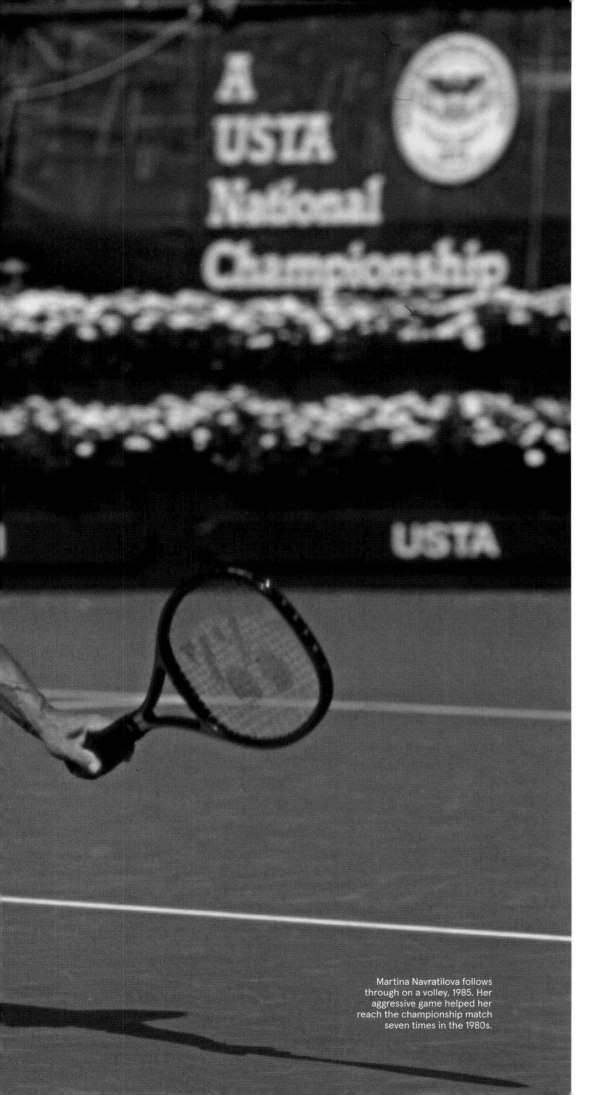

Martina Navratilova follows through on a volley, 1985. Her aggressive game helped her reach the championship match seven times in the 1980s.

applause and Martina burst into tears; a show of emotion prompted by her loss, certainly, but more by the crowd's reaction. It was really the first time they'd ever embraced her as a great athlete, the first time she truly felt the love from the New York crowd. The title had once again eluded her, but the connection that she wanted so badly and had worked so hard for was at long last complete. So much more greatness was to come; but this was the moment when Martina, the US Open, and the New York fans had finally come together.

After I beat her in the quarters in 1982, Martina captured her first US Open singles crown in 1983, with a convincing 6–1, 6–3 win over Chris Evert. That began a period of incredible dominance at the Open for Martina, as she won four titles in five years from 1983–1987. In 1985, the only year in that stretch that she didn't finish first, she reached the final. Twice more, she reached the US Open's second Saturday, playing her way into the final in 1989 and 1991. We won the women's doubles at the Open four times, and together we captured the women's doubles Grand Slam in 1984 and won 109 consecutive matches from 1983–1985.

That was another thing that made Martina so special. Apart from Billie Jean King and John McEnroe, no other great singles champion has ever had such a commitment to doubles. Martina not only loved playing doubles, she wanted—expected—to win every time we walked out on that court. Together, we did a lot of work to make sure that we lost as few major titles as possible, and I think our record shows that. Martina's passion for doubles makes her last major title—the mixed-doubles crown with Bob Bryan at the US Open in 2006 at the age of forty-nine— all that much sweeter and more special.

All in, Martina Navratilova owns sixteen US Open titles, winning championships across a span of four decades. It's hard to say whether the title total or the remarkable longevity is the most staggering of those stats. But the thing that makes both so impressive to me is that, for somebody who had such an easy time winning virtually everywhere else, I know it was never an easy go for her at the Open. For the most part, in New York, she always had to pull up her competitive pants and just go to work. And that she did.

As a result, this player who, early on, never really liked the US Open learned to really love it. And it, in turn, really loved her as well. ●

TOP TANDEMS

Capturing a major championship in women's doubles is never a minor feat,
even for the game's most singular talents.

"WHEN THEY SAY YOUR NAME, and they say so-and-so has *X* number of titles, guess what?" said Venus Williams, who has won all four Grand Slam women's doubles titles with her sister Serena at least twice. "Those doubles ones feel real good."

Venus is not the only top player who feels that way. Indeed, all twenty-three US Open women's singles champions have played doubles at the US Open at least once, with nearly half of them capturing at least one doubles championship. Occasionally, they have joined forces to win the title.

Virginia Wade and Margaret Court, the US Open's first two women's singles champions, were the first pair of titleholders to do so, teaming up to capture the 1973 and 1975 tournaments. Billie Jean King and Martina Navratilova were at opposite ends in their careers in 1978 when they played doubles together at the US Open for the first time. King, at age thirty-four, was a three-time US Open singles champion, but Navratilova, only twenty-one years old, was still five years away from claiming the first of her four US Open singles crowns. Still, they arrived at the 1978 US Open as one of the teams to beat. Each player had already captured a US Open doubles championship, albeit with different partners—King with Rosie Casals in 1974, and Navratilova with Betty Stöve in 1977. Forming their partnership early in 1978, King and Navratilova won eight doubles tournaments leading up to the US Open, where they continued their winning ways by marching through the draw without losing a set.

The following year, King and Navratilova secured their second Grand Slam doubles crown at Wimbledon and reached the 1979 US Open final. In 1980, they claimed their second US Open doubles championship by defeating Navratilova's former partner, Stöve, and her future partner, Pam Shriver, in the title match. The victory proved to be the thirty-ninth major title in King's career—and her last. A month later, Navratilova decided to seek out a new doubles partner and contacted Shriver, who readily accepted the invitation. Their games would mesh seamlessly, and they soon became a nearly unbeatable combination, winning seventy-four championships together, the most for a women's tandem in the Open era. Twenty of their titles came at the majors, tying Louise Brough and Margaret Osborne duPont for the all-time Grand Slam mark. They won four titles on the US Open's hard courts, where their record was virtually spotless from 1983 to 1987. Their only defeat during that five-year span was in the 1985 US Open final, which they lost in three sets to Claudia Kohde-Kilsch and Helena Suková.

Away from the US Open, Navratilova and Shriver were just as dominant, winning a record 109 consecutive matches from April 1983 to July 1985. Meanwhile, at the 1984 US Open, they became the only women's doubles team in the Open era to complete a calendar-year Grand Slam. Since then, only Martina Hingis, a three-time US Open women's doubles champion, has joined them, achieving a doubles Grand Slam (with two partners), capping off the feat at the 1998 US Open.

Navratilova went on to win two more US Open women's doubles titles after her run with Shriver ended, partnering with fellow US Open singles champion Hana Mandlíková in 1989 and with Gigi Fernández in 1990. All told, Navratilova's total of nine US Open women's doubles titles is the most in the Open era. Shriver ranks second on the list for most championships with five, tied with Fernández, who won three of her titles with Natasha Zvereva, including back-to-back crowns in 1995 and 1996. Zvereva, who teamed with Shriver for the 1991 title, stands fourth on the list as a four-time US Open champion, tied with Margaret Court.

Notably, this list does not include the team that has won three Olympic gold medals in doubles and the second-most Grand Slam women's doubles championships in the Open era: Venus and Serena Williams, who made their US Open doubles debut in 1997. The two sisters teamed up to win their first US Open doubles title in 1999—one day after Serena captured her first US Open singles championship and one year before Venus won her first US Open singles title. Ten years later, they raised the trophy for a second time. However, due largely to reasons of injury and health, they have competed at the US Open as a tandem only eight times overall and only twice since 2010.

As a result, the US Open's winningest women's doubles team in the twenty-first century has been Virginia Ruano Pascual and Paola Suárez, who captured three straight titles from 2002 to 2004. The only other players to claim multiple US Open women's doubles titles since the turn of the century are Liezel Huber, Lisa Raymond, and Hingis, who netted her third doubles crown at the 2017 US Open, in her final Grand Slam event, twenty years after winning her lone US Open singles championship. "I couldn't ask for a better finish," she said. ●

CLOCKWISE FROM TOP LEFT: Martina Navratilova (left) and Billie Jean King, 1978; Serena Williams (left) and Venus Williams, 1999; Lisa Raymond (left) and Liezel Huber, 2011; Natasha Zvereva (left) and Gigi Fernandez, 1992; Navratilova (left) and Pam Shriver, 1992.

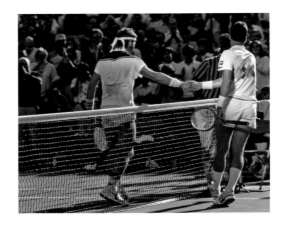

A LONG DAY'S JOURNEY

EPIC ENCOUNTERS ON THE SECOND SATURDAY OF THE 1984 US OPEN PRODUCE AN ERA-DEFINING DAY THAT IS TRULY "SUPER."

•

RIGHT FROM THE START, the US Open scheduled its semifinals and finals differently than the other Grand Slam tournaments did. Rather than having a day of rest separate the semifinals and finals, the US Open opted to conduct most of its concluding matches over the weekend in an effort to make them more accessible for fans. The tournament held the women's singles semifinals on Friday, the men's singles semifinals and the women's singles final on Saturday, and the men's singles final on Sunday. The result was a jam-packed Saturday schedule that became a regular occurrence over the years—until September 8, 1984, when it became something altogether remarkable.

Traditionally, one of the US Open men's semifinals was played first, beginning at 11:00 a.m. The television broadcast did not begin until noon, however, which meant that fans tuning in for the action always missed some of the first men's match. In 1980, television viewers who turned on their sets at noon for the opening semifinal between No. 1 seed

Björn Borg and unseeded Johan Kriek found the favorite already trailing by two sets. Borg righted the ship and won the next three sets by identical 6–1 scores to complete his comeback, but there was a growing concern with scheduling a men's semifinal to kick off the day's action.

In response, the USTA and its domestic broadcast partner, CBS, devised a plan to give fans more time to arrive at Flushing Meadows and to accommodate the afternoon on-air time. The first men's semifinal was moved down a slot in the scheduling, with its place in the day's lineup taken by a match in the men's 35-and-over event. The new order of play was introduced at the 1984 US Open. No one could have foreseen what would follow.

It remains, to this day, widely regarded as the single greatest day of tennis in the history of the US Open, with every match held in Louis Armstrong Stadium going the distance. Play began at 11:07 a.m. with two former US Open champions—John Newcombe and Stan Smith—squaring off in a men's

35-and-over semifinal. As the match went past the noon hour, and CBS began broadcasting the action, Newcombe and Smith were still engaged in an extended back-and-forth battle. Smith came from behind to win, 4–6, 7–5, 6–2, but by then, the first match of the day had thrown everything off schedule.

Next up was the first men's semifinal, featuring No. 2 seed Ivan Lendl and No. 15 seed Pat Cash. After losing the first set, Lendl gained control of the action, as his hitting from the baseline got the better of Cash's serve-and-volley game, and put himself in position to wrap up the match in the fourth set. Yet Lendl wound up losing the set in a tiebreak, and so on they went to a fifth set. With the score at 6–5, Lendl found himself facing match point, which he saved with a lob that went over Cash's head and landed just inside the baseline. Two netted volleys from Cash sent the match into a fifth-set tiebreak, which Lendl won with a running forehand to advance to his third straight US Open final. The 3–6, 6–3, 6–4, 6–7, 7–6 victory took three

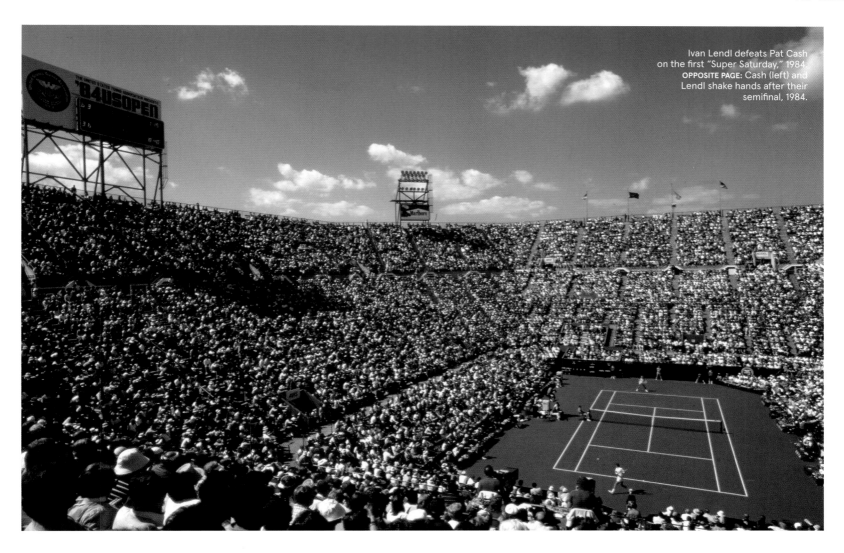

Ivan Lendl defeats Pat Cash on the first "Super Saturday," 1984. **OPPOSITE PAGE:** Cash (left) and Lendl shake hands after their semifinal, 1984.

hours and thirty-nine minutes to complete.

"This was definitely satisfying," Lendl said post-match, "but it would have been nice to have love, love, and love and fresh legs for tomorrow."

Longtime friends—and rivals—Martina Navratilova and Chris Evert watched the match together in the locker room as they waited for their turn to take the court for their women's final.

"We were going crazy after every point," Navratilova said. "My palms were sweating, and all of a sudden I said, 'Wait a minute. I've got to play a match.'"

The top two seeds, Navratilova and Evert played one of the most entertaining matches not only of the tournament but also of their careers. Evert gained the upper hand with a barrage of passing shots to take the opening set, 6–4. At that point, Navratilova made the decision to stay back on her second serve and pick her spots in coming to the net. The strategy worked well, and she won the next two sets by the same score, 6–4, to secure the victory in

one hour and forty-seven minutes for her second straight US Open title over Evert and her sixth consecutive Grand Slam championship.

Tony Trabert, who provided commentary for CBS for the entire television broadcast, said, "We kept coming back on the air after each match saying, 'Wow, you can't get much better than that.' And then they did."

One more match remained: the second men's semifinal, pitting top seed John McEnroe against two-time defending champion Jimmy Connors, who was the No. 3 seed.

"Normally, there'd be a lot of pressure on him, being [that] he's going for his third straight Open," McEnroe said of Connors leading up to the match. "But because I'm No. 1 in the world and have beaten him a lot of times, the pressure's off him. He loves it when you write him off."

McEnroe sensed a furious battle was coming, and he was right. The match began at 7:28 p.m. By then, the brilliant sun had melted into the shadows, blanketing the USTA National Tennis Center in darkness. Those

hardy souls who stayed for the marathon session hardly noticed the chill in the night air as it crackled with the heat of the electricity being generated on the court. Connors hit more winners, 45–20, but McEnroe's superior serving made the difference. By the time McEnroe put away the day's last shot at 11:14 p.m. to win the match by the score of 6–4, 4–6, 7–5, 4–6, 6–3, in three hours and forty-five minutes, fans and players alike knew that they had been part of a most remarkable happening. Over the course of twelve hours and seven minutes, sixteen sets of tennis had been played in the stadium, with each of the four matches going the maximum number of sets.

"There aren't a whole lot of tennis matches that I'd buy tickets for," McEnroe said afterward. "But looking back over the day, today would definitely be a day I'd have wanted to have a ticket."

No one referred to the day as "Super Saturday" before it began, but that is how it has been known ever since. ●

IVAN LENDL

By Cindy Shmerler

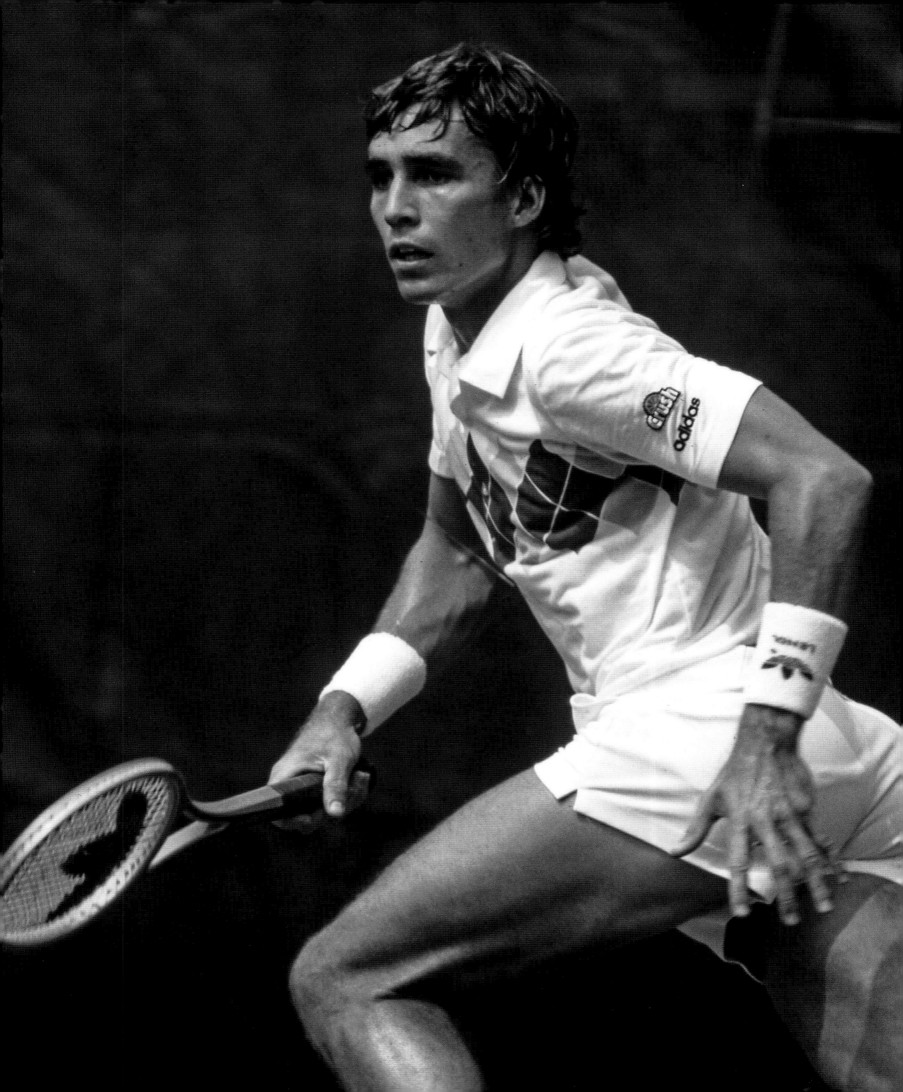

As a schoolboy in Ostrava, in what was then Czechoslovakia, Ivan Lendl never got lower than an *A* in math.

"Math was never a problem for me," says the now fifty-eight-year-old Lendl, a Vero Beach, Florida, and Goshen, Connecticut, resident. "I've always enjoyed working with numbers. When I had to go to music class, there was zero chance I was going to pay attention. Instead, I would just take out my math book and solve problems for fun."

Lendl has always been a numbers guy. And throughout his seventeen-year career in professional tennis, his numbers, especially at the US Open, were impressive. He reached the final at Flushing Meadows eight consecutive times, from 1982–1989, tying the US Nationals record of Bill Tilden from 1918 through 1925. Lendl won the championship three straight times, dropping just three sets in twenty-one matches, and defeating John McEnroe in 1985, Miloslav Mečíř in 1986, and Mats Wilander in 1987. He also lost to Wilander in a five-set, four-hour-and-fifty-five-minute final in 1988 that was, at the time, the longest men's final in US Open history. His twenty-seven straight match wins at the Open rank third all-time behind Tilden and Roger Federer. His record at the tournament is a stunning 73–13.

Overall, Lendl won ninety-four singles tournaments in his career—fifteen in 1982 alone—including eight majors (three at the French Open and two at the Australian Open, in addition to his US Open wins) and seven year-end championships. He won more than one thousand professional matches and was ranked No. 1 in the world for 270 weeks. He remains the only male player in history to win 90 percent of his matches during five different seasons.

But even more astounding than the raw numbers is Lendl's uncanny recall of the details that comprised them. Not only can he recite exactly whom he beat and lost to every year at the US Open, beginning when he was just nineteen years old in 1979 (he fell to Roscoe Tanner in straight sets in the second round) and ending with a loss to German Bernd Karbacher (in the second round in 1994 in what became the final match of his career due to a bad back), Lendl can spout off the exact score for almost every match. He can even retell pertinent points shot by shot.

"In 1985, I was playing John [McEnroe] in the final, and he led the first set 5–2 and had a set point," Lendl says, as if the match were played one week earlier. "He came in on my second serve and I passed him. At 4–4 in the third, he came in, but I hit a running forehand topspin lob over his head. Then, on match point, I came in, he hit a backhand pass to my forehand. I hit the forehand volley into the open court for the winner."

Whether you call him a savant or simply a student of the game, Lendl won't argue with either description. Employing the same work ethic that changed the face of men's tennis—an unwavering focus and attention to every detail from physical fitness to diet to his sleep regimen—Lendl has, over the last several years, used the same tactics to guide the career of Andy Murray, leading the Brit to two Wimbledon championships—the only major that he couldn't conquer—as well as the US Open in 2012, two Olympic gold medals, and the world No. 1 ranking. Lendl has also, for the past three years, worked with a group of elite American boys through a unique program he designed with the USTA.

While Lendl competed, his dedication to his craft was unparalleled. Every year before the US Open, he would have his backyard court in nearby Greenwich, Connecticut, resurfaced by the exact team responsible for surfacing the US Open, thus ensuring ideal practice conditions. Rather than stay in a hotel, he would drive himself to and from Flushing in his Porsche each match day, bypassing the locker room and heading straight to the parking lot following his matches and press conferences.

"I really think that was a big part of my success there," he says. "I avoided all of the energy-zapping stuff that goes on."

Despite his extraordinary career, Lendl is humble about his personal numbers, still musing about the ones that got away.

"I had a decent career," he says, "but I would have liked to win five or seven more [majors]. I'm proud of what I did, but you can always win more. My goal wasn't the No. 1 ranking. It was always to win as many majors as I could. In some ways, I could never achieve my goal." ●

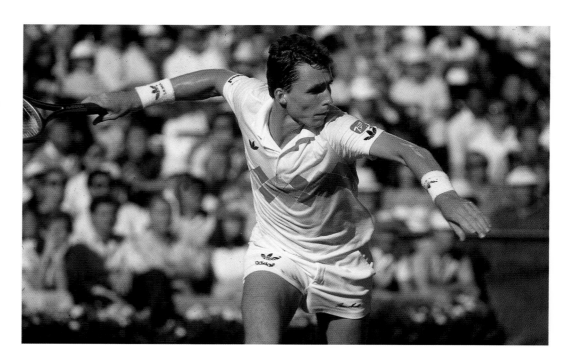

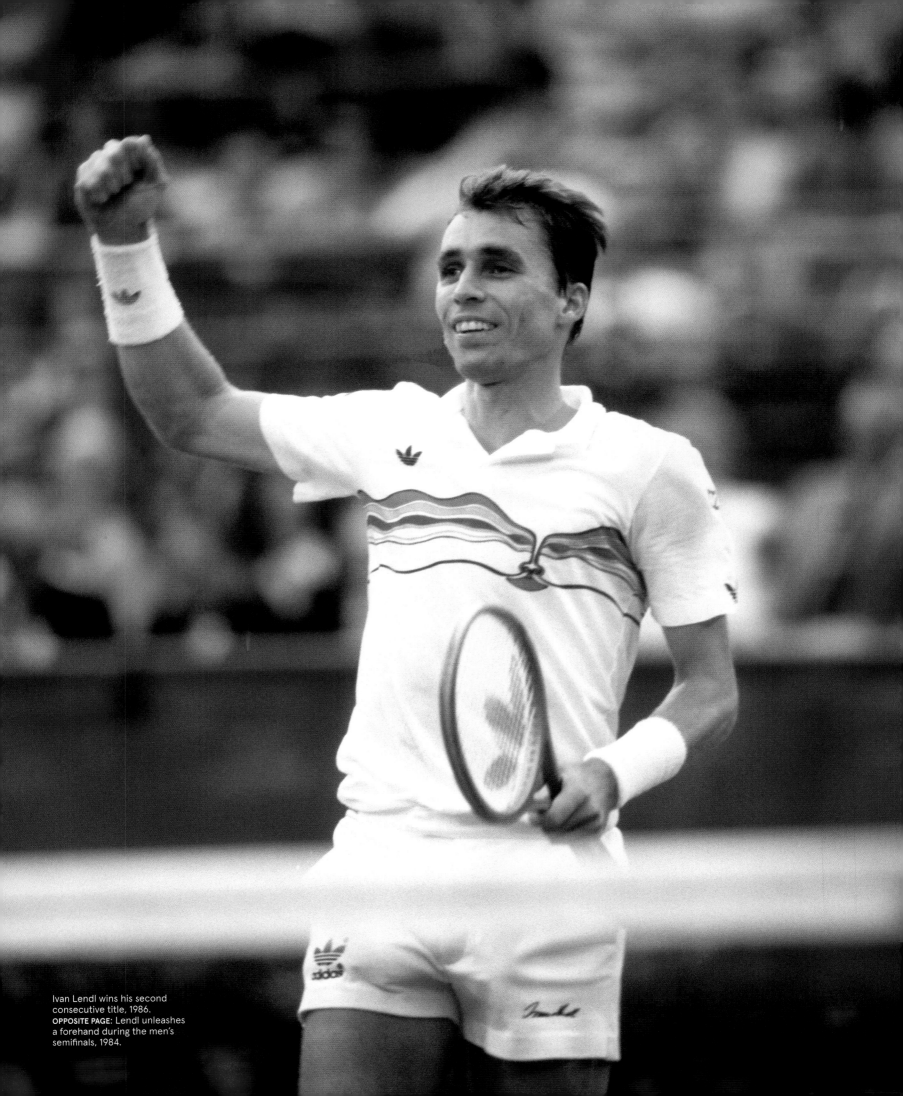

Ivan Lendl wins his second
consecutive title, 1986.
OPPOSITE PAGE: Lendl unleashes
a forehand during the men's
semifinals, 1984.

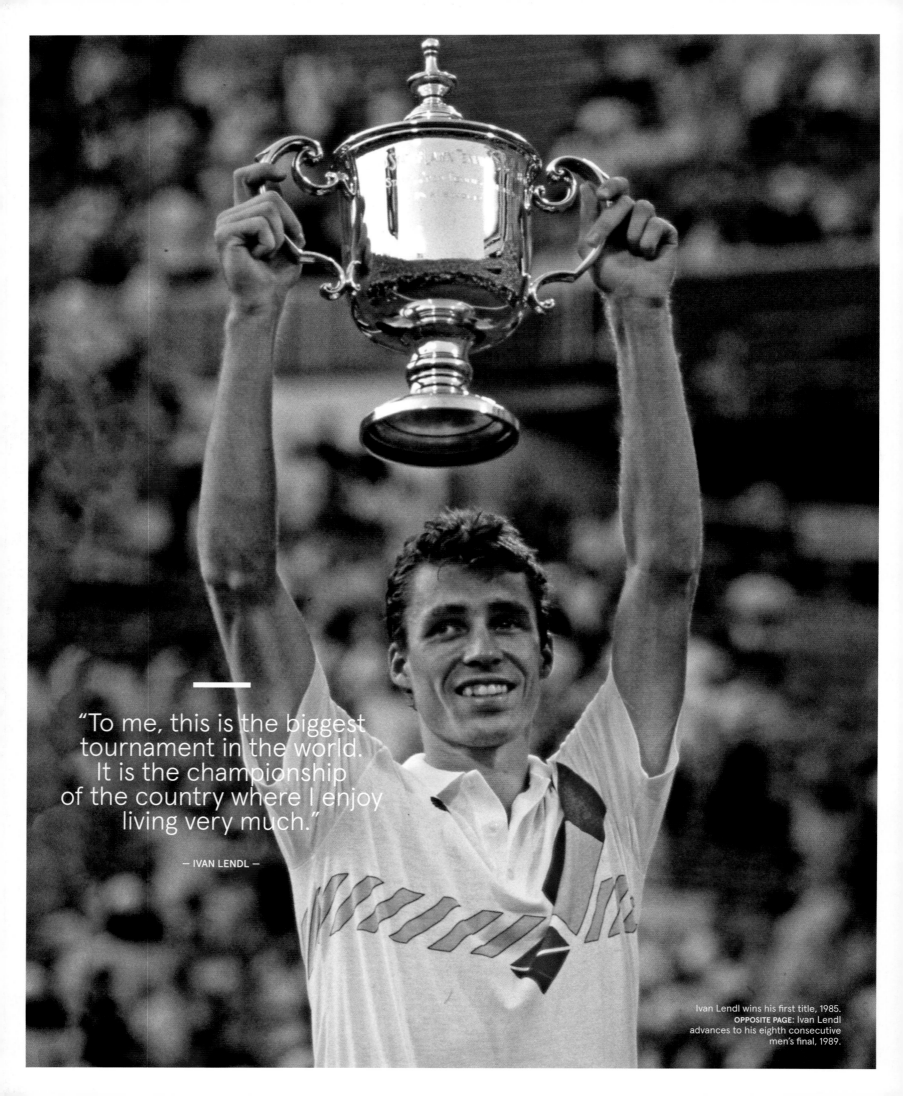

"To me, this is the biggest tournament in the world. It is the championship of the country where I enjoy living very much."

— IVAN LENDL —

Ivan Lendl wins his first title, 1985.
OPPOSITE PAGE: Ivan Lendl advances to his eighth consecutive men's final, 1989.

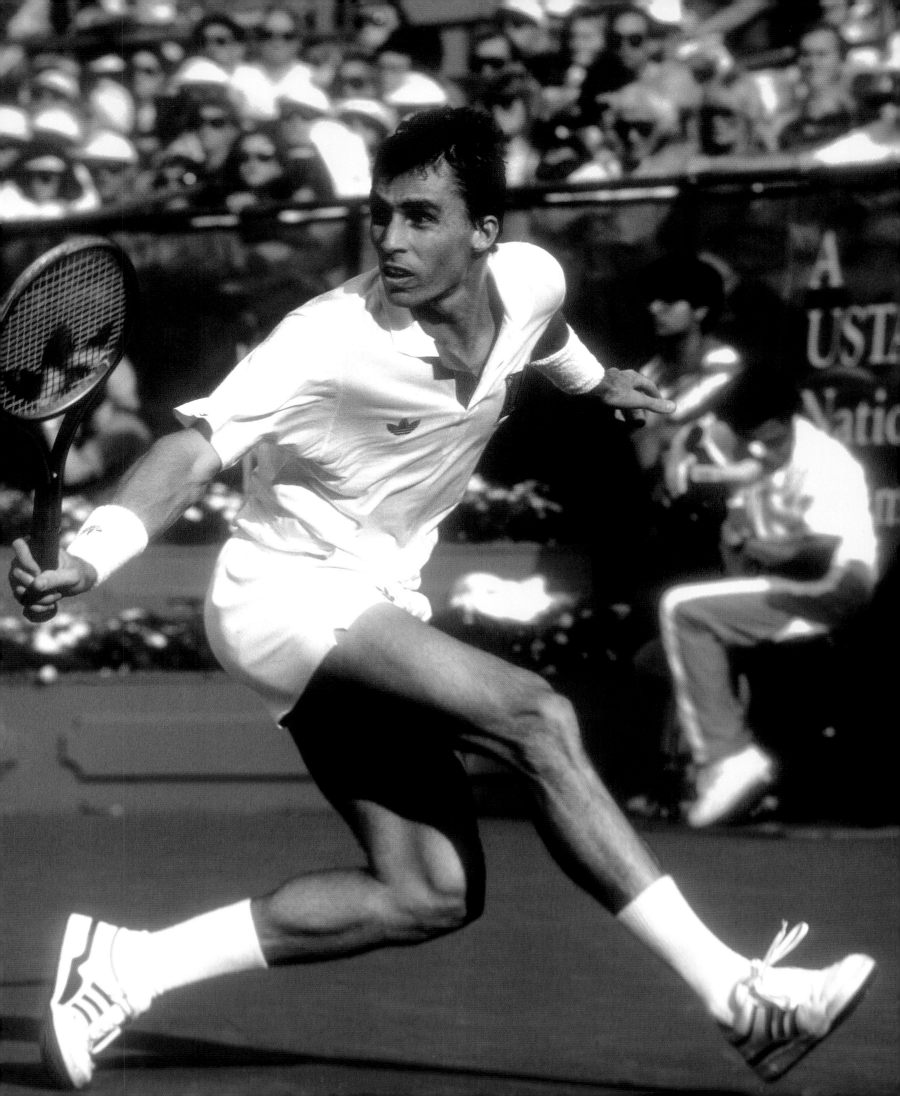

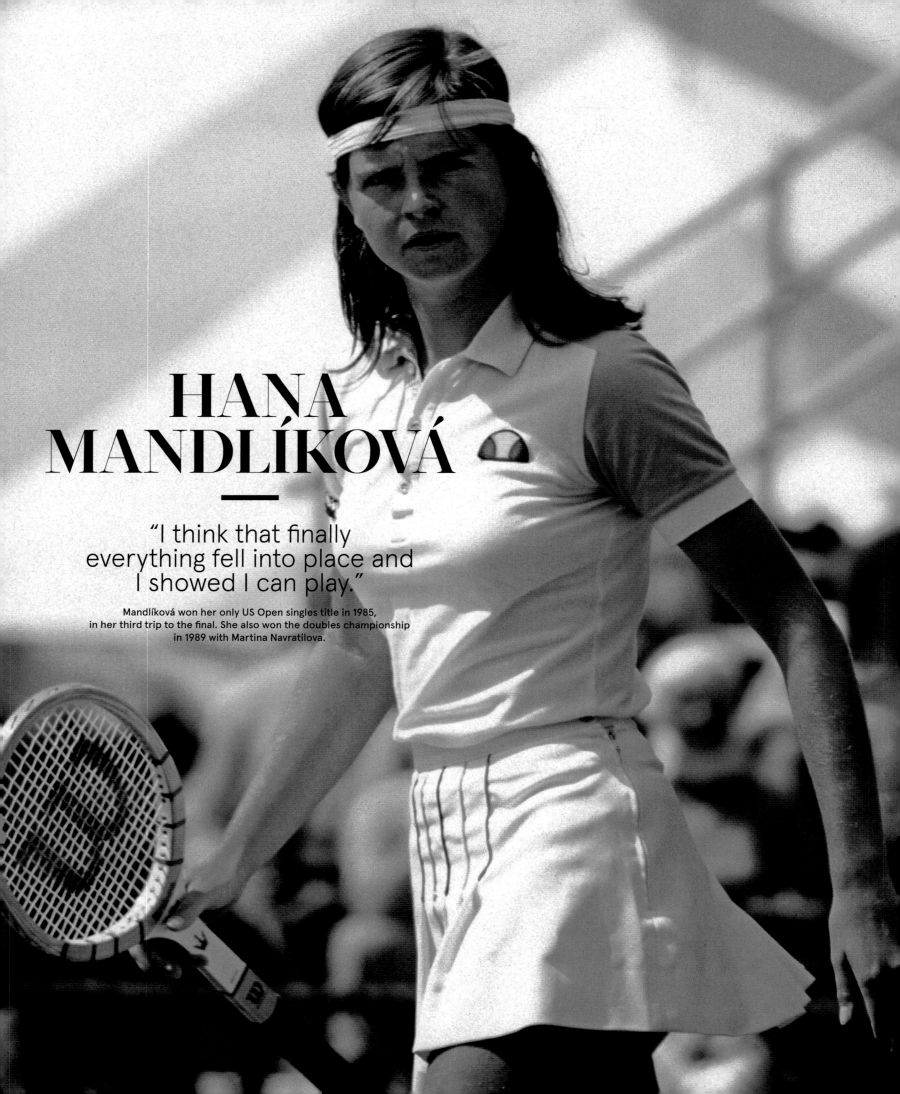

HANA MANDLÍKOVÁ

—

"I think that finally everything fell into place and I showed I can play."

Mandlíková won her only US Open singles title in 1985, in her third trip to the final. She also won the doubles championship in 1989 with Martina Navratilova.

MATS WILANDER

The US Open was Wilander's third major title in 1988 and cemented his hold on the year-end world No.1 ranking.

UNRIVALED

THE US OPEN BRINGS OUT THE BEST IN CHRIS EVERT AND MARTINA NAVRATILOVA, WHOSE RIVALRY AT THE TOP OF THE GAME LIFTS WOMEN'S TENNIS EVEN HIGHER.

•

GREAT RIVALRIES DRIVE SPORTS. In bringing out the best in both combatants, they provide riveting entertainment and create arguments and debates about the superiority of each player—all of which helps to increase fan interest and raise the sport's profile. Over the years, a handful of thrilling rivalries forged by the game's top stars have graced the US Open courts and have resulted in classic clashes: Björn Borg vs. John McEnroe, Jimmy Connors vs. Ivan Lendl, Andre Agassi vs. Pete Sampras, Steffi Graf vs. Monica Seles, and Serena Williams vs. Venus Williams. First and foremost, though, there were Chris Evert and Martina Navratilova, whose head-to-head battles were contrasts in style: Evert, the right-handed baseliner and two-handed backhander who played with

patience and precision; Navratilova, the left-handed net-rusher whose hard-charging game was built on daring and aggression. The pair faced each other across the net in eighty singles matches played over the course of sixteen years and met at the US Open four times.

Chris Evert and Martina Navratilova began their rivalry inauspiciously, in March 1973, at the University of Akron Memorial Hall in Akron, Ohio. Eighteen-year-old Evert, from Fort Lauderdale, Florida, had been competing in pro events for two years, while Czechoslovakian Navratilova, at age sixteen, was just getting her tennis career started. They played on an indoor carpet in the first round of the Akron Tennis Open, with Evert winning the match in straight sets, 7–6, 6–3, and going on to win the tournament.

The two players faced each other for the first time at the US Open in the 1975 semifinals. By then, they had played thirteen times, with Evert winning all but two of their matches, including a victory over Navratilova in the 1975 French Open final, the first of their twenty-two Grand Slam tournament contests. Playing on the newly installed Har-Tru clay court in Forest Hills, Evert continued her mastery over Navratilova. The top seed at the US Open for the second consecutive year, Evert was pushed by Navratilova, the No. 3 seed—and, as it happened, Evert's doubles partner—but held on for the win, 6–4, 6–4, to extend her string of victories on clay to eighty-three matches. The number rose to eighty-four the next day as she beat Evonne Goolagong in three sets to capture the first

of her six US Open titles. In fact, during the three years in which the US Open was held on clay at the West Side Tennis Club, Evert won all her matches—and the title—each year.

While Evert was celebrating her initial US Open triumph, Navratilova was observing a different kind of celebration. Immediately after losing to Evert in the 1975 semifinal, Navratilova went to the New York City office of the United States Immigration and Naturalization Service and applied for political asylum in the United States. Tennis officials in her homeland had been complaining about the "Westernization" of their communist athletes and had said Navratilova was becoming "too American-ized." In response to their trying to prevent her from playing in the 1975 US Open, she defected to the United States so she could pursue a tennis career on her own terms.

It would be six years before Evert and Navratilova would meet again at the US Open, in the 1981 semifinals. By that time, they had played forty-one matches, including twenty-seven finals, and Evert was no longer dominating their rivalry. Navratilova would come out on top in this meeting, too. Having split the first two sets, 7–5 and 4–6, she found herself trailing by 2–4 in the third set. At that point, she ran the table, taking the next four games to win the match and advance to her first US Open final.

Two years later in New York, Evert and Navratilova faced each other in a US Open final for the first time. It was their fifty-fourth meeting, and Navratilova entered it having captured nine of their eleven matches since the 1981 US Open.

"You never can tell what's going to happen out there," Evert said before the final. "Martina's never won and maybe there'll be nerves. There's so much pressure on her. I've won six times, but I'm definitely the underdog."

But instead of displaying a case of nerves, Navratilova showcased her power game, overwhelming Evert, 6–1, 6–3 in sixty-three minutes to earn the first of her four US Open singles championships. The victory also marked the continuation of her phenomenal season. Navratilova went 86–1 in 1983, with her lone loss coming at the French Open—a record of sustained excellence that has remained unsurpassed in women's tennis.

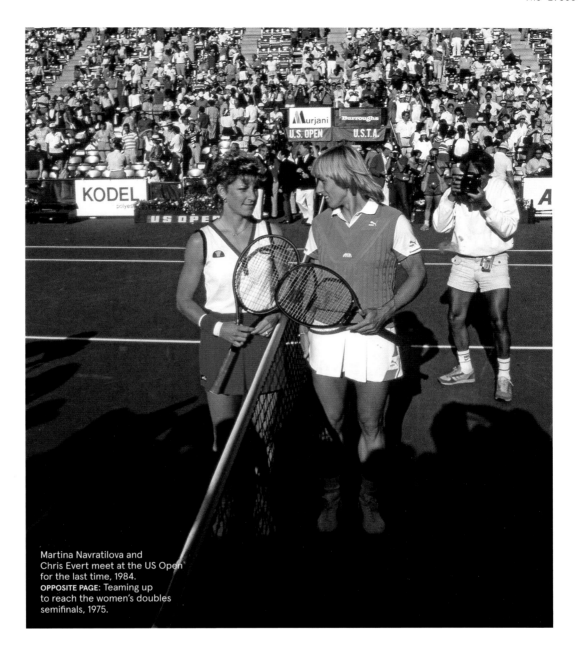

Martina Navratilova and Chris Evert meet at the US Open for the last time, 1984.
OPPOSITE PAGE: Teaming up to reach the women's doubles semifinals, 1975.

The duo's last showdown in New York took place the very next year, at the 1984 US Open, and was among the finest women's final ever played at Flushing Meadows and among the best matches the two women ever played. Scheduled as the third match in Louis Armstrong Stadium on Super Saturday, the start was delayed due to the length of the first two matches, and they sat next to each other in the locker room while waiting to go on. They may have been fierce rivals, but they were also longtime friends.

"We always talk before a match," Evert said. "We're not aware of trying to get one another nervous. We're beyond that now."

Seeded second for the third straight year behind Navratilova, Evert began the final by taking the opening set, 6–4.

She had lost to Navratilova twelve straight times, and the crowd tried to spur her on to victory with a standing ovation. But Navratilova had a different result in mind. She rallied gamely in the second set, 6–4, and ended up taking the final set by the same score to defend her crown.

"I just reached down," Navratilova said afterward, "and pulled everything I had in me to hang in there."

By the time their rivalry came to an end in November 1988, with a 6–2, 6–2 victory by Navratilova in the final of the Virginia Slims of Chicago, she had established a 43–37 edge over Evert in their career head-to-heads. By every other measure, however, their illustrious and long-standing rivalry had truly been a meeting of equals. ●

STEFFI GRAF

By Stephen Tignor

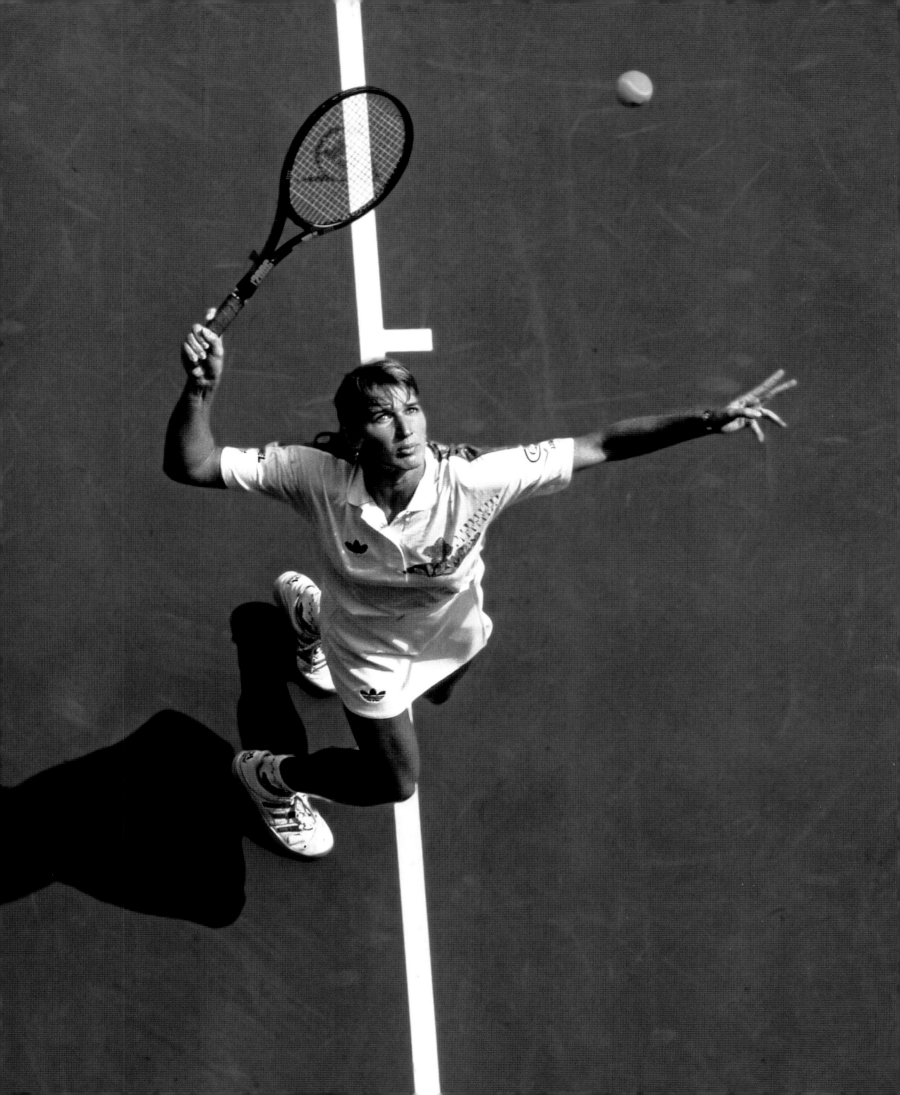

Steffi Graf is one of the most prolific winners in tennis history, but the moment that most succinctly sums up her career came at the end of a rare defeat at the US Open.

The year was 1986, and a seventeen-year-old Graf had just lost a taut three-set semifinal to Martina Navratilova. The deciding 10–8 tiebreak may have been the most thrillingly tense eighteen points of the Open era. For a half hour, mass hysteria reigned in Louis Armstrong Stadium as the game's dominant champion collided head-on with her successor.

When it was over, Navratilova tried to console Graf at the net. But Graf didn't want to be consoled. She stuck out her hand and quickly marched toward the sideline; even at seventeen, the German had no time for moral victories. She wasn't going to slow down until she had won everything in sight.

From that point on, very little would stand in Graf's way. The following spring at the French Open, she turned the tables on Navratilova, winning 8–6 in the third set for her first major title. For women's tennis, the guard had changed; for Graf, the floodgates had opened. She played, as commentator Mary Carillo put it, "like she was double-parked," and she would tear through the record books with the same ruthlessness.

Over the next twelve years, Graf would win twenty-one more major titles and become the only player to win each of them at least four times. She would spend a record 377 weeks at No. 1. From 1987 to 1990, Graf reached the finals of thirteen straight majors, another record. Two years after her loss to Navratilova, she returned to Flushing Meadows to complete the first calendar-year Grand Slam since 1970. Later that month, Graf dipped that Slam in gold with her victory at the 1988 Summer Olympics in Seoul.

Yet, even the most outlandish of Graf's statistics can't do justice to the way she lit up a court with her bounding, pounding athleticism. No player in the Open era transformed the sport as thoroughly as she did. Before Graf, the women's game was split between serve-and-volleyers and steady baseliners; she obliterated those categories with her lightning-strike winners and long-legged, blur-of-blond speed. Much of what we call the modern game was made in her image.

"Fraulein Forehand," Bud Collins dubbed her, for good reason. That shot—hit, whenever possible, in mid-leap—was as lethal as any in the game's history. It also made net-rushing unnecessary. Why volley when you can belt the ball past your opponent from anywhere you like? The same went for Graf's serve. She was just five nine, but she hit her forceful first delivery like someone much taller. Rather than follow her serve to net, she turned it into a point-ending weapon in its own right.

Graf's father, Peter, trained her to be a

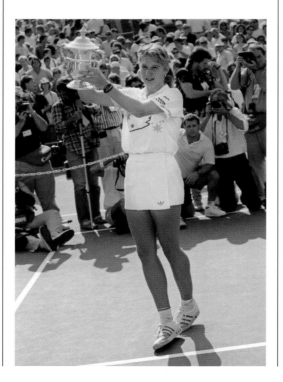

tennis player virtually from birth, and he turned her pro at thirteen. She would persevere through injuries to her foot, calf, back, and knee, and while she mostly avoided the tour's social swirl, her impatience to win the next point, match, and title never flagged. Graf was a dominant champion, but she was an epic-making one, too. Her rivalries with Navratilova, Arantxa Sánchez-Vicario, Monica Seles, and Gabriela Sabatini left us with a dozen finals for the ages.

Sadly, Graf's story will always be most closely tied to that of Seles, who was stabbed by a lunatic fan of the German's in Hamburg in 1993. Two years later, they met again for the first time in the US Open final; there, Graf ended a storybook comeback run by Seles with a topsy-turvy three-set win and an embrace at the net. The two would play again, and Graf would win again, in the 1996 final at Flushing Meadows. Still, never knowing the heights these two women might have scaled together remains one of the tragic what-ifs in sports.

Graf ended her career, fittingly, with one last epic. In the 1999 French Open final, after three seasons without a major title, she rolled back the years and beat Martina Hingis in three tumultuous sets. Afterward, Graf's steely facade gave way to tears. The deep emotion that she always kept hidden had finally overflowed, and the girl who hadn't wanted to be consoled by one Martina now did her best to console another.

That same month, Graf turned thirty; it was time to move on. She began a relationship with another child star, Andre Agassi, which would lead to marriage. One month later, after losing the Wimbledon final, she was gone—no farewell tour needed. Graf had done everything she set out to do. She had blazed a new trail across the court and changed the game forever. More important, she had won everything in sight. ●

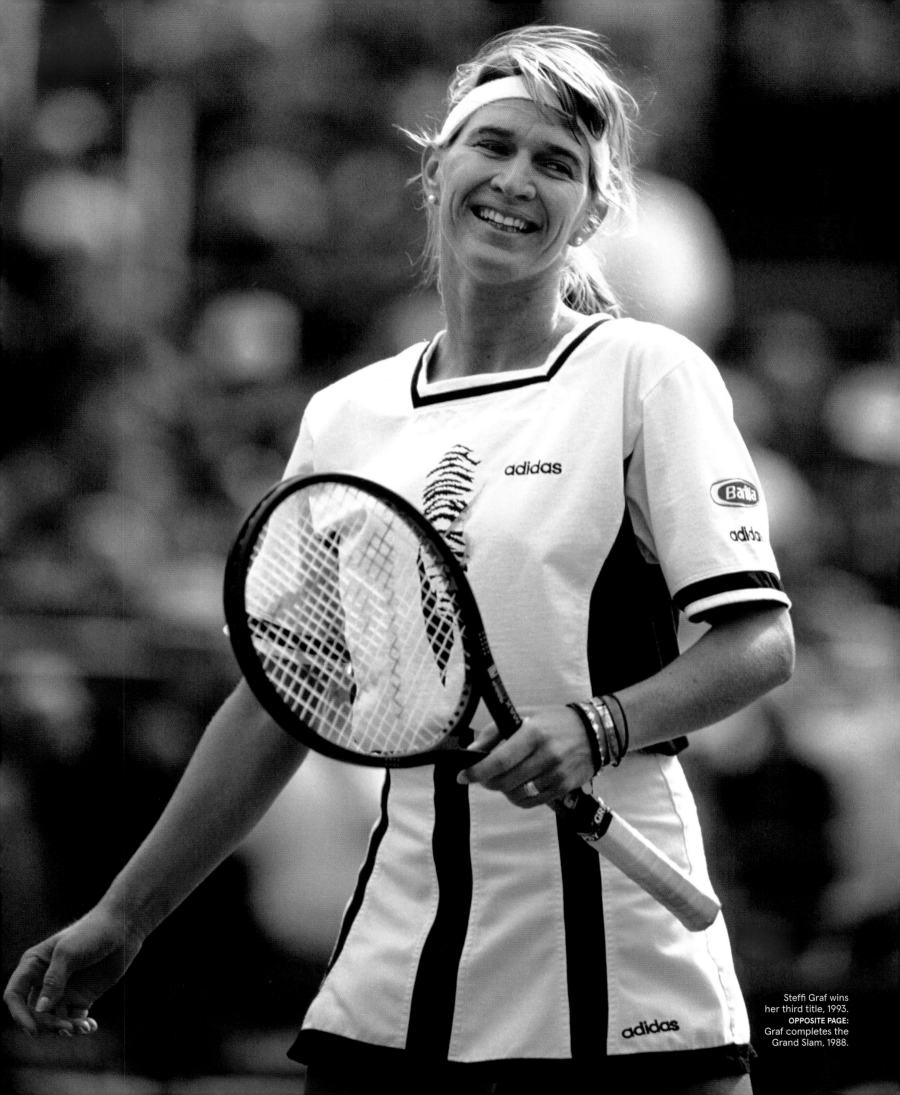

Steffi Graf wins her third title, 1993.
OPPOSITE PAGE: Graf completes the Grand Slam, 1988.

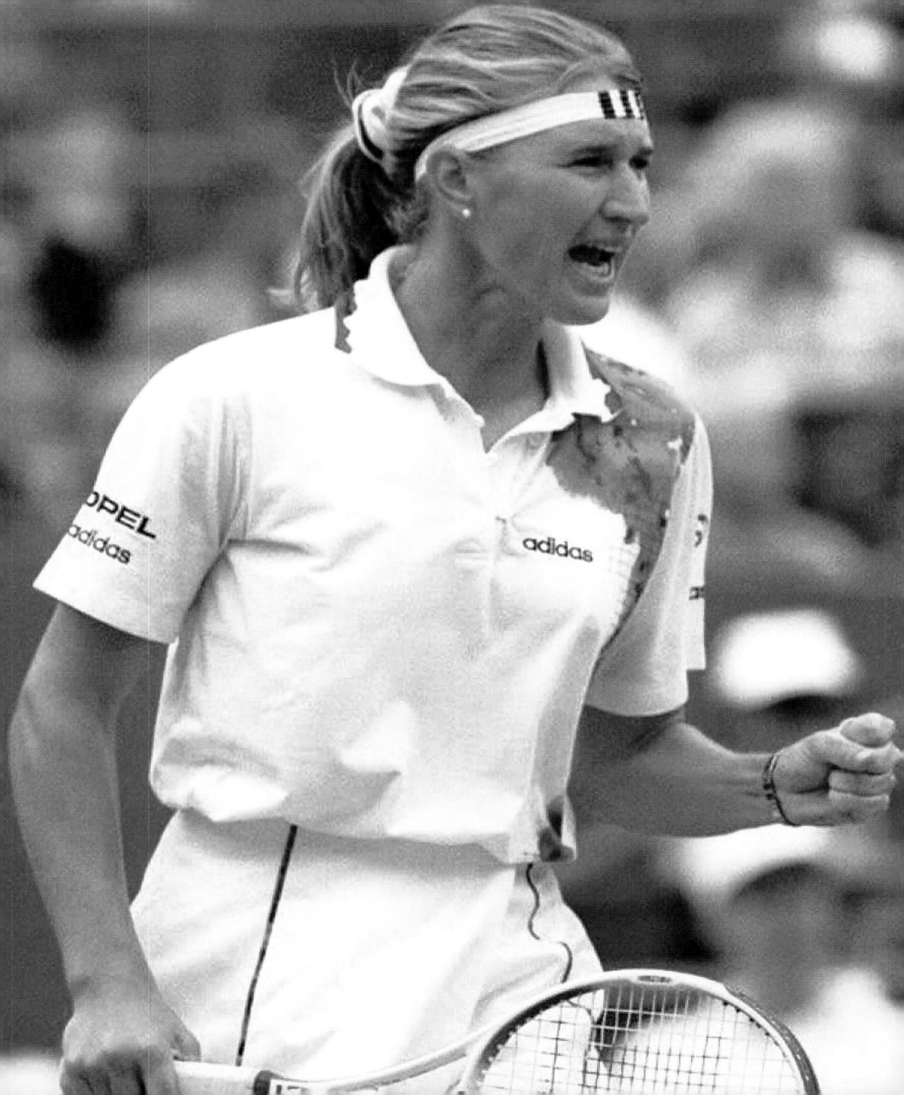

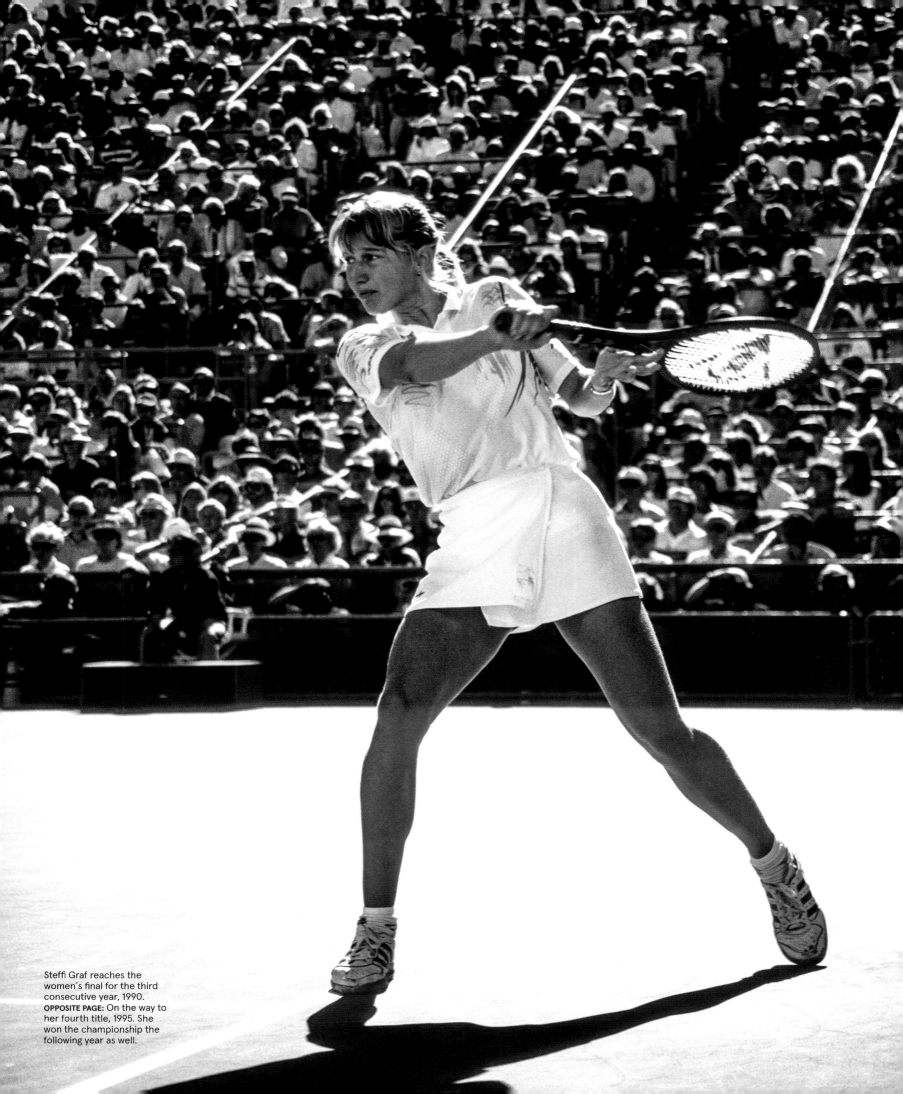

Steffi Graf reaches the women's final for the third consecutive year, 1990. **OPPOSITE PAGE:** On the way to her fourth title, 1995. She won the championship the following year as well.

BORIS BECKER

—

"You have to almost love it here.
There are so many things which can
distract you—the planes, the heat,
the noise of the spectators. You just
have to go out and have fun."

Becker, already a three-time Wimbledon champion
at age twenty-one, added the 1989 US Open title to his résumé.

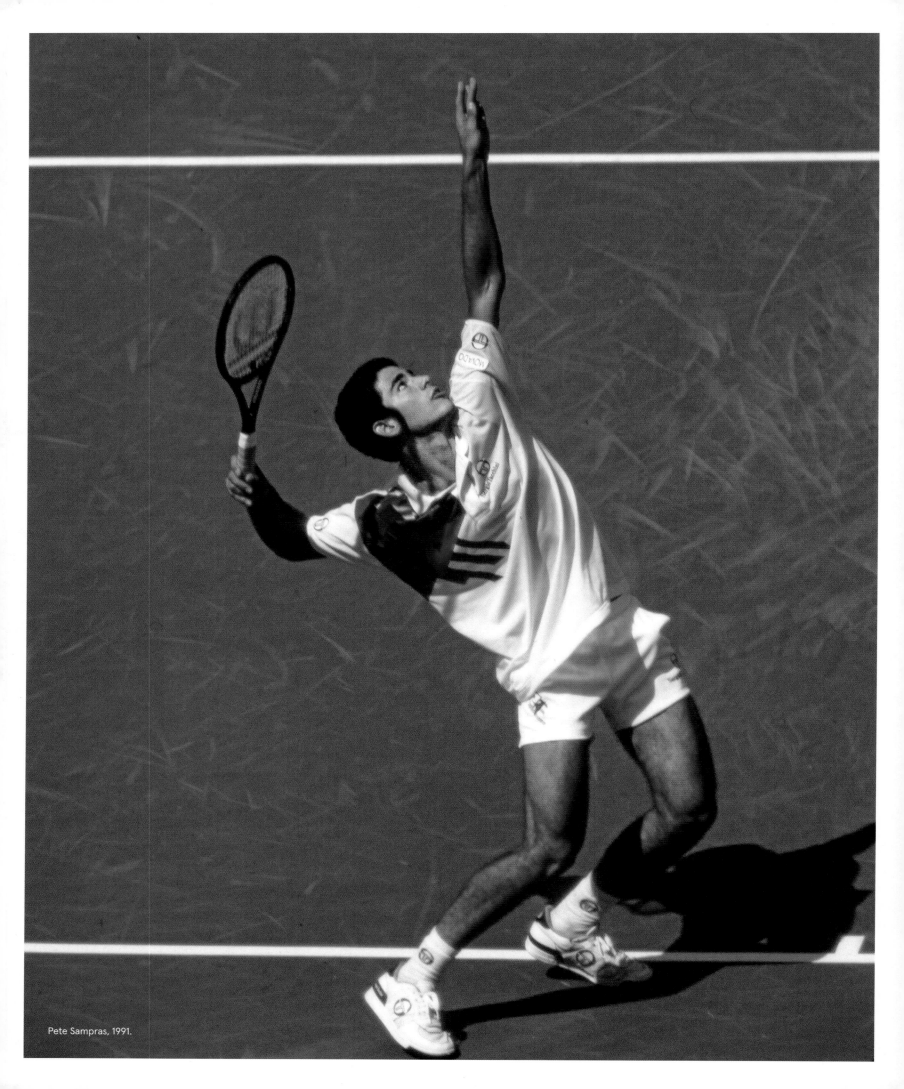

Pete Sampras, 1991.

19

THE

90s

The US Open began the 1990s by drawing four times as many fans as the tournament did in its first year. Attendance figures continued to rise as the decade unfolded, abetted by a major expansion of the tournament grounds and the creation of a new centerpiece, Arthur Ashe Stadium, the world's largest tennis stadium.

1990

Stefan Edberg becomes only the second No. 1 seed in the Open era to lose in the first round. / Jennifer Capriati makes her US Open debut at age fourteen. / Gabriela Sabatini defeats Steffi Graf in the women's final, 6–2, 7–6. / Pete Sampras, at the age of nineteen years and twenty-eight days, becomes the youngest US Open men's singles champion, defeating Andre Agassi in the men's final, 6–4, 6–3, 6–2. The No. 12-seeded Sampras also becomes the lowest men's seed to win the US Open.

1991

Wild-card entrant Jimmy Connors, ranked No. 174, reaches the men's semifinals at age thirty-nine. / Monica Seles defeats Martina Navratilova in the women's final, 7–6, 6–1. / Stefan Edberg becomes the first player to win the US Open one year after losing in the first round by defeating Jim Courier in the men's final, 6–3, 6–3, 6–2.

1992

Jimmy Connors finishes his US Open career by playing in his record twenty-second men's singles tournament and 115th match. / John McEnroe records his last US men's singles victory. / Players from the US sweep all four junior championships, led by Lindsay Davenport, who wins the girls' singles and teams with Nicole London to win in girls' doubles. / Stefan Edberg defeats Michael Chang in five hours and twenty-six minutes, the longest US Open men's match. / Monica Seles defeats Arantxa Sánchez-Vicario in the women's final, 6–3, 6–3. / Edberg wins three straight five-set matches before defeating Pete Sampras in the men's final, 3–6, 6–4, 7–6, 6–2.

Peter Max's cover illustration of the tournament program, featuring the opening of Arthur Ashe Stadium, 1997.

1993

Grounds passes are sold for the first time. / Martina Navratilova is seeded for the nineteenth consecutive year, the most in tournament history. / Goran Ivanišević and Daniel Nestor play the longest tiebreak in US Open history: thirty-eight points, with Ivanišević prevailing, 20–18, in the third and final set. / Mats Wilander defeats Mikael Pernfors in a match that sets the men's record for the latest finish at 2:26 a.m. / Steffi Graf defeats Helena Suková in the women's final, 6–3, 6–3. / Pete Sampras defeats Cédric Pioline in the men's final, 6–4, 6–4, 6–3.

1994

Arantxa Sánchez-Vicario defeats Steffi Graf in the women's final, 1–6, 7–6, 6–4, and teams with Jana Novotná to win the women's doubles. / Andre Agassi defeats five seeded players—including Michael Stich in the men's final, 6–1, 7–6, 7–5—to become the first unseeded player to win the US Open.

1995

Construction begins on Arthur Ashe Stadium. / For the first time at the US Open, four players who have been ranked No. 1 in the world—Andre Agassi, Boris Becker, Jim Courier, and Pete Sampras—reach the men's semifinals. / Steffi Graf defeats Monica Seles in the women's final, 7–6, 0–6, 6–3, becoming the first player to win a US Open title match after failing to win a game in one of the sets. / Pete Sampras defeats Andre Agassi in the men's final, 6–4, 6–3, 4–6, 7–5.

1996

The inaugural Arthur Ashe Kids' Day is held to kick off the tournament. / The last singles finals are played in Louis Armstrong Stadium. / Pete Sampras, the defending champion and No. 1 seed, fights off fatigue and becoming ill on court to defeat Àlex Corretja in the quarterfinals, 7–6, 5–7, 5–7, 6–4, 6–7. / Steffi Graf defeats Monica Seles in the women's final, 7–5, 6–4. / Pete Sampras defeats Michael Chang in the men's final, 6–1, 6–4, 7–6, on the day his late close friend and coach, Tim Gullikson, would have celebrated his forty-fifth birthday.

1997

The US Open has a coming-out party as Arthur Ashe Stadium opens as the centerpiece of an expanded and enhanced USTA National Tennis Center, with a dedication ceremony on August 25. / Tamarine Tanasugarn defeats Chanda Rubin in the first match played in Arthur Ashe Stadium. / Venus Williams overcomes two match points and a controversial changeover collision with her opponent, Irina Spîrlea, in the women's semifinals. / Playing in the youngest Grand Slam women's final in the Open era, Martina Hingis, at age sixteen, defeats seventeen-year-old Venus Williams, 6–0, 6–4. / Patrick Rafter defeats Greg Rusedski in the men's final, 6–3, 6–2, 4–6, 7–5.

1998

Patrick Rafter avoids becoming the first US Open defending champion to lose in the first round by coming back from two-sets-to-love to defeat Hicham Arazi. / Martina Hingis completes a Grand Slam in women's doubles (with two partners). / Lindsay Davenport defeats Martina Hingis in the women's final, 6–3, 7–5, becoming the only player to win both the girls' singles title and the women's singles title. / Patrick Rafter defeats Mark Philippoussis in the men's final, 6–3, 3–6, 6–2, 6–0.

1999

The rededication of a newly downsized Louis Armstrong Stadium marks the completion of the USTA National Tennis Center's $285-million expansion project. / Patrick Rafter becomes the first defending US Open champion to lose in the first round. / Serena Williams sets the women's record for most aces in a tournament with seventy. / Williams defeats Martina Hingis in the women's final, 6–3, 7–6. / Andre Agassi defeats Todd Martin in the men's final, 6–4, 6–7, 6–7, 6–3, 6–2.

PETE
SAMPRAS

By Paul Annacone

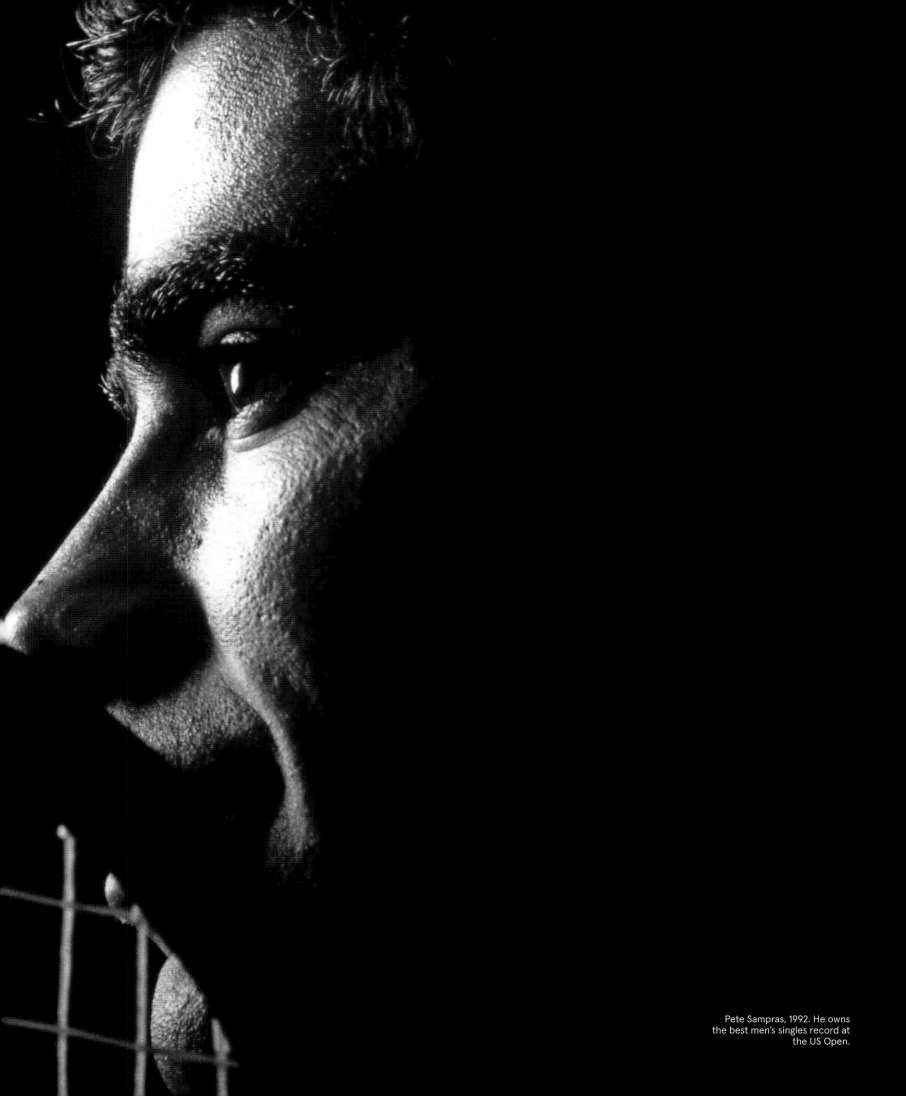

Pete Sampras, 1992. He owns the best men's singles record at the US Open.

"This kid is going to be some great player."

I remember saying that to my brother, Steve, who was also my coach, as I came off the court in Palm Springs, California, after hitting with Pete Sampras. It was the spring of 1989, and I was turning twenty-six years old and beginning my sixth year as a tennis pro. A month earlier, I had won the eleventh doubles title of my career, teaming, as usual, with Christo van Rensburg, with whom I had won the only Grand Slam title of my career four years earlier, at the Australian Open. Pete was seventeen years old.

Even then, you could see his development into a Grand Slam champion was simply a matter of his learning to manage all his tools. Pete had so many weapons in his arsenal, including a serve so lethal that it could, at times, make his greatest rival and one of the all-time top returners, Andre Agassi, feel like he had no chance. None. Going through the process of deciding how and when to strike would determine when it would all come together for Pete.

It didn't take long. At the 1990 US Open, Pete, just nineteen years old, became the youngest men's singles champion in tournament history. Seeded No. 12, he was also the lowest men's seed to win the US Open. He did so by defeating Ivan Lendl, John McEnroe, and Agassi in succession and served up the championship point with his one-hundredth ace—a mark he would surpass each of the next four times he won the US Open. In fact, when he won his fifth and last US Open title in 2002, he served 144 aces, which is still the tournament record.

By the time I began coaching Pete in the spring of 1995, he had won four more Grand Slam singles championships, including the 1993 US Open. I learned a lot about him during

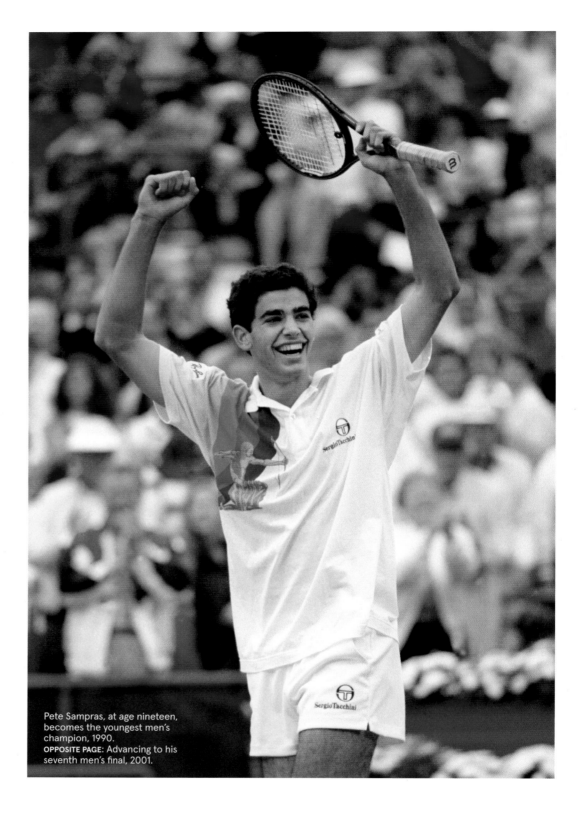

Pete Sampras, at age nineteen, becomes the youngest men's champion, 1990.
OPPOSITE PAGE: Advancing to his seventh men's final, 2001.

those first few months on the tour. Throughout the clay-court season, he seemed to be struggling with his tennis. But as we headed to England for the start of the summer season, he was calm, composed, and clear about what he needed to do to be successful during the upcoming grass- and hard-court seasons. That was target serving, return of serve, and the athletic skills that made him so difficult

to pass at the net. Sure enough, he started putting it all together and won at Queen's Club and Wimbledon, and carried the momentum through to the 1995 US Open.

In a hotel room, just prior to the start of the tournament, Pete and I had a conversation that centered on two key topics: One was Agassi's terrific run that summer, in which he had not lost a match leading into the US Open;

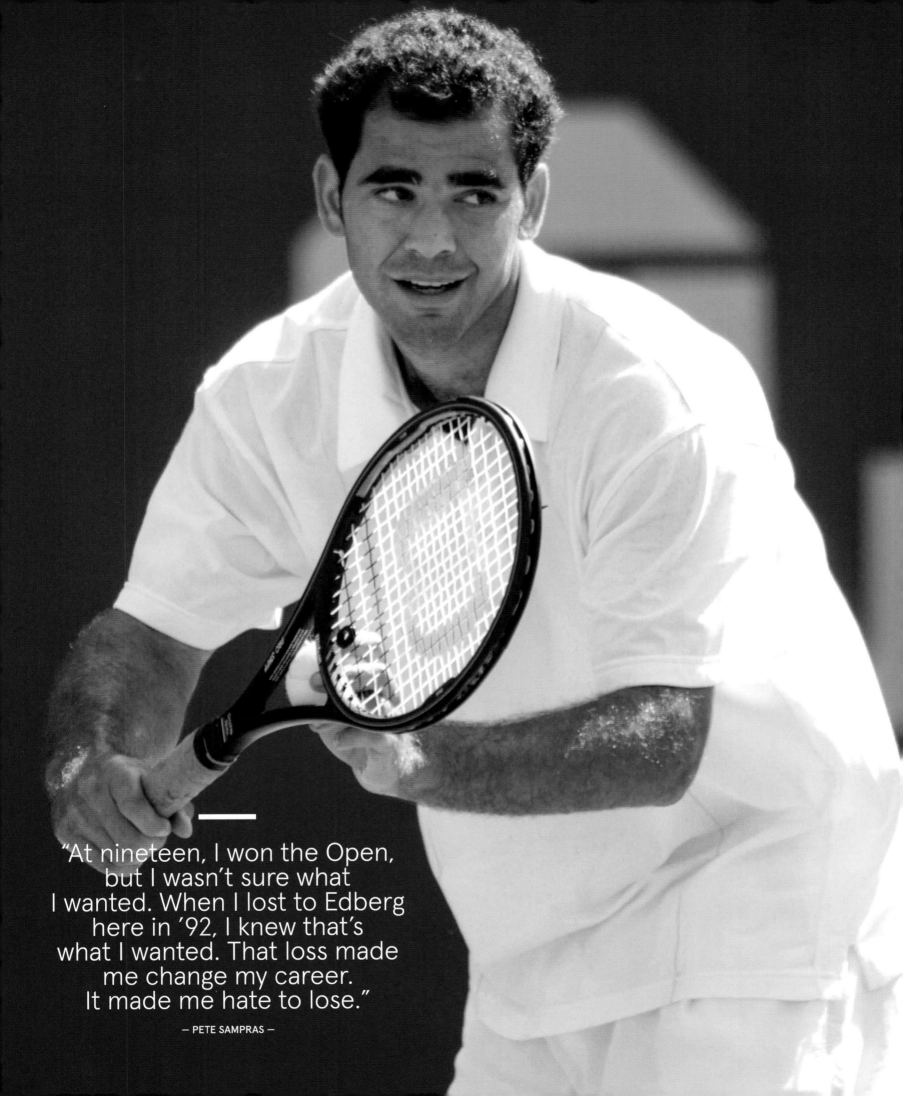

"At nineteen, I won the Open, but I wasn't sure what I wanted. When I lost to Edberg here in '92, I knew that's what I wanted. That loss made me change my career. It made me hate to lose."

— PETE SAMPRAS —

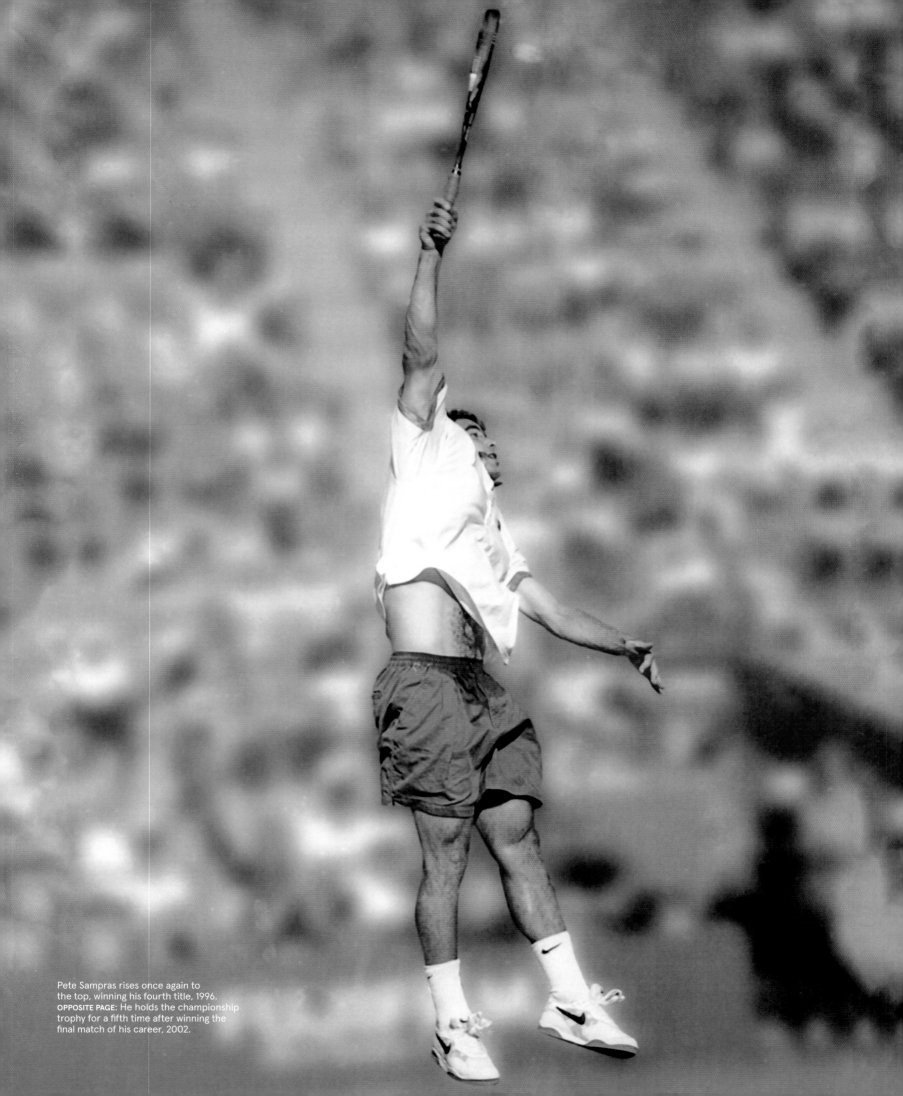

Pete Sampras rises once again to
the top, winning his fourth title, 1996.
OPPOSITE PAGE: He holds the championship
trophy for a fifth time after winning the
final match of his career, 2002.

the other was the tragic situation of Pete's former coach, Tim Gullikson, who was battling brain cancer.

As the conversation unfolded, we touched on human nature. How when people are feeling good and everything is optimal, much can be achieved. But also how to deal with life when there seems to be nothing but adversity.

As a twenty-three-year-old tennis champion, Pete had never been in a situation like this—his best friend was fighting for his life and, at the same time, his red-hot tennis rival was demolishing every opponent he met on the court. Agassi, who had started the year by beating Pete in the Australian Open final, went undefeated during the US summer swing, winning four straight tournaments.

This made the 1995 US Open final very significant for both Sampras and Agassi, each of whom was not only looking to claim supremacy in the men's game but also over his opponent. Pete would later say it was his biggest match of the year and one of the biggest in his career. Andre would say pretty much the same thing. Coming into the final with a record of 26–1, he'd give up all those victories to have beaten Pete in their US Open showdown. But it was not to be. Pete was locked in and hit almost twice as many winners as Andre to take their title match.

As I've said many times, there's no panic in Pete. His ability to stay calm in the face of adversity, along with his aptitude for remaining on an even keel and keeping everything in perspective when all is going well, is what makes him a true champion. Add to those qualities his will to win, his eagerness to improve as a player, and his desire to work hard at a game he loves, and you have every coach's recipe for success.

Pete won the US Open for a fourth time in 1996. Maybe a month or two later, he was going through a workout on an indoor court in Europe when his practice partner tried a crazy shot and missed. Pete turned to me and said, in his best imitation Clint Eastwood voice, "A man's gotta know his limitations." He knew what he could do and what he couldn't do. He had so many skills that he knew if he made good shot selections, used variety, and imposed his athletic style and steel will on his opponents, he would come out on top.

Pete truly believed that. And his opponents believed it, too. When he stepped up to the service line for the final time in his career, to

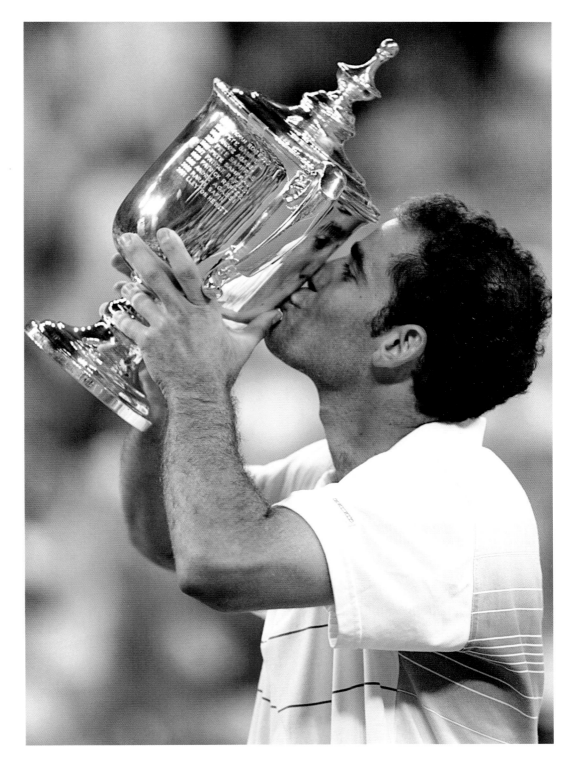

serve for the championship at the 2002 US Open against Agassi, he looked the same as always—cool and confident. Meanwhile, you could detect a sense of resignation in Andre's face. It just seemed that Andre was left to hope Pete would miss or falter, and that the end result was up to Pete.

Pete left the game on top, with fourteen Grand Slam singles titles—at the time, the most in the Open era. Throughout his career, people liked to talk about how gifted he was and how he made the sport look easy, almost effortless. Yet as successful as he was and as talented as he was, he never liked to show off, or show someone up, or make a big deal of things. That wasn't Pete. He was all about doing his job. His clarity of thought about his process, goals, and the way in which he would embark on his journey resonate with me today. He was an awesomely talented individual driven by a heart that would exhaust all resources to achieve the loftiest of his goals. ●

GABRIELA SABATINI

—

Having lost to Steffi Graf in the 1988 final and the 1989 semis, Sabatini reversed the outcome at the 1990 US Open to win her only Grand Slam singles championship.

STEFAN EDBERG

"It is great, any time you can defend your title in a Slam. I mean, not many guys do that."

A consummate serve-and-volley player, Edberg won back-to-back US Open titles in 1991 and 1992.

REQUIEM FOR A COUNTERPUNCHER

JIMMY CONNORS TURNS BACK THE CLOCK AT THE 1991 US OPEN.

By Joel Drucker

•

NO PLAYER HAS BETTER DEFINED *the essence of the US Open than Jimmy Connors, who won five US Open titles on three different surfaces, beginning with his first crown in 1974. Employing a two-fisted backhand that pounded foes into submission, he was a fighter who relished each and every fight.*

His 115 singles matches played are the most in US Open history, and he remains the men's all-time leader in singles matches won with ninety-eight victories. He was seeded at the US Open every year from 1972 to 1989—eighteen successive years—which still stands as the tournament record for sustained excellence.

As Connors's career entered its twilight years, he took over the US Open one last time. Joel Drucker spent approximately seven hours in Connors's orbit on the day he pulled out of the 1990 US Open—and was there to witness Connors's return trip the following year.

By 1990, Jimmy Connors had played in the US Open twenty consecutives times. No one had done more to electrify the tournament and tennis. Often at the US Open, Connors had been not just a star but a supernova.

On August 27, 1990, though, Connors's star appeared to have dimmed. It was the first day of the 1990 US Open. Just prior to the tournament's start, Connors announced his withdrawal, the result of a wrist injury that had kept him away from competition since February. But Connors was present that day at Flushing Meadows. Akin to an exiled CEO at a trade show, Connors held court with the beloved Vitas Gerulaitis, bumped into his former coach Pancho Segura, and practiced with Michael Chang's brother, Carl. Past 10:30 p.m., about to enter a taxi to Manhattan, Connors glanced at Louis Armstrong Stadium and said to a friend, "If I ever get back there, that place is going to rock and roll."

Pity anyone who'd dare doubt the word of one James Scott Connors.

After undergoing surgery to repair his injured wrist, he returned to the tour in February 1991 with his ranking at No. 990. It was unfamiliar territory for Connors, who, before injuring his wrist, had always been ranked inside the Top 20 and had held the No. 1 ranking longer than any other man. Third-round showings at the French Open and Wimbledon enabled him to lift his ranking to No. 174 heading into the 1991 US Open, but it was still not high enough for a direct entry into the main draw. The five-time US Open champion was awarded a wild card.

In the first round, playing in a night match in Louis Armstrong Stadium, Connors came up against a familiar name: McEnroe. But this time it was John's brother, Patrick. McEnroe sprinted to a 6–4, 7–6 lead. At her home in Belleville, Illinois, Connors's lifelong coach, his mother, Gloria, turned away from the television and began to scrub her kitchen floor. In the third, Connors served at 0–3, love–40.

And then Jimmy Connors did what he lived for: He won a point. A game. Gloria peeked at a few points. In front of a stadium now half empty, half full—if you saw the world like Connors—he took the third set, 6–4, then the fourth, 6–2. Past midnight, only six thousand spectators remained inside Louis Armstrong Stadium. At 4-all in the fifth, Connors broke McEnroe's serve. At 1:35 a.m., after four hours and eighteen minutes, Connors struck a service winner.

"I just have to stick in there," said Connors after the match. "That's what they pay to see. That's what I'm supposed to do."

Once again, tennis's enfant terrible had grabbed New York by the throat. Said Connors's former doubles partner and good friend Ilie Năstase, "What Jimmy has is what we'd all kill for. Just one more time."

Routine victories in the next two rounds brought Connors to a Labor Day matchup in the fourth round versus twenty-four-year-old Aaron Krickstein. This was also Connors's thirty-ninth birthday. After losing the first set, 3–6, Connors went up 5–1, 40–15—only to see that lead vanish and the set go to a tiebreak.

If Connors's 1991 US Open run was twenty years compressed into a fortnight, what happened next was his entire career in five points. At 7–7, Connors struck an overhead into the northeast corner of the court, extremely close to the baseline and sideline. The linesman called it good, but Krickstein appealed to chair umpire David Littlefield, who awarded the point to Krickstein.

"It was clearly wide," Littlefield said.

"You're a bum!" said Connors. "I'm out here playing my butt off at thirty-nine years old and you're doing that? Very clear my butt!"

His wrath aimed at Littlefield, Connors won three straight points to take the set. Connors and Krickstein split the next two. But in the fifth set, Krickstein went up 5–2. Connors persevered, and soon enough, another tiebreak. As the crowd cheered— "those twenty thousand sounded like sixty thousand," said Connors—he paused for breath, sat in the southeast corner, and yelled into a courtside microphone, "This is what they want."

Krickstein, by this stage, was merely a bystander. Connors went up 5–2, then closed it out at 6–4 with a crisp backhand volley.

"This is what I live for, to win a match 7–6 in the fifth," Connors said afterward. The match took four hours and forty-one minutes, with the fifth set heightening the drama by taking one hour and twenty-nine minutes to conclude. Said CBS's Mary Carillo, "He knows how to throw a party."

Three nights later, Connors's revival tour continued, his quarterfinal match versus Paul Haarhuis personified by a single point. Haarhuis had won the first set and served for the second at 5–3, 30–40. As Haarhuis approached, Connors threw up a lob. Then another. Then two more, followed by a screeching crosscourt forehand. Haarhuis's tepid volley opened up the court for Connors to lace a down-the-line backhand pass.

Long live rock.

Connors went on to level the match and handily take the next two sets. For a record fourteenth time, he was in the semis of his

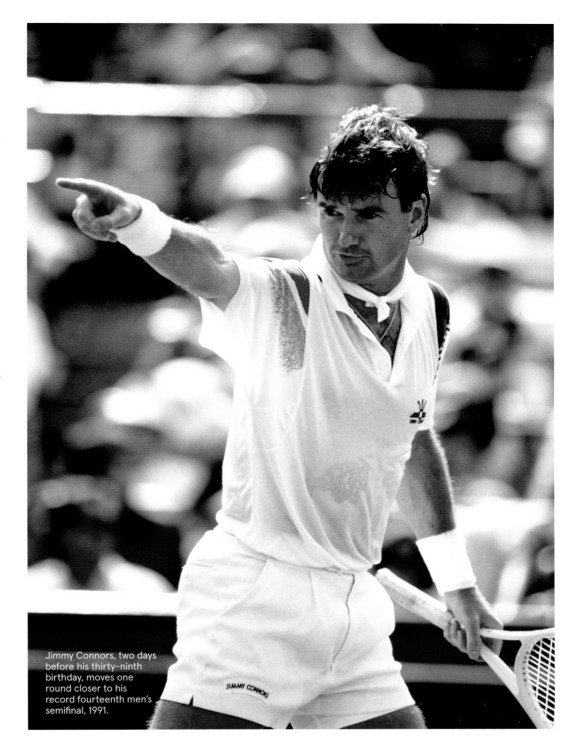

Jimmy Connors, two days before his thirty-ninth birthday, moves one round closer to his record fourteenth men's semifinal, 1991.

homeland Slam. The world was again his stage, as dozens of print and broadcast stories told the tale of the aged icon who had dared to persist, even if he'd had to crack a few eggs along the way.

Another American named Jim—Jim Courier—brought down the curtain on Connors's memorable show at the 1991 US Open. Turning to the crowd as he underwent a convincing straight-sets defeat against Courier in the semis, Connors said, "I guess this is the final frontier."

Connors would, in fact, compete once more at the US Open. The following year, he played in the singles tournament for an all-time record twenty-second time and celebrated his fortieth birthday with what turned out to be his final victory at the US Open, a straight-sets, opening-round win over Jaime Oncins. As always with Connors, the match was great theater and brought back memories of the year before, when, as he had done so many times, he had drawn and quartered the US Open. ●

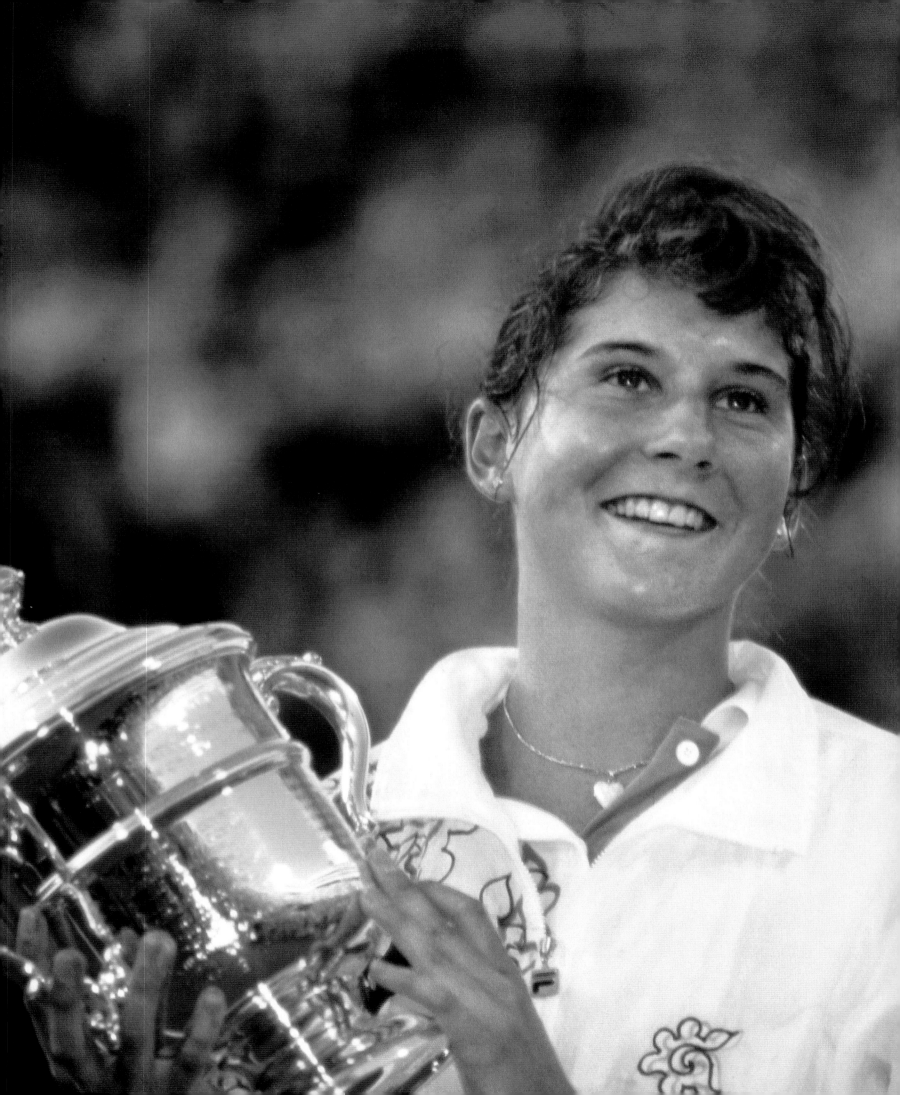

MONICA SELES

—

"It is all about just playing great tennis.
That is why I am here. That is what I love to do.
That is why I started this whole thing."

Seles won back-to-back US Open championships in 1991 and 1992,
and played in the title match two more times, in 1995 and 1996.

DEFINING MOMENTS

THE 1991 SEMIFINAL BETWEEN JENNIFER CAPRIATI AND MONICA SELES IS JUST ONE OF MANY CLASSIC US OPEN MATCHES WHOSE OUTCOMES HAVE BEEN DECIDED BY TIEBREAKS.

By Bud Collins

•

EVER SINCE BEING INTRODUCED *at the 1970 US Open, when twenty of the forty-six matches held on opening day featured at least one set of sudden death, the tiebreak has played a pivotal role in some of the US Open's most notable contests. Bud Collins recalls some of these moments in this excerpt from the official 2001 US Open tournament magazine that foreshadows that year's classic quarterfinal between Pete Sampras and Andre Agassi, which was decided in four sets, each one extended to a tiebreak.*

How long could this thing go on?

That's what a US Open champ, the sturdy Swede Mats Wilander, was wondering as he struggled, seemingly endlessly enmeshed in the longest tiebreak of his life.

It was the 1993 US Open, five years after he'd taken the title away from Ivan Lendl, and Wilander was being hounded by a lanky Brazilian, Jaime Oncins, out on the Meadow's Court 16, which no longer exists. Up they went as though on an uncontrollable elevator. At 14-all in the third-set tiebreak, a bemused Wilander turned to a cluster of reporters in the first row and inquired, "What's the record?"

"You've still got a ways to go," was the reply, because only an hour or so before, on that same afternoon, the Open's record—20–18— had been set in the Grandstand by a pair of monster-serving left-handers, Canadian Danny Nestor and the Croatian Croaker, Goran Ivanišević. Tipping back and forth,

it expanded excitingly, going to [Ivanišević], along with victory, 6–4, 7–6(5), 7–6(18). He won on his eighth match point after resisting Nestor's seven set points.

Though Wilander and Oncins's breaker grippingly swayed one way, then the other, the Swede saving two set points and the Brazilian nine match points, they could amass but thirty-four overtime points, and Mats took the decision, 7–5, 7–6(2), 7–6(16).

This tiebreaking tension is an American invention from the brain of perhaps the game's foremost original thinker, Jimmy Van Alen. The most significant of a scant few procedural alterations in more than a century, it was launched at Forest Hills in 1970 as a bold, controversial, even radical experiment to eliminate interminable deuce sets that had stretched as far as 49–47 at the 1967 Newport, Rhode Island, tourney.

An immediate success, the tiebreak was soon adopted by the other three major championships: the Australians in 1971, Wimbledon in 1972, and the French in 1973. By 1975, Van Alen's hybrid "Sudden Death" version (best of nine points) had been reformed to the present "Lingering Death" (best of twelve points, but requiring a margin of at least two).

However, only in the United States are all sets created equal. Elsewhere, ultimate sets, the fifth for men, third for women, are still contested the archaic way, enduring beyond 6–6 until somebody is ahead by two games.

Merely two US Open Championships

have been decided by breakers at the farthest end, and, amazingly, that superlative champ, Martina Navratilova, was the victim both times. In 1981 and 1985, Navratilova's final-round opponents, surging spectacularly in the stretch run, brought her down in the closest of singles finishes: first Tracy Austin, 1–6, 7–6(4), 7–6(1); then Hana Mandlíková, 7–6(3), 1–6, 7–6(2).

Two years later, though, in 1987, [Navratilova] was triumphant in an even tighter situation, the mixed doubles title bout alongside Spaniard Emilio Sánchez. In a conclusive, breathtaking twenty-six-point breaker, Navratilova and Sánchez fended off two match points and won on their seventh, 6–4, 6–7(6), 7–6(12). For Navratilova, who had seized her fourth (and last) US singles the day before, and the doubles with Pam Shriver earlier in the afternoon, the mixed rounded out a triple crown. An extremely rare feat, it hadn't been accomplished at the US Open by an American since Billie Jean King in 1967.

Talk about classic tiebreaks! The semifinal clash that ended in an explosive tiebreak between a couple of American kiddies, fifteen-year-old Jennifer Capriati and seventeen-year-old Monica Seles, still evokes many fond memories, serving in the heads of many tennis fans as the ultimate example of what a great match should be like. It may as well have decided the 1991 US Open championships, even though their incessant bombardment of ground strokes was a semifinal.

The combatants were at different points in their careers. Seles was already a three-time Grand Slam champion whose domination of the WTA Tour was consistently gaining ground. (She would win an astonishing total of eight Grand Slam singles titles from 1990 up until her stabbing in April of 1993.) In contrast, Capriati was the rising star, glittering with youthful exuberance and promise. Her foray into the US Open semifinals made her the youngest player to make it there since American Andrea Jaeger in 1980, and she had deftly eliminated defending champ Gabriela Sabatini in the quarterfinals.

The Capriati–Seles matchup was a vicious baseline battle of unwavering intensity. Both players, each big hitters, went at each other at full force for three sets. Seles took the first set, utilizing her lethal two-handed ground strokes with amazing pace and accuracy. After falling behind 3–1 in the second set, Capriati seized the next five games to take the set and led 3–1 in the third. Seles managed to even the score at 3–3. Capriati tried to pull away, serving for the match at 5–4 and at 6–5, but each time, Seles, demonstrating why she is one of the best competitors in the game, managed to take that advantage away from her.

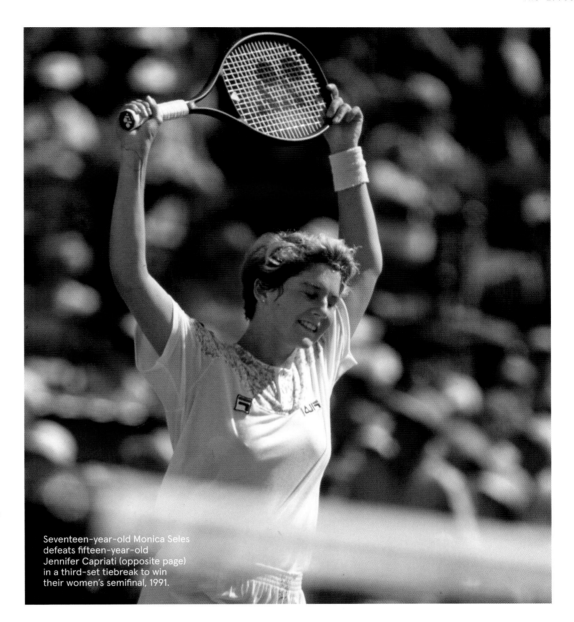

Seventeen-year-old Monica Seles defeats fifteen-year-old Jennifer Capriati (opposite page) in a third-set tiebreak to win their women's semifinal, 1991.

During the conclusive thirteenth game, the *jeu décisif*, as the French call it, mini-breaks were rife. In the end, Seles, who continued to be unerring in her shots, was the firmer in the crunch, taking it, 6–3, 3–6, 7–6(3).

"We both didn't want to give up until the last ball," said Seles, who went on to beat Martina Navratilova in the final for her third Grand Slam title of the season.

Nothing is hopeless in a tiebreak. Jan Siemerink, a left-handed Netherlander, would tell you that. As the lone figure in Open history to revive from 0–6 in a tiebreak—six successive match points in his case—he astounded compatriot Richard Krajicek in the first round in 1994. Krajicek, who would rule Wimbledon two years later, did regain his balance to win, 7–6(2), 6–4, 6–7(2), 6–7(8), 6–4, but Siemerink had his

mini-miracle as a Houdini in short pants.

You may be surprised to learn that the male players vehemently opposed the 1970 introduction of the tiebreak. They presented US Open director Bill Talbert with a petition demanding that he junk the experiment.

Talbert was too smart to give in. "This will bring new excitement to the game, and the fans will love it," he predicted correctly.

Arthur Ashe, for whom the stadium is named and who won the 1968 US Open and was finalist to Romanian Ilie Năstase in 1972, quickly concurred. "When you get to a tiebreak, everybody's suddenly quiet, and very nervous," he said after his first involvement.

Soon, the curious-looking 7–6 scores were regarded not as typographical errors but as symbols of adrenaline-pumping battles within the war. Isn't it good that Jimmy Van Alen gave us a break? ●

ANDRE AGASSI

•

By Wayne Coffey

Andre Agassi blows kisses
to the crowd as he closes in
on his second title, 1999.

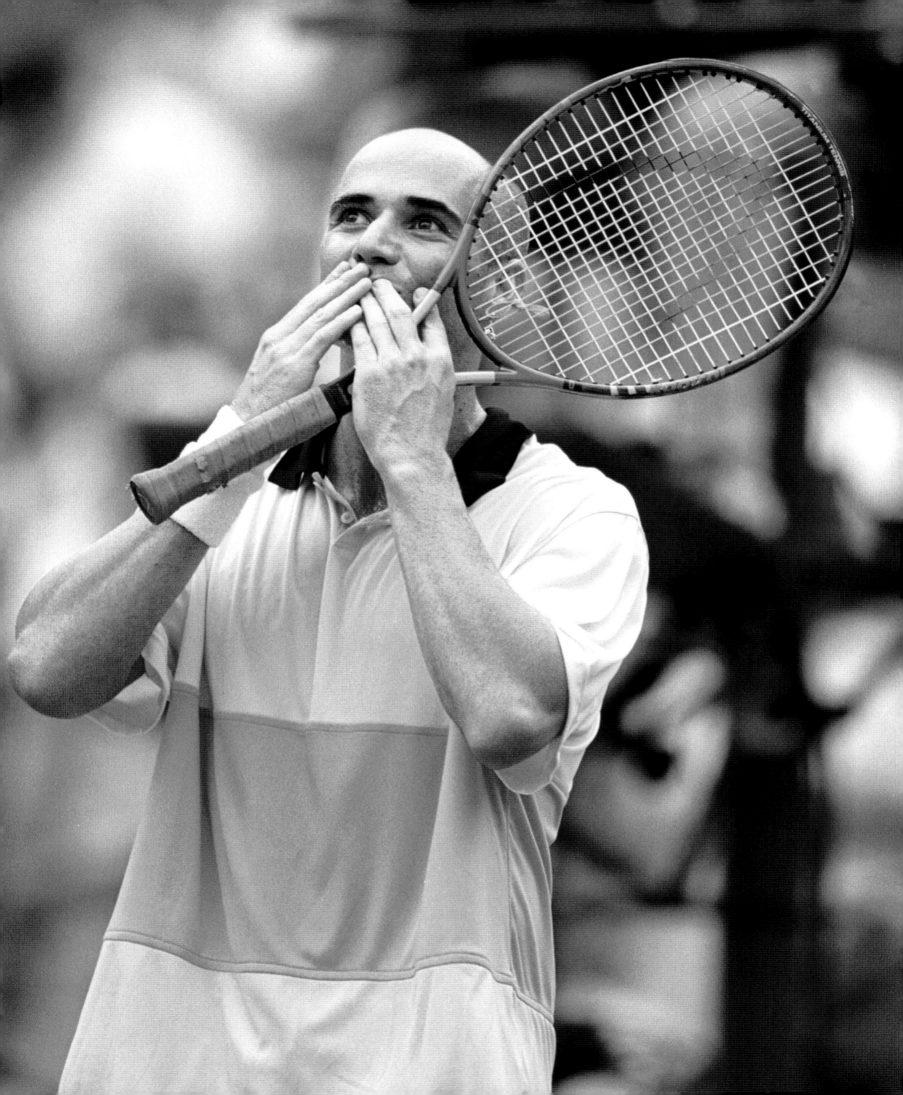

His career in Flushing Meadows spanned three decades and ninety-eight matches, beginning with a first-round loss to a Brit named Jeremy Bates and closing with a third-round loss to a German named Benjamin Becker, twenty-one US Opens later. In between, Andre Agassi didn't merely win seventy-nine matches and two Open titles. He became the most charismatic and irresistibly watchable player of his generation, a man who seemed to change outfits and hairdos as often as cars change lanes on the Grand Central Parkway but who stayed true to his baseline brilliance, taking the ball early and showcasing some of the greatest ball striking the sport has ever seen.

It's the opinion of no less an authority than Pete Sampras, Agassi's longtime rival and contemporary, and the winner of fourteen Grand Slam titles—six more than Agassi.

"When Andre's on, forget it," Sampras once said. "He does practically everything better than anybody else."

If Agassi was widely seen as a player of vastly more style than substance as a teenage prodigy—and when you are the centerpiece of an advertising campaign with the slogan "Image is everything," it's a difficult conclusion to argue—by the end of his career, he was universally regarded as a humble, hardworking,

and kindhearted champion, a top-spinning sage with a pigeon-toed walk, a philanthropic soul, and emotions as plain as the strings on his racquet. Indeed, when Agassi returned to the locker room in the USTA Billie Jean King National Tennis Center following his loss to Becker in his Open farewell, he got a standing ovation from his fellow players.

"The greatest applause that any person will ever receive in their life is that which comes from their peers," Agassi said in the Open interview room not long after. "It's not like we're a company who's working together to accomplish something. We're people that succeed, in some cases, at the demise of the other. To have them applaud you is the ultimate compliment."

A lifelong resident of Las Vegas, Agassi was taught the game by his father, Mike Agassi, a former Olympic boxer in his native Iran, who pushed his son mercilessly almost from infancy, imploring the kid to pummel opponents not with punches but with salvos of ground strokes. Mike Agassi's son learned well, and though Andre would later write of his complicated love-hate relationship with the game in his remarkably candid memoir, *Open*, he was a profoundly gifted player, albeit one who embodied—at least at the outset of his career—the gaudiness and sizzle for which his hometown is renowned.

Agassi was tennis's resident matinee idol when he arrived on the tour, playing in long, streaked hair and denim shorts with Day-Glo spandex underneath, and baggy shirts that

would ride up and expose his hard, hirsute midsection with most every swing, much to the delight of squealing fans. He broke into the top three in the world by eighteen, powered by his turbocharged ground strokes and perhaps the greatest return game in the annals of the sport, and won the first of his eight major titles at Wimbledon at age twenty-two. Agassi would go on to capture the first of his two US Open titles with a convincing victory over Michael Stich in 1994, making him the first and only unseeded man to become a US Open champion. Five years later, at age twenty-nine, Agassi won his second title in Flushing Meadows with a gritty comeback to take the final two sets against fellow American Todd Martin—a triumph made even more remarkable considering that it came scarcely two years after he'd fallen to No. 141 in the world.

Amid a prolonged slump and questions about his motivation and commitment to the game, Agassi was thought by many to be finished as an elite player at the close of 1997—an opinion that was summarily thrashed when he climbed all the way back to No. 6 in the world in 1998, a turnaround of record proportion. Agassi would go on to play the highest sustained level of his career between the ages of twenty-nine and thirty-three, and he wasn't far from capturing his ninth Slam and third Open title at age thirty-five, in 2005, when he pushed Roger Federer hard through four sets before succumbing in the final.

By then, Agassi had long since completed

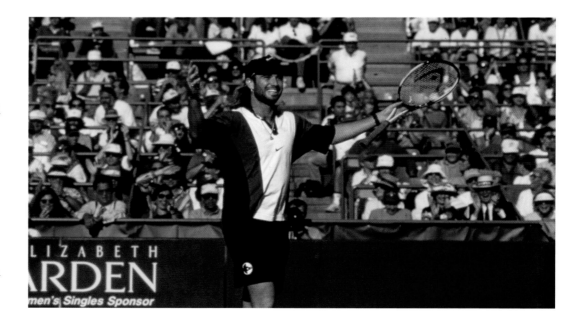

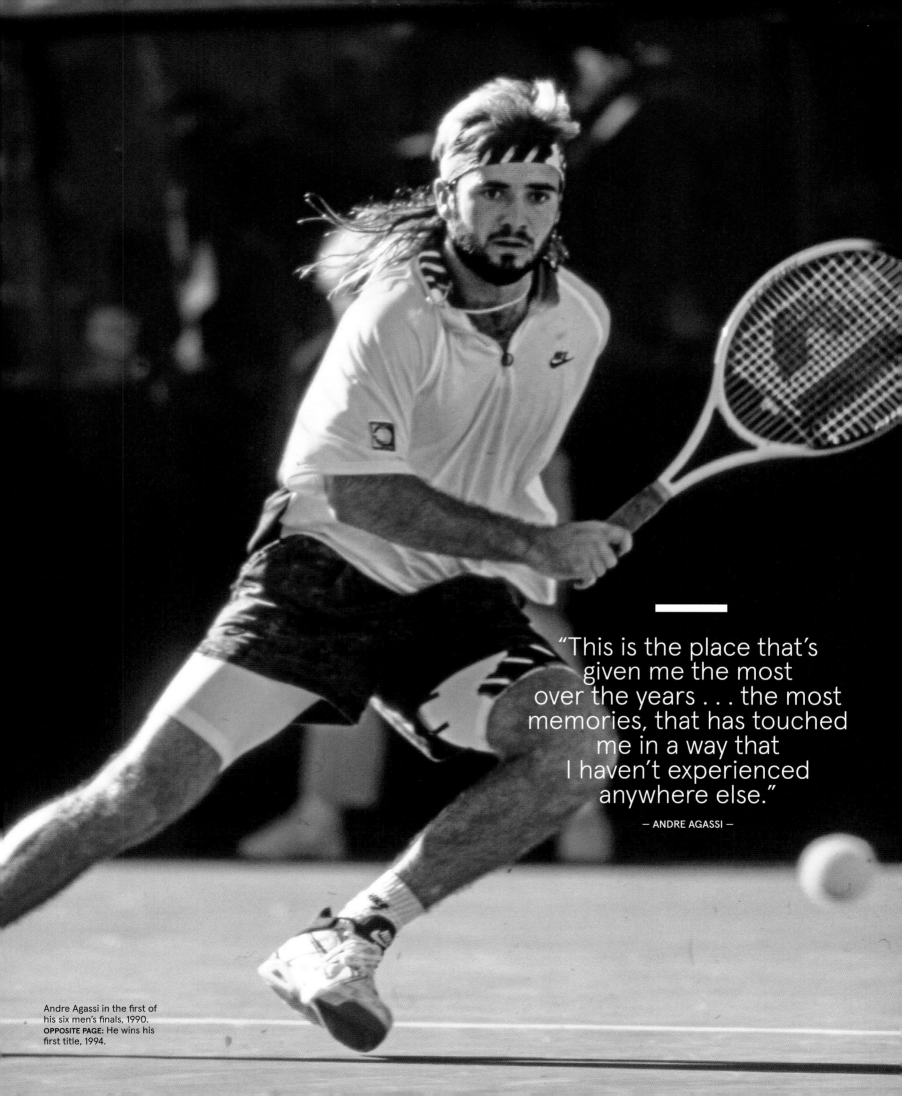

"This is the place that's given me the most over the years . . . the most memories, that has touched me in a way that I haven't experienced anywhere else."

— ANDRE AGASSI —

Andre Agassi in the first of his six men's finals, 1990.
OPPOSITE PAGE: He wins his first title, 1994.

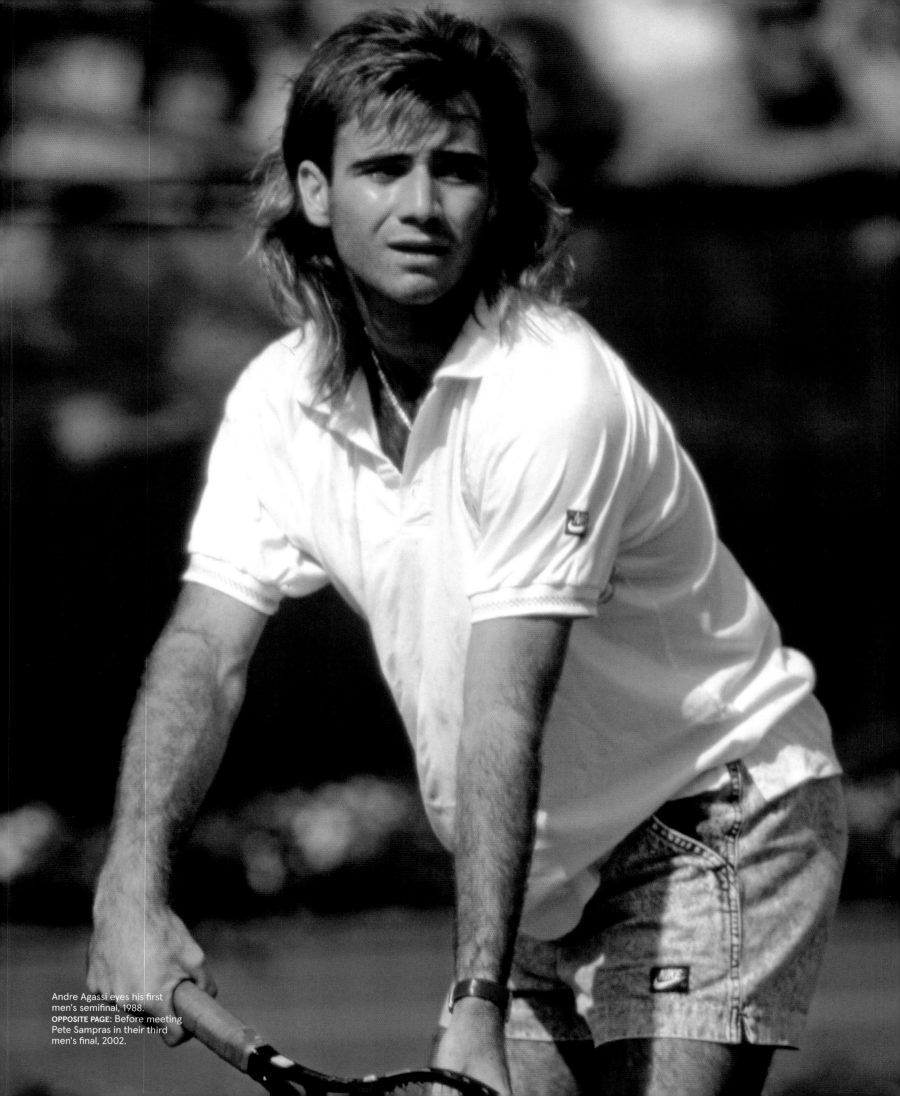

Andre Agassi eyes his first men's semifinal, 1988.
OPPOSITE PAGE: Before meeting Pete Sampras in their third men's final, 2002.

another radical transformation in Queens, having turned the robust boos he routinely heard in his early years into full-throated cheers. A player who was once seen as a self-promoting renegade with little heart was now universally hailed as a ball-bashing icon whose heart stretched to the upper reaches of Arthur Ashe Stadium, the biggest tennis venue in the world. Indeed, how could you not root for a man whose debilitating back condition required him to take injections just to get on the court? A man who had become the foremost philanthropist in his sport, raising tens of millions of dollars through his foundation and establishing an acclaimed

preparatory school for underserved children in his native Las Vegas?

Andre Agassi departed tennis as one of only two people in history to capture all four Grand Slams and an Olympic gold medal, the other being his wife, Steffi Graf. His twenty-one-year career included sixty singles titles, more than thirty-one million dollars in prize money, and a career mark of 870–274. It's a stunning numerical legacy, to be sure, but it only begins to explain why everybody in Arthur Ashe Stadium was standing after Agassi lost to Benjamin Becker in his final match in 2006, and why so many people were overcome with emotion, Agassi among them.

It was time to say goodbye—and thank you. A time to celebrate the human capacity for change and the sweeping power of authenticity. Andre Agassi knew long before he played his final professional match that he would want to do it right there, in a place where he'd traveled the path from pariah to icon. Somebody asked him about his Open journey before the 2006 tournament began.

"It started with lack of acceptance and has grown to a wonderful embracement, and on both parts," Agassi said. "I think I started off a little unsure about playing here, and I grew into loving this more than any place in the world." •

ARANTXA
SÁNCHEZ-VICARIO

Twice a US Open singles finalist, Sánchez–Vicario captured the 1994 title
to go along with three doubles crowns, one in mixed.

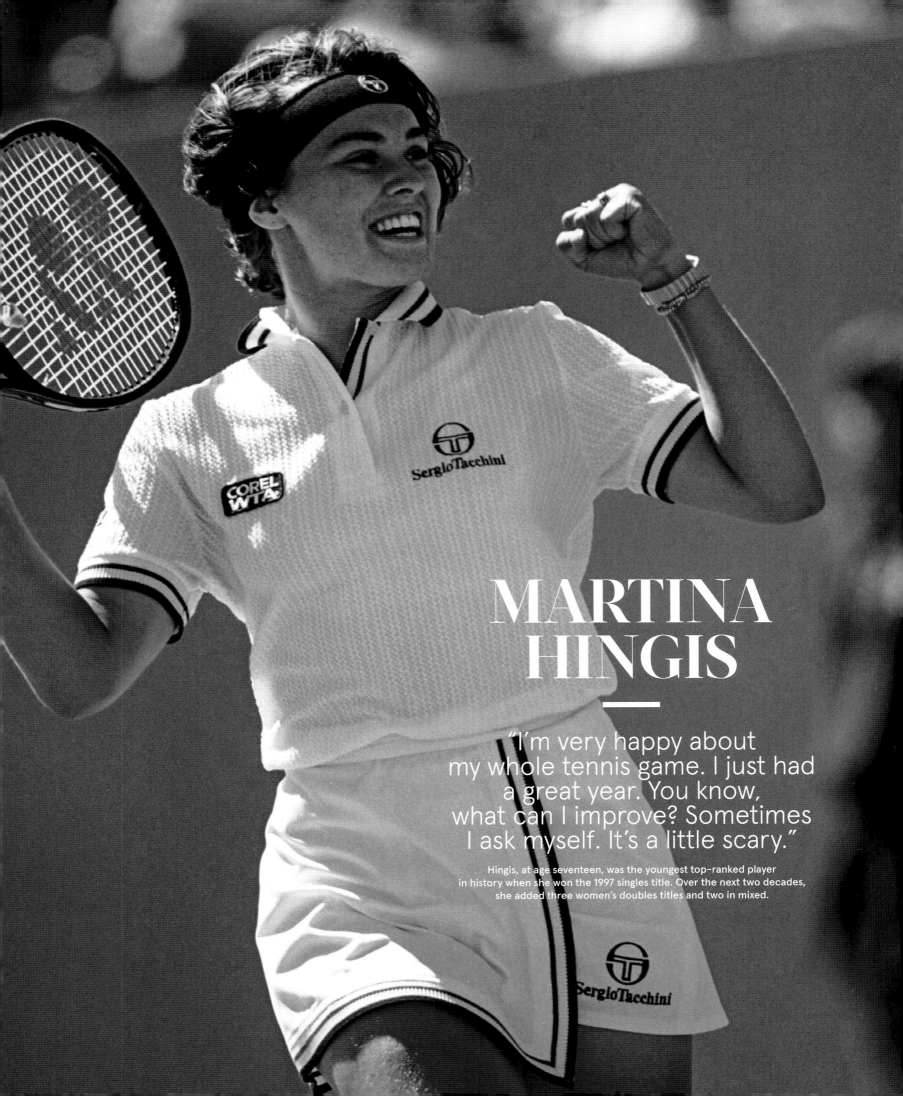

MARTINA HINGIS

"I'm very happy about my whole tennis game. I just had a great year. You know, what can I improve? Sometimes I ask myself. It's a little scary."

Hingis, at age seventeen, was the youngest top-ranked player in history when she won the 1997 singles title. Over the next two decades, she added three women's doubles titles and two in mixed.

ARTHUR ASHE KIDS' DAY

The 1996 US Open begins the tradition of staging the world's largest single-day, grassroots tennis and entertainment festival.

ARTHUR ASHE KIDS' DAY, a celebration of the life and legacy of Arthur Ashe, has been serving as the US Open's annual kickoff event for more than two decades. Held throughout the grounds of the USTA Billie Jean King National Tennis Center, the day begins with a free Grounds Festival, which provides families with an opportunity to experience how tennis has been "sized-right" for kids. The morning is filled with lots of child-friendly tennis programming, including interactive games and tennis clinics, along with juggling workshops, face painting, hair beading and braiding, storytelling, roving entertainers, and up-and-coming performers. Fans also have the opportunity to watch some top pros practice as they prepare for the US Open. In the afternoon, Arthur Ashe Kids' Day continues to serve as a showcase for promoting interest in tennis by putting on a Stadium Show featuring some of the biggest names in the sport—including US Open champions Kim Clijsters, Novak Djokovic, Roger Federer, Rafael Nadal, Serena Williams, and Venus Williams—along with some of the hottest acts in music. Over the years, Arthur Ashe Kids' Day has been a launching ground for artists such as Justin Bieber, Ariana Grande, Shawn Mendes, Rihanna, the Jonas Brothers, Fifth Harmony, Ne-Yo, Demi Lovato, Britney Spears, Backstreet Boys, and more. The inaugural Arthur Ashe Kids' Day was held at the start of the 1996 US Open. Merging two previously held events, the Arthur Ashe AIDS Tennis Challenge and Kids' Day, the daylong festival proved immediately popular and has since combined tennis and entertainment each year. Proceeds from the day benefit the USTA Foundation, which helps fund the National Junior Tennis & Learning (NJTL) network, a nationwide group of more than five hundred nonprofit youth-development organizations that provide free or low-cost tennis, education, and life-skills programming to more than 225,000 children each year. NJTL was founded by Ashe, along with Charlie Pasarell and Sheridan Snyder. ●

THIS PAGE—Top: Serena Williams, Jack Sock, and Michelle Obama, 2013. Middle: Kim Clijsters (left), Roger Federer, and Martina Navratilova, 2005. Bottom: Venus Williams and Rafael Nadal, 2017. OPPOSITE PAGE—Top left: Rihanna, 2005. Top right: Jonas Brothers, 2010. Bottom left: Novak Djokovic, 2014.

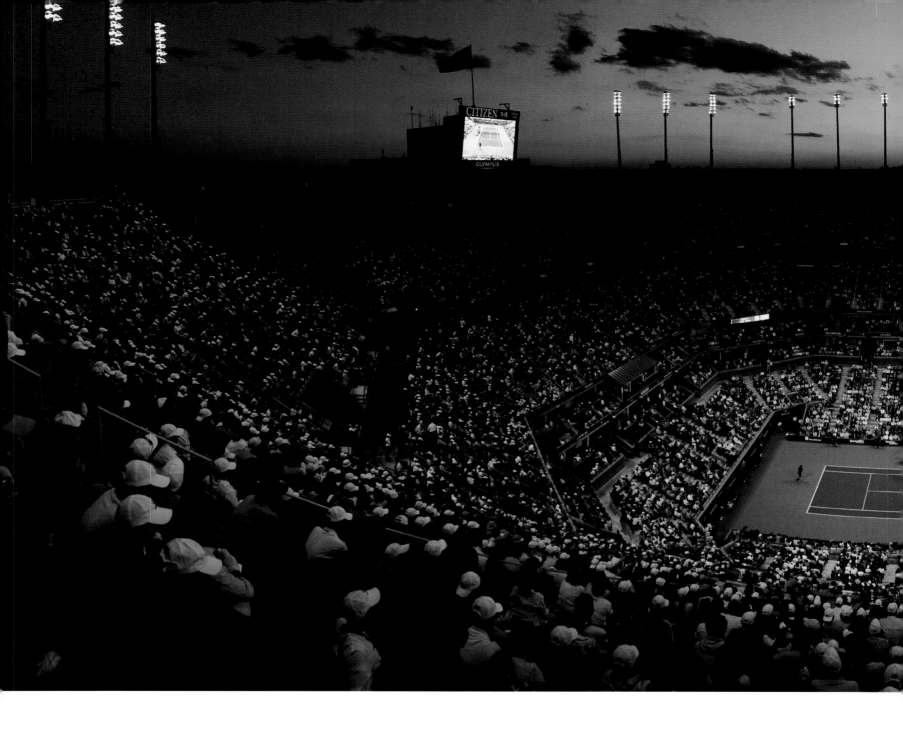

CENTER STAGE

THE US OPEN TAKES A BOLD STEP TOWARD ITS FUTURE
WITH THE 1997 OPENING OF ARTHUR ASHE STADIUM AS
THE CENTERPIECE OF ITS REVAMPED GROUNDS.

•

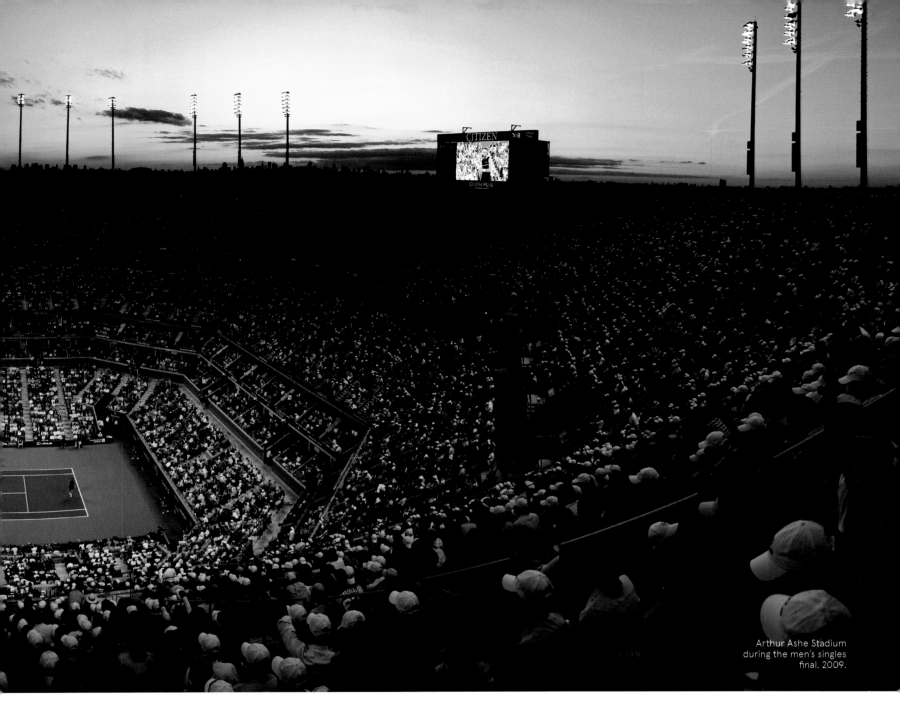

Arthur Ashe Stadium during the men's singles final, 2009.

IN 1978, THE US OPEN moved from Forest Hills to the newly constructed USTA National Tennis Center in Flushing, New York. The distance was just a few miles, but the two locations were worlds apart. The private West Side Tennis Club was nestled in a residential neighborhood, whereas the new venue was a public—and much more spacious—facility in the largest park in Queens. Finally, the US Open was based where it could accommodate more fans and grow the game as well.

And that's exactly what happened. US Open attendance in the first year at the USTA National Tennis Center exceeded 275,000. It surpassed three hundred thousand the next year and four hundred thousand for the first time in 1985. For the next half dozen years, the event's increasing popularity continued to grow—and the growing crowds became an issue. By 1992, when more than five hundred thousand fans attended the US Open, plans were already in place to expand and improve the public facility in a way that would ensure the tournament's continued strength and growth.

Arthur Ashe called the USTA National Tennis Center in Flushing Meadows–Corona Park "the greatest thing since sliced bread" when the new home for the US Open debuted in 1978, and others were quick to sing the Queens facility's praises as well. Jimmy Connors, who would win the men's singles title that inaugural year, gave the place a thumbs-up after he arrived prior to the tournament to get a feel for the new DecoTurf II surface and became the first player to hit on the venue's main stage, Louis Armstrong Stadium. Chris Evert, who easily made the transition to the hard courts from Forest Hills's clay courts by winning her fourth consecutive US Open title—and her third straight without losing a set—played in the opening match in Louis Armstrong Stadium on its first full day of tennis and also gave the twenty-thousand-seat arena her blessing.

Perhaps the highest accolade came from Philippe Chatrier. "When tennis historians look back on the development of the game

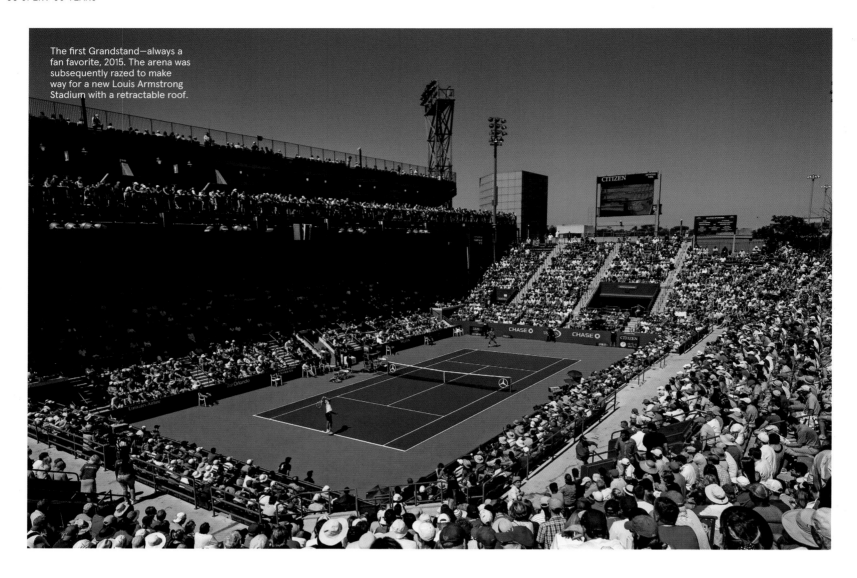

The first Grandstand—always a fan favorite, 2015. The arena was subsequently razed to make way for a new Louis Armstrong Stadium with a retractable roof.

in the 1970s," the International Tennis Federation president wrote in *ITF News*, "they may well feel that the most significant event of the decade was the USTA's achievement in planning and building the first great new stadium of the modern era of the game."

Nevertheless, suggestions for improving the USTA National Tennis Center started to roll in as soon as the 1978 US Open ended.

"We only had time to build, not to worry about plans, costs, and details," maintained William "Slew" Hester, the USTA president who was the driving force behind the facility's rapid construction. When his term as president ended in early 1979, the USTA leadership began to discuss a number of development plans of varying size and scope. By 1982, the plans were put on hold as the USTA began to consider not only renovating the site but relocating the US Open to a new facility. Nothing concrete was decided. What major improvements should be made to the USTA National Tennis Center, if any, continued to be debated

over the next five years, with the talk culminating in a long-range planning study initiated in 1987 "to look into the options that are available . . . [and] provide an excellent long-term, concrete course of action for the US Open that we've never really had."

With the study nearing completion two years later, incoming USTA president David Markin wrote to the USTA membership, "You can put a lot of Band-Aids on old facilities and spend an incredible amount and really not show anything for the future. We're going to come to a time very shortly when we're going to have to make a major investment with the National Tennis Center in Flushing Meadows, where we're at right now, with the city of New York's cooperation, or start giving some thought in a timely way to finding another facility, hopefully in the New York area. . . . We have to be careful that we don't suddenly find ourselves with a second-class facility and a first-class tournament."

Ultimately, the USTA opted to keep the US

Open where it was. Following a commitment by the Federal Aviation Administration to stop nearby LaGuardia Airport flights over the tennis center during the tournament (except for when safety required), and more than two years of negotiations and government approvals, an agreement was finalized with New York City mayor David Dinkins in December 1993 that provided for a significant expansion of the grounds. The area of the USTA National Tennis Center would more than double in size, to 46.5 acres, with the number of courts increasing from twenty-five to forty-five, with one of those courts serving as a new main stadium built on the parkland added to the west of Louis Armstrong Stadium. The agreement, which Dinkins called "fair to the city as well as to the USTA," was as important to the metropolitan region's economy as it was to the tournament. The US Open generates close to eight hundred million dollars in direct revenue for the tristate area— more than any other sports entertainment

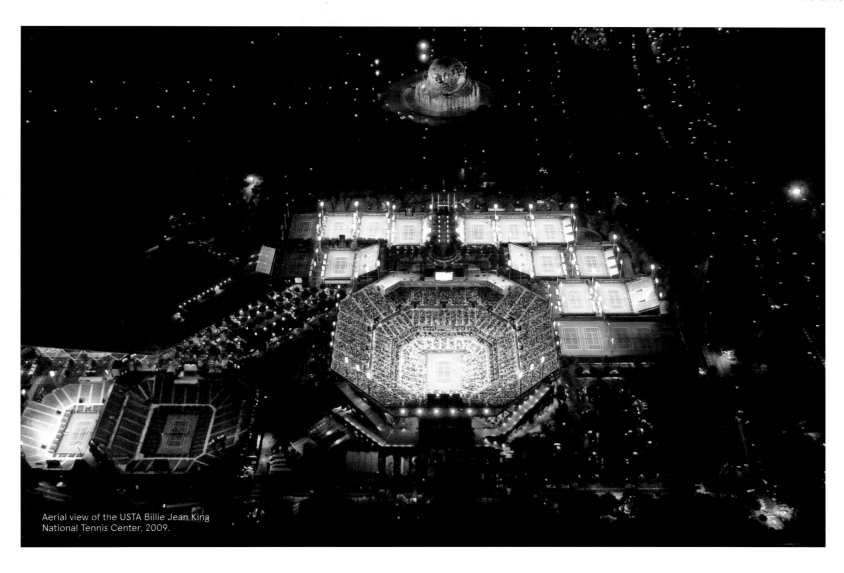

Aerial view of the USTA Billie Jean King National Tennis Center, 2009.

event in any city in the United States.

Begun in March 1995, the four-year construction project cost $285 million and sought to address a host of problems that had steadily increased as attendance rose, including overcrowded food service areas and an insufficient amount of seats for the show and field courts. The centerpiece of the expansion became Arthur Ashe Stadium, the world's largest stadium, coupled with the redesigned grounds, which, for the first time, made it possible for fans to view the action on each field court from all four sides. Ending the USTA National Tennis Center's tenure as a makeshift home, the makeover linked the site to its New York World's Fair roots by having its main stadium face the Unisphere erected at the center of the 1964–65 New York World's Fair grounds. More important, the expansion project enabled the US Open to burnish its status as a world-class event and to grow with the times. When the revamped facility opened in 1997, the tournament drew nearly a

half million more fans than when Arthur Ashe won the first US Open men's singles championship in 1968.

"Through the years, many people have honored Arthur and his work," Jeanne Moutoussamy-Ashe said when the USTA announced in early 1997 that the main stadium would be named for her late husband. "All of the honors have been very flattering and much appreciated. But I think Arthur would be extremely proud of this honor because he was very committed to the USTA and to helping it create opportunities for those who need them most."

Opening day of the 1997 US Open and the debut of the revamped USTA National Tennis Center featured more than the usual share of luminaries as the night session began on August 25. Every living US singles champion was invited to take part in an on-court dedication ceremony in Arthur Ashe Stadium. There were nearly as many stars standing inside the baselines as in the night

sky when pop diva Whitney Houston serenaded the assembled throng with "One Moment in Time" and fireworks rocketed above the stadium. Mayor Dinkins spoke about his friend Ashe, as did John McEnroe. Afterward, defending men's champion Pete Sampras took the court for the evening's first match, followed by second-seeded Monica Seles, who was seeking her third US Open title.

"It's one of those nights, you maybe have ten moments like this in your tennis career," Seles said.

Along with the stars who came out at night, US Open fans witnessed the ascendancy of another luminous figure as a seventeen-year-old prodigy Venus Williams played in Arthur Ashe Stadium in the second match of the day session. A newcomer to the US Open, she would advance all the way to the title match. Just like the new stadium in which she debuted, Williams would play a central role in ushering in a new era of star power that would electrify fans and shine a bright light on the sport. ●

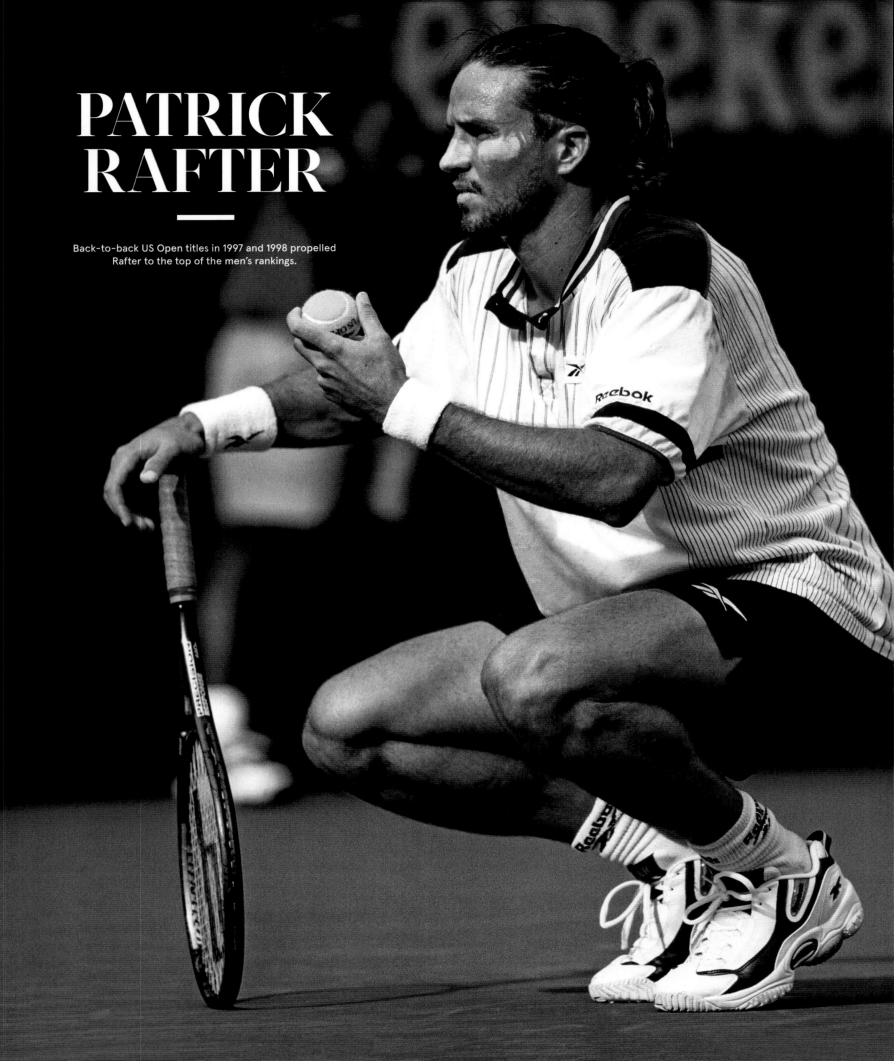

PATRICK
RAFTER

—

Back-to-back US Open titles in 1997 and 1998 propelled
Rafter to the top of the men's rankings.

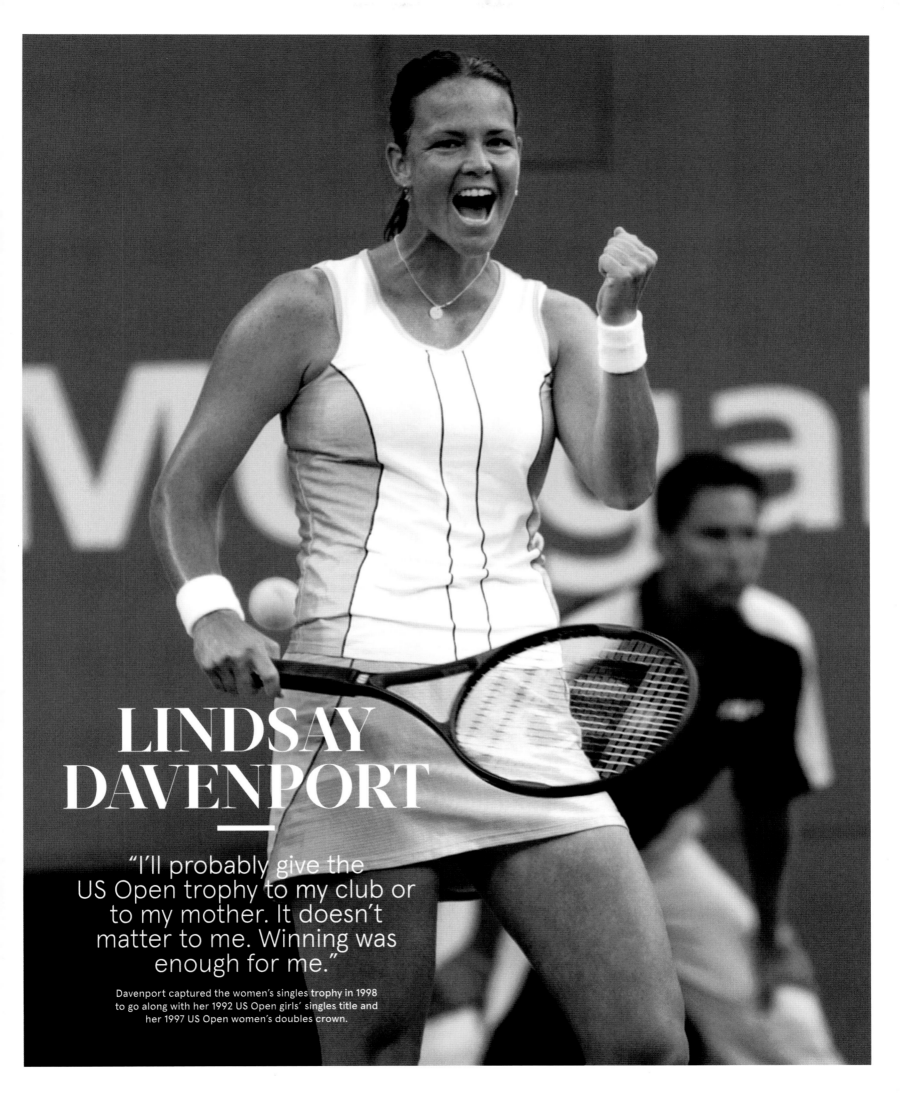

LINDSAY DAVENPORT

"I'll probably give the US Open trophy to my club or to my mother. It doesn't matter to me. Winning was enough for me."

Davenport captured the women's singles trophy in 1998 to go along with her 1992 US Open girls' singles title and her 1997 US Open women's doubles crown.

SERENA WILLIAMS

By Sean Gregory

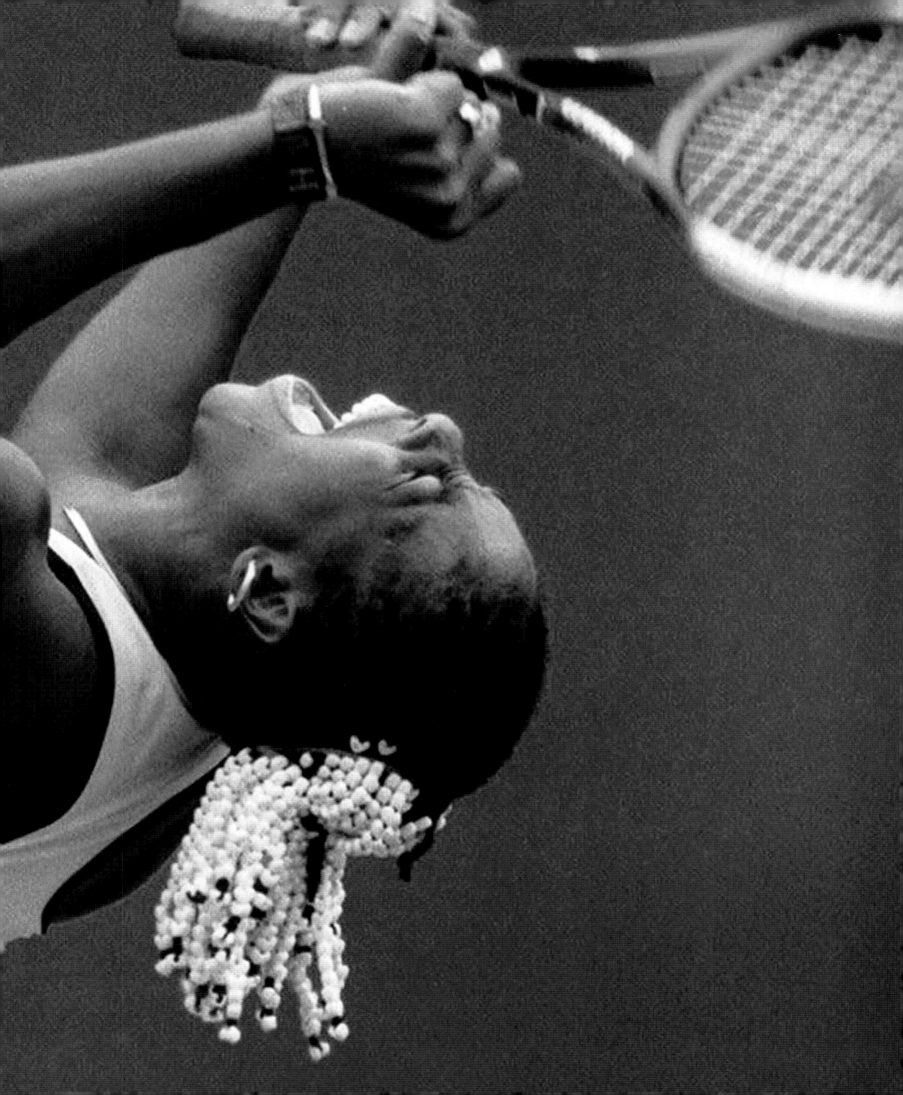

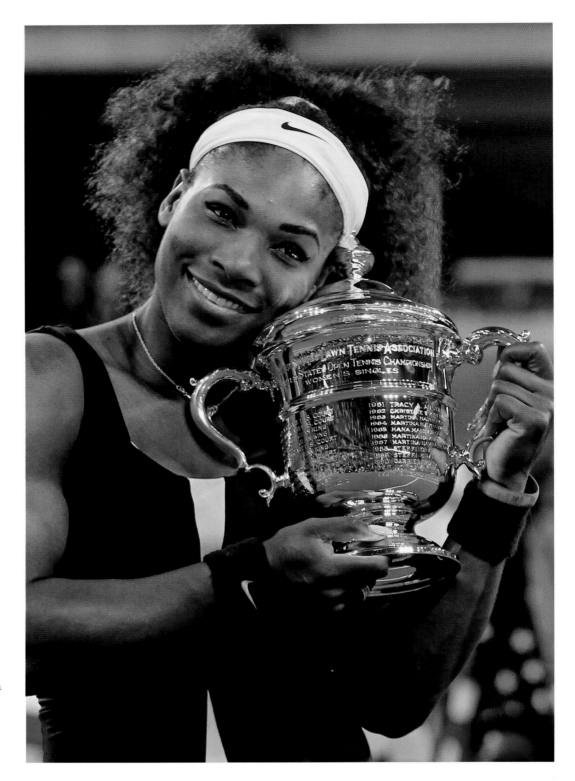

After she watched the backhand from Swiss superstar Martina Hingis sail long, secure that she had just won her first Grand Slam title, at seventeen, on the green hard court of two-year-old Arthur Ashe Stadium, Serena Williams placed both hands on her heart. She wore white beads in her hair and hoop earrings—a precocious teen with unbreakable power. "Oh my God," Serena screamed, her smile stretching all the way to her hometown, Compton, California, where her father, Richard, had taught Serena and older sister Venus how to play the game.

Richard Williams told everyone in earshot that his daughters would dominate tennis. So many scoffed at him. But here, on September 12, 1999, at the US Open, Serena Williams became the first African American woman to win the tournament since Althea Gibson forty-one years earlier. At the US Open, Serena began her feverish rewrite of sports history.

She'd go on to win twenty-three Grand Slam singles championships, more than any other player in the Open era, by the end of 2017; that tally includes six titles in Flushing Meadows. She's the greatest women's tennis player of all time, having overcome injuries, illnesses, and tragedy to win major championships in three different decades. The tennis court, however, has never boxed Williams in. All around the world, her singular name—Serena—represents self-empowerment, pride, and so much more. "Strong is beautiful," she once told me during a discussion about the impact of her career. "And it's powerful. It's been amazing for me. It can be amazing for anyone."

Tennis fans can spend hours debating their top Serena moments. The star player first ascended to the world's top ranking at Wimbledon, in 2002, after defeating her sister—the two-time defending champ—in the final, 7–6(4), 6–3. Thirteen years later, at the 2015 French Open, Williams curled up in the fetal position, crying, after the semifinals because she was too sick to move. Still suffering flu symptoms the next day, Serena dispatched Lucie Šafářová in three sets in the final to complete the penultimate leg of a second Serena Slam—in which she swept four straight majors over two calendar years. (She first did it in 2003.)

In 2017, she broke Steffi Graf's Open–era record of twenty-two Slam singles titles at the Australian Open—while playing the tournament roughly eight weeks pregnant with her first daughter. "She won a Grand

"I was just a kid with a dream
and a racquet."

— SERENA WILLIAMS —

Going for the Grand Slam, 2015.
OPPOSITE PAGE: Serena Williams
wins the first of three consecutive
titles, 2012.

Slam pregnant," supermodel Brooklyn Decker, who's married to 2003 US Open champ Andy Roddick, wrote on Twitter. "I needed Andy to dress me, carry me, and delicately place me on the toilet when I was 4 weeks pregnant."

But it's at the US Open, with the raucous Flushing crowd exploding on every key shot, where Serena has reached her most thrilling heights. Two years after her first US Open championship, she faced big sister Venus in the 2001 final. The match aired on network prime-time TV, attracting more than twenty-two million viewers, as Serena won in straight sets. She had to wait six more years to return to a final. Fighting injuries and still grieving the death of her half sister Yetunde Price—who was killed in September 2003—Serena fell to 140th in the rankings in 2006. Many critics questioned her commitment to tennis. She responded, in full, by reclaiming the No. 1 ranking after beating Jelena Janković in the 2008 Open final. She did not drop a set in the tournament, claiming her ninth major title. "I'm pushing the doors to double digits, which I obviously want to get to," she said afterward. "I feel like I can do it."

What a quaint comment. She was very far from done. Serena showed that by taking breaks from tennis and pursuing outside interests like fashion, players can avoid the type of burnout that curtailed so many other careers. A highlight of her thirties renaissance was the three consecutive US Open titles she took from 2012 to 2014. The last one gave her eighteen majors, tying her with Chris Evert and Martina Navratilova on the all-time list. "I couldn't ask to do it at a better place," she said.

For Serena, Arthur Ashe Stadium has also hosted some heartbreak. Roberta Vinci shocked her in the 2015 US Open, denying her the first calendar-year Grand Slam since Graf twenty-eight years earlier. A year later, a semifinal loss to Karolína Plíšková prevented her from breaking Graf's all-time major singles title record on home soil.

Serena Williams, however, has never let her lows define her. Throughout her remarkable pro career, which began in 1995, she's learned lessons from defeat and has refused to be written off. The longer she plays, the more she seems to enjoy tennis. And as long as she's healthy and hungry at the Open, New York City will be raring to go. Another chapter awaits. ●

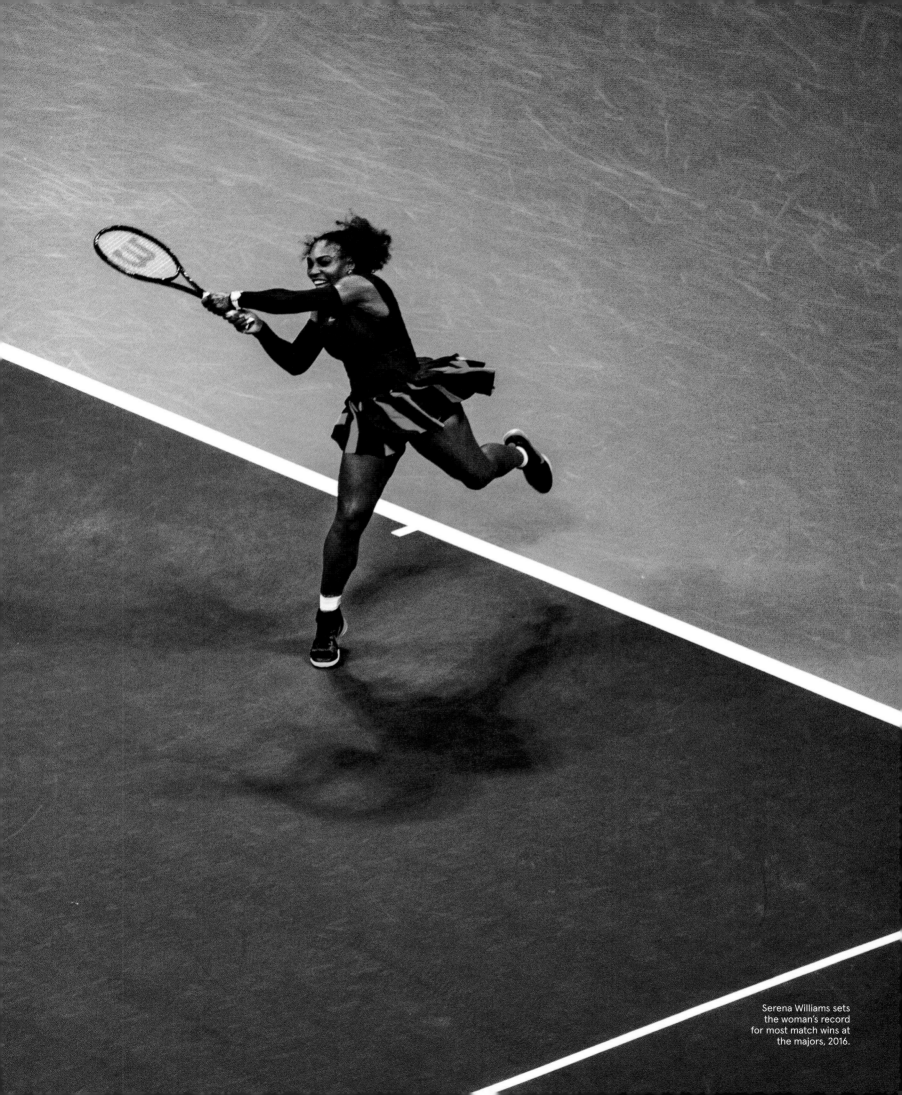

Serena Williams sets
the woman's record
for most match wins at
the majors, 2016.

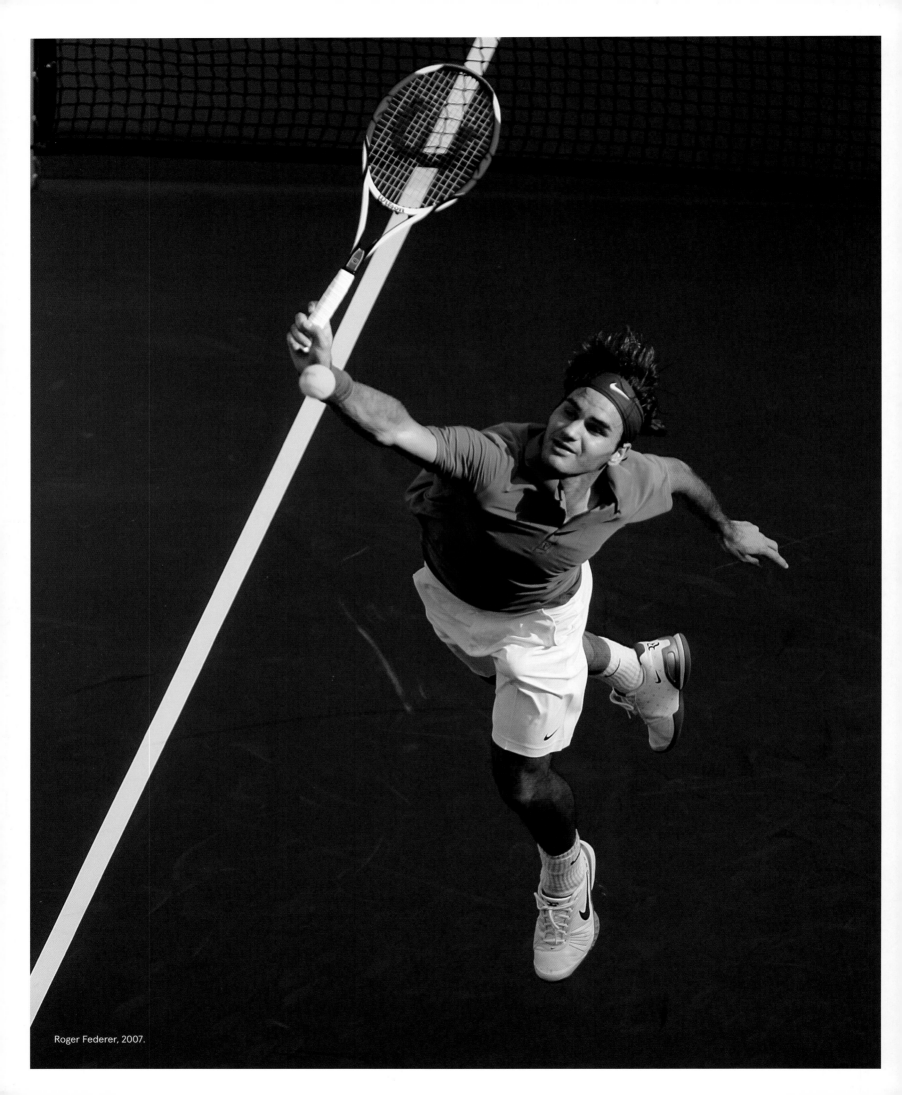

Roger Federer, 2007.

20
00s

Sports and entertainment began mixing at the US Open in a truly spectacular way in the 2000s. Introducing exciting new talents and a new wave of fan-friendly innovations, the tournament became tennis's greatest show, a star-powered event that brought down the curtain on the Grand Slam season in grand fashion.

2000

Five years after her last US Open match, Martina Navratilova competes in women's doubles and becomes the only person to play in all three of the US Open's main stadiums. / Bill Clinton attends the women's final and becomes the first sitting US president to attend a US Open match. / Venus Williams defeats Lindsay Davenport in the women's final, 6–4, 7–5. / Marat Safin defeats Pete Sampras in the men's final, 6–4, 6–3, 6–3.

2001

Seeds in singles are increased from 16 to 32. / Giant video screens are installed inside Arthur Ashe Stadium. / The US Open becomes the first Grand Slam tournament to schedule its women's final in prime time on network television. / A junior qualifying event is added. / Andre Agassi and Pete Sampras play an epic quarterfinal in which neither player loses serve. / Venus Williams defeats Serena Williams in the first all-sister US Open women's singles final, 6–2, 6–4. / Lleyton Hewitt defeats Pete Sampras in the men's final, 7–6, 6–1, 6–1.

2002

The first all-women's night session is played, with Martina Hingis defeating Amanda Coetzer, Jennifer Capriati topping Meghann Shaughnessy, and Hingis and Anna Kournikova defeating Laura Granville and Jennifer Hopkins. / Due to rains during the previous day, a record 103 matches are played on September 3. / Pete Sampras sets the men's record for most aces in a tournament with 144. / Serena Williams defeats Venus Williams in the second prime-time women's final, 6–4, 6–3. / Pete Sampras defeats Andre Agassi in the men's final, 6–3, 6–4, 5–7, 6–4, for his record-tying fifth title.

Cover of the US Open tournament program, 2006.

2005

"US Open Blue" tennis courts make their US Open debut. / Svetlana Kuznetsova becomes the first defending US Open women's champion to lose in the first round. / The US Open Wheelchair Competition is introduced. / Kim Clijsters collects a record $2.2 million paycheck for winning the US Open Series and defeating Mary Pierce in the women's final, 6–3, 6–1. / Roger Federer defeats Andre Agassi in the men's final, 6–3, 2–6, 7–6, 6–1.

2006

The USTA National Tennis Center is renamed for Billie Jean King during an opening-night ceremony. / Instant replay debuts in the main stadiums, with Mardy Fish being the first player to challenge a call. / Andre Agassi plays the final match of his career. / Maria Sharapova defeats Justine Henin-Hardenne in the women's final, 6–4, 6–4. / Martina Navratilova teams with Bob Bryan to win the mixed-doubles title in her final Grand Slam match. / Roger Federer defeats Andy Roddick in the men's final, 6–2, 4–6, 7–5, 6–1, to win back-to-back Wimbledon and US Open titles for three straight years.

2007

Total attendance tops seven hundred thousand for the first time. / Venus Williams hits the fastest women's serve at 129 miles per hour. / Justine Henin defeats Svetlana Kuznetsova in the women's final, 6–1, 6–3. / Roger Federer defeats Novak Djokovic in the men's final, 7–6, 7–6, 6–4, to become the first man to win four consecutive US Open titles and collects a record $2.4 million payout for also winning the US Open Series.

2008

The US Open begins with a parade of champions to celebrate the fortieth anniversary of Open tennis. / Andy Roddick and Ernests Gulbis age one year as their match goes past midnight and ends on Roddick's twenty-sixth birthday and Gulbis's twentieth. / Americans contest seven of the nine finals (all but men's singles and boys' doubles). / The women's final is moved to Sunday and the men's final to Monday due to Tropical Storm Hanna. / Serena Williams defeats Jelena Janković in the final, 6–4, 7–5. / Roger Federer defeats Andy Murray in the men's final, 6–2, 7–5, 6–2, for his record fifth consecutive title.

2009

Seventeen-year-old American Melanie Oudin, ranked No. 70, comes from a set down in consecutive rounds to defeat No. 4 Elena Dementieva, 2006 US Open champion Maria Sharapova, and No. 13 Nadia Petrova. / Four unseeded women reach the quarterfinals, the most since the seeding system was instituted in 1922. / Kim Clijsters, who retired in 2007, defeats Caroline Wozniacki in the women's final, 7–5, 6–3, to become the first wild card and first unseeded player to win the title. / Juan Martín del Potro defeats Roger Federer in the men's final, 3–6, 7–6(5), 4–6, 7–6(4), 6–2.

2003

The tournament begins with Pete Sampras announcing his retirement in an on-court ceremony. / Prize money for the singles winners reaches $1 million. / The US Open Court of Champions is introduced. / The US Open's first "four-day" match is completed as Francesca Schiavone defeats Ai Sugiyama after the players go on and off the court seven times during four days of rain. The wet conditions force a Friday night session for the women's singles semifinals. / Justine Henin-Hardenne defeats Kim Clijsters in the women's final, 7–5, 6–1. / Andy Roddick defeats Juan Carlos Ferrero in the men's final, 6–3, 7–6, 6–3.

2004

The US Open Series, linking summer tournaments in North America to the US Open, is launched. / Andy Roddick hits the fastest men's serve at 152 miles per hour. / Svetlana Kuznetsova defeats Elena Dementieva in the women's final, 6–3, 7–5. / Roger Federer defeats Lleyton Hewitt in the men's final, 6–0, 7–6, 6–0.

VENUS WILLIAMS

By Katrina M. Adams

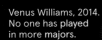

Venus Williams, 2014.
No one has played
in more majors.

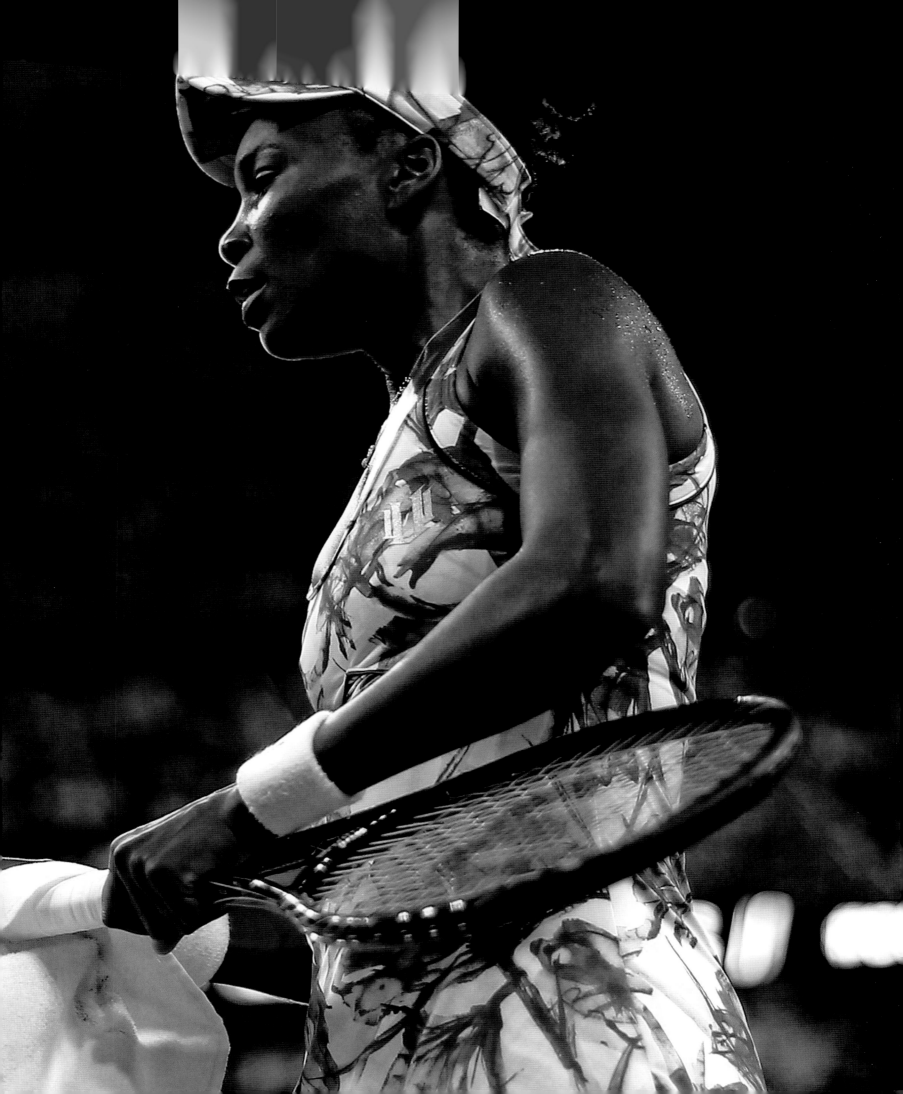

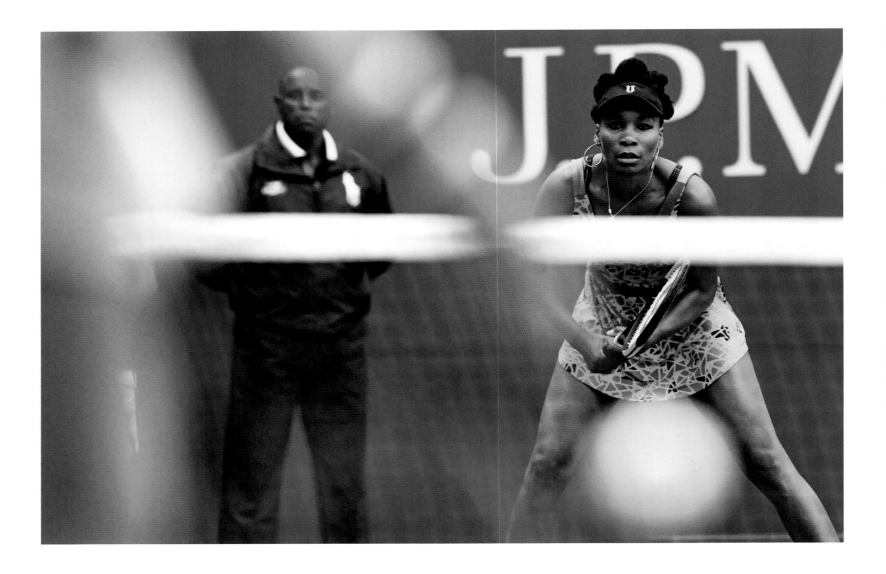

I was still playing on the WTA Tour when a fourteen-year-old Venus Williams made her professional debut. The time was October 1994, and the tournament that provided the stage for her premier bow was in Oakland. Now, you have to understand that as a rule, once you've played your match for the day, players don't usually stick around to watch other players play. But so

much had been said and written about this heralded "can't miss" phenom from the rough environs of Compton, California, that there were probably twenty or so players—myself included—in the stands that night, eager to see what all the buzz was about. No one came away disappointed. If anything, the hype undersold the advanced talent of this remarkable young woman, who won her first professional match, beating fellow American Shaun Stafford before losing to Arantxa Sánchez-Vicario in the second round. We knew even then—every one of us—that we were watching the start of something special.

Venus had a bit more experience under her belt by the time she made her US Open debut in 1997, but not much more. Tall and gangly, all arms and legs and beads, she dazzled the New York crowd, playing her way into the final of her very first Flushing Meadows foray at the age of seventeen. With that, she became the first unseeded woman finalist at the tournament since 1958. Her tremendous talent was

obvious from the start, but her run to the final of her first US Open also showed the power, poise, and amazing grace that would come to define her throughout her career. At just seventeen, it was already abundantly clear: Here was a star who would own the game's biggest stages for years to come.

And as those years have come—and gone— Venus has proven herself to be one of the greatest champions of her time—or any time, for that matter. She has indeed owned the game's biggest stages and now also owns seven Grand Slam singles crowns—including two US Open titles, posting back-to-back championships in Flushing Meadows in 2000 and 2001.

Venus has been an integral part of the heart of the US Open since her debut, her great talents and singular grace helping to pump up the event's popularity and define its essence. And the Open, in turn, has helped to define her as well. There are countless examples to prove that statement, but two immediately come to mind. The first occurred in that magical

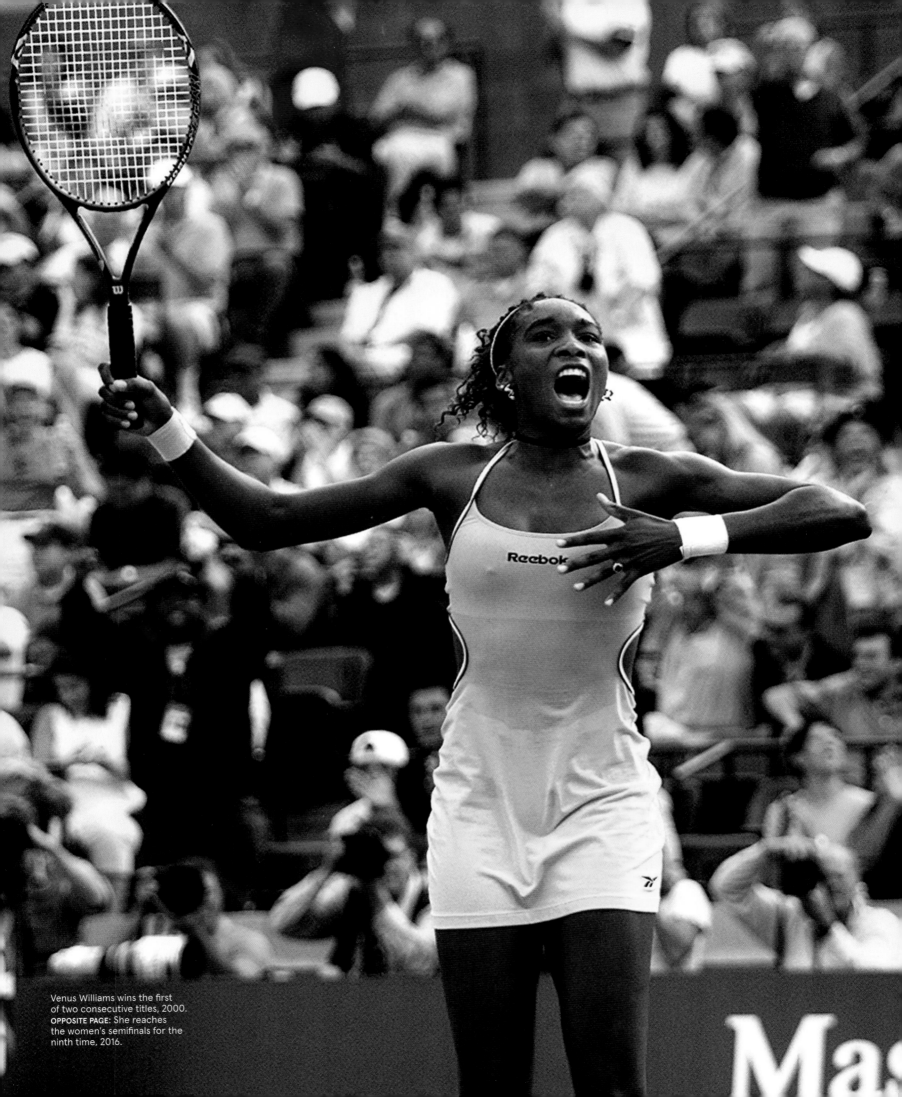

Venus Williams wins the first of two consecutive titles, 2000. **OPPOSITE PAGE:** She reaches the women's semifinals for the ninth time, 2016.

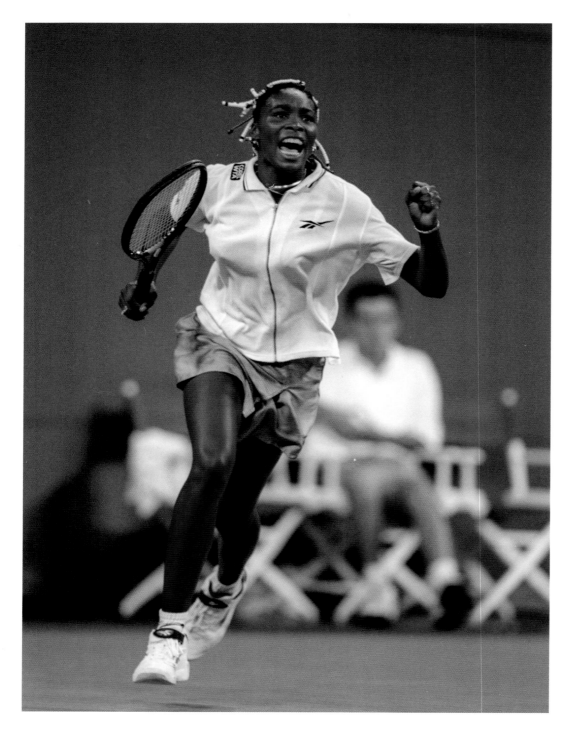

illuminated the match but also lit up women's tennis and the US Open for a worldwide audience to see. Here was a brilliant example of Venus's remarkable ability to block out all but the task at hand, to focus only on winning one more point than her opponent, whoever that opponent might be. The 6–2, 6–4 decision earned Venus a second consecutive US Open crown and took her reputation for mental toughness to a whole new ethereal level.

Venus needed to be tough right from the start. Her background and her upbringing were a long way from the tennis textbook. There was controversy, and there was racism—sadly, there still is. It takes a tough person to stare those things down.

She didn't need to be gracious, and yet, she became one of our sport's most gracious champions, both in winning and in losing. And when you look at Venus as a whole, it is that grace that stands out. She is inspiring, and she continues to inspire the next generation of players. She has been a great mentor to many of them—particularly to players of color. When she walks into a room, everything stops, because you can feel her presence; you can feel her greatness. She's very humble and quiet, and yet she makes a loud impression, because of all that she's accomplished—both on and off the court.

But for all of Venus's off-court accomplishments—and there are many—the tennis court always has been her haven . . . and her heaven. Through personal strife and illness, through family tragedy and myriad distractions, once she is inside the lines, she is safe inside her world. She has always been straightforward and focused within those lines. She's not a player who really engages with the crowd, and yet the crowd loves her. For Venus, it's all business until it's time for the twirl and the wave after the victory. But first, it's the victory. She proved that again in 2017, reaching two Grand Slam finals and the US Open semis, and breaking back into the game's Top 5 at the age of thirty-seven.

As I first saw that evening in Oakland many years ago, Venus is special. She has the deepest passion for the sport of anyone I know. Since that 1997 US Open, she has been a great ambassador for our tournament and a great champion—even in the years she didn't win. I know that the US Open holds a special place in her heart, just as she will always hold a special place in the heart of the Open and its fans. ●

US Open debut of 1997 when, in her tightly contested semifinal against Irina Spîrlea, her Romanian opponent bumped Venus as they were making their way to their respective seats on a changeover. A tour veteran at that point, Spîrlea likely figured she could intimidate teenage Venus, but the move only served to anger her, and Venus dug deep for the 7–6, 4–6, 7–6 win. With that victory, Venus gained not only the final but also a legion of fans who appreciated that she wouldn't be—couldn't be—rattled or intimidated. New Yorkers love that attribute in their athletes because it's an

attribute that largely defines them as well. One thing was for sure: Venus knew that she belonged, and her mental toughness—at only seventeen—was nothing less than remarkable—a telltale sign of things to come.

The second example was Venus's performance in the first-ever prime-time US Open women's final in 2001. In that greatly hyped and heralded matchup against younger sister Serena, Venus, now the defending US Open champ, was again the picture of poise, her singular vision serving her well as the bright lights of Arthur Ashe Stadium not only

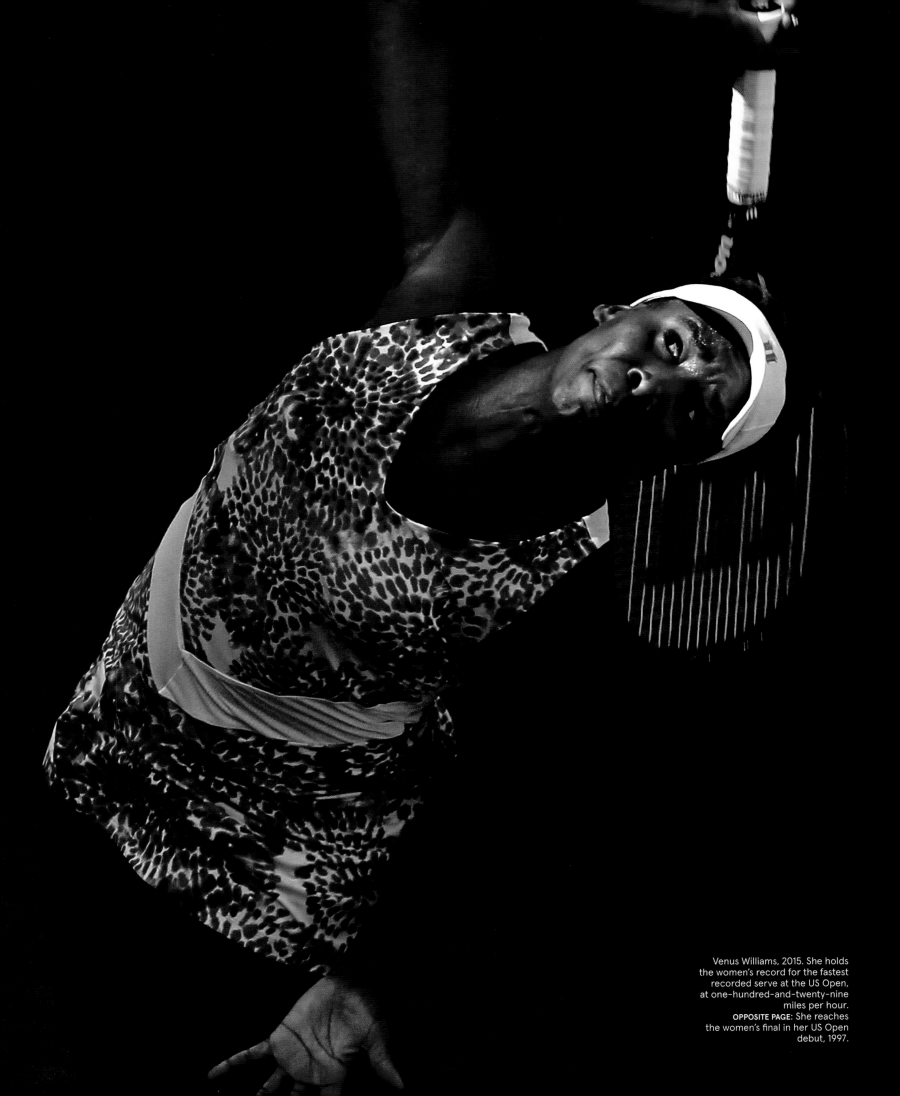

Venus Williams, 2015. She holds the women's record for the fastest recorded serve at the US Open, at one-hundred-and-twenty-nine miles per hour. **OPPOSITE PAGE:** She reaches the women's final in her US Open debut, 1997.

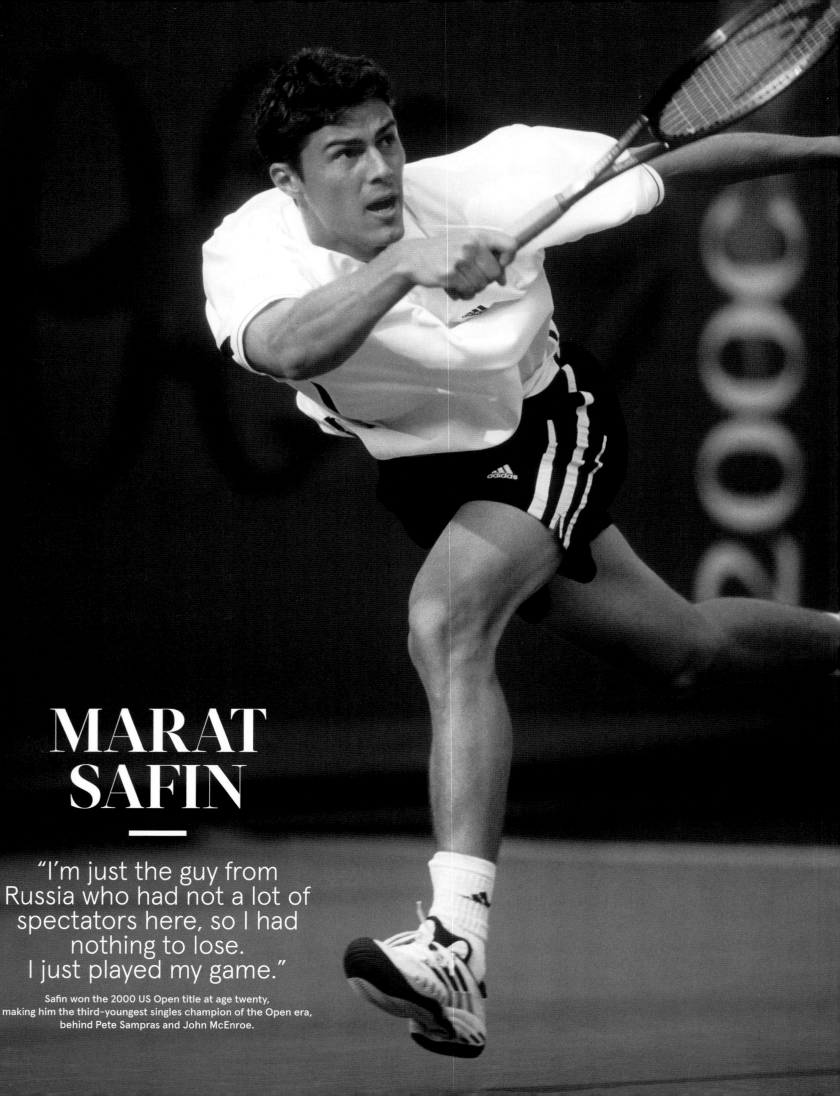

MARAT SAFIN

—

"I'm just the guy from Russia who had not a lot of spectators here, so I had nothing to lose. I just played my game."

Safin won the 2000 US Open title at age twenty, making him the third-youngest singles champion of the Open era, behind Pete Sampras and John McEnroe.

LLEYTON HEWITT

—

Hewitt captured the men's singles championship in 2001, one year after winning his first US Open title in men's doubles.

SHOWTIME

AN AWARD-WINNING SPORTS HOST AND ANCHOR, SERVING AS A FIELD REPORTER ON NATIONAL BROADCASTS OF THE US OPEN FOR NEARLY TWO DECADES, MASTERS THE ART OF FINDING FAMOUS FANS.

By Michael Barkann

•

COMEDIAN ALAN KING *is the first celebrity who became a fixture at the US Open. He attended the tournament so frequently at Forest Hills that when a group of politicians and dignitaries were invited in October 1977 to take part in the official ground-breaking ceremony for the USTA National Tennis Center, he was among them, shovel in hand. Figures from the worlds of entertainment, fashion, and sports have long been gravitating to the US Open, and so have political figures—ever since Vice President Spiro Agnew attended the 1971 women's singles semifinal won by Billie Jean King over Chris Evert. Henry Kissinger was a frequent fan. Jimmy Carter, who placed a congratulatory phone call from the White House to fourteen-year-old Tracy Austin in 1977 after she became the youngest player to win a US Open match, made the trip to Flushing Meadows after his time in office. Bill Clinton, in 2000, was the first sitting president to visit the US Open. Michelle Obama, in 2011, was the first First Lady to make an appearance in Arthur Ashe Stadium. For decades, Donald Trump attended the US Open on a regular basis.*

It was Michael Barkann's business, as a field reporter at the US Open for USA Network on its national broadcasts from 1991 to 2008, to find the famous fans in Flushing and bring them into our living rooms. Here, he tells us how he went about looking for luminaries.

My first year at the US Open was 1991. If we could snap our fingers and go back in time to the USTA National Tennis Center, as it was known then, you wouldn't recognize the place. There was no Arthur Ashe Stadium with a retractable roof. The same with Louis Armstrong Stadium. It was a shell of the new Louis Armstrong Stadium making its debut in 2018. There was no 8,125-seat Grandstand. There were no dancing fountains beckoning in the South Plaza, their mist cooling you off on a sweltering day as you check the scores around the grounds.

No, in 1991, there was a creaky, old Louis Armstrong Stadium with the Grandstand attached and about seventeen outer courts. And there was the food court—from which emanated the most delicious blend of aromas as you could find in New York. The signature dish of the Open was and is the hamburger,

which everyone loves. Everyone but Goran Ivanišević. Court 5 was just behind the burger stand, where Tim Sullivan and his crew from Paul Smith's College would cook up a storm. Timmy would say all the American players would stop by for a pre-match burger, which, of course, would lead them to victory. Goran hated it. He said the smells from the food court were distracting, and he campaigned to have the burger stand moved. (It didn't happen, of course.)

I was at the Open for eighteen summers, from 1991 to 2008, reporting for USA Network/NBC Sports. Initially, I was brought in to provide flavor at the USTA National Tennis Center during the tournament. I'd put together feature stories and celebrity interviews. Eventually, I made a transition from solely features and celebs to also covering pre- and post-match interviews with the players. My favorite part of the Open, though, was celebrities. And definitely the celebrities during night matches.

Arthur Ashe Stadium for a night match (especially if it featured a top-ranked player) was part sporting event, part rock concert,

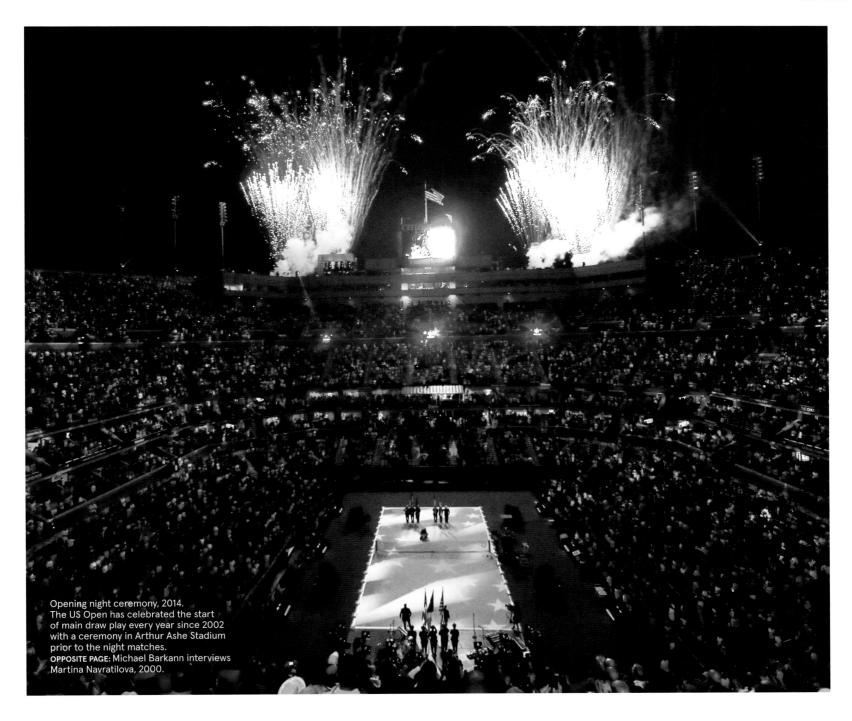

Opening night ceremony, 2014.
The US Open has celebrated the start
of main draw play every year since 2002
with a ceremony in Arthur Ashe Stadium
prior to the night matches.
OPPOSITE PAGE: Michael Barkann interviews
Martina Navratilova, 2000.

part Broadway show opening, and completely crackling with electricity.

Where to start?

Well, let's begin with how I would find these famous persons. In the old Armstrong Stadium, fans were jammed in everywhere. So were the celebrities.

I remember Tony Bennett—in his standard chalk-blue suit and tie—being shoved into a portal as play was about to resume and the chair umpire piped in, "Seats, please." This was *Tony Bennett*! The security guards rerouted everyone into the exit tunnels to the concourse, and there was Tony, jammed in

and corralled with the rest of us until the next changeover.

I would usually park myself on the court opposite the chair, right where the players would enter and exit, and, section by section—seat by seat, even—scour the stadium until I found the subject of my search.

My *search*? Well, yes, and I had a search party helping me. Whether production assistants, producers, camera persons, security guards, or fans, I was often tipped off to the night's celebrities, and I would make it my mission to find them and secure interviews.

My biggest helper was Judi Lerner, who ran

the tournament referee's office. I've known Judi for more than thirty years. She would usually get the call directly from either the celebrities themselves or their representatives about going to the matches. I'd always stop in to ask her if there were any big names coming.

Like the one night I was hovering outside her office door, which was just off Arthur Ashe Stadium court. Who walks out but Larry David and Jerry Seinfeld. Seinfeld hit the restroom, leaving David to wait for him. I asked him, "Can I come to your seats and interview you and Jerry during the matches *live* for USA Network?" He thought and thought, his face

191

in a half smile. "I'll do it if he'll do it," nodding toward the restroom. When Seinfeld reappeared, I asked him, and he said blandly, "Yeah, I'll do it." It would go like that.

Sometimes, at Armstrong, celebrities would be sitting in the President's Box at one end of the court, and I couldn't easily get to them. But, many times, they'd have headphones on, listening to the telecast on closed-circuit TVs in the box, and when we went to commercial, I would ask the producer to open my microphone. Then, I would talk *directly* to, say, Jack Nicholson. "Jack, mind if I come over there and talk with you for a few minutes about the matches? I'm watching you, Jack. Over here, to your left. Yeah, here I am. Give me a thumbs-up if it's okay? It is?! Be right over, Jack." Then, I'd have to calm myself down when I realized I'd be talking to Jack Nicholson. And so it went.

I think the celebrities were captivated by the Open because of the sheer magnitude of the event—it was bigger than they were, in almost every case—and, of course, they came to see the players.

Or date the players?

That's what drew Barbra Streisand to Louis Armstrong Stadium in 1992. She'd been dating Andre Agassi, and she showed up one night to watch him play Carlos Costa of Spain in a fourth-round match.

I was in my usual spot and watched her breeze in and take a courtside seat, and after some coaxing by my security guard pals, she said okay to an interview.

Me: "What moves you about Andre on the court?"

Barbra: "He's very, very intelligent; very, very sensitive; very evolved—more than his linear years. He's an extraordinary human being. He plays like a Zen master."

ZEN MASTER?! That quote went viral. And that was before the Internet. My wife and I were on our honeymoon in Bermuda not long after the Open, and I was watching *Monday Night Football* and heard Al Michaels mention the quote. It was pretty cool.

When Arthur Ashe Stadium opened in 1997, there were places for the celebrities to watch play undetected.

But, usually . . . I found them.

It was a great eighteen years. ●

Stars from the worlds of music, entertainment, fashion, sports, and politics come out for the US Open.

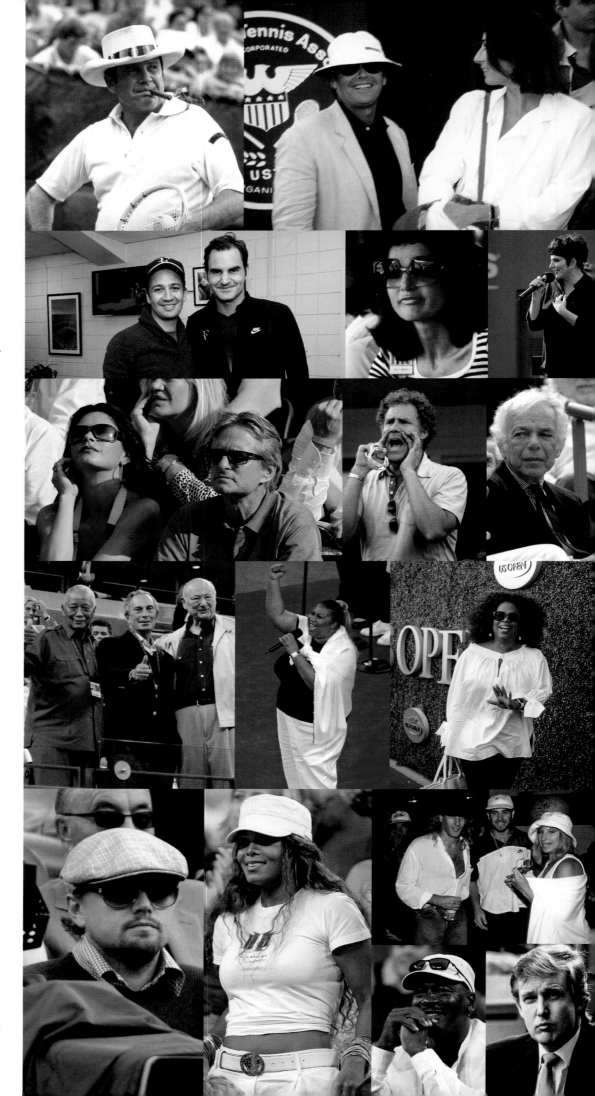

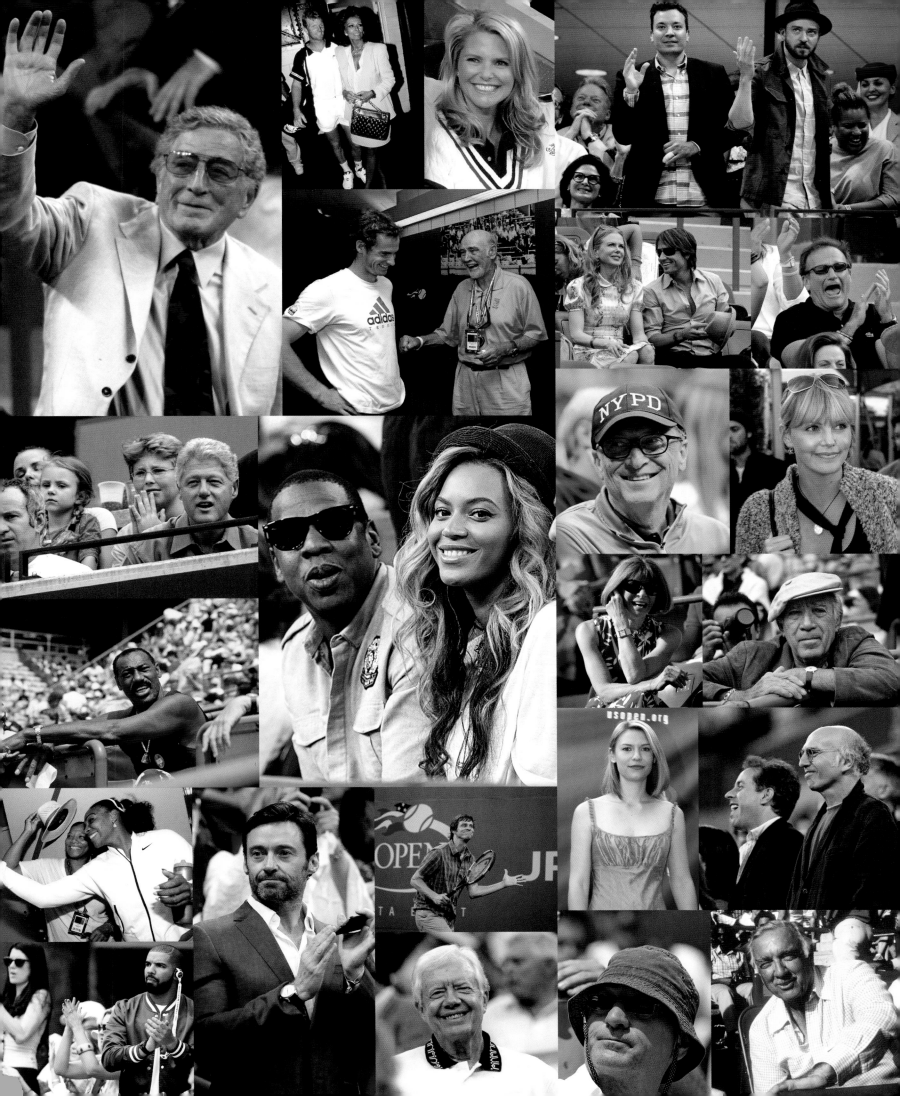

A FAMILY AFFAIR

VENUS WILLIAMS AND SERENA WILLIAMS
MAKE HISTORY BY TURNING THE 2001 US OPEN
WOMEN'S SINGLES FINAL INTO A SISTER ACT.

By Joel Drucker

•

THE 2001 US OPEN, *capitalizing on the increasing popularity of women's tennis—due, in no small part, to the arrival of the Williams sisters on the tennis scene—became the first Grand Slam tournament to schedule its women's singles final in prime time on network television. The move proved to be a big hit, as Venus Williams and Serena Williams reached the final and became the first sisters to play for the title in the history of the US National Championships/US Open. The September 8 final turned out to be the most-viewed event on television that evening.*

Venus, at age twenty-one, was the No. 4 seed, and Serena, at nineteen, was seeded No. 10. Yet their seeding belied their youthful success at the US Open. Venus was the defending champion and had been a finalist in 1997 (her first US Open) and a semifinalist in 1998 and 1999. Serena had won the title in 1999 (her second US Open) and had reached the quarterfinals in 2000. Prior to the 2001 US Open women's singles final, the past two champions had met for the title only twice: in 1984, when Martina Navratilova (1983)

defeated Chris Evert (1982) for the title; and in 1989, when Steffi Graf (1988) topped Navratilova (1987). The Williams sisters would repeat their 2001 title tilt the following year, with Serena reversing the outcome to capture her second US Open singles crown. "It is the most amazing thing in sports," said Lindsay Davenport after losing to Serena in the 2002 semifinals. "Could you imagine Tiger Woods challenging a sibling to go head-to-head for all the majors?"

Joel Drucker, in USTA Magazine's *November/December 2001 issue, recounts the events leading up to their first encounter at a Grand Slam tournament.*

The folklore remains vivid. The tennis journey had started for Venus Williams and Serena Williams on a garbage-strewn, stark hard court in Compton, California.

Of course, it had really begun when Richard Williams watched pro Virginia Ruzici hoist a big check after winning a tournament, at which point Richard decided he wanted to sire two athletes. Following Compton, the Williamses' ride had continued to Florida,

where the two sisters, eschewing junior competition, honed their games under the guidance of Jennifer Capriati's former coach, Rick Macci. Then, it was on to the pro tour, where the sisters rapidly stepped into the spotlight, winning at singles and doubles—at least when they chose to play.

Now, here they were, on practice court P-2 on the second Saturday of the US Open fortnight, hitting with each other nine hours before entering Arthur Ashe Stadium for a historic women's final, which would be won by Venus, 6–2, 6–4.

As usual, the practice was cluttered, the same confab of tennis and business and cameras that had groomed them for that evening's prime-time broadcast on CBS. One of the Williamses' business managers was strolling across the court in a snappy white suit and hat. Hitting partners gathered up balls. As Serena hit overheads, father Richard kneeled next to the net, looking up at her and snapping photos. Watching the practice session through a window in the players' dining lounge, US Fed Cup coach

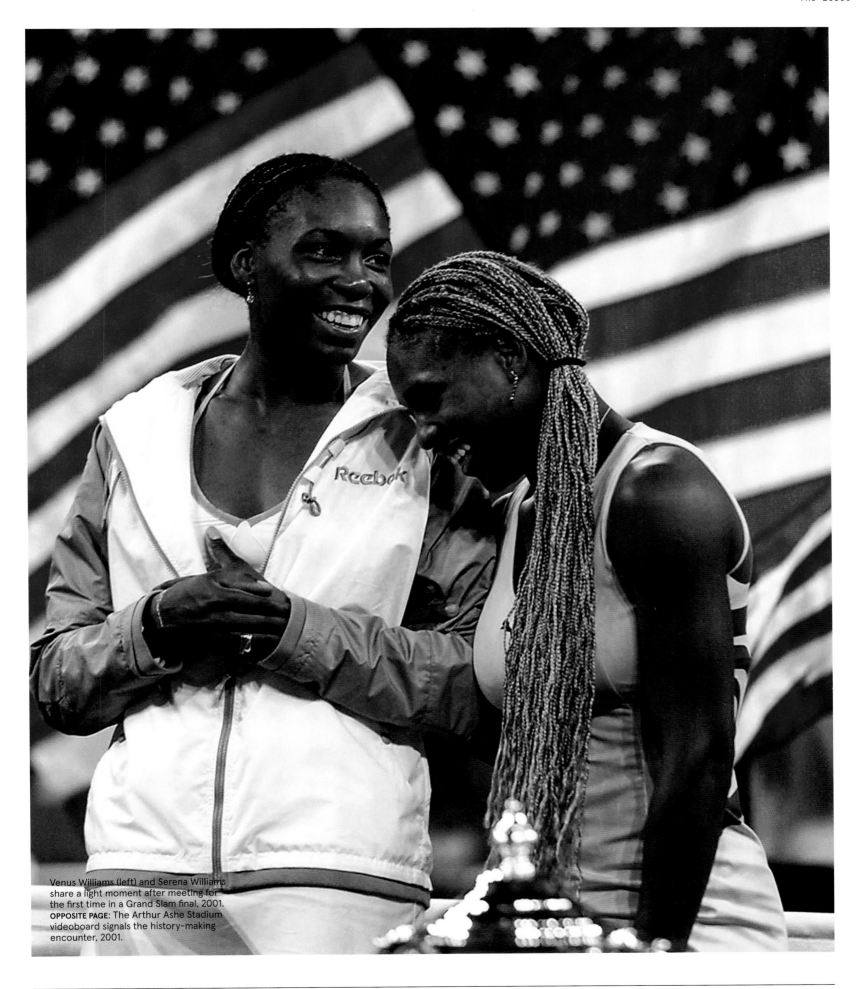

Venus Williams (left) and Serena Williams share a light moment after meeting for the first time in a Grand Slam final, 2001. **OPPOSITE PAGE:** The Arthur Ashe Stadium videoboard signals the history-making encounter, 2001.

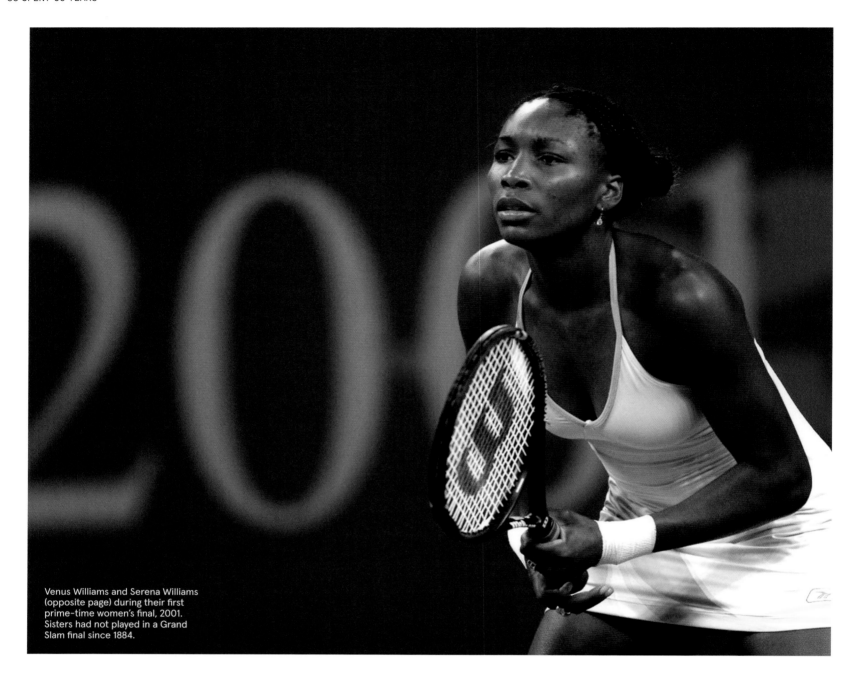

Venus Williams and Serena Williams (opposite page) during their first prime-time women's final, 2001. Sisters had not played in a Grand Slam final since 1884.

Billie Jean King reflected on the incredible impact the Williams family has had on their daughters' tennis.

"They don't have institutional involvement from coaches and other forces, so the family's got to play a key role in providing support in everything," King said. "Venus and Serena have done it their own way. Their family is remarkably grounded. Richard is the guy who jolts them, and while that can seem odd, there's a balance they get from their mother, Oracene. She knows what to ask, what kind of intensity to demand, and how to support them."

Then again, the notion of two world-class athletes coming from the same family is not foreign to King. Her brother, Randy Moffitt,

enjoyed a decade-long major-league baseball career. "Who knows?" mused King, as she waited to toss the ceremonial coin for the final. "If Randy had been a girl, maybe we'd have met in the finals."

What the Williamses have done is extraordinary—and yet, by now, so heavily publicized that it all seems as preordained as the annual introduction of a new line of cars. Yet consider: The last time two sisters met in a Grand Slam singles final was in 1884.

"Sisters are rivals," Serena said. "A lot of people in families fight. Not our family. I guess our fighting is done on the court."

Venus and Serena fight in a vastly different era, an era where the line between sport and

entertainment has been blurred, if not altogether erased. This final was in front of a huge television audience of 22.7 million and a prime-time crowd that filled Arthur Ashe Stadium and included such celebrity attendees as Spike Lee, Diana Ross, Bruce Willis, and Robert Redford.

"People like to watch good entertainment," Serena said. "I wouldn't have missed it either if I knew something so historic was happening."

"I think definitely we're the top story in tennis," added Venus. "It's real exciting because every time I go out there—especially if I'm playing someone like Lindsay [Davenport], Martina [Hingis], Serena,

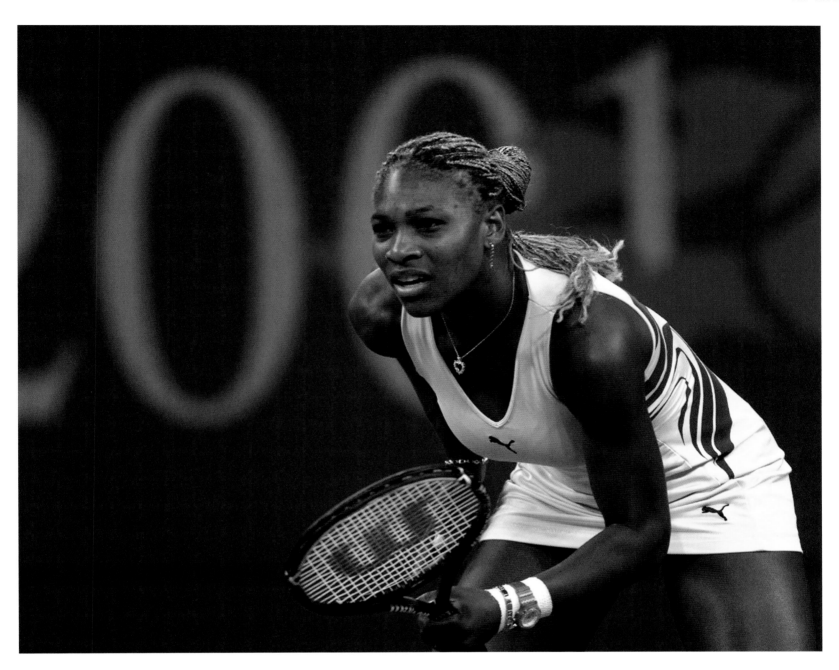

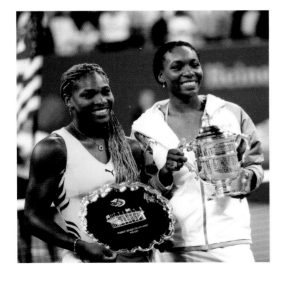

Jennifer [Capriati], Monica [Seles]—I'm going to be in for a battle. That's exciting; good for all of us and for the sport, too."

Peel away the glitter, though, and you'll see that the sisters have taken strides not just as icons but also as players. Venus's successful US Open defense boosted her into company with Martina Navratilova and Steffi Graf as the only women players to win both Wimbledon and the US Open in consecutive years.

"I decided I was going to become a competitor," Venus said during the US Open. "When I was younger, I played tennis because my parents wanted me to. I suppose as I got older and I kind of understood what was going on around me,

that's when I decided I wanted to be a player."

Serena also is trying to improve her game, mostly by taking advantage of the ease with which she can charge forward and the way her great balance and movement make her a sharp volleyer. Both sisters are learning to use their speed for offensive forays rather than defensive scrambling.

Can they fulfill Richard's prediction of becoming the top two players in tennis? Certainly, Venus now rules the world, and if each sister plays more, it might well happen. Still, the 2001 US Open showed just how much these two have raised the bar for the entire sport—both on and off the court. You can't really fake it in sports. ●

AMERICAN IDOLS

THE LONG-RUNNING DRAMA STARRING PETE SAMPRAS AND ANDRE AGASSI FEATURES SOME OF THE BEST THEATER EVER STAGED AT THE US OPEN.

•

THE CELEBRATED RIVALRY between Pete Sampras and Andre Agassi, the two biggest American stars in men's tennis in the 1990s and early 2000s, was played out over thirty-four meetings (nearly half of them in finals) and ended in 2002 precisely where it began in 1990. The two players shared the grand stage of the US Open only four times, yet each occasion proved memorable, providing great theater to a packed house.

"Pete was the one guy Andre knew he could play great against and still lose," said Brad Gilbert, Agassi's longtime coach, "and Pete knew if he wasn't on, he'd lose for sure. When they played, it was the ultimate test. I always thought of it like the battle in *Mad Max Beyond Thunderdome:* Two guys enter, one leaves."

"Their matches were some of the most enjoyable times for me as a coach," said Sampras's coach, Paul Annacone. "I just enjoyed seeing them bang heads for so many years, like everybody else did."

Their first US Open meeting took place in the 1990 final, with Andre Agassi, at age twenty, owning a far more accomplished résumé than the nineteen-year-old Pete Sampras. Agassi had been a US Open semifinalist in 1988 and 1989 and a finalist at the French Open earlier in the summer of 1990. Already an electrifying presence at the US Open, he had reached the 1990 title match by defeating defending champion Boris Becker in the semifinals with a newfound precision and patience. "No question this match is probably gonna do a lot for how people perceive me," Agassi said.

Sampras was changing perceptions at the tournament as well. After ending Ivan Lendl's string of eight successive finals appearances in the quarterfinals and dispatching a rejuvenated John McEnroe in the semifinals, Sampras lifted his game even higher in the final and demolished Agassi with an overwhelming barrage of serves, volleys, and passing shots. Agassi later described his 6–4, 6–3, 6–2 loss to Sampras as "a good old-fashioned street mugging."

With their rivalry deadlocked at 3–3 in Grand Slam matches and 8–8 overall, Agassi and Sampras met for the second time at the US Open in the 1995 final. Agassi, who was the defending champion and No. 1 seed, entered the tournament with a twenty-match winning streak, while Sampras, the No. 2 seed, in July, had become the first American to win three straight Wimbledon titles. Their 1995 Open final turned in the first set, after Agassi missed an overhead to give Sampras a set point. The ensuing point produced a furious, nineteen-stroke rally that ended with Sampras hitting a clean winner to break Agassi and clinch the opening frame.

"One of the best points I've ever played in my life," Sampras said. "Unbelievable."

After gaining the upper hand, Sampras relaxed his grip only in the third set, as he secured a 6–4, 6–3, 4–6, 7–5 victory. Following the match, Agassi said of his match record for the summer, "I'm twenty-six and one. I'd give up all twenty-six to have that one back."

They met for a third time at a US Open final in 2002, in what proved to be the last match of Sampras's career. Like their previous final, Sampras won the first two sets, only to have Agassi mount a stand in the third and come close to forcing a five-setter. But Sampras held on and won, 6–3, 6–4, 5–7, 6–4, breaking a twenty-six-month title drought to win his fifth US Open title and become, at age thirty-one, the event's oldest champion in thirty-two years.

Although Agassi and Sampras met in three US Open finals, their quarterfinal confrontation at the 2001 US Open, played under the lights in Arthur Ashe Stadium in front of 23,033 eager fans, is considered their greatest match. They battled for three hours and thirty-two minutes, playing sparkling, error-free tennis all night, with neither player having his serve broken. The match was decided by four tiebreaks.

In the first-set tiebreak, Agassi came back from being down a triple-set point to claim the set. When the second set also reached 6–6, Sampras again jumped out to the lead in the tiebreak but this time held on, hitting a backhand volley winner to even the match. On they went, to a third-set tiebreak, which Sampras closed out with consecutive aces, and then to yet another tiebreak. The capacity crowd gave the pair a prolonged standing ovation as they prepared to begin the fourth-set tiebreak, which ended with Sampras defeating Agassi, 6–7(9), 7–6(2), 7–6(2), 7–6(5).

"That's as good as it gets," Sampras said afterward, talking about the match.

He could just as easily have been referring to their rivalry. ●

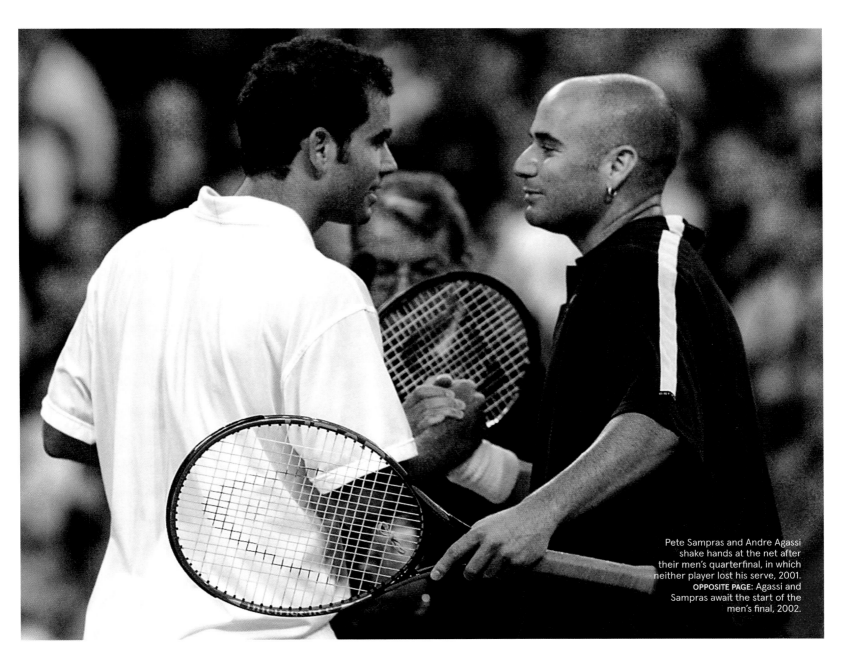

Pete Sampras and Andre Agassi shake hands at the net after their men's quarterfinal, in which neither player lost his serve, 2001. **OPPOSITE PAGE:** Agassi and Sampras await the start of the men's final, 2002.

ANDY RODDICK

—

"I always said if I had to pick
a Grand Slam to win,
it would be the US Open."

**Roddick won the 2003 US Open men's title
three years after winning the US Open boys' championship.**

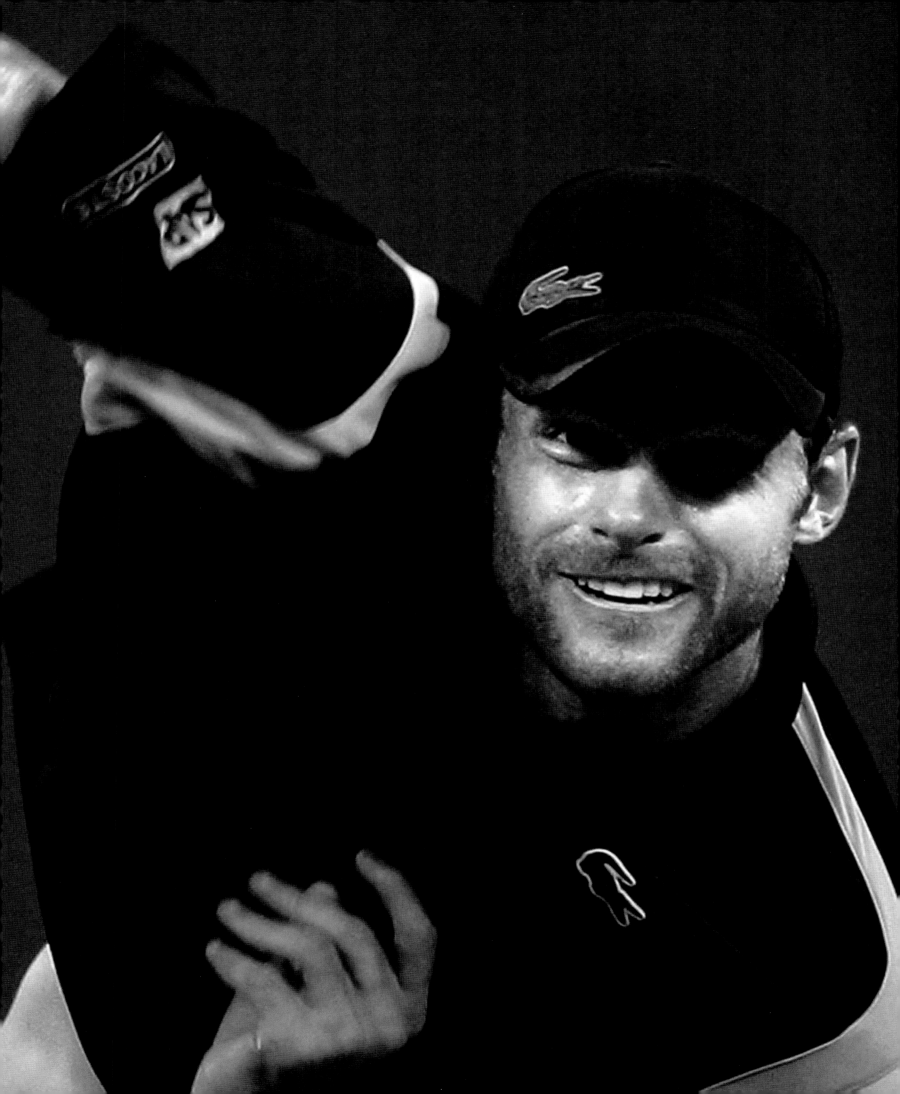

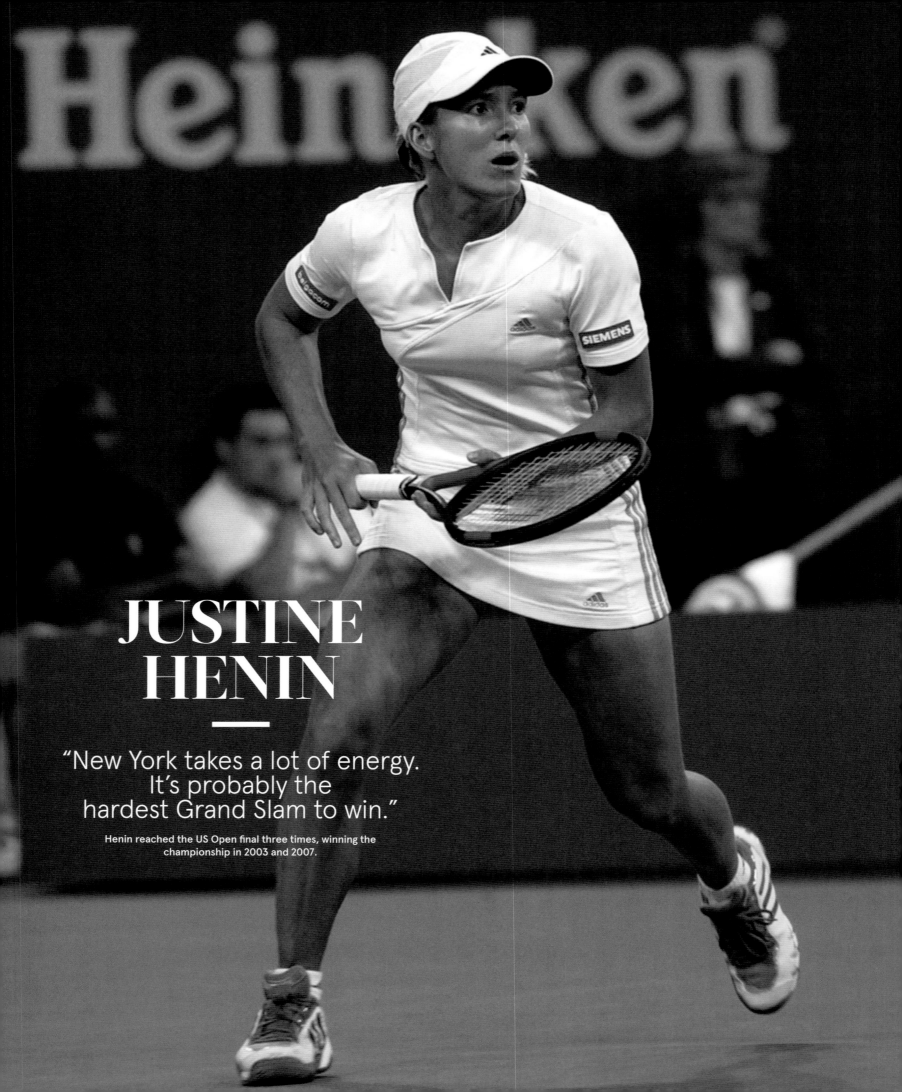

JUSTINE HENIN

—

"New York takes a lot of energy.
It's probably the
hardest Grand Slam to win."

Henin reached the US Open final three times, winning the
championship in 2003 and 2007.

SVETLANA KUZNETSOVA

Kuznetsova defeated countrywoman Elena Dementieva
in an all-Russian final to win the 2004 US Open championship.

TEEN TITANS

The world's top boys and girls compete in the US Open Junior Championships.

THE US OPEN LAUNCHED its junior singles tournaments—for the game's best young players age eighteen and under—in 1973, five years after the start of tennis's Open era. The first boys' singles championship was won by Billy Martin, an American prodigy who also claimed the title the following year to become the only junior to capture consecutive US Open singles crowns (only to have his promising tennis career cut short by injury). The US Open girls' singles championship was first held in 1974 and was captured by Ilana Kloss. The boys' and girls' doubles tournaments kicked off at the 1982 US Open. Kim Clijsters, Gabriela Sabatini, Sloane Stephens, Svetlana Kuznetsova, and Lindsay Davenport are the only US Open girls' doubles champions to win a US Open women's singles title, while no junior boys' doubles champion has claimed a US Open men's singles crown, although Bob Bryan and Mike Bryan, who won the 1996 boys' doubles title, have achieved more success in doubles at the US Open than any other team.

Andy Murray captured the 2004 US Open boys' singles championship at the age of seventeen, defeating future top players Juan Martín del Potro and Sam Querrey on his way to the title.

"I'm really looking forward to playing against the best players in the world," Murray said in a post-match interview after defeating Sergiy Stakhovsky in the final. "I've not really played . . . against Top 100 players. You don't know how good you're going to be until you start beating them."

Eight years later, in the men's singles tournament at the 2012 US Open, Murray beat them all, turning aside a valiant comeback by defending champion Novak Djokovic to take the title match, 7–6(10), 7–5, 2–6, 3–6, 6–2, and become the first British man to win a Grand Slam title since Fred Perry in 1936.

In winning the two US Open crowns, Murray joined Stefan Edberg and Andy Roddick as the only players who have won both a US Open junior title and a US Open men's singles championship. Edberg was first to do so, winning the men's singles title in 1991 and 1992 after securing all four major boys' titles in 1983 to become the only player to achieve a Junior Grand Slam. Andy Roddick made the jump the fastest, winning the boys' single title in 2000 and the men's single championship three years later. Davenport is the only female to win both the girls' singles and women's singles titles, claiming the junior crown in 1992 and the women's championship in 1998.

Jennifer Capriati (1989), Marion Bartoli (2001), and Victoria Azarenka (2005) are US Open junior singles champions who also captured other Grand Slam singles titles, though not the US Open, while Boris Becker (1984), Martina Hingis (1994), Roger Federer (1998), and Kuznetsova (2001) are US Open junior singles finalists who became adult singles champions at the US Open main draw. The 1993 US Open boys' singles champion, Marcelo Ríos, along with fellow US Open junior champions Edberg, Capriati, Davenport, Roddick, Murray, and Azarenka, attained the game's No. 1 ranking, while among today's active players, US Open junior champions CoCo Vandeweghe (2008), Grigor Dimitrov (2008), and Jack Sock (2010) have risen into the world's Top 10.

Be it singles or doubles, the US Open Junior Championships continue to serve as a major proving ground for the game's next generation of players as they seek to collect junior tennis's ultimate prize—a Grand Slam title.

"I wanted to win a junior Slam so bad," said Taylor Fritz, who capped off his junior career at the 2015 US Open by winning the boys' singles championship. "I can't believe I actually got the perfect ending." ●

Clockwise from top right: Boys' singles champions—Andy Murray, 2004; Andy Roddick, 2000; Stefan Edberg, 1983. Girls' singles champions—Victoria Azarenka, 2005; Lindsay Davenport, 1992; Jennifer Capriati, 1989.

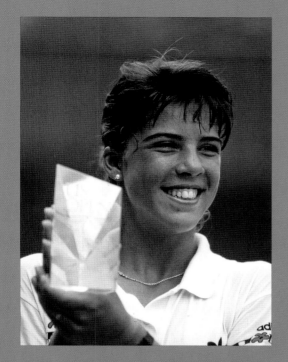

205

ROGER FEDERER

By L. Jon Wertheim

Roger Federer, 2013.
He has won more matches
in Arthur Ashe Stadium
than any other man.

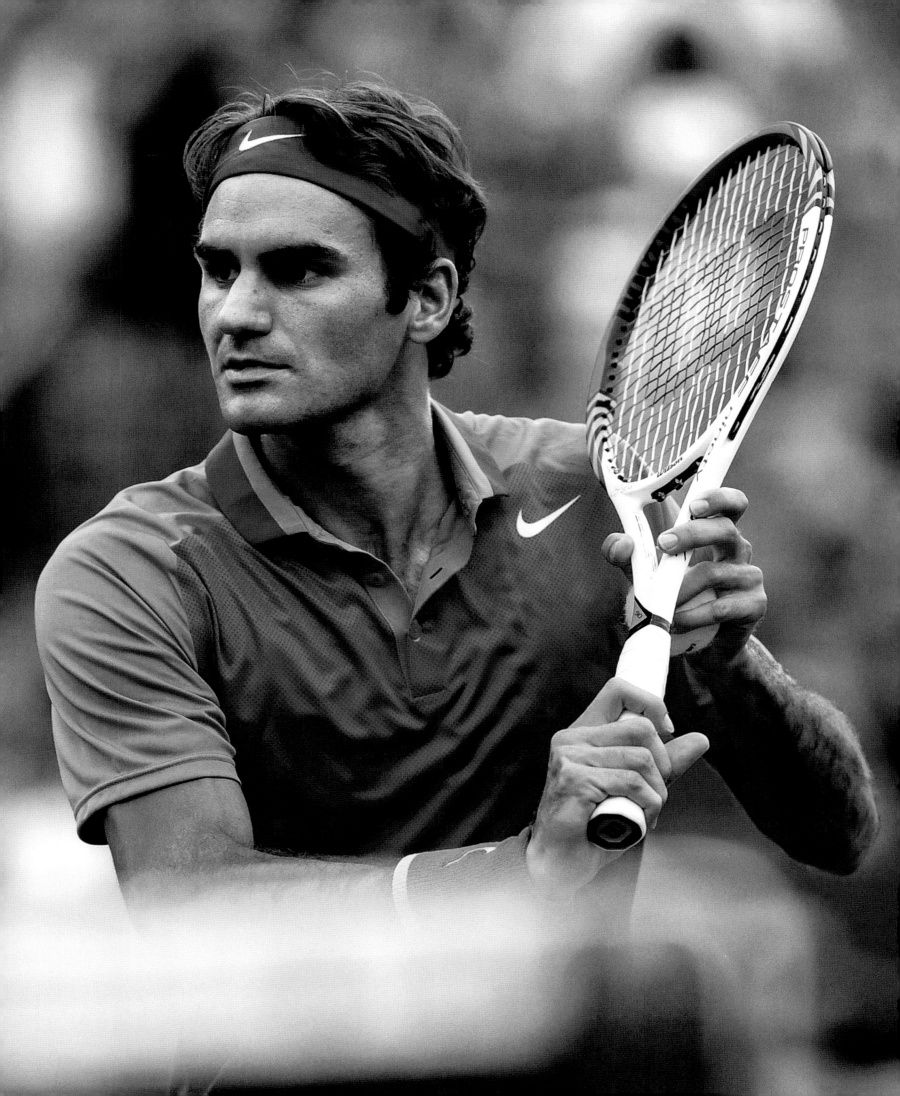

At a remarkably early point in his unparalleled career, Roger Federer became the encapsulation of grace. Quickly, the descriptions of Federer's game started to draw comparisons from art and light: It's poetry, ballet, a Renaissance painting, a symphony. He's an artist, a calligrapher, a maestro, a virtuoso skillfully playing a stringed instrument. He's luminescent, phosphorescent, incandescent.

This all came with good reason. Inevitably, there are those spasms in a Federer match when he elevates the sport of tennis with a bit of extravagant shot-making. That curling, angled one-handed backhand flick. That hissing forehand on the dead run. Oil-painting volleys that rate high on a degree-of-difficulty scale but are executed with so much flair and confidence as to look effortless. "Federer Moments," the late David Foster Wallace called them in his essay "Roger Federer as Religious Experience."

Yet, all these instances of grace have the effect of shortchanging another one-syllable *gr-* word that is just as responsible for Federer's success: *grit*. The tennis salon, quite reasonably, fixes its collective gaze on the bells and whistles of Federer's talent; but this diverts attention from Federer's persistence, his attention to detail, his dedication to the craft of maneuvering a tennis ball.

Even in the latter stages of his career, Federer will, without fanfare, go down to the basement and tinker with his game, adding new elements and fine-tuning old ones. He'll reassess his equipment, say, switching to a larger racquet head in his thirties. He'll displace himself from his comfort zone and commit to changes in strategy—for instance, taking more violent cuts on his backhand. He'll—as gracefully as possible—make

personnel changes to his staff. Multiple times during the year, Federer heads to Dubai for training blocks. There, in striking anonymity and in striking heat, he goes through elaborate stretching and flexibility routines, the legacy of which is a striking lack of injuries.

Federer's mental state during competition also epitomizes grit; without histrionics or drama, he pushes through the inevitable lapses and substandard days at the office. During individual points, he is willing to prolong rallies and hit as many balls as necessary to prevail, aesthetics be damned.

Above all, it's grit that has enabled Federer's career to continue, doggedly, ruling the roost deep into his thirties. At an age when

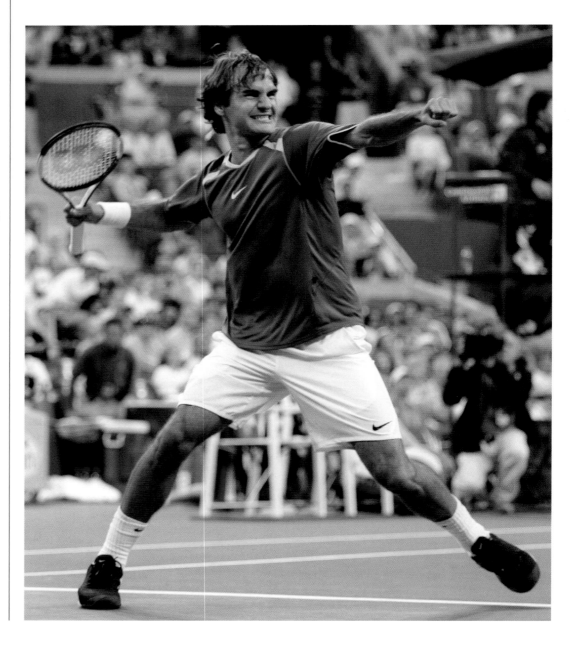

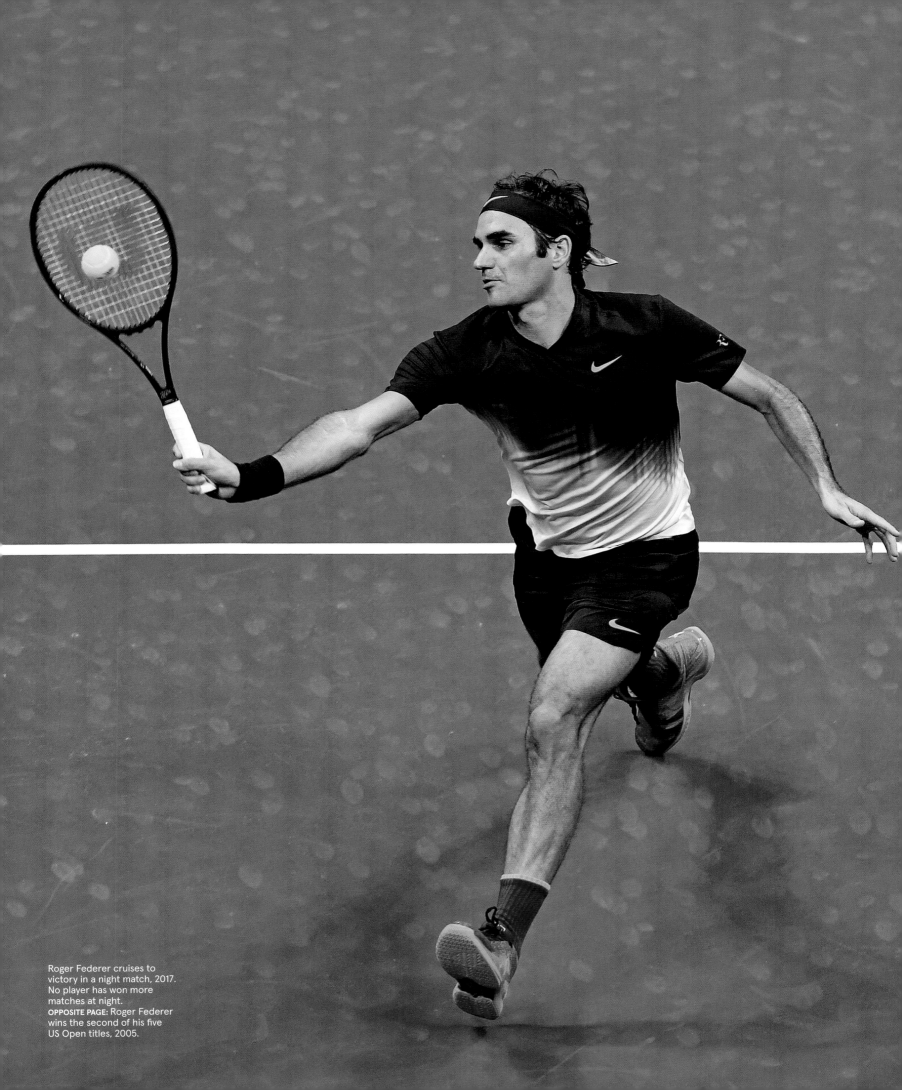

Roger Federer cruises to victory in a night match, 2017. No player has won more matches at night.
OPPOSITE PAGE: Roger Federer wins the second of his five US Open titles, 2005.

Roger Federer plays in his sixth
consecutive men's final, 2009.

Federer—a husband and father of four—would be eligible for the Champions Tour, he's still winning majors. He started off 2018 by winning number twenty. By the time you read this, it may well be more.

At the 1999 US Open—two weeks before Andre Agassi won the men's title and Serena Williams won the women's—Federer entered the qualifying draw. An eighteen-year-old, long on talent (and hair) and short on temper, Federer lost in straight sets and returned to Switzerland. Though it was a non-event at the time, the match would mark a hinge point in tennis history.

From that point on, Federer's talent was cleaved open. After that US Open, Federer would appear in the main draw of every major for the next fifteen years. He would start arrowing up the rankings. And, of course, he would start winning, ritually and relentlessly. Federer would win on grass and clay and surfaces in between. He would win in different hemispheres and different time zones. He would win tight, hard-fought battles. He would win other matches where the outcome was never in doubt, but the suspense resided in how his genius would express itself.

He officially broke through at Wimbledon in 2003, and for the next five years, he would win twelve of the twenty majors he played. At the US Open, he won for the first time in 2004. He wouldn't lose again in New York until 2009, a record forty-match win streak. Want to know from grit? In 2017, closer to age forty than to thirty, Federer won two of the four majors, a fifth Australian Open, and a record eighth Wimbledon.

The longevity of Federer's career has been a great bonus to tennis fans. It's rare that we ever get two full decades to admire an athlete's handiwork. That's a lot of "Federer Moments." But this longevity brings professionalism and work ethic into sharper focus as well. Native gifts are one thing; alchemizing those native gifts into results is quite something else. As Federer himself put it: "Yes, I was blessed with a lot of talent. But I also had to work for it. Talent only gets you that far really."

Right on. It's a gentle reminder that, yes, Roger Federer plays tennis—note the present tense—better than anyone ever to have gripped a racquet. But too often we forget this: Roger Federer *works* tennis at an extraordinary level as well. ●

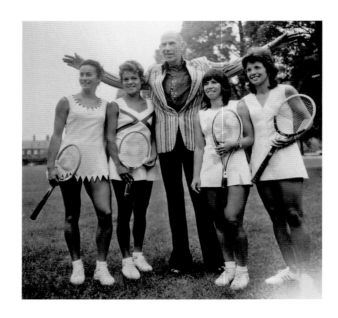

STYLE POINTS

TURNING COURTS INTO CATWALKS,
THE US OPEN HAS LONG BEEN A POPULAR SCENE FOR
MAKING FASHION STATEMENTS.

•

"I HAVE ALWAYS LOVED the heritage of the sport of tennis," said Ralph Lauren. "Since 2005, it has been such an honor to partner with the USTA in creating a new tradition of style for the US Open, one of the most celebrated sporting events around the world. To be part of this ultimate sports environment further defines the kind of authenticity that has inspired our design process for fifty years."

It was also fifty years ago, as the Open era began, that the players' clothing underwent what couturier Ted Tinling called "major adjustments."

A pioneering figure in the world of tennis fashion since 1949, when he famously designed ruffled undershorts for American tennis star Gussie Moran to wear under a short dress, Tinling helped to boost the sport's image in the 1960s and 1970s by dressing a number of its leading women—including Billie Jean King, Margaret Court, Evonne Goolagong, and Virginia Wade—in alluring designs and mod outfits of tennis whites highlighted by different textural elements.

"If a woman feels that she is prettier or better dressed than her opponent, nothing can stop her," Tinling maintained.

The traditional attire of tennis whites remained the standard outfit at the US Open during its first four years. But in 1972, the tournament took a colorful turn as Tournament Director Bill Talbert, breaking from the other Grand Slam events, decreed that players were no longer required to wear tennis whites.

"I was among a group that broke the color-clothing barrier," said Arthur Ashe, who began sporting the pastel colors that came into vogue at the 1972 US Open.

Colorful tennis wear and stylish-looking outfits have become synonymous with the US Open ever since. From men wearing terrycloth headbands, stonewashed denim shorts, fluorescent spandex, and pirate pants; to women attired in lace dresses, pleated skirts, trend-setting colors, and cutting-edge designs, including, most memorably, a black bodysuit; to tournament officials and ball persons outfitted to the nines by Polo Ralph Lauren, the US Open has reinforced the unique role of fashion and style in the sport of tennis. •

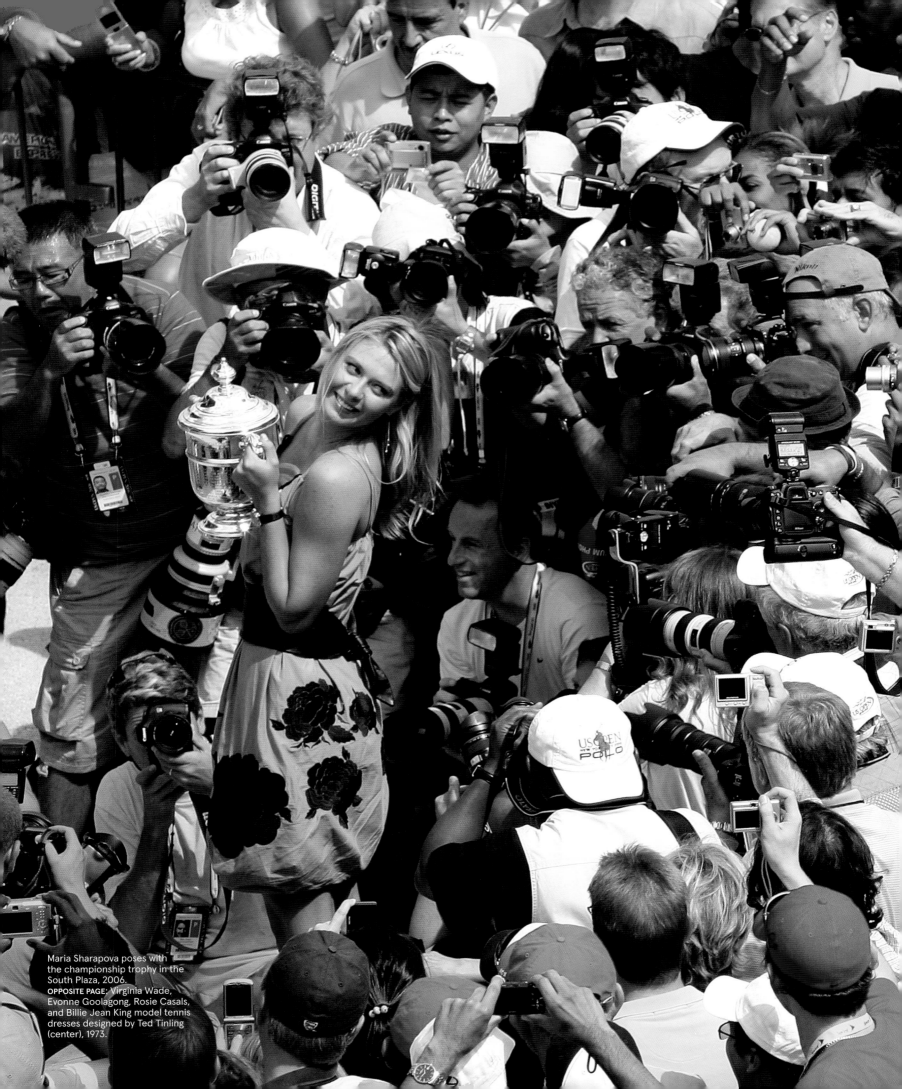

Maria Sharapova poses with the championship trophy in the South Plaza, 2006.
OPPOSITE PAGE: Virginia Wade, Evonne Goolagong, Rosie Casals, and Billie Jean King model tennis dresses designed by Ted Tinling (center), 1973.

KIM CLIJSTERS

By Louisa Thomas

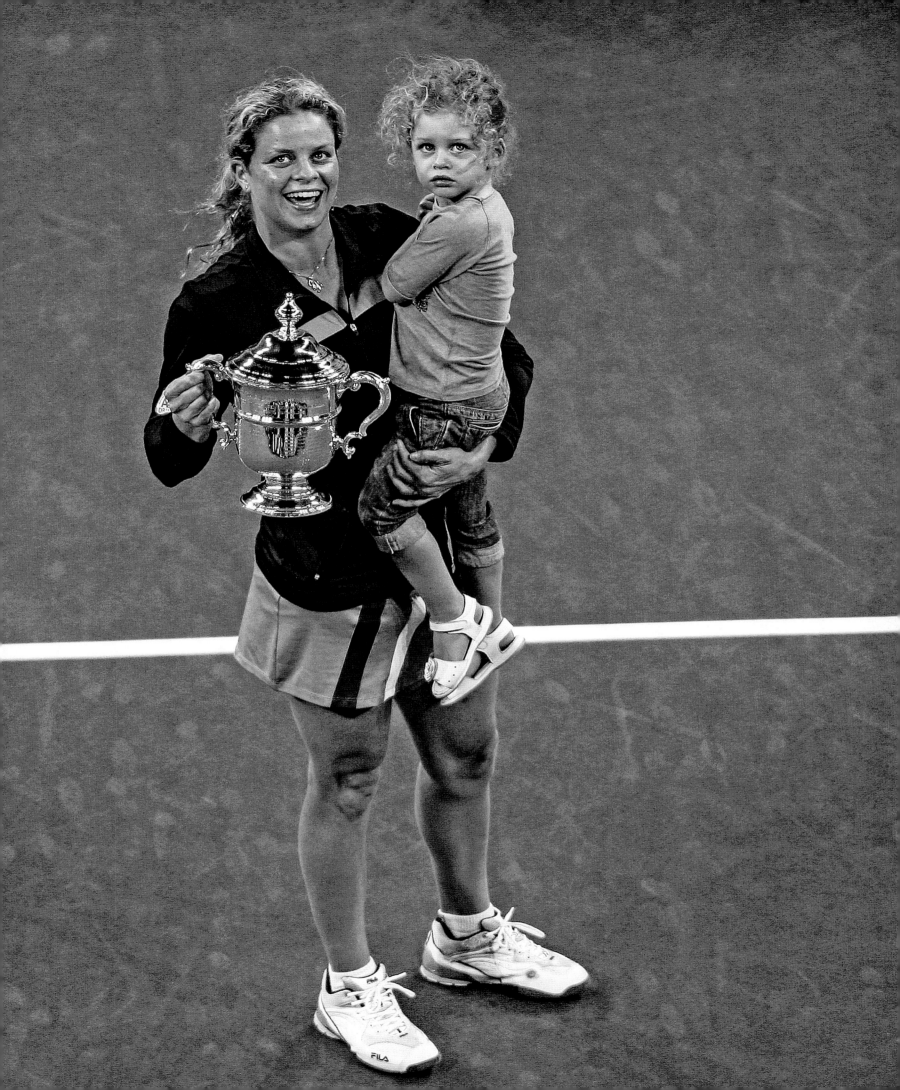

Kim Clijsters was too kind, the critics said. They talked about her good nature as if it were a weak backhand. Never mind that she had been ranked No. 1 in the world. For proof of their theory, they pointed to her record: four Grand Slam finals, four smiles, four losses. They shook their heads. She seemed too nice to win.

No one doubted that Clijsters had the skills to be a champion. She had powerful, consistent ground strokes, with a solid two-handed backhand and a forehand she could whip for a winner from any spot on the court. She was agile and quick, able to hit strong shots even as she slid into splits—on any surface. She was also adept at the net, the rare top player who was also a No. 1 doubles player in the world. The problem, it was said, was in her head, or perhaps her heart. Some were even crueler during those earlier years, calling her a choker.

In truth, it must have been hard to smile sometimes. There was a painful public break-up with Lleyton Hewitt; there were devastating injuries. After surgery on her left wrist, she missed the 2004 US Open and wondered if she would ever play again. It kept her off the tour for eight months. When she came back in 2005, she was strong and fit and happy again— but announced that she would be retiring after the 2007 season to focus on having a family.

At the US Open in 2005, she proved that it was possible to be a good person and a good player, to play nice and to win. She thrashed Mary Pierce in the final, 6–3, 6–1, to win her first major. It was a dominant performance, showcasing Clijsters's flexibility, strength, and speed. Still, she said afterward that the victory would not change her decision to walk away from the game while she was still in her prime. "At the end of the day, when you go home, the trophies are not talking to you," she said after the match. "They're not going to love you. I want the people I love with me."

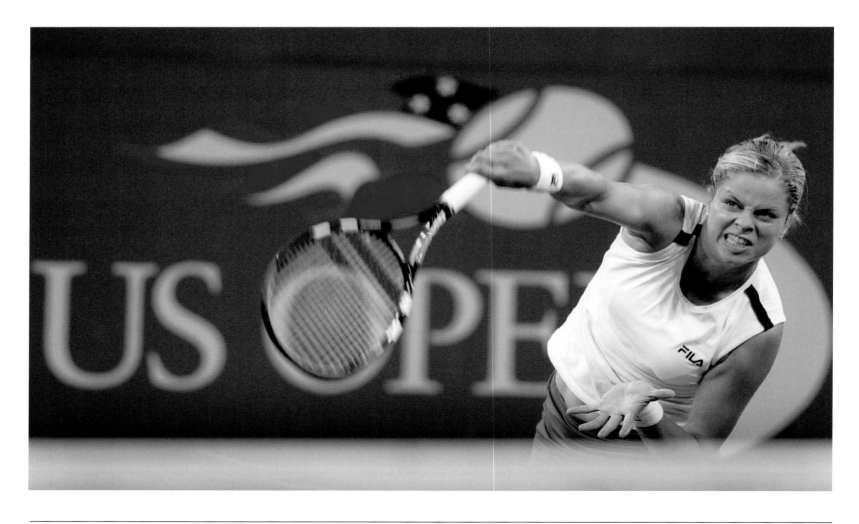

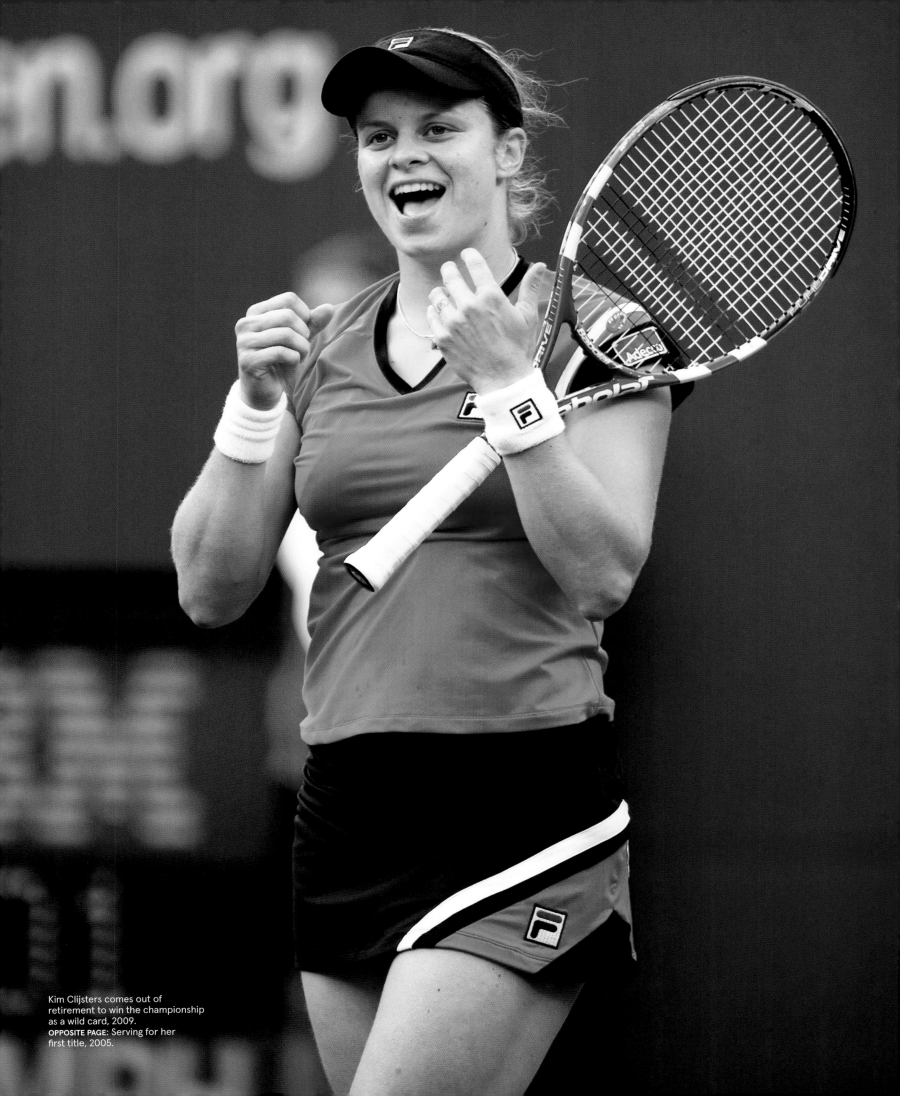

Kim Clijsters comes out of retirement to win the championship as a wild card, 2009.
OPPOSITE PAGE: Serving for her first title, 2005.

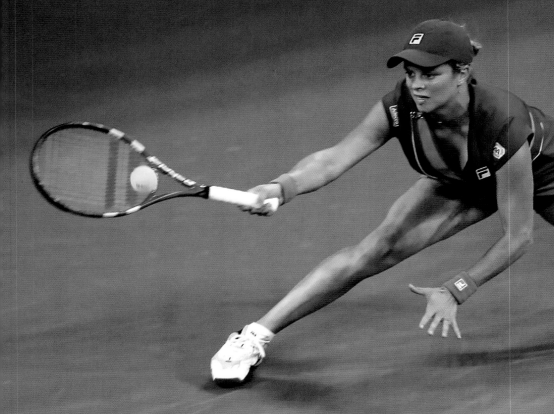

POLO

Kim Clijsters wins her second
consecutive title, 2010.

"I always felt like it just clicked for me whenever I played here."

— KIM CLIJSTERS —

She did not have a chance to defend her title the following year, after another wrist injury, and in May 2007, she retired. She married, had a baby, and seemed to move on with her life.

If that had been all, it would have been a career to be proud of. But two years after retiring, one year after the birth of her daughter, she returned to the tour. Tennis made her happy. Why not see what else she could do?

She played two tournaments before entering the 2009 US Open as a wild card. Her chances of winning were slim, to say the least. No wild card had ever won the US Open. No mother had won a Grand Slam title since Evonne Goolagong won Wimbledon nearly thirty years before. When Clijsters faced world No. 3 Venus Williams in the fourth round, she had played only ten competitive matches.

She beat Venus, 6–0, 0–6, 6–4, then defeated Li Na, and then faced Serena Williams in the quarterfinals. She won that match in straight sets, becoming the only player ever to have beaten both Williams sisters in the same tournament twice. In the final, she faced future No. 1 Caroline Wozniacki. Clijsters beat her, 7–5, 6–3, for her second US Open title. Her tiny daughter, Jada, came onto the court during the trophy presentation to celebrate.

As remarkable as that victory was, even more impressive was what came next. In 2010, Clijsters ran deep in tournament after tournament, steadily raising her ranking. Unranked the year before, she came into the US Open as the No. 2 seed. Clijsters made the quarterfinals without dropping a set, then came back from a breakdown in the third to defeat Samantha Stosur to reach the semis, where she faced Venus Williams. Clijsters came back from a set down to defeat Williams in a close-fought match, 4–6, 7–6, 6–4, and went on to beat Vera Zvonareva in the final. Clijsters crushed her, 6–2, 6–1, to defend her US Open title.

Clijsters would play for two more years, retiring—this time for good—after the 2012 US Open. She finished with four major titles, three of them won in Flushing. In 2017, Clijsters was inducted into the International Tennis Hall of Fame. She is remembered not only for her excellence on the court and for her stirring comeback, but for—yes—her kindness. Rarely has a player been so beloved by fans and competitors alike. She was right when she said that the trophies would not love her. But on and off the court, she found many people who did. ●

MARIA SHARAPOVA

—

Sharapova won the 2006 US Open title on her way
to becoming only the tenth woman in history to win
all four majors for a career Grand Slam.

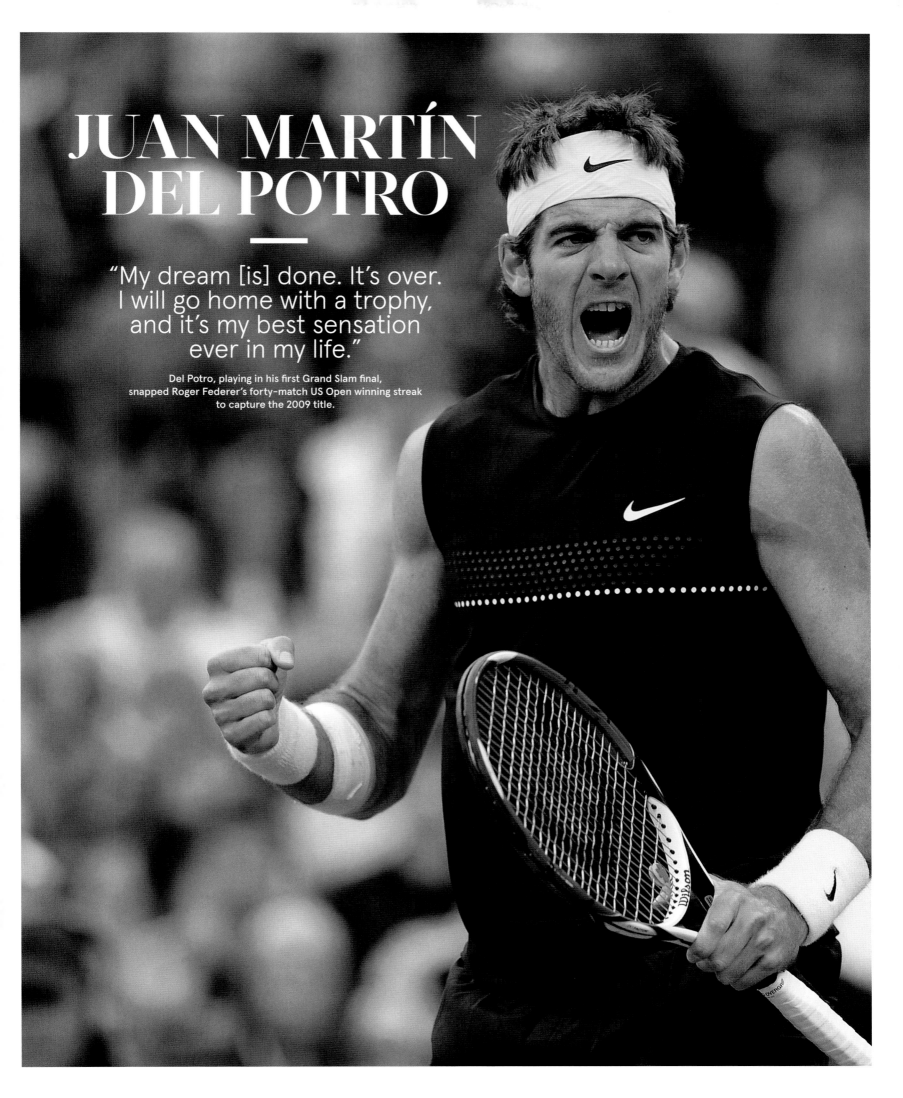

JUAN MARTÍN DEL POTRO

—

"My dream [is] done. It's over.
I will go home with a trophy,
and it's my best sensation
ever in my life."

Del Potro, playing in his first Grand Slam final,
snapped Roger Federer's forty-match US Open winning streak
to capture the 2009 title.

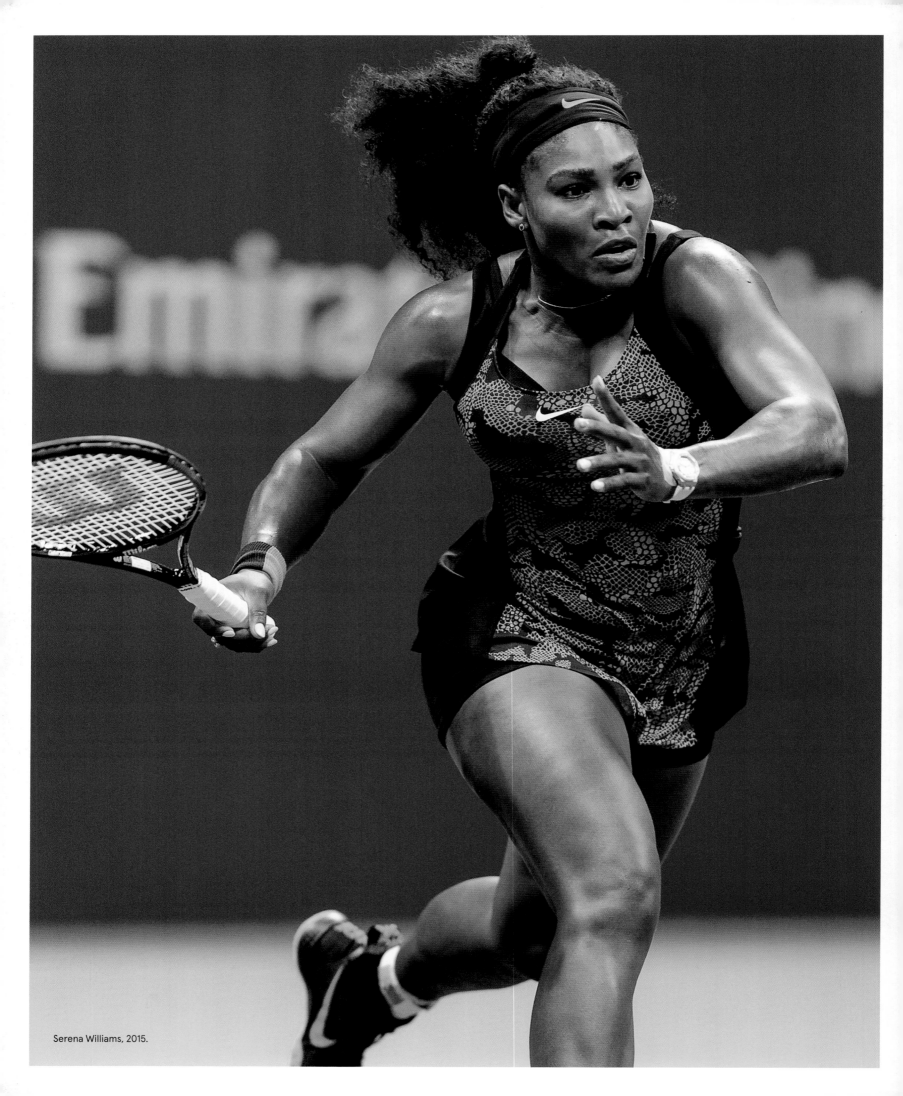

Serena Williams, 2015.

20

THE

10s

As the USTA Billie Jean King National Tennis Center completes a major transformation on the 50th anniversary of the Open era, the US Open remains an unparalleled celebration of the game and its greatness, featuring the world's finest tennis players competing for the sport's grandest prizes.

2010

Bob Bryan becomes the first man in twenty-eight years to sweep the doubles titles as he teams with his brother, Mike, to win men's doubles and with Liezel Huber to win mixed doubles. / Rain pushes the men's singles final back to Monday for an unprecedented third year in a row. / Kim Clijsters defeats Vera Zvonareva in the women's final, 6–2, 6–1, for her second consecutive title. / Rafael Nadal defeats Novak Djokovic in the men's final, 6–4, 5–7, 6–4, 6–2, to become the first man to complete the career Grand Slam with a US men's singles title since Rod Laver in 1962.

2011

An earthquake strikes during the qualifying tournament, a hurricane sweeps through New York City the day before the start of the tournament, and two days of rain wipe out four sessions in the second week. / Court 17, the US Open's fourth-largest show court, debuts. / Maria Kirilenko wins the longest women's tiebreak in US Open history, 17–15, against Samantha Stosur. / The top four men's seeds advance to the semifinals for the first time since 1992. / Novak Djokovic fights off double match point on Roger Federer's serve and wins their semifinal. / Stosur defeats Serena Williams in the women's final, 6–2, 6–3. / Djokovic defeats Rafael Nadal in the men's final, 6–2, 6–4, 6–7(3), 6–1.

2012

A tournament-record ten men rebound from two sets down to win. / Philipp Kohlschreiber defeats John Isner in a match that ties the men's record for the latest finish at 2:26 a.m. / Rain forces the women's final to Sunday for the fourth time in five years and the men's final to Monday for the fifth straight year. / Serena Williams defeats Victoria

US Open tournament theme art, 2018.

fifth US Open men's doubles crown. / Serena Williams defeats Caroline Wozniacki in the women's final, 6–3, 6–3, for her record-tying sixth title. / Marin Čilić defeats Kei Nishikori in the men's final, 6–3, 6–3, 6–3.

2015
Madison Keys defeats Alison Riske in a match that sets the women's record for the latest finish at 1:48 a.m. / Serena Williams sets the women's record for most aces in a match with eighteen. / The Grandstand hosts its last scheduled US Open match. / Williams's bid to become the first woman to complete the Grand Slam in twenty-seven years is stopped by Roberta Vinci in the semifinals. / Flavia Pennetta defeats Vinci in the women's final, 7–6(4), 6–2. / Novak Djokovic defeats Roger Federer in the men's final, 6–5, 5–7, 6–4, 6–4.

2016
The US Open unveils a series of physical improvements and upgrades, including a retractable roof over Arthur Ashe Stadium and a new Grandstand. / Rafael Nadal hits the first match ball under a closed roof in Arthur Ashe Stadium. / Ivo Karlović sets the men's record for most aces in a match with sixty-one. / Serena Williams ties her women's record for most aces in a match with eighteen. / Angelique Kerber defeats Karolina Plíšková in the women's final, 6–3, 4–6, 6–4. / Stan Wawrinka defeats Novak Djokovic in the men's final, 6–7(1), 6–4, 7–5, 6–3. / Construction begins on a new Louis Armstrong Stadium.

2017
Total player compensation tops $50 million for the first time. / Angelique Kerber becomes the second defending US Open women's champion to lose in the first round. / Shelby Rogers defeats Daria Gavrilova in three hours and thirty-three minutes, the longest US Open women's match. / Four American women—Madison Keys, Sloane Stephens, CoCo Vandeweghe, and Venus Williams—reach the semifinals for the first time since 1981. / Stephens defeats Keys in the women's final, 6–3, 6–0, and becomes the second unseeded woman to win the title. / Rafael Nadal defeats Kevin Anderson in the men's final, 6–3, 6–3, 6–4.

2018
The new Louis Armstrong Stadium makes its debut, completing the five-year strategic transformation of the USTA Billie Jean King National Tennis Center. / Equipped with a retractable roof, the new Louis Armstrong Stadium joins Arthur Ashe Stadium in holding dedicated day and night sessions. / The US Open celebrates its fiftieth anniversary.

Azarenka in the women's final, 6–2, 2–6, 7–5. / Andy Murray defeats Novak Djokovic in the men's final, 7–6(10), 7–5, 2–6, 3–6, 6–2, in four hours and fifty-four minutes, tying the record for the longest final and making Murray the first man to win the Olympic gold medal and the US Open title in the same year.

2013
Plans for a major transformation of the US Open grounds are unveiled. / Three of the four women's semifinalists are age thirty or older, while none of the four men's semifinalists is younger than twenty-six. / Serena

Williams defeats Victoria Azarenka in the women's final, 7–5, 6–7(6), 6–1, and becomes, at thirty-two, the oldest champion in the Open era. / Rafael Nadal defeats Novak Djokovic in the men's final, 6–2, 3–6, 6–4, 6–1.

2014
The West Stadium Courts and Practice Gallery open. / Kei Nishikori defeats Milos Raonic in a match that ties the men's record for the latest finish at 2:26 a.m. / For the first time, only one of the top eight seeds advances to the women's quarterfinals. / Bob Bryan and Mike Bryan win their record

RAFAEL NADAL

By John Feinstein

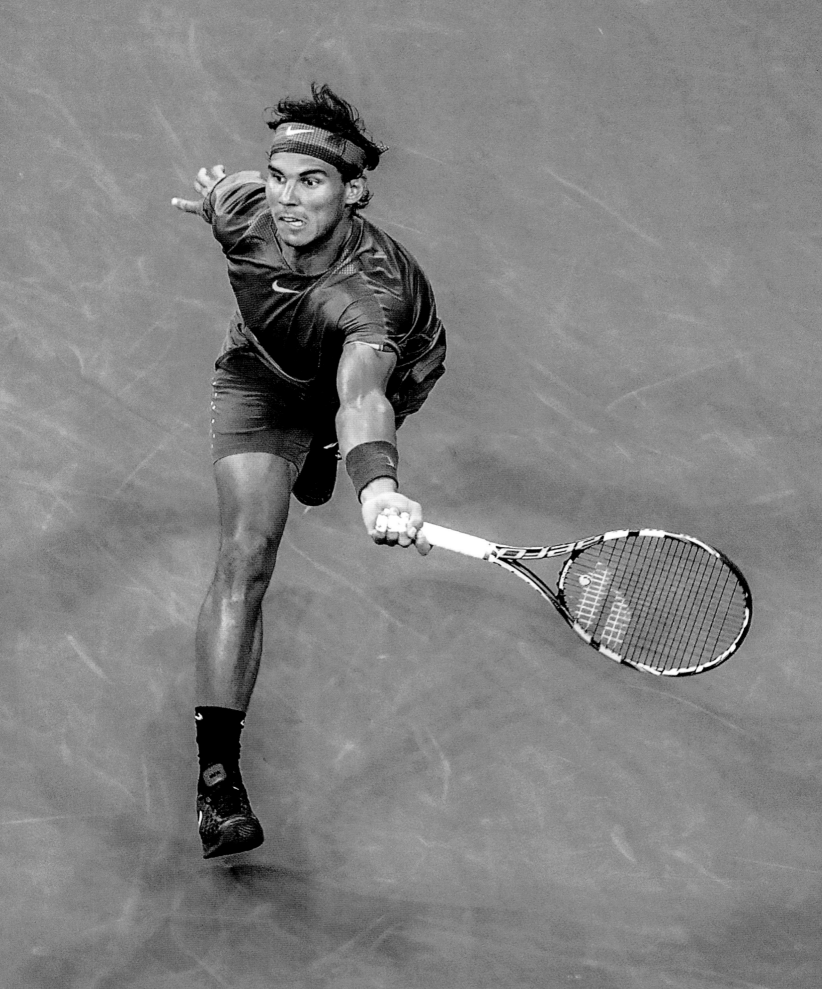

One of the reasons why Rafael Nadal's remarkable rivalry with Roger Federer has been such a joy to watch for so many years is that the two men have such entirely different playing styles.

Federer seems to flow around the court, making almost everything look effortless. Nadal is completely the opposite—you can almost feel the strain he puts into every stroke, especially as he pounds away from the baseline, grinding opponents into dust. It's proven especially effective on the red clay of Stade Roland–Garros—where Nadal has dominated the French Open.

That said, the argument can be made that it is in New York—specifically in Queens—that a blue-collar work ethic is most admired and revered. And that's why the US Open was both the ultimate challenge and the ultimate achievement for the Spaniard, who has taken his championship mettle to its highest level in Flushing Meadows.

Nadal is the classic European clay courter. Most often, he treats the net as if it is radioactive and loves nothing more than a four- or five-hour slugfest; the kind of match that leaves everyone—opponents and spectators alike—exhausted.

But the greatest champions are those who can step out of their element and win there, too. As great as Pete Sampras, John McEnroe, Jimmy Connors, Boris Becker, and Stefan Edberg were, they could never master the red clay in Paris. Ivan Lendl passed on a chance to win another French Open in 1990 to put body and soul into trying to win Wimbledon just once before he retired—and he couldn't do it.

Nadal won his first French Open in 2005, days after turning nineteen. That same year, he played his third US Open and lost in the third round. It wasn't until the next year that he even reached the quarterfinals in Flushing.

But Nadal knew that no matter how many times he might win in Paris, if he was going to be considered as more than a great clay courter, he had to adapt his game to win in London and Melbourne and New York.

Surprisingly, he figured out Wimbledon first, helped by his left-handed serve, which was a weapon on grass. His classic five-set win in the 2008 final over Federer not only helped him reach the No. 1 ranking but also removed his "clay-courter" label for good.

Seven months later, he won the 2009 Australian Open. That left only New York.

Nadal had reached the semifinals at the Open in both 2008 and 2009. There were some who believed that New York just didn't fit him: the raucous crowds, the unavoidable traffic, the relatively fast hard courts. At that point, his record at the Open was 21–7—not awful by any stretch, but nowhere close to his record at the other three majors, especially Paris, where he was 31–1 at that point in his career.

Nadal had been the top seed at the Open in 2008 after his victories that year at Stade Roland-Garros and the All England Club, only to lose in the semifinals to Andy Murray. A year later, he again reached the semis and was stunned by Juan Martín del Potro—who went on to beat Federer in the final.

Nadal was top-seeded again in 2010 but still the subject of much doubt. The US Open represented his second attempt to finish off the career Grand Slam. He had won eight major titles at that point—five in Paris, two in London, one in Melbourne—and now, at long last, he would reach the final in New York. He had expected to meet his chief rival, Federer, there, but an up-and-coming Novak Djokovic shocked the Swiss in a five-set semifinal and was waiting for Nadal in the final.

Both players had to wait out rain delays that pushed the match into Monday evening. It was a tough, hard-fought match between two talented sluggers—exactly the sort of thing Nadal's clay-court experience had made him so perfectly cut out for. Once the Spaniard got his nose in front in the third set, he wasn't going to be denied, grinding out the 6–4, 5–7, 6–4, 6–2 triumph to complete the career Grand Slam.

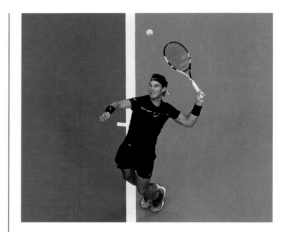

After proving to himself and to the world that he could indeed be king in Queens, Nadal has since added two more Open titles to his résumé, his most recent at the 2017 US Open, where he completed a remarkable comeback from the injuries that slowed him for much of the previous year. Once again, with his trademark blue-collar work ethic, Nadal fought his way into the final, where he easily beat South African Kevin Anderson in straight sets for his sixteenth major title and the game's No. 1 ranking.

At age thirty-one, Nadal had become a three-time US Open champ—just the sixth man in the Open era to score the New York hat trick, joining the likes of Federer, Pete Sampras, Jimmy Connors, Ivan Lendl, and John McEnroe.

There's no doubt his body has taken a pounding through the years because of his playing style, but Nadal's talent is matched only by his toughness, and his tenacity and drive have been key factors in his battling back from every injury he's faced. He's been slowed at times, but he's never been stopped. His three US Open titles are testament to his resolve and resilience, as well as his belief that—on any surface—when he's on his game, no one is better.

Many wrote off Nadal's chances of ever winning the Open; many were wrong. Toughness and the willingness to work hard are good attributes to have in most places—but they tend to play especially well in New York. ●

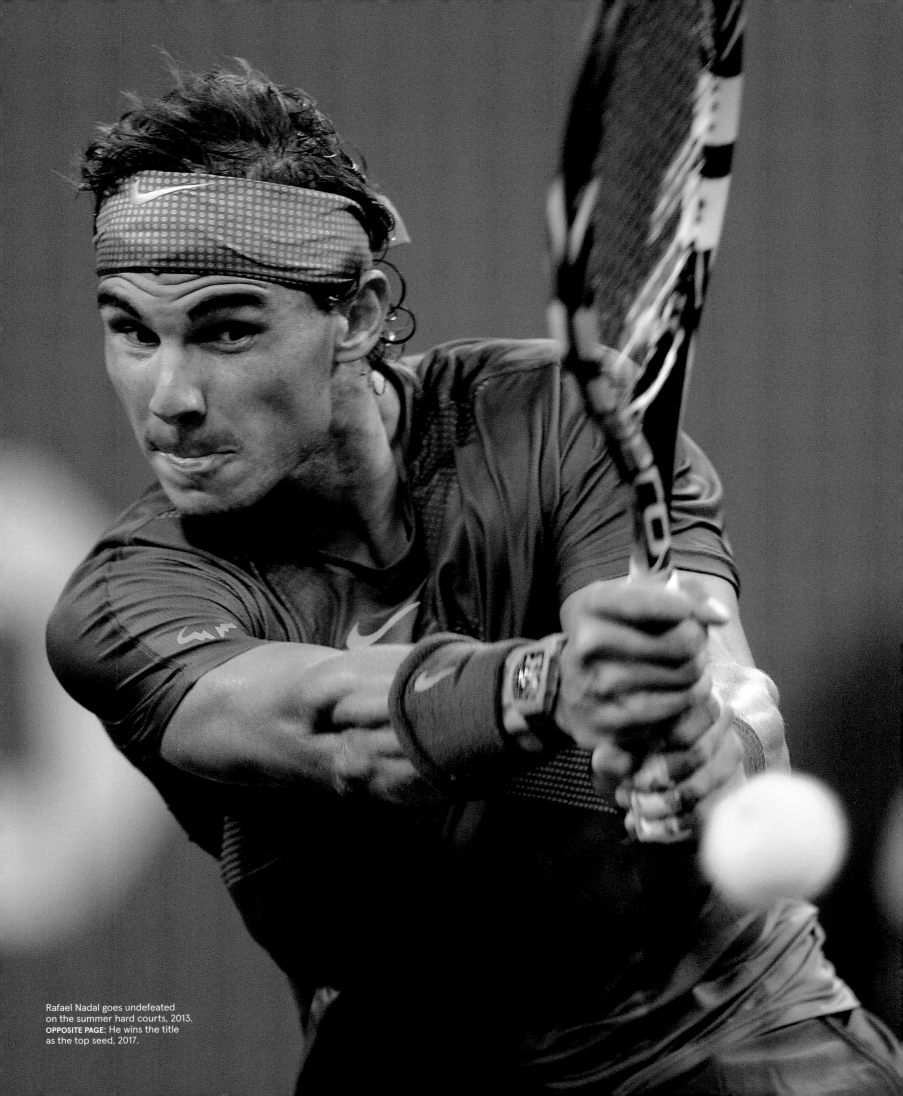

Rafael Nadal goes undefeated
on the summer hard courts, 2013.
OPPOSITE PAGE: He wins the title
as the top seed, 2017.

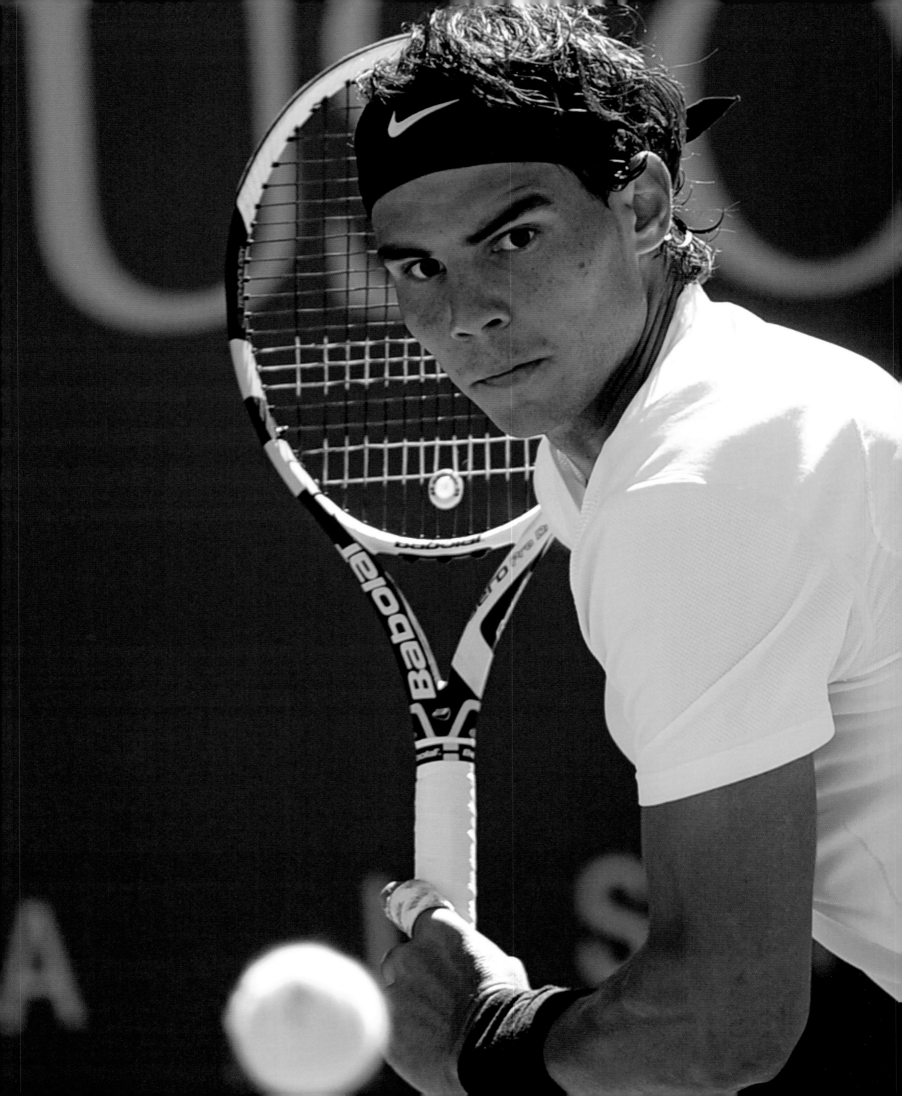

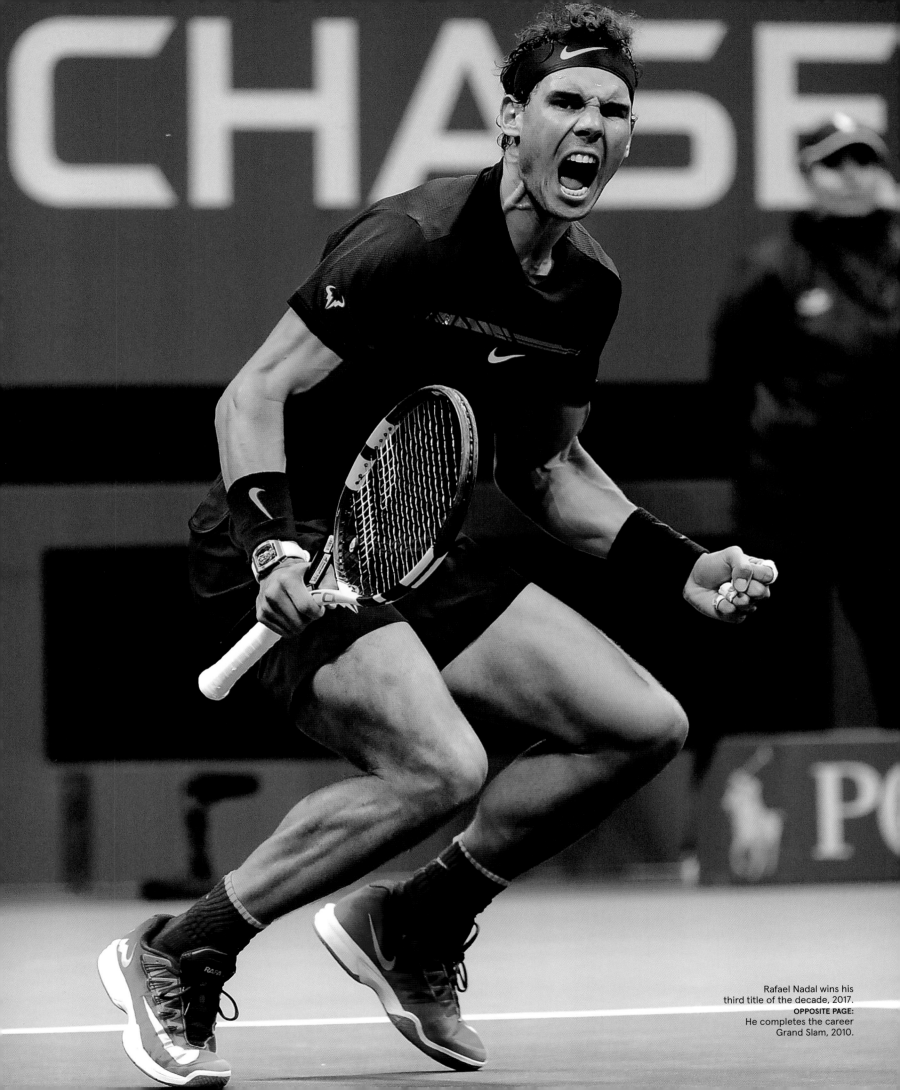

Rafael Nadal wins his
third title of the decade, 2017.
OPPOSITE PAGE:
He completes the career
Grand Slam, 2010.

SAMANTHA
STOSUR
—

Stosur, a world No. 1 in doubles with five Grand Slam doubles championships, won her first and only major singles title at the 2011 US Open.

NOVAK DJOKOVIC

—

"I'm looking for what most of the players are looking for here, and that's the trophy."

Djokovic has played in seven US Open singles finals, winning the championship twice, in 2011 and 2015.

TWO BOUNCES

Tennis being one of the most inclusive of sports, the US Open recognizes the talents of those competing at wheelchair tennis's highest level by providing a showcase of the world's top wheelchair athletes.

SINCE ITS INCEPTION IN 1977, when the Los Angeles City Parks and Recreation Department hosted the first-ever tournament for about twenty players, wheelchair tennis has become one of the world's most popular wheelchair sports. Founded a year earlier as a recreational activity by Brad Parks, a former acrobat skier, with input from Jeff Minnenbraker, a wheelchair athlete, its rules are the same as able-bodied tennis, with the lone exception being that wheelchair players are allowed to hit the ball after it has bounced twice. The first international wheelchair tennis tournament was held in Paris in 1983, and the sport became a medal competition at the Paralympic Games nine years later. In 2002, the US Olympic Committee officially designated the USTA as the national governing body for wheelchair tennis, making the USTA the first Olympic national governing body to also oversee a Paralympic sport.

In 2005, the US Open added the US Open Wheelchair Competition to its lineup of events. The competition originally consisted of four championships: men's singles, men's doubles, women's singles, and women's doubles. Quad singles and doubles—for players with a substantial loss of function in one or both upper extremities, in addition to a substantial loss of function in one or both lower extremities—were added to the US Open's slate of events in 2007, the same year US Open wheelchair events were first played at all four Grand Slam tournaments. The competition has been held annually—except for every fourth year, when the Paralympic Games are staged.

No tennis player—abled-bodied or wheelchair—has rivaled the record of Esther Vergeer of the Netherlands, who ranks as one of the greatest female athletes of all time. The women's top-ranked player in wheelchair tennis for nearly thirteen years, she retired from the sport in February 2013 with a 470-match winning streak dating back to January 2003, losing only eighteen sets during that time. In her six appearances at the US Open Wheelchair Competition, Vergeer never lost, posting an 18–0 record in singles and 11–0 in doubles. She retired from competition at the age of thirty-one, having won twenty-one Grand Slam titles and four Paralympic gold medals in singles, along with twenty-three Grand Slam titles and three Paralympic gold medal (and one silver) in doubles.

"It's so amazing that I can spread the message to the world that if you have a disability, there's so much that you can still do, and a lot of people in the world still don't know that," said Vergeer during her last year as an active player. The US Open honored her with a special on-court retirement ceremony in 2013.

Over the years, Shingo Kunieda of Japan has been a somewhat similarly dominant force in the men's competition. Like Vergeer, he has enjoyed a long winning streak, recording 107 consecutive wins over the course of three years, 2007–10. In 2007, he became the first man in wheelchair tennis to achieve a Grand Slam, capped by winning the men's US Open Wheelchair Competition championships in both singles and doubles. He subsequently became the world No. 1 for four years in a row and has continued to add to his résumé over the years, amassing six US Open singles titles in all.

"I have always believed that I can endlessly become a better tennis player as long as I try," Kunieda said. "That belief is really what constitutes the bedrock of tennis for me."

The quad division at the US Open Wheelchair Competition has featured a pair of star players as well, with David Wagner of Fullerton, California, and Nick Taylor of Wichita, Kansas, going undefeated in their seven appearances as a team in the quad doubles competition.

"What makes us so good as a team," Wagner said well into their run, "is togetherness and our common drive to want to succeed and be our best at all times."

Wagner and Taylor posted their last US Open win together in 2015. Because Taylor did not enter the 2017 US Open, Wagner played in the tournament without his longtime partner and added his eighth US Open quad doubles title by partnering with Andrew Lapthorne. Wagner also won his third quad singles title in 2017 for good measure, giving him a total of eleven US Open championships—just one shy of Vergeer's record. ●

Clockwise from top left: Esther Vergeer, 2009; David Wagner, 2011; Wagner (left) and Nick Taylor, 2014; Shingo Kunieda, 2015; Jiske Griffioen (left) and Aniek Van Koot, 2011.

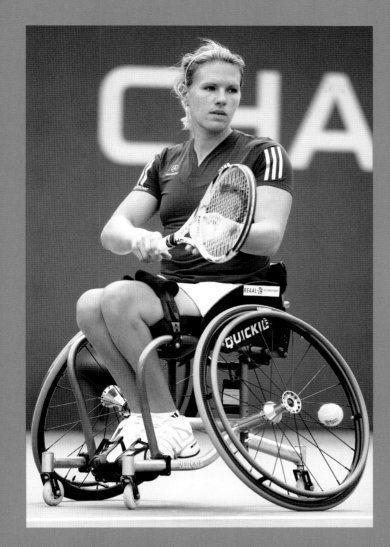

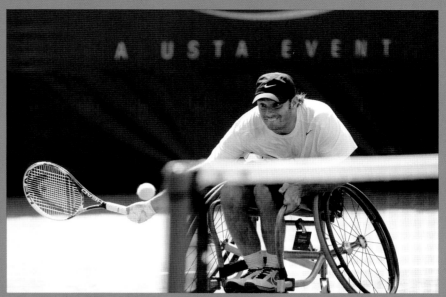

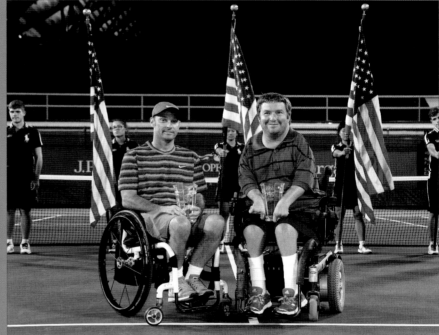

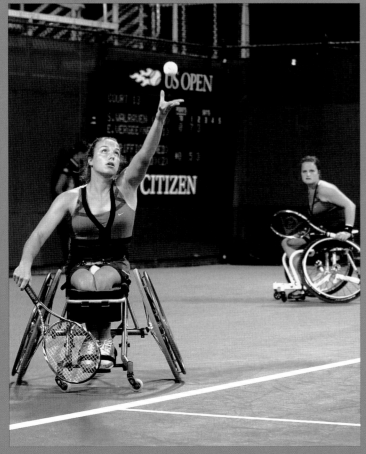

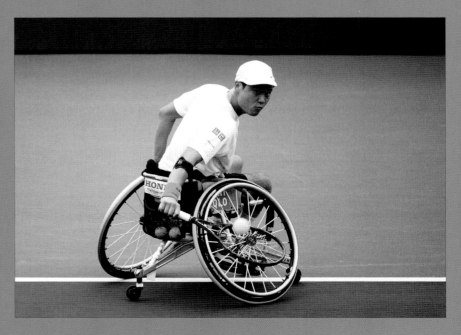

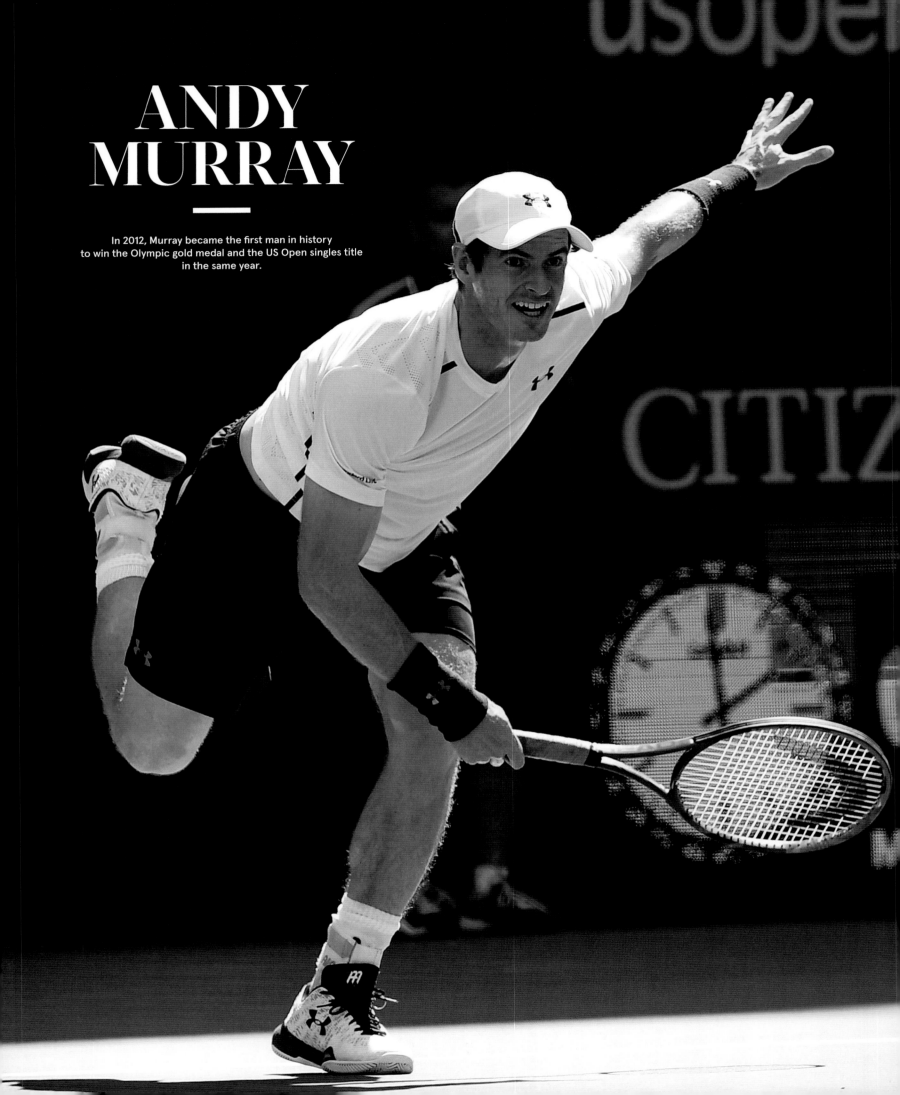

ANDY MURRAY

In 2012, Murray became the first man in history to win the Olympic gold medal and the US Open singles title in the same year.

MARIN ČILIĆ

—

"Seems completely unreal to be called Grand Slam champion."

Čilić, in 2014, became the second-lowest seed in the Open era to win the US Open men's title.

STRATEGIC TRANSFORMATION

A SERIES OF PHYSICAL IMPROVEMENTS AND UPGRADES SET A NEW STANDARD FOR SPECTACULAR AT THE USTA BILLIE JEAN KING NATIONAL TENNIS CENTER.

•

DETAILS OF A PROPOSED STRATEGIC VISION for the development of the USTA Billie Jean King National Tennis Center were first announced shortly before the summer of 2012. A series of interconnected construction projects would enhance the facility and preserve its stature as a world-class venue while providing a superior experience for players and fans alike. The project would positively impact the facility's ability to host the US Open and allow the City of New York to continue to reap substantial economic benefits from hosting one of the world's highest-attended annual sporting events.

"You almost won't recognize this place—

the changes are that sweeping," said Gordon Smith, USTA chief executive officer and executive director. "It's going to make a great tournament better than it's ever been before."

Indeed, it would prove to be as sweeping an overhaul as any venue in the annals of American sports, transforming the tournament in a remarkable way.

The first national lawn tennis tournament was held at the Staten Island Cricket and Baseball Club in St. George, a neighborhood on the northeastern tip of Staten Island in New York City, in 1880. Several other clubs also staged tournaments that same year that purported to be the national championships. The "national"

designation truly became meaningful, however, in 1881, when the United States National Lawn Tennis Association was formed in May—becoming the nation's first sports governing body—and scheduled its first championships to begin on August 31. Initially played over four days on the grass courts of the Casino in Newport, Rhode Island, the US National Championships/US Open has been staged as an outdoor tournament ever since.

That status changed, however slightly, on the night of August 31, 2016, as Rafael Nadal prepared to serve at 3–3 in the second set of his first-round match against Andreas Seppi. Inclement weather forced the suspension of

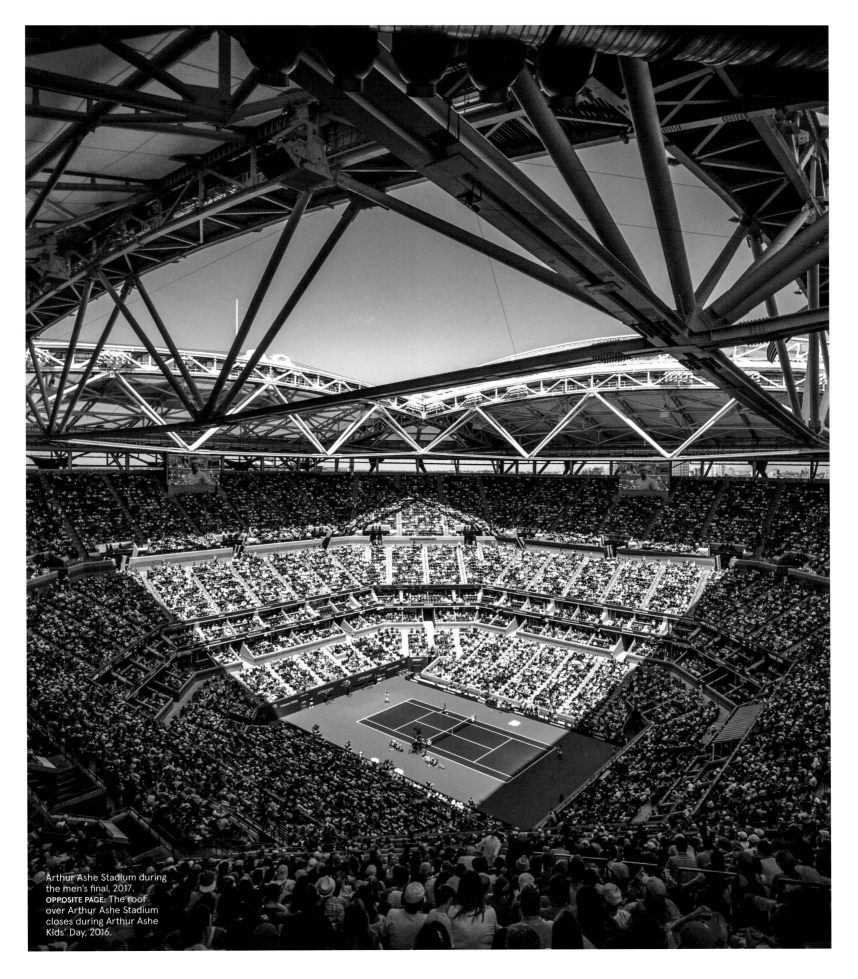

Arthur Ashe Stadium during the men's final, 2017.
OPPOSITE PAGE: The roof over Arthur Ashe Stadium closes during Arthur Ashe Kids' Day, 2016.

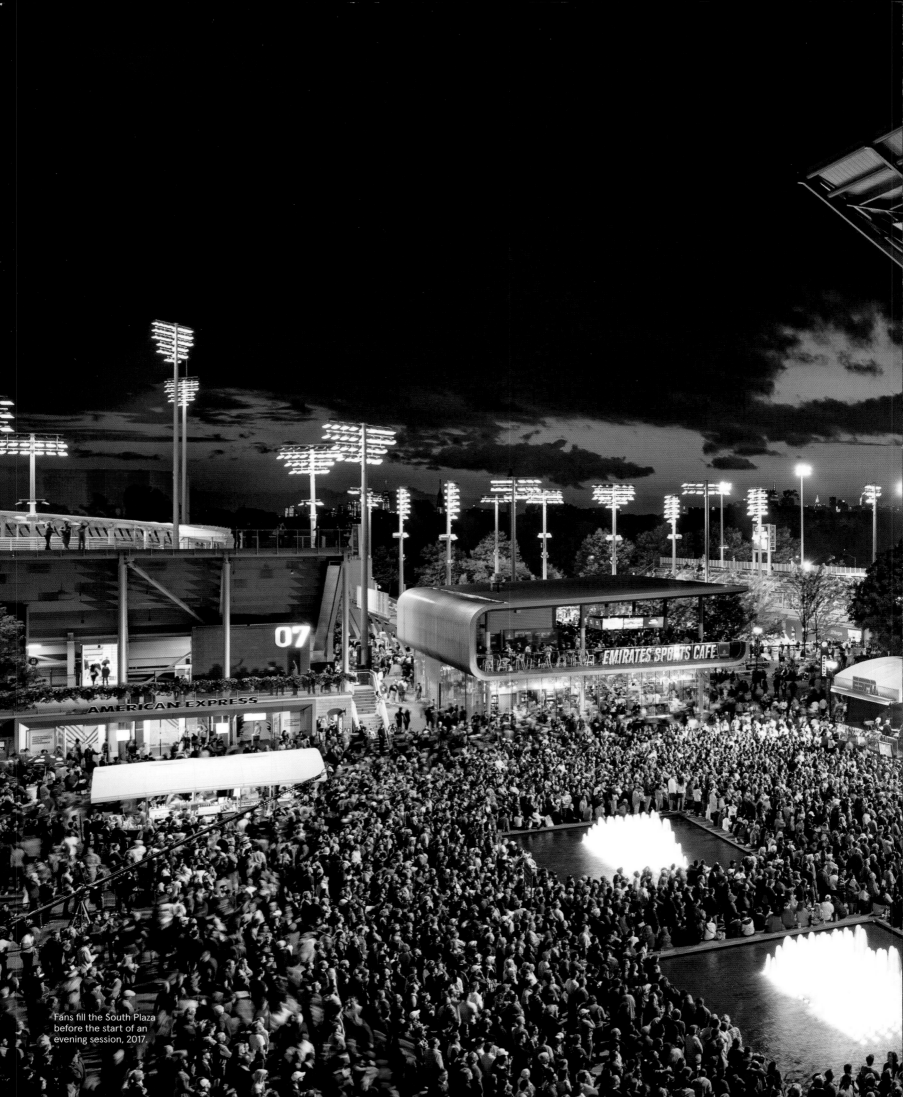

Fans fill the South Plaza before the start of an evening session, 2017.

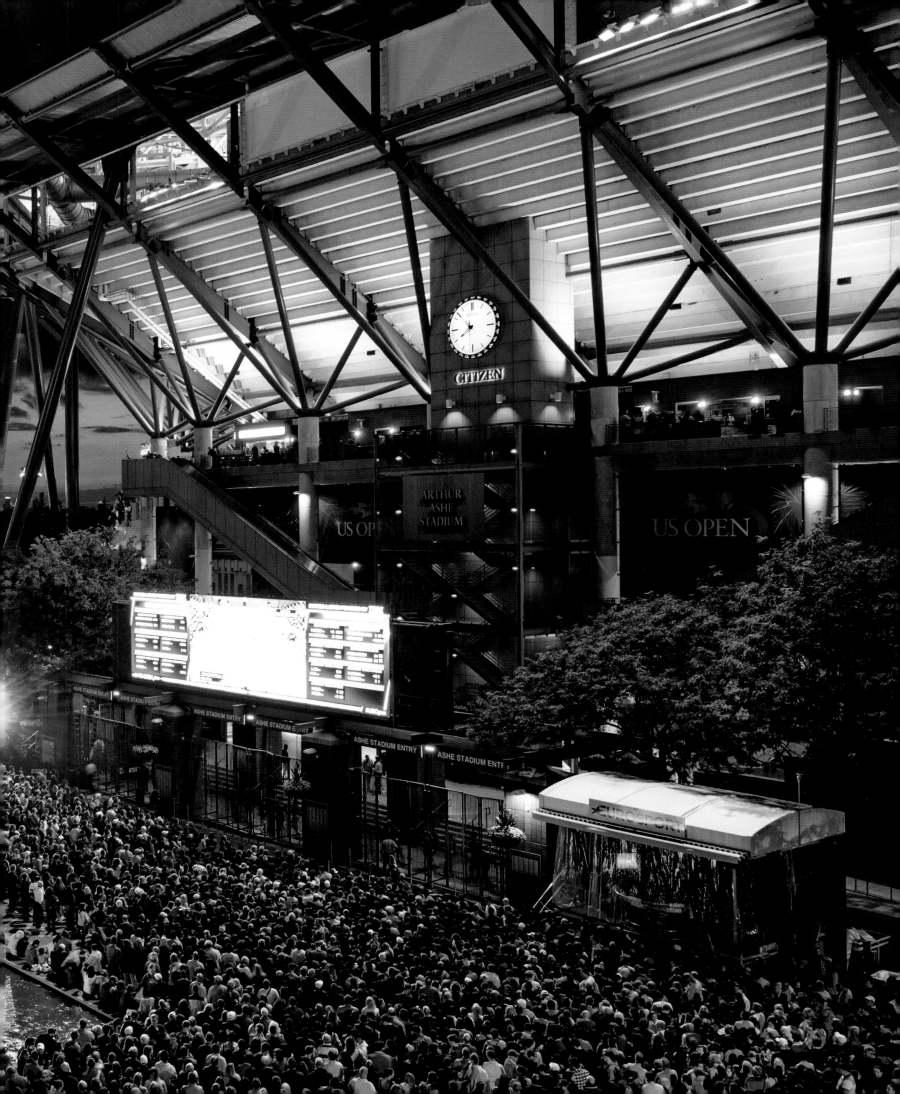

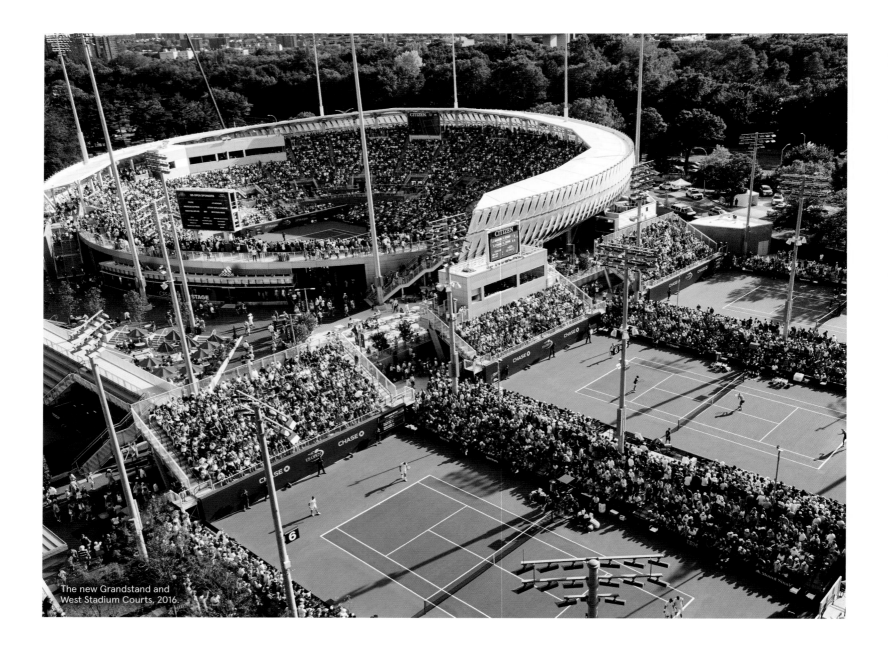

The new Grandstand and West Stadium Courts, 2016.

play and, at precisely 10:38 p.m., prompted a new development for the tournament–the turning of an outdoor match into an indoor contest, with the activation of a retractable roof over Arthur Ashe Stadium. The roof's four winches went to work and closed two eight-hundred-ton panels, with their tops positioned 205 feet above the court, in five minutes and thirty-five seconds. Nadal was the first player to hit a practice ball under a closed roof in Arthur Ashe Stadium, and moments after he stepped to the service line to resume play with Seppi, he became the first player to hit a ball indoors during a US Open match. The roof panels remained

closed for the rest of the evening as Nadal proceeded to win the initial US Open match played under a roof.

The most celebrated component of the USTA Billie Jean King National Tennis Center's five-year transformation project, the retractable roof over Arthur Ashe Stadium ranks as the largest of any tennis stadium in the world, with a 62,500-square-foot opening, making it larger than the area of a football field. Construction of US Open's biggest marquee attraction required more than thirteen million pounds of steel in order to achieve a technological first of erecting a stand-alone support system

for a retractable roof over an existing stadium.

Hampered by rain off and on over the years, the tournament had been extended due to inclement weather eighteen times since the men's and women's championships were first played at the same site in 1935. That year, rain affected play on six days of the US National Championships, with five being near-complete washouts. In 1938, a hurricane that killed more than five hundred people on the Eastern Seaboard postponed play for a record six days. The tournament was delayed for nearly a week in 1960 due to Hurricane Donna. Rain delayed the conclusion of the 1971 US Open by three days, and in 2012, it forced the women's sin-

gles final to be played on Sunday for the fourth time in five years and the men's singles final to be held on Monday for the fifth straight year.

With one bold innovation, rain delays on center court have become a thing of the past. The USTA had been working toward a viable design for a roof on Arthur Ashe Stadium for more than a decade before unveiling its strategic vision for the site's development shortly before the 2013 US Open. The transformation of the site would include not only the building of a retractable roof over Arthur Ashe Stadium but also the construction of two new stadiums, with the work beginning at the conclusion of the 2013 tournament.

The 2014 US Open introduced the first phase of the strategic transformation of the USTA Billie Jean King National Tennis Center with the opening of the West Stadium Courts and Practice Gallery. Featuring elevated seating that makes it possible to watch competitive action simultaneously on three tournament courts—Nos. 4, 5, and 6—the two-story viewing area also provides unobstructed views of US Open seeded players preparing for their next match on five practice courts to the west of Arthur Ashe Stadium.

The 2016 US Open marked the completion of phase two of the construction agenda. In addition to the debut of the retractable roof over Arthur Ashe Stadium, a new Grandstand stadium opened in the southwestern corner of the campus, with a fabric canopy ensuring almost all the 8,125 seats remain in shade during the day. Other upgrades introduced in 2016 included nineteen completely renovated field courts with hundreds of extra seats, a redesigned South Plaza featuring an expanded landscaped area, and a five-hundred-foot allée connecting the new Grandstand with Court 17.

After the 2016 US Open, construction began on the final phase of the five-year construction project: the building of an all-new Louis Armstrong Stadium with a retractable roof. Rising from the same spot as the Singer Bowl—the oval-shaped arena that triggered the tournament's move to Flushing Meadows and served as the US Open's premier court for nineteen years—the new Louis Armstrong Stadium makes its debut at the 2018 US Open and marks the completion of a series of visionary steps undertaken to showcase the sport of tennis at its very best. ●

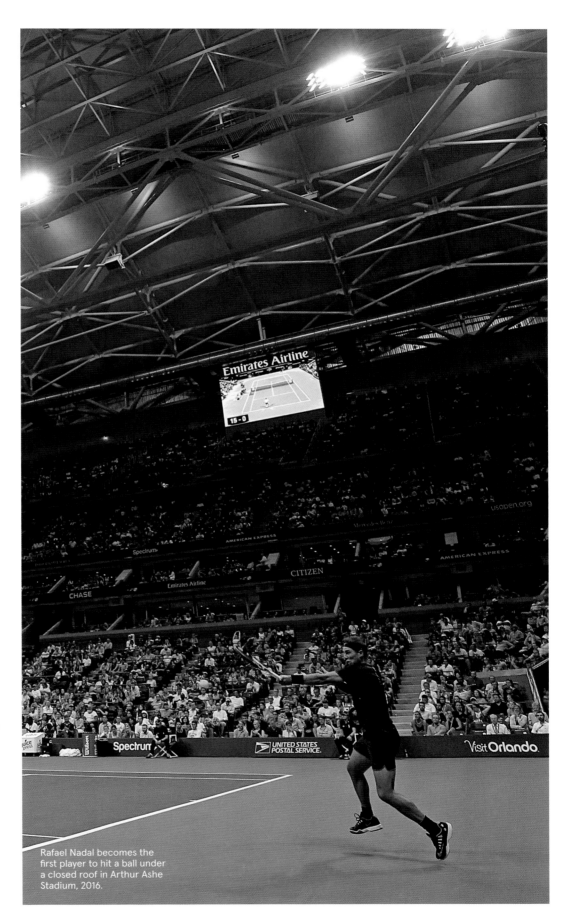

Rafael Nadal becomes the first player to hit a ball under a closed roof in Arthur Ashe Stadium, 2016.

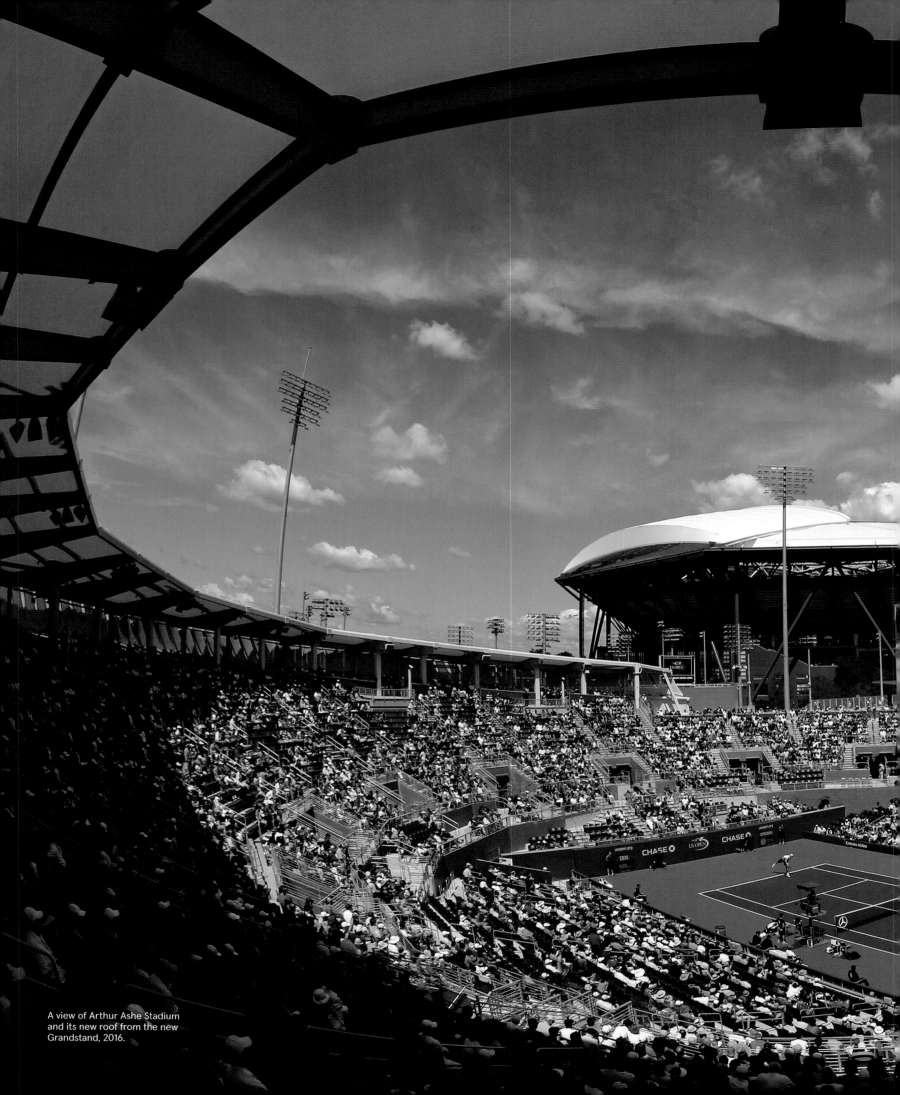

A view of Arthur Ashe Stadium and its new roof from the new Grandstand, 2016.

FLAVIA
PENNETTA

—

"If I have to dream
about how I want to finish,
to stop playing,
this is the perfect way."

Pennetta, after defeating Italian countrywoman
Roberta Vinci in the 2015 final, announced her retirement from
the game during the trophy ceremony.

STAN WAWRINKA

—

Wawrinka won the 2016 US Open championship
as he did his first two Grand Slam titles, by defeating
the world's No. 1 player in the final.

GREAT EXPECTATIONS

DELIVERING ON THEIR EARLY PROMISE,
BOB BRYAN AND MIKE BRYAN HAVE BECOME TENNIS'S
MOST CELEBRATED MEN'S DOUBLES TEAM.

•

BORN THREE MINUTES APART, twins Bob and Mike Bryan began separating themselves from every other doubles team early on. Growing up in Southern California, they won their first doubles tournament at age six and went on to capture more than one hundred titles together in their junior careers, which they capped in 1996 by becoming the first duo in fifty years to win consecutive USTA Boys' 18 National Championship titles—and by claiming their very first US Open crown, in the boys' doubles competition. That fall, they enrolled at Stanford University and continued their winning ways. Along with leading the Cardinal to back-to-back NCAA team championships in 1997 and 1998, they won the NCAA doubles championship in 1998 and were the nation's top-ranked collegiate doubles team. Bob also won the 1998 NCAA men's singles title.

Pro tennis naturally became their next pursuit, first on the USTA Pro Circuit, where they captured a dozen titles across the United States from 1998 to 2000, and then, finally and most emphatically, on the ATP World Tour, where their first title came in 2001 at Memphis, setting into motion the most successful men's doubles partnership of all time. Entering 2018, the Bryan brothers had won more doubles titles (114) and more Grand Slam doubles championships (16) than any other men's team. They were the year-end No. 1 doubles team a record ten times, first achieving the top ranking in 2003, when they won their first major championship at the French Open. They reached their first US Open final that year as well but had to wait until 2005 to capture their first US Open men's doubles championship. They added four more US Open men's doubles titles, the result of claiming a championship every even year from 2008 to 2014. They are the only team to win at least one Grand Slam title for ten consecutive years (2005–14). Among their highlights during this period was their Golden Slam: Capturing the 2012 US Open title shortly after winning the Olympic gold medal at the 2012 London Games started them on their journey to become the only team in history to hold all four Grand Slam titles plus the Olympic gold medal simultaneously. There is also their stalwart play for the US Davis Cup team to take into account. Over the years, they teamed up to win twenty-four Davis Cup doubles matches, far more than any other American tandem.

"They have been spectacularly consistent," said their father, Wayne, who was an early coach and mentor. "The main thing is they love to play and are passionate about their tennis. They still enjoy practicing and traveling the world and competing. They love to play together. And they love the great game of doubles."

Indeed, it's hard to think of more passionate ambassadors for the sport of tennis in general—and for doubles in particular. No other pair has been more successful. Their five US Open men's doubles titles stand as the most in the Open era, one ahead of Bob Lutz and Stan Smith. As for all of US championship history, they are tied with James Dwight and Richard Sears, who won their five titles in the 1880s.

Certainly, longevity has been a key to the Bryans' success. In the US Open's first fifty years, they have played in nearly half of the competitions. Their twenty-three consecutive US Opens put them second on the all-time list for most tournament appearances, one behind Daniel Nestor. What follows are some of the Bryan brothers' recollections of playing for nearly a quarter of a century at the US Open.

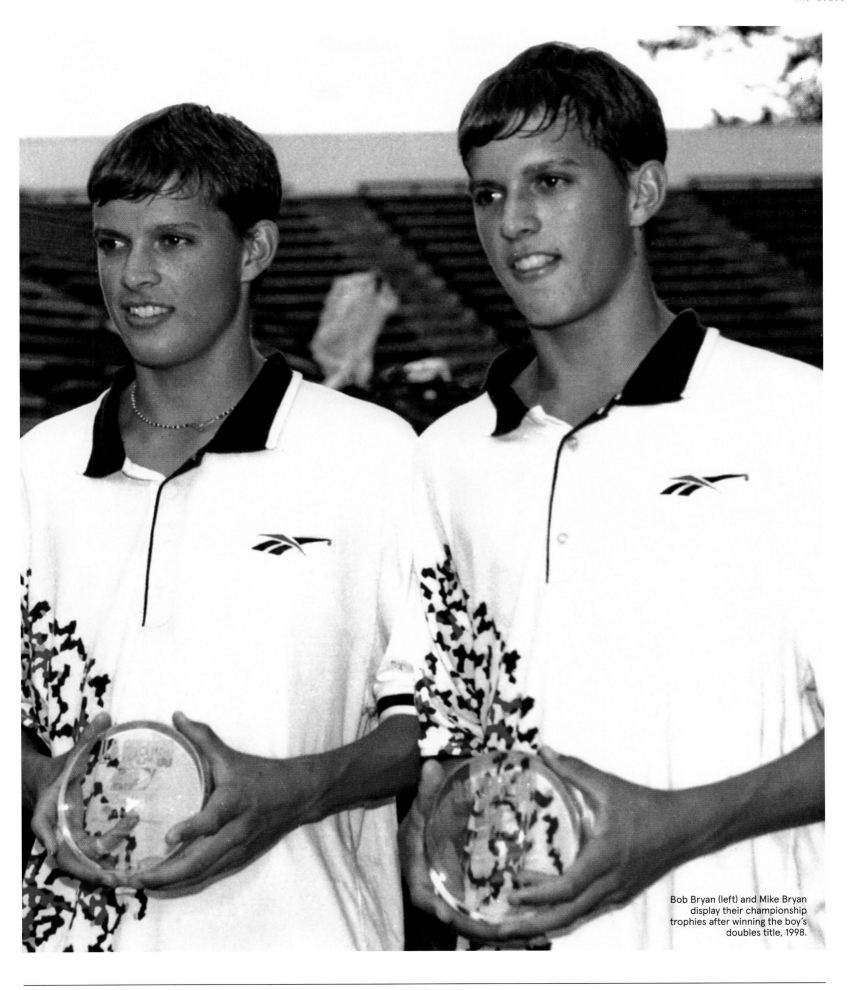

Bob Bryan (left) and Mike Bryan display their championship trophies after winning the boy's doubles title, 1998.

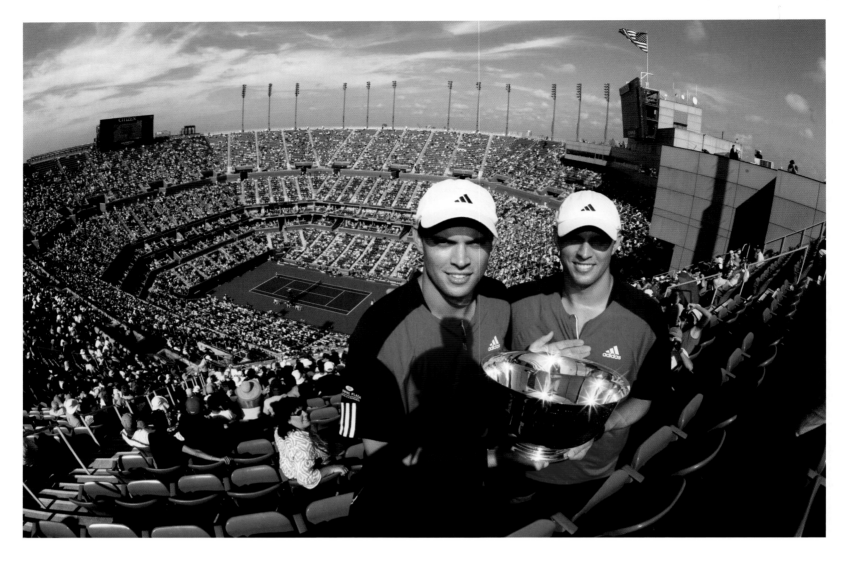

You were seventeen years old when you earned a wild card to play in the main draw of the 1995 US Open men's doubles. What stands out in your memory about that first trip to New York and your initial experience at the US Open? We were still so young and huge fans of all the players. We felt like kids in a candy store and had to pinch ourselves every time we walked by one of the huge stars like Andre Agassi or Pete Sampras. Everything was new and exciting. We were late bloomers and grew a lot in college, so oftentimes we were mistaken for ball kids!

Your five championships make you the winningest men's doubles team to play at the US Open. Does one title stand out above the others? It's an amazing feeling knowing that we've been able to play some of our best tennis at our home Slam. Our first title in 2005 stands out because it was one of the best matches we've ever played. It was also a pivotal match because

it prevented a fourth Grand Slam final loss in one year.

Winning your one-hundredth doubles title was an unprecedented achievement in the men's game. How special was it that you managed to reach the century mark at your home Slam? The stars aligned for us! Hitting one hundred titles at our favorite Slam in front of our home fans was a script we could never dream up.

Bob, you've won more US Open championships than any other man, including the 2006 mixed-doubles title with the leading US Open women's titleholder, Martina Navratilova, in her last match. Did you feel any added pressure to make sure she ended her career on a high note? I did feel a little pressure. I didn't want to let Martina down. She had such a special career, and I wanted to help her go out on top, the way she deserved.

You've played on all the US Open's show courts over the years, including the old Grandstand, the new one, and Court 17. You actually played in Louis Armstrong Stadium's last scheduled match. Have you had a favorite place to play? The old Grandstand was a very special court because of how intimate it was. It felt like the fans were hovering over you, and the electricity and excitement would oftentimes boil up to a fever pitch.

With twenty-three US Opens behind you, you still display a great passion for the game every time you step on the court. What's the secret? We're always excited to step out onto the biggest stage in tennis. We really appreciate the opportunity to connect with the New York crowd, and it seems like their energy always brings out the best in us. The feeling of possibly lifting another US Open trophy drives us to work hard and give everything we have. ●

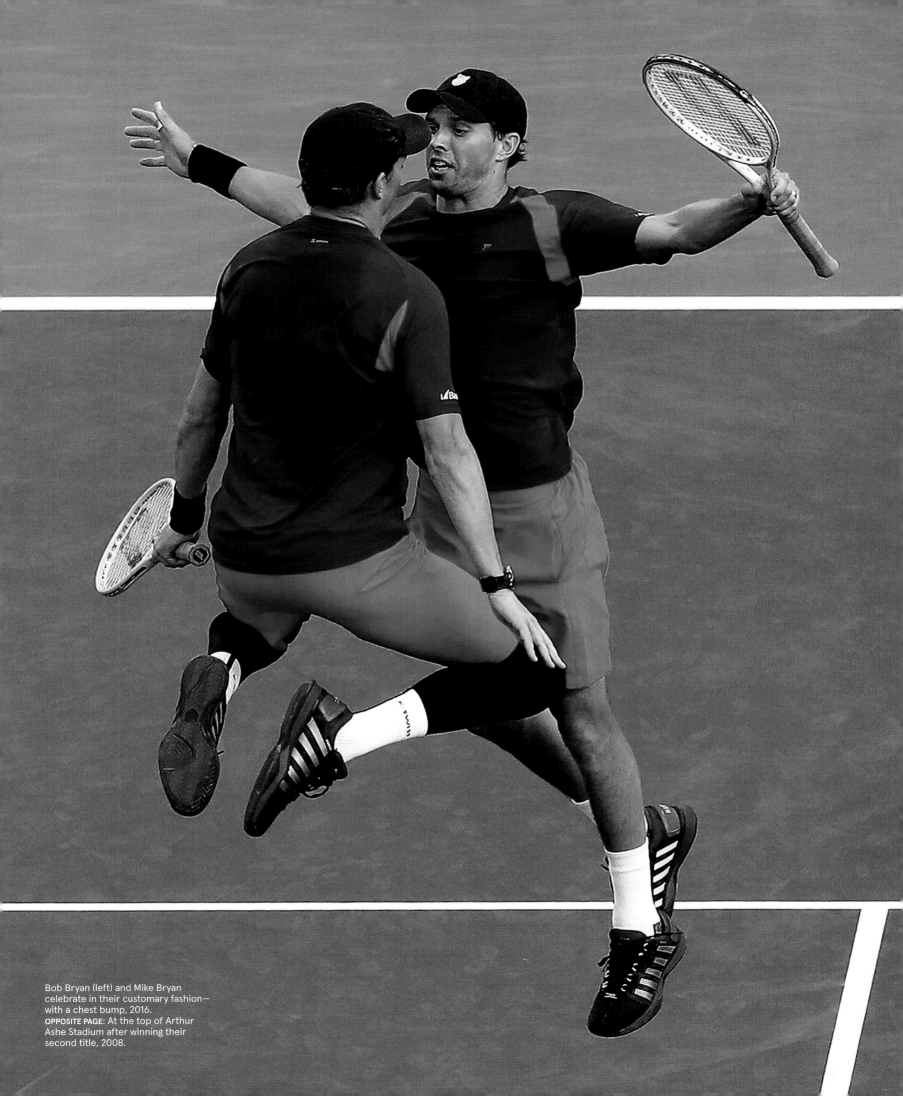

Bob Bryan (left) and Mike Bryan celebrate in their customary fashion—with a chest bump, 2016.
OPPOSITE PAGE: At the top of Arthur Ashe Stadium after winning their second title, 2008.

THREE FOR ALL

NO TRIO OF PLAYERS AT THE US OPEN HAS BEEN QUITE AS MASTERFUL AS ROGER FEDERER, RAFAEL NADAL, AND NOVAK DJOKOVIC.

By E. J. Crawford

•

THE MODERN ERA OF TENNIS has been dominated by three men, all of whom arrived at the US Open in the early part of this century and remain fixtures in Flushing to this day. Roger Federer, of course, came first, winning five consecutive men's singles titles to stamp himself as one of the Open's greatest champions. Typically, legends such as Federer do not come around very often; this time, they came again and again. Novak Djokovic reached his first US Open final in 2007, losing to Federer, and has appeared in seven title matches in his career. Rafael Nadal claimed his maiden US Open championship in 2010 and has since won it twice more, including during his resurgent 2017 campaign.

Three might be company, or perhaps a crowd, but when it comes to parsing out US Open titles, it certainly makes for some compelling theater.

While US Open women's tennis has been dominated by one woman—Serena Williams—in the twenty-first century, the men's crown has alternately been owned by a trio of all-time greats: Novak Djokovic, Roger Federer, and Rafael Nadal. Together, the three men have captured ten men's singles championships and have appeared in an astounding eighteen finals. Two of the three have faced off for five of those titles, and at least one member of the triumvirate has appeared in every US Open final since 2004, save one: 2014, when Federer and Djokovic were both upset in the semifinals.

There have been, of course, threesomes to rival the modern-day Big Three (often expanded to the Big Four to incorporate Andy Murray, a two-time US Open finalist and 2012 champion). First, there were the Australians Rod Laver, Ken Rosewall, and Tony Roche, with John Newcombe easily subbing in for any of the aforementioned, and the late 1970s/early 1980s grouping of Björn Borg, Jimmy Connors, and John McEnroe segued nicely into the early 1980s/mid-1980s outfit of Connors, McEnroe, and Ivan Lendl. But none had the punch—or the staying power—of Djokovic, Federer, and Nadal.

To wit: Federer has made US Open finals appearances eleven years apart (2004 to 2015) and was the pre-tournament favorite for

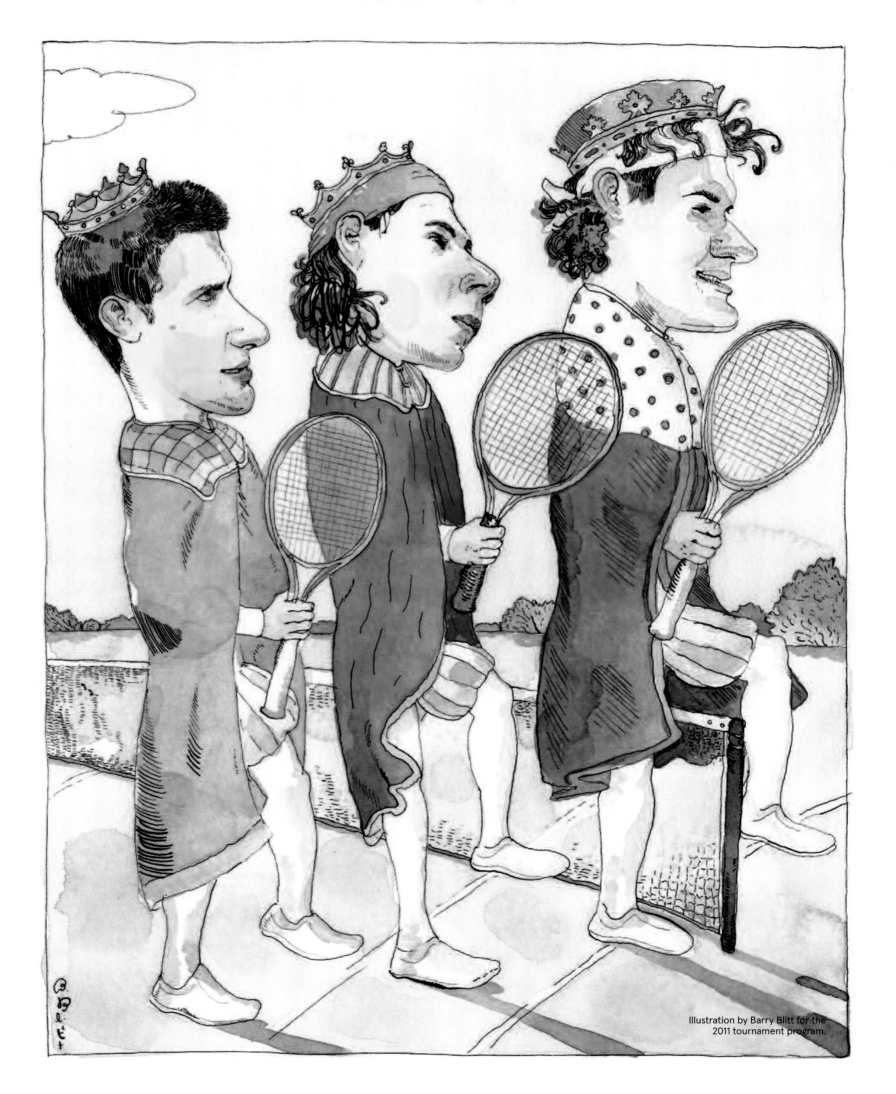

Illustration by Barry Blitt for the
2011 tournament program.

Novak Djokovic (left), Rafael Nadal, and Roger Federer (right) in New York City a few days before the US Open begins, 2013.

the 2017 crown; Djokovic's finals have spanned 2007 to 2016; and Nadal won his first title in 2010 and his most recent in 2017—a seven-year gap that serves as the third-longest in the Open era, trailing only Connors (1974 to 1982) and Pete Sampras (1990 to 2002). Moreover, in the history of the Open era, only one threesome has won more titles than Djokovic-Federer-Nadal's ten—McEnroe, Connors, and Lendl combined for twelve—but the current trio is nowhere near done gobbling championships. And when you expand the comparison across all Slams, the trio's grand total (as of this writing) of forty-eight major singles crowns is far clear of any other possible three-man combination, with Federer (twenty Slams) ranking No. 1 on the all-time list, Nadal (sixteen) coming in at No. 2, and Djokovic (twelve) just two behind Sampras for third all-time. True, in past eras not all four majors were prized equally, with many Americans and Europeans forgoing the trip down under, but still, the overall body of work from Djokovic, Federer, and Nadal is truly overwhelming.

The three greats have also teamed to produce some of the best US Open matches of the Open era. Federer and Djokovic met in Flushing Meadows each year from 2007 through 2011—a run unmatched since the pros and amateurs mixed—with Federer winning the first three and Djokovic the last two. In both of his victories, the Serbian Djokovic erased two match points, once on a wild blast he struck with his eyes closed and another on a forehand that painted the line—and in the latter, in 2011, Djokovic rebounded from two sets down for the win, completing his title run one round later with a victory over Nadal in the final. That was one of three enthralling finals Djokovic and Nadal staged from 2010 to 2013, with the Spaniard Nadal prevailing in 2010 and 2013, both times in four sets. And for good measure, Djokovic and Federer squared off again in the 2015 final, with Djokovic prevailing in four taut frames.

Sadly for tennis fans, Federer and Nadal have yet to meet in Flushing Meadows, an ongoing lament for those who love the game but hardly a stain on what these three men have achieved—and what they continue to accomplish. Their run of domination is as delightful as it is rare, the kind of historical feat that is dazzling in the present—and will grow only more luminous in the years to come. ●

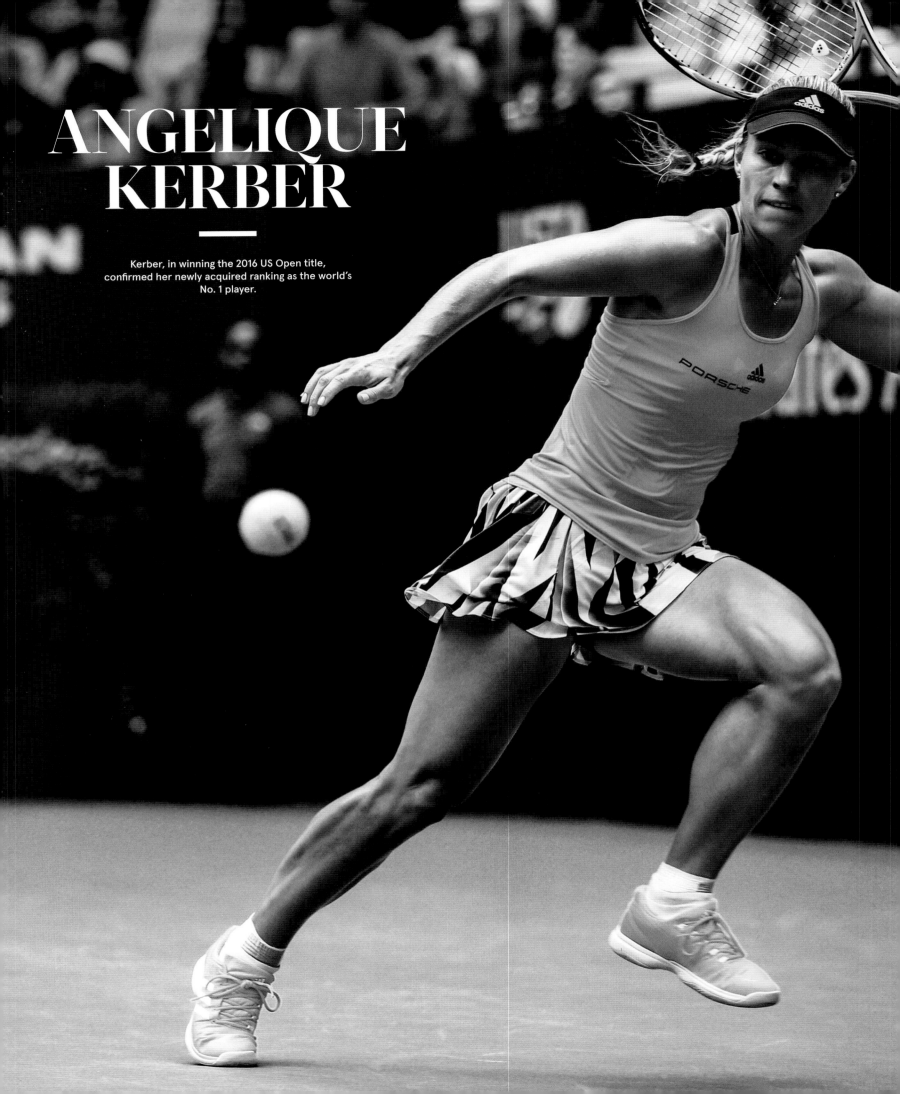

ANGELIQUE KERBER

Kerber, in winning the 2016 US Open title, confirmed her newly acquired ranking as the world's No. 1 player.

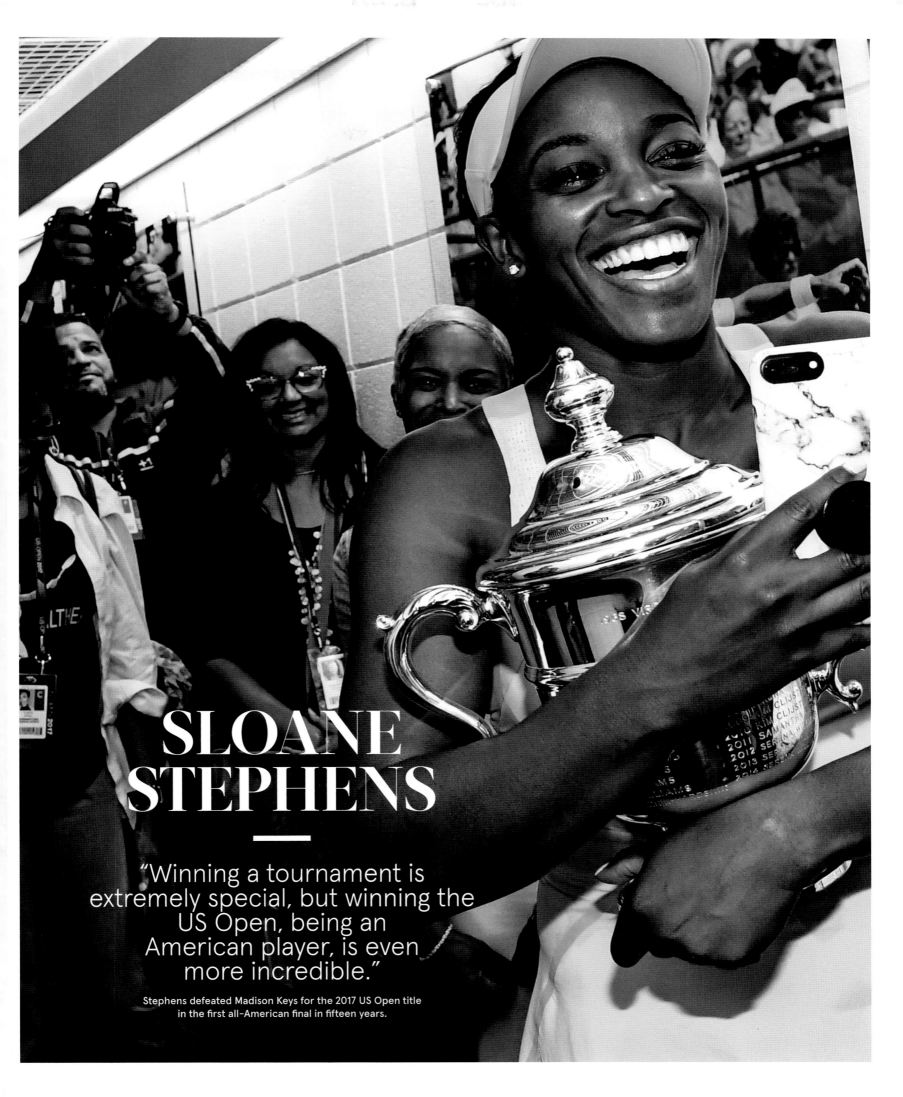

SLOANE STEPHENS

—

"Winning a tournament is extremely special, but winning the US Open, being an American player, is even more incredible."

Stephens defeated Madison Keys for the 2017 US Open title in the first all-American final in fifteen years.

FAN FARE

On a late summer evening in New York, there's no better place to be than the US Open.

By Alec Baldwin

NEW YORK IS FAMOUS for teeming with unique, glamorous, and significant cultural events on an almost daily basis. Yet a quick look at a list of those events reveals that much of what makes New York so dynamic, so thrilling, can be found in any number of cities across America. There are symphonies, museums, and professional sports teams, Shakespeare and jazz and dance festivals, literary evenings and poetry readings and food fairs in most major (and some not-so-major) cities in every corner of the country. But only four cities in the entire world hold the distinction of hosting one of the four Grand Slam events in tennis. And only New York has the US Open.

For New Yorkers with a flair for the kind of drama where you can never truly predict the outcome . . . where the nail-biting anticipation of athletic competition that once surrounded a Muhammad Ali heavyweight title fight is in the air for an entire fortnight . . . where the cool late summer evenings can bring New Yorkers of every tax bracket away from their Hamptons homes or swimming pools or just a shady spot on their front porch to be a part of the spectacle . . . Flushing becomes *the* place. You grab a drink, you grab your seat, and you buckle in.

Jimmy Connors and John McEnroe. Björn Borg and Ivan Lendl. Chris Evert versus Martina Navratilova. Then Tracy Austin, Steffi Graf, Monica Seles, Williams times two—Venus and Serena. Pete Sampras, Andre Agassi, Roger Federer, Rafael Nadal. Before all of them, Billie Jean King and Arthur Ashe. The list is long and the index of heart-stopping moments is even longer. I remember watching Stefan Edberg and Michael Chang going head to head for nearly five and a half hours in the 1992 semifinals—the longest match in the history of the US Championships; Mats Wilander and Lendl battling for almost five hours for the 1988 title—the longest US Open final in the Open era, a record Andy Murray and Novak Djokovic matched in their 2012 final; Djokovic facing Federer in the semifinals for the fourth straight year in 2011 and saving two match points to win a five-set thriller; Roberta Vinci coming back from down a set in the 2015 semis to derail Serena Williams's quest for the Grand Slam. While some matches begin with the air of an execution, all cold formality, the New York crowd revels in the display of the underdog's guts, believing that the brazen spirit of New York itself can help lift a player into the next round.

We watch the US Open because the greatest players in tennis are giving their all to compete on the sport's highest level. It's a hit TV show for all of those around the world not lucky enough to come to the stadium and get a seat, any seat, and experience, up close, the "nowhere-to-hide" pressures of the singles game or the tennis equivalent of team sports found in a great doubles match. But the US Open is also New York at its most magical and memorable. It's the power of Ali–Foreman, the grace of American Ballet Theatre, and the drama of the Metropolitan Opera all in one event.

New York is a great city because talented people come here in droves to leave it all on the field in their chosen careers. It's intense, it's competitive, and it's awesome. And if there's a cool breeze in the September air and the men and women of professional tennis are doing battle at Arthur Ashe Stadium, there's no place else you'd rather be. And when it ends, you're kind of numb from the excitement. I know I am. ●

AT THE US OPEN

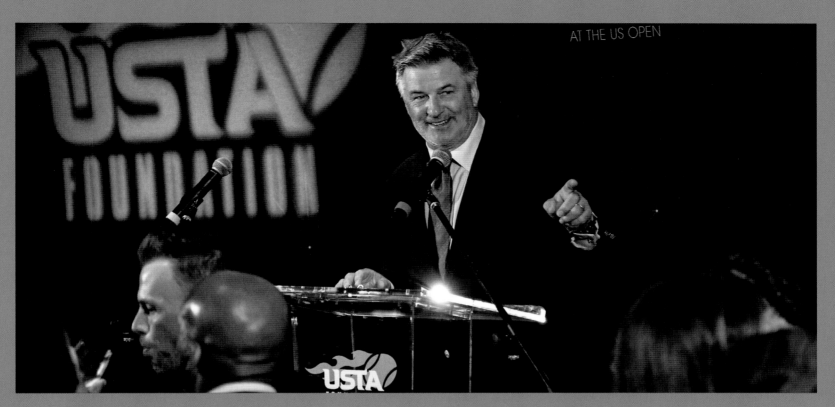

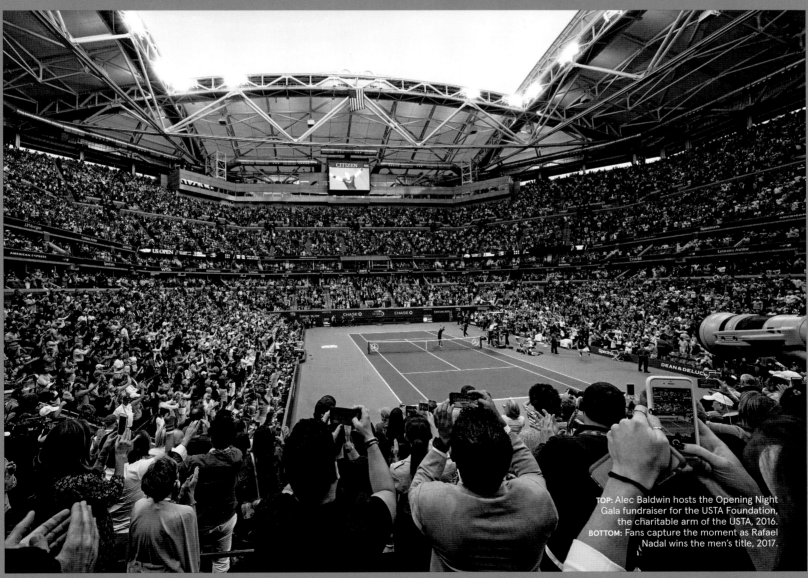

TOP: Alec Baldwin hosts the Opening Night Gala fundraiser for the USTA Foundation, the charitable arm of the USTA, 2016.
BOTTOM: Fans capture the moment as Rafael Nadal wins the men's title, 2017.

LOVE–50

FIVE DECADES OF MAGNIFICENCE HAVE TURNED THE US OPEN INTO A TRULY MAJOR EVENT.

By Mark Preston

•

PRIOR TO 1968, the grand irony of the sport of tennis was that those who were skilled enough to play it as a profession were not allowed to play it at any of the sport's major events. Tennis's best players were, in fact, pariahs in a sport in which they should have been pillars. The four Slams might as well have been called that for the way in which they emphatically shut their doors in the collective faces of those who played for pay. It was a backward approach for a sport looking to move forward.

But in 1968, the sport, at long last, decided to throw open its doors to professional players, ushering in a new era of open tennis. In the late summer—fittingly, a time when so much in this country was changing—the US National Championships became the US Open. And nothing has been the same since.

Australian pro Ken Rosewall won the first open major, taking the title at the 1968 French Open. His countryman and fellow professional, Rod Laver, won Wimbledon in its inaugural Open year. But as would be the case across the half-century to follow, the US Open was different. Apropos in a summer in which this country often seemed upside down, the US Open, now featuring a host of outstanding professionals, was won by an amateur. US Army Lieutenant Arthur R. Ashe, Jr., on leave from West Point, captured that very first US Open men's singles title. An African American army lieutenant standing alone—higher than the rest—at the close of the first fortnight of open admission. It was at once perfectly crazy and crazily perfect. Take that, convention.

That first year set the tone for an event—and a sport—that would come to be known for both evolution and revolution. Change was coming. It would be slow. But it would come nonetheless. An elite sport would become much more egalitarian; a tennis championship would become much more of an event. The players would become celebrities, bigger-than-life personalities whose personas positively surged off the playing field. As most had expected, open tennis turned out to be a good idea. And the US Open turned out to be a great place to showcase it.

It has always been a unique place, the US Open. Even when it was contested on the finely manicured lawns of Forest Hills, it was never a finely manicured event. If the four Slams are indeed brethren, then the US Open has always been the brashest and loudest member of the family—less about atmosphere than it is about attitude. Refinement has never played particularly well here. The Open always has been unapologetically loud on every level.

And in 1978, when the US Open left behind the serene surroundings of Forest Hills for the urban sprawl of Flushing Meadows, every one of its dials was immediately turned up to eleven. It was a short move if measured in miles, but a quantum leap when measured in impact. No longer did the US Open—or the sport of tennis, for that matter—belong to the country club. It now belonged to the country.

That defining move was critical in helping the US Open define itself. Hard courts. High heat. Tough tennis. Vocal fans. Vocal New York fans, moreover. Crazy? More than slightly; this was bedlam with baselines. And the word spread quickly: You wouldn't want to miss it for the world.

And so, the US Open's grounds, which had twice hosted world's fairs, now hosted the world, as eager fans from all corners of the globe flocked to Flushing Meadows to be part of this grand spectacle. Across the Open's cement acres, the sport grew stronger, its players grew more popular, and a tennis tournament became an event.

Few things look as good at fifty as does the US Open. Five decades of magic and memories have given the event a resilient glow that makes it one of tennis's most brilliant gems. You think of the names who have won here—and the names never able to—and you appreciate the magnitude of the achievement of standing alone at the end of the Flushing fortnight. Each year, 128 men and 128 women start the journey; only fifty in these fifty years have finished it.

It's hard to say whether the names of those great champions have helped to define the magnificence of the US Open more than the magnificence of the Open has helped to define each of them as champions. And in the end, it hardly matters, as both sides of the equation have prospered through these five decades—and figure to for decades to come.

Just as it was in its first year, the US Open, at fifty, remains different. Proudly so. Still crazy after all these years, and attitude and volume remain its defining features. Though the event grows every year, it never outgrows those things.

You see, in the end, everything about the US Open—from its courts upward—is hard. For players, it's hard to win; for fans, it's hard to forget. For all, it's an experience that's hard to compare to anything else. •

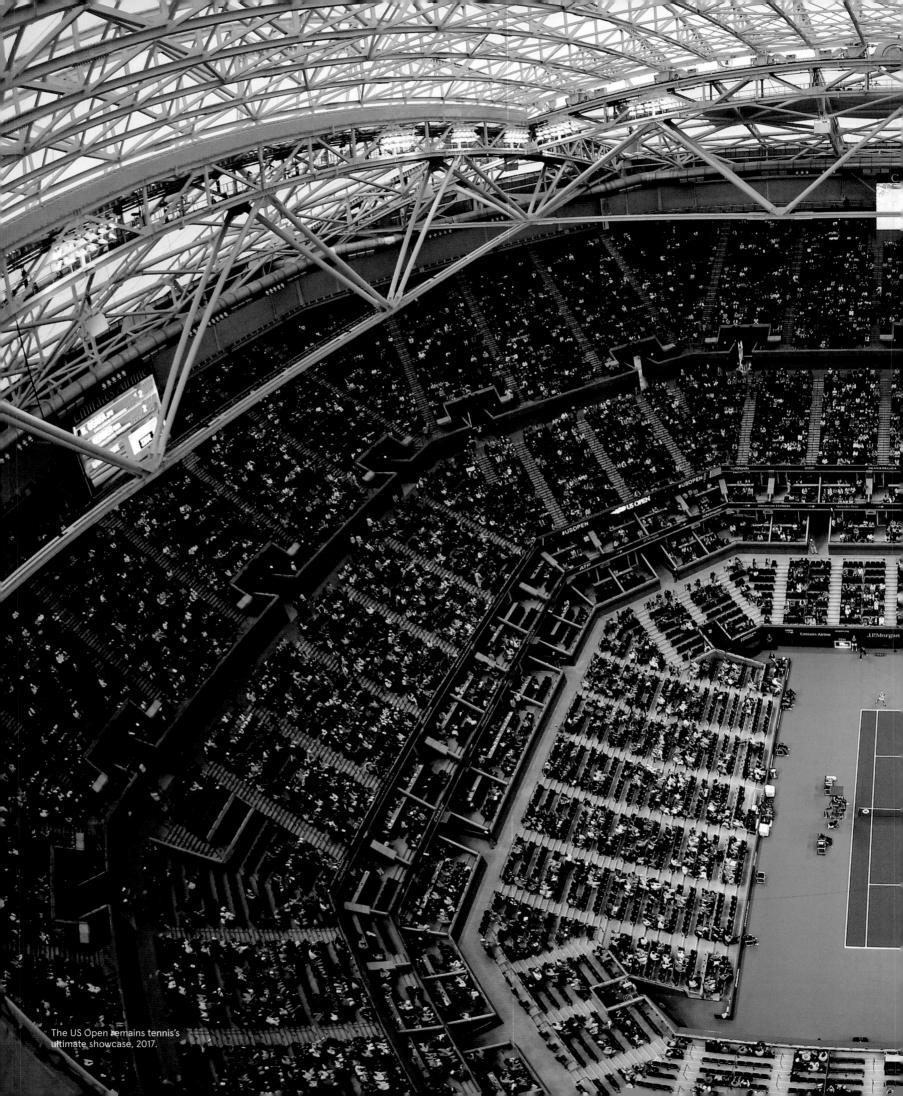

The US Open remains tennis's
ultimate showcase, 2017.

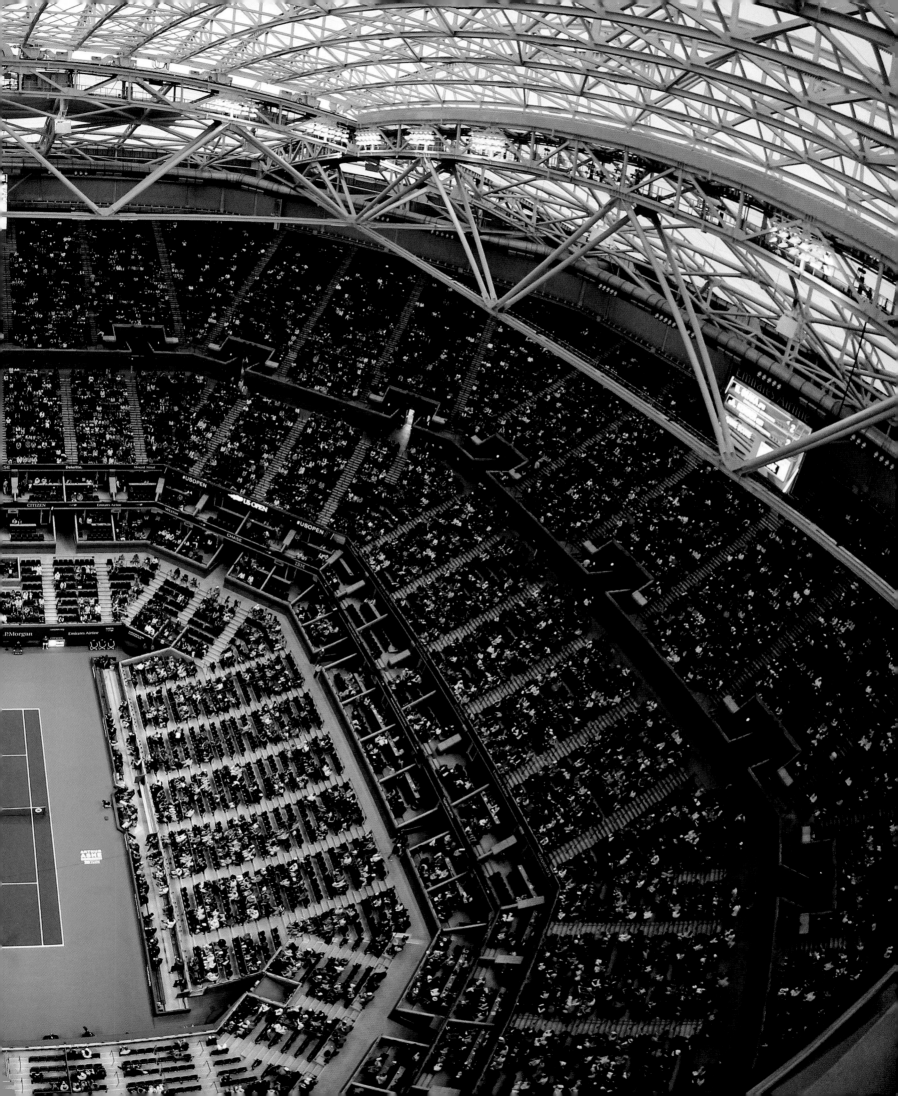

US OPEN
Champions

Martina Navratilova, 1984; she won sixteen titles—the most of any player.

John McEnroe, 1980; his eight total titles are the most by a men's singles champion.

YEAR	MEN'S SINGLES	WOMEN'S SINGLES
2017	Rafael Nadal	Sloane Stephens
2016	Stan Wawrinka	Angelique Kerber
2015	Novak Djokovic	Flavia Pennetta
2014	Marin Čilić	Serena Williams
2013	Rafael Nadal	Serena Williams
2012	Andy Murray	Serena Williams
2011	Novak Djokovic	Samantha Stosur
2010	Rafael Nadal	Kim Clijsters
2009	Juan Martín del Potro	Kim Clijsters
2008	Roger Federer	Serena Williams
2007	Roger Federer	Justine Henin
2006	Roger Federer	Maria Sharapova
2005	Roger Federer	Kim Clijsters
2004	Roger Federer	Svetlana Kuznetsova
2003	Andy Roddick	Justine Henin-Hardenne
2002	Pete Sampras	Serena Williams
2001	Lleyton Hewitt	Venus Williams
2000	Marat Safin	Venus Williams
1999	Andre Agassi	Serena Williams
1998	Patrick Rafter	Lindsay Davenport
1997	Patrick Rafter	Martina Hingis
1996	Pete Sampras	Steffi Graf
1995	Pete Sampras	Steffi Graf
1994	Andre Agassi	Arantxa Sánchez-Vicario
1993	Pete Sampras	Steffi Graf
1992	Stefan Edberg	Monica Seles
1991	Stefan Edberg	Monica Seles
1990	Pete Sampras	Gabriela Sabatini
1989	Boris Becker	Steffi Graf
1988	Mats Wilander	Steffi Graf
1987	Ivan Lendl	Martina Navratilova
1986	Ivan Lendl	Martina Navratilova
1985	Ivan Lendl	Hana Mandlíková
1984	John McEnroe	Martina Navratilova
1983	Jimmy Connors	Martina Navratilova
1982	Jimmy Connors	Chris Evert Lloyd
1981	John McEnroe	Tracy Austin
1980	John McEnroe	Chris Evert
1979	John McEnroe	Tracy Austin
1978	Jimmy Connors	Chris Evert
1977	Guillermo Vilas	Chris Evert
1976	Jimmy Connors	Chris Evert
1975	Manuel Orantes	Chris Evert
1974	Jimmy Connors	Billie Jean King
1973	John Newcombe	Margaret Smith Court
1972	Ilie Năstase	Billie Jean King
1971	Stan Smith	Billie Jean King
1970	Ken Rosewall	Margaret Smith Court
1969	Rod Laver	Margaret Smith Court
1968	Arthur Ashe	Virginia Wade

MEN'S DOUBLES	WOMEN'S DOUBLES	MIXED DOUBLES
Jean-Julien Rojer – Horia Tecau	Chan Yung-Jan – Martina Hingis	Martina Hingis – Jamie Murray
Jamie Murray – Bruno Soares	Bethanie Mattek-Sands – Lucie Safarova	Laura Siegemund – Mate Pavić
Pierre-Hugues Herbert – Nicolas Mahut	Martina Hingis – Sania Mirza	Martina Hingis – Leander Paes
Bob Bryan – Mike Bryan	Ekaterina Makarova – Elena Vesnina	Sania Mirza – Bruno Soares
Leander Paes – Radek Stepanek	Andrea Hlavackova – Lucie Hradecka	Andrea Hlavackova – Max Mirnyi
Bob Bryan – Mike Bryan	Sara Errani – Roberta Vinci	Ekaterina Makarova – Bruno Soares
Jurgen Melzer – Philipp Petzschner	Liezel Huber – Lisa Raymond	Melanie Oudin – Jack Sock
Bob Bryan – Mike Bryan	Vania King – Yaroslava Shvedova	Liezel Huber – Bob Bryan
Lukas Dlouhy – Leander Paes	Serena Williams – Venus Williams	Carly Gullickson – Travis Parrott
Bob Bryan – Mike Bryan	Cara Black – Liezel Huber	Cara Black – Leander Paes
Simon Aspelin – Julian Knowle	Nathalie Dechy – Dinara Safina	Victoria Azarenka – Max Mirnyi
Martin Damm – Leander Paes	Nathalie Dechy – Vera Zvonareva	Martina Navratilova – Bob Bryan
Bob Bryan – Mike Bryan	Lisa Raymond – Samantha Stosur	Daniela Hantuchova – Mahesh Bhupathi
Mark Knowles – Daniel Nestor	Virginia Ruano Pascual – Paola Suárez	Vera Zvonareva – Bob Bryan
Jonas Bjorkman – Todd Woodbridge	Virginia Ruano Pascual – Paola Suárez	Katarina Srebotnik – Bob Bryan
Mahesh Bhupathi – Max Mirnyi	Virginia Ruano Pascual – Paola Suárez	Lisa Raymond – Mike Bryan
Wayne Black – Kevin Ullyett	Lisa Raymond – Rennae Stubbs	Rennae Stubbs – Todd Woodbridge
Lleyton Hewitt – Max Mirnyi	Julie Halard-Decugis – Ai Sugiyama	Arantxa Sánchez-Vicario – Jared Palmer
Sebastien Lareau – Alex O'Brien	Serena Williams – Venus Williams	Ai Sugiyama – Mahesh Bhupathi
Sandon Stolle – Cyril Suk	Martina Hingis – Jana Novotná	Serena Williams – Max Mirnyi
Yevgeny Kafelnikov – Daniel Vacek	Lindsay Davenport – Jana Novotná	Manon Bollegraf – Rick Leach
Todd Woodbridge – Mark Woodforde	Gigi Fernandez – Natasha Zvereva	Lisa Raymond – Patrick Galbraith
Todd Woodbridge – Mark Woodforde	Gigi Fernandez – Natasha Zvereva	Meredith McGrath – Matt Lucena
Jacco Eltingh – Paul Haarhuis	Jana Novotná – Arantxa Sánchez-Vicario	Elna Reinach – Patrick Galbraith
Ken Flach – Rick Leach	Arantxa Sánchez-Vicario – Helena Suková	Helena Suková – Todd Woodbridge
Jim Grabb – Richey Reneberg	Gigi Fernandez – Natalia Zvereva	Nicole Provis – Mark Woodforde
John Fitzgerald – Anders Järryd	Pam Shriver – Natalia Zvereva	Manon Bollegraf – Tom Nijssen
Pieter Aldrich – Danie Visser	Gigi Fernández – Martina Navratilova	Elizabeth Sayers Smylie – Todd Woodbridge
John McEnroe – Mark Woodforde	Hana Mandlíková – Martina Navratilova	Robin White – Shelby Cannon
Sergio Casal – Emilio Sánchez	Gigi Fernández – Robin White	Jana Novotná – Jim Pugh
Stefan Edberg – Anders Järryd	Martina Navratilova – Pam Shriver	Martina Navratilova – Emilio Sánchez
Andres Gomez – Slobodan Zivojinovic	Martina Navratilova – Pam Shriver	Raffaella Reggi – Sergio Casal
Ken Flach – Robert Seguso	Claudia Kohde-Kilsch – Helena Suková	Martina Navratilova – Heinz Gunthardt
John Fitzgerald – Tomas Smid	Martina Navratilova – Pam Shriver	Manuela Maleeva – Tom Gullikson
Peter Fleming – John McEnroe	Martina Navratilova – Pam Shriver	Elizabeth Sayers – John Fitzgerald
Kevin Curren – Steve Denton	Rosie Casals – Wendy Turnbull	Anne Smith – Kevin Curren
Peter Fleming – John McEnroe	Kathy Jordan – Anne Smith	Anne Smith – Kevin Curren
Robert Lutz – Stan Smith	Billie Jean King – Martina Navratilova	Wendy Turnbull – Marty Riessen
Peter Fleming – John McEnroe	Betty Stöve – Wendy Turnbull	Greer Stevens – Bob Hewitt
Robert Lutz – Stan Smith	Billie Jean King – Martina Navratilova	Betty Stöve – Frew McMillan
Bob Hewitt – Frew McMillan	Martina Navratilova – Betty Stöve	Betty Stöve – Frew McMillan
Tom Okker – Marty Riessen	Delina Boshoff – Ilana Kloss	Billie Jean King – Phil Dent
Jimmy Connors – Ilie Năstase	Margaret Smith Court – Virginia Wade	Rosemary Casals – Richard Stockton
Robert Lutz – Stan Smith	Rosie Casals – Billie Jean King	Pam Teeguarden – Geoff Masters
Owen Davidson – John Newcombe	Margaret Smith Court – Virginia Wade	Billie Jean King – Owen Davidson
Cliff Drysdale – Roger Taylor	Françoise Dürr – Betty Stöve	Margaret Smith Court – Marty Riessen
John Newcombe – Roger Taylor	Rosie Casals – Judy Tegart Dalton	Billie Jean King – Owen Davidson
Pierre Barthes – Niki Pilić	Margaret Smith Court – Judy Tegart Dalton	Margaret Smith Court – Marty Riessen
Ken Rosewall – Fred Stolle	Françoise Dürr – Darlene Hard	Margaret Smith Court – Marty Riessen
Robert Lutz – Stan Smith	Maria Bueno – Margaret Smith Court	

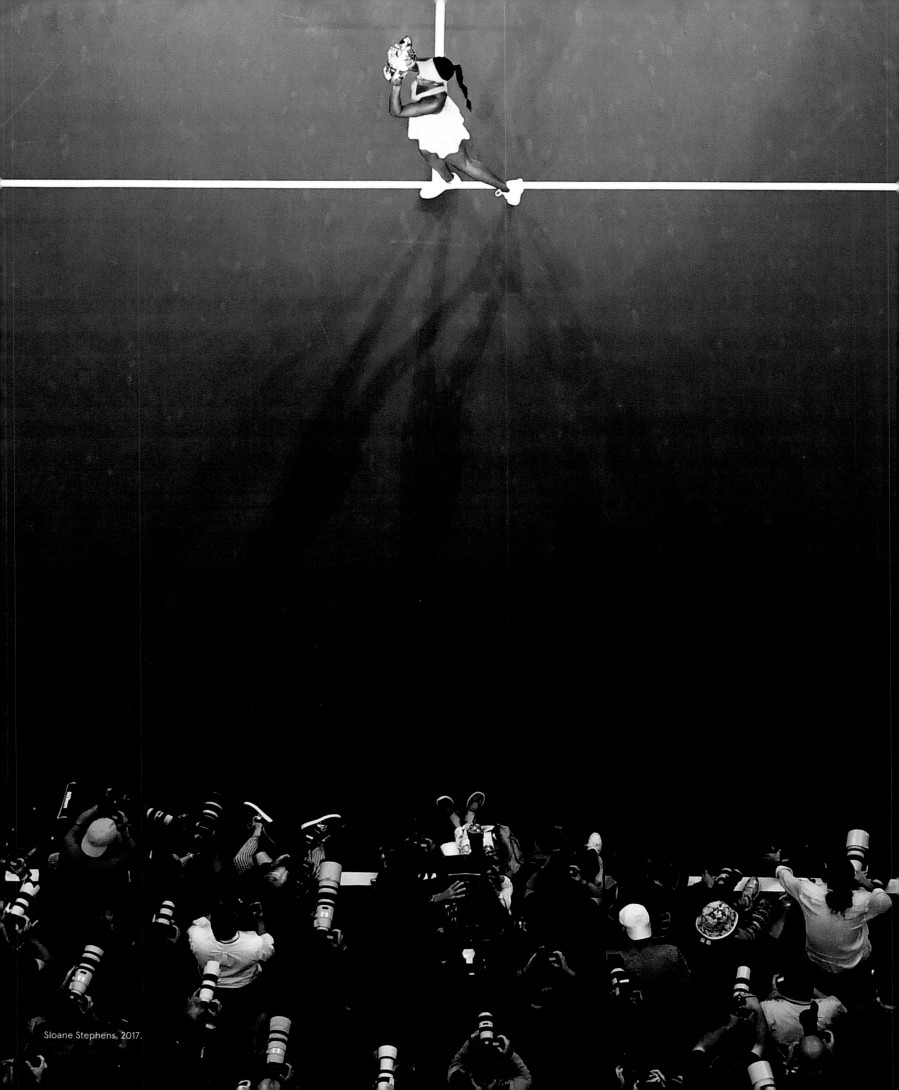

Sloane Stephens, 2017.

About the Contributors

Katrina M. Adams is chairman of the board and president of the United States Tennis Association. She competed for twelve years on the WTA Tour and was ranked as high as No. 67 in the world in singles and No. 8 in doubles, winning twenty doubles titles and reaching the quarterfinals or better in doubles at all four Grand Slam events. She is also a contributor on CBS Sports Network's first all-female sports show, *We Need to Talk*, and serves as a television analyst for Tennis Channel.

Neil Amdur was the lead tennis writer for the *New York Times* from the start of the Open era to the mid-1980s and, after working for CBS Television Sports and becoming editor-in-chief of *World Tennis*, served for a dozen years a sports editor of the *New York Times*. He has written *Chrissie: My Own Story* (with Chris Evert; Simon & Schuster, 1981) and *Off the Court* (with Arthur Ashe; New American Library, 1982).

Paul Annacone reached a career-high ranking of No. 12 in singles and No. 3 in doubles, winning three singles titles and fourteen doubles titles on the ATP tour, including the 1985 Australian Open. He has coached Pete Sampras, Roger Federer, Sloane Stephens, and other top players and is the author of *Coaching for Life* (Irie, 2017). He also serves as a commentator for Tennis Channel.

Alec Baldwin is a multiple Emmy–, Golden Globe–, and Screen Actors Guild Award–winning actor, producer, comedian, and philanthropist. He has also been nominated for an Oscar and a Tony Award. He is the author of several bestselling books, including *You Can't Spell America Without Me* (Penguin, 2017) and *Nevertheless: A Memoir* (HarperCollins, 2017).

Michael Barkann is an award-winning television and radio host, anchor, and sportscaster who was seen regularly on national television from 1991 to 2008 as a field reporter during USA Network's coverage of the US Open.

Peter Bodo has been covering tennis for more than thirty-five years, most recently for ESPN.com. He is the author of several books on tennis, including the classic *The Courts of Babylon* (Scribner, 1995), the bestselling *A Champion's Mind* (with Pete Sampras; Crown, 2008), and *Ashe vs. Connors: Wimbledon 1975: Tennis That Went Beyond Centre Court* (Diversion, 2015).

Wayne Coffey is an award-winning sportswriter and author who has covered the US Open for more than twenty-five years. Among his numerous books are *When Nobody Was Watching* (with Carli Lloyd; Houghton Mifflin Harcourt, 2017), *The Closer* (with Mariano Rivera; Little Brown, 2014), and *The Boys of Winter* (Crown, 2005).

Bud Collins was the nation's foremost tennis journalist, television commentator, and historian for more than half a century. He was inducted into the International Tennis Hall of Fame in 1994. The US Open Media Center is named in his honor.

E. J. Crawford has been writing about tennis for more than a dozen years and has been a frequent contributor to the US Open tournament program and *US Open Daily*. From 2013 to 2017, he served as managing editor of USOpen.org, the official tournament website.

Joel Drucker is a historian-at-large for the International Tennis Hall of Fame and, since 1982, has written for numerous media outlets, including *Tennis* magazine, *Cigar Aficionado*, ESPN, HBO, CBS, Tennis Channel, and the *Huffington Post*. He is the author of *Jimmy Connors Saved My Life* (Sports Media, 2004).

Chris Evert won eighteen Grand Slam singles titles, including six US Open championships, and spent 260 weeks as the No. 1 ranked player in the world. She was inducted into the International Tennis Hall of Fame in 1995. She has served as a tennis analyst for ESPN since 2011.

John Feinstein is a bestselling author of nearly forty books, which include *Hard Courts: Real Life on the Professional Tennis Tours* (Villard, 1992), and his newest book, *The Prodigy* (Farrar, Straus and Giroux, 2018). He is a columnist for the *Washington Post* and a commentator for television and radio. He was inducted into the National Sportscasters and Sportswriters Hall of Fame in 2012.

Steve Flink is one of the sport's leading journalists and historians and was inducted last summer into the International Tennis Hall of Fame, having been enshrined in the USTA Eastern Tennis Hall of Fame in 2010. He has been reporting on tennis full time since 1974 and is the author of *The Greatest Tennis Matches of All Time* (New Chapter Press, 2012). He has been a columnist for TennisChannel.com since 2007.

Sean Gregory is a senior writer at *Time*, covering sports. He has written feature stories about Serena Williams, Roger Federer, Rafael Nadal, Sloane Stephens, and other tennis stars.

Beatrice E. Hunt has been a member of the West Side Tennis Club since 1971. She currently serves as cochair of the Tennis History & Archives Committee of the West Side Tennis Club Foundation.

Rod Laver holds the all-time record for the most singles titles won, with more than two hundred career titles. He became the second man in tennis history to win the Grand Slam in 1962 and repeated the feat in 1969, when he became the first player to achieve the Grand Slam in the Open era. He was inducted into the International Tennis Hall of Fame in 1981.

Barry Lorge covered tennis in more than twenty-five countries, writing for publications ranging from *Sports Illustrated* to the *Encyclopaedia Britannica*, and was sports editor of the *San Diego Union* and a staff editor for the *Washington Post*.

Mark Preston has been writing about the US Open since 1982, first at *Tennis* magazine and for the past twenty years for the USTA, where his responsibilities include directing the editorial content on USOpen.org. He served as coeditor of the book *US Open Unmatched* (Universe, 2002).

Cindy Shmerler is an award-winning journalist and a contributing editor at *Tennis* magazine who has also done commentary for ESPN/DIRECTV, Tennis Channel, and USTA.com. She has been reporting on tennis since the late 1970s.

Pam Shriver is a twenty-two–time Grand Slam champion who won five US Open women's doubles titles (four with Martina Navratilova) while reaching No. 1 in the world in doubles and No. 3 in singles. She was inducted into the International Tennis Hall of Fame in 2002. She serves as an analyst and reporter for ESPN's tennis telecasts.

Louisa Thomas is a contributing writer for NewYorker.com, having previously written for Grantland. She also is the author of the acclaimed biography *Louisa: The Extraordinary Life of Mrs. Adams* (Penguin, 2016).

Steve Tignor is a senior writer at *Tennis* magazine and Tennis.com, where he writes a daily blog. He is the author of *High Strung: Bjorn Borg, John McEnroe, and the Untold Story of Tennis's Fiercest Rivalry* (Harper, 2012).

George Vecsey, as an urchin in Queens, saw Althea Gibson and Rod Laver play at Forest Hills, and had wonderful times schmoozing with Arthur Ashe in tennis press boxes. Later, as sports columnist for the *New York Times*, he covered more than a dozen Wimbledons and more than thirty US Opens. He also helped Martina Navratilova write her autobiography.

L. Jon Wertheim is executive editor at *Sports Illustrated*, a commentator for Tennis Channel, and a bestselling author whose books include *Strokes of Genius* (Houghton Mifflin Harcourt, 2010). His work has been featured in the *Best American Sports Writing* anthology five times.

Serena Williams has won more Grand Slam singles titles in the Open era than any other player, including six US Open championships, and has twice been in possession of all four majors at the same time for a "Serena Slam." She has been the No. 1 ranked player in the world for 319 weeks and ranks first among active players in career titles.

Photo and Illustration Credits

KEY

AP: Associated Press
CU: Camerawork USA
GI: Getty Images
ITHOF: International Tennis Hall of Fame
TM: TENNIS Magazine
USTA: United States Tennis Association

Jacket
Front: Darren Carroll/USTA; **Back:** Melchior DiGiacomo.

Frontmatter
2: Tim Camuso/USTA; **4:** Ashley Marshall/USTA; **7, 8:** Chris Trotman/GI/USTA; **10-11:** Darren Caroll/USTA.

Introduction
12-13: Art Seitz; **14:** Bettmann/GI; **15:** Bob Gomel/The LIFE Images Collection/GI; **16:** (top) Fred Mullane/CU, (bottom) Gary Prior/GI; **17:** (top) June Harrison, (bottom) Fred Mullane/CU; **18:** Corinne Dubreuil; **19:** Al Bello/GI.

The 1960s
20: William N. Jacobellis/New York Post archives/NYP Holdings, Inc. via GI; **23:** USTA; **24:** Willard Mullin; **25:** USTA; **26:** George Kaminsky; **27:** (left) Seymour Wally/NY Daily News Archive via GI, (middle) AP, (right) USTA; **28:** Beatrice Hunt; **29:** USTA; **30-31:** Rolls Press/Popperfoto/GI; **32:** ITHOF; **33:** Bettmann/GI; **34:** Art Seitz; **35:** Russ Adams/USTA; **36:** Chaloner Woods/GI; **37:** Russ Adams/USTA; **39:** (top left) USTA, (middle left) Stephen Szurlej/TM, (bottom left) Stephen Szurlej/TM, (top right) Bob Straus, (bottom right) Clive Brunskill/GI; **40-41:** Harry Harris/AP; **42:** Russ Adams/USTA; **43:** ITHOF; **44:** George Kalinsky; **45:** Bettmann/GI; **46:** George Kalinsky; **47:** ITHOF; **48:** (left) Bettmann/GI, (right) UPI; **49:** Russ Adams/USTA.

The 1970s
50: Melchior DiGiacomo; **53:** USTA; **54-55:** Melchior DiGiacomo; **56:** Tony Triolo/Sports Illustrated/GI; **57:** Bettmann/GI; **58:** George Kalinsky; **59:** June Harrison; **60:** George Kalinsky; **61:** Art Seitz; **62:** Lynn Pelham/The LIFE Images Collection/GI; **63, 64-65:** Art Seitz; **66:** USTA; **67, 68:** Russ Adams/USTA; **69:** ZUMA Press/Alamy; **70:** Melchior DiGiacomo; **71:** June Harrison; **73** (top left) Tommy Hindley/Professional Sport/Popperfoto/GI,(middle left) Focus on Sport, (middle) Matthew Stockman/GI, (bottom left) Stephen Szurlej/TM, (top right) Corinne Dubreuil, (middle right) Clive Brunskill/GI, (bottom right) June Harrison; **74-75:** Jack Mecca/TM; **76-77:** Stephen Szurlej/TM; **78:** Bob Kenas; **79:** Stephen Szurlej/TM; **80, 81:** Art Seitz; **82-83:** CBS via GI; **84-85:** John Newcomb/TM; **86:** Melchior DiGiacomo; **87:** June Harrison; **88-89:** Russ Adams/USTA; 90-91: Stephen Szurlej/TM; **92-93:** Jack Mecca/TM; **94-95:** Carrie Boretz; **96, 97, 98:** June Harrison; **99:** Stephen Szurlej/TM; **100-01:**Melchior DiGiacomo; **103:** Stephen Szurlej/TM; **104:** Art Seitz; **105:** Stephen Szurlej/TM.

The 1980s
106: Bob Straus; **109:** USTA; **110-11:** June Harrison; **112:** (left) Suzanne Vlamis/AP, (right) Leo Mason/Popperfoto/GI; **113:** (left) Stephen Szurlej/TM, (right) Matthew Stockman/GI; **114-15:** Melchior DiGiacomo; **117:** (top left, middle right) Bob Straus, (bottom left) June Harrison, (top right) Bob Kenas, (bottom right) Fred Mullane/CU; **118:** Stephen Szurlej/TM; **119:** Fred Mullane/CU; **120-21:** Stephen Szurlej/TM; **122:** Walter Iooss Jr./Sports Illustrated/GI; **123:** Bob Straus; **124:** Stephen Szurlej/TM; **125:** June Harrison; **126, 127:** Stephen Szurlej/TM; **128:** Melchior DiGiacomo; **129:** Fred Mullane/CU; **130-31:** Stephen Szurlej/TM; **132:** Bob Kenas; **133:** Ronald C. Modra/Sports Imagery/GI; **134:** Carol Newsom/AFP/GI; **135:** June Harrison: **136-37:** Stephen Szurlej/TM.

The 1990s
138: Stephen Szurlej/TM; **141:** USTA; **142-43:** Dom Furore/TM; **144:** Bob Thomas/GI; **145:** Ezra Shaw/GI; **146:** Bob Kenas; **147:** Timothy A. Clary/AFP/GI; **148:** Stephen Szurlej/TM; **149:** Bob Straus; **151, 152-53, 154, 155:** Stephen Szurlej/TM; **156-57:** Clive Brunskill/GI; **158:** David Kenas; **159,160:** Stephen Szurlej/TM; **161:** Mark Mainz/GI; **162:** Stephen Szurlej/TM; **163:** Clive Brunskillo/GI; **164:** (top) Matthew Stockman/GI, (middle) Manuela Davies/manuela.com, (bottom) Darren Carroll/USTA; **165:** (top left) Bryan Bedder/GI, (middle left) Michael Reaves/GI/USTA, (bottom left, top right) USTA, (middle right) Rachel Kaplan/USTA, (bottom right) Steven Ryan/GI; **166-67:** Michael Heiman/GI; **168:** GI/USTA; **169:** Direct TV/GI; **170:** June Harrison; **171:** David Kenas; **172-73:** Mark Sandten/Bongarts/GI; **174:** Mike Stobe/GI; **175:** Michael Le Brecht/USTA; **176-77:** Brian Friedman/USTA.

The 2000s
178: David Kenas; **181:** USTA; **182-83:** Streeter Lecka/GI; **184:** Jewel Samad/AFP/GI; **185:** Matt Campbell/AFP/GI; **186:** Al Bello/GI; **187:** Clive Brunskill/GI; **188:** Bob Straus; **189:** Timothy A. Clary/AFP/GI; **190:** June Harrison; **191:** Chris Trotman/GI; **192:** (Alan King, Jack Nicholson/Anjelica Huston, Jackie Onassis, Liza Minnelli, David Dinkins/Michael Bloomberg/Ed Koch, Michael Bolton/Andre Agassi/Barbra Streisand) Art Seitz, (Lin-Manuel Miranda/Roger Federer) Jennifer Pottheiser/USTA, (Catherine Zeta-Jones/Michael Douglas, Janet Jackson) Matthew Stockman/GI, (Will Ferrell, Leonardo DiCaprio) Timothy A. Clary/AFP/GI, (Ralph Lauren) Bob Straus, (Aretha Franklin) Mark Mainz/GI, (Oprah Winfrey) Rachel Kaplan/USTA, (Michael Jordan) Louie Lu, (Donald Trump) June Harrison; **193:** (Tony Bennett, Andy Murray/Sean Connery, Hugh Jackman) Matthew Stockman/GI, (Jim Courier/Sophia Loren, Wilt Chamberlain, Jay-Z/Beyoncé, Robert DeNiro) Art Seitz, (Christie Brinkley, Anthony Quinn, Walter Cronkite) Bob Straus, (Jimmie Fallon/Justin Timberlake) Al Bello/GI, (Nicole Kidman/Keith Urban, Robin Williams) Corinne Dubreuil, (John McEnroe/Bill Clinton) Stan Honda/AFP/GI, (Bill Gates) Elsa/GI, (Charlize Theron, Claire Danes) Russ Adams/USTA, (Anna Wintour) Ray Giubilo, (Jerry Seinfeld/Larry David, Jimmy Carter) Bob Kenas, (Queen Latifah/Serena Williams) Jennifer Pottheiser/USTA, (Drake) Maddie Meyer/GI, (Jim Carrey) GI/USTA; **194:** Ezra Shaw/GI; **195:** Timothy A. Clary/AFP/GI; **196:** Jamie Squire/GI; **197** (top) Jamie Squire/GI, (bottom) David Kenas; **198:** Ezra Shaw/GI; **199:** Don Emmert/AFP/GI; **200-01:** Jim McIsaac/GI; **202:** Russ Adams/USTA; **203:** Timothy A. Clary/AFP/GI; **205:** (top left and bottom middle) Stephen Szurlej/TM, (bottom left, top right, bottom right) Russ Adams/USTA, (middle left) USTA; **206-07:** Ashley Marshall/USTA; **208:** Don Emmert/AFP/GI; **209:** Andrew Ong/USTA; **210-11:** Jim McIsaac/GI; **212:** Art Seitz; **213:** David Kenas; **214:** (Martina Navratilova/Billie Jean King) Art Seitz, (Serena Williams) Corinne Dubreuil, (Bjorn Borg) Jack Mecca/TM, (ball person) Brian Friedman/USTA, (Tracy Austin, Ivan Lendl) June Harrison, (Andre Agassi, Natasha Zvereva/Gigi Fernandez) Stephen Szurlej/TM, (Venus Williams) Al Bello/GI, (Bethanie Mattek-Sands) Clive Brunskill/GI; **215:** (Maria Sharapova, Venus Williams) Matthew Stockman/GI, (Roger Federer) Rob Loud/USTA, (Serena Williams) Corinne Dubreuil, (Lleyton Hewitt) Nick Laham/GI, (James Blake) Al Bello/GI, (Rafael Nadal) Clive Brunskill/GI, (lines persons, ball person) Andrew Ong/USTA, (Alexander Zverev) Garrett Ellwood/USTA, (chair umpire) GI/USTA; **216-17:** GI/USTA; **218:** Don Emmert/AFP/GI; **219:** Susan Mullane/CU; **220-21:** GI/USTA; **222:** Matthew Stockman/GI; **223:** Corinne Dubreuil.

The 2010s
224: Chris Nicholson; **227:** USTA; **228-29:** Chris Nicholson; **230:** Al Bello/GI; **231:** Emmanuel Dunand/AFP/GI; **232:** Timothy A. Clary/AFP/GI; **233:** Mike Lawrence/USTA; **234:** Pete Staples/USTA; **235:** Mike Stobe/GI; **237:** (top left) Matthew Stockman/GI, (bottom left, top right, middle right) GI/USTA, (bottom right) Alex Goodlett/GI; **238:** Garrett Ellwood/USTA; **239:** Richard Heathcote/GI; **240:** Darren Carroll/USTA; **241:** Brian Friedman/USTA; **242-43, 244:** Jennifer Pottheiser/USTA; **245, 246-47; 248:** GI/USTA; **249:** Ray Giubilo; **251:** Russ Adams/USTA; **252;** Art Seitz; **253:** Elsa/GI; **255:** Barry Blitt; **256-57:** Matthew Stockman/GI; **258:** Darren Carroll/USTA; **259:** Jennifer Pottheiser/USTA; **261:** (top) Michael Le Brecht/USTA, (bottom) GI/USTA; **263:** (Arthur Ashe Stadium) Mike Stobe/GI, (Andy Roddick) Al Bello/GI, (Madison Keys) Darren Carroll/USTA, (signs) Chris Nicholson, (Samantha Stosur, Caroline Wozniacki) Chris Trotman/GI, (Rafael Nadal) Ed Goldman, (Juan Martin del Potro, Roger Federer, Maria Sharapova, Marat Safin, James Blake, Victoria Azarenka, fans) GI/USTA, (Todd Martin) Roberto Schmidt/AFP/GI, (Novak Djokovic, Serena Williams) Pete Staples/USTA, (Lleyton Hewitt, Venus Williams/Serena Williams/Bob Bryan/Mike Bryan, Jim Courier) Russ Adams/USTA, (Andy Murray) Clive Brunskill/GI; **264-65:** Elsa/GI.

Backmatter
266: Russ Adams/USTA; **268:** Jewel Samad/AFP/GI; **270:** (top, middle right) Art Seitz, (middle left, bottom) Rachel Kaplan/USTA.

Acknowledgments

JUST AS A GREAT MANY PEOPLE come together to put on the US Open every year, so too has it taken a talented team of people to bring the history of the tournament's first fifty years to life in this book.

Special thanks to Katrina M. Adams, Gordon A. Smith, Andrea Hirsch, and Stacey Allaster for their support of this project, along with other members of the USTA leadership–particularly past presidents J. Howard Frazer, Lucy Garvin, Jane Brown Grimes, David Haggerty, Franklin R. Johnson, Julia A. Levering, Alan Schwartz, and Jon Vegosen–for their efforts in growing the game and, with it, the US Open.

At the USTA–I am deeply grateful to Chris Widmaier for his encouragement, insight, and acumen, which made it possible for this book to be produced. Like the best of doubles partners, Mark Preston came through with flying colors whenever his talents and advice were needed. Brent Stauffer was helpful and generous with his time and proved to be a knowledgeable and valuable resource. Mike Floyd went above and beyond in helping with the creation of this book. Thanks are also in order for David Brewer, Amy Choyne, Jeanmarie Daly, Carrie Ehorn, Andrew Hickcox, Jenna Higueras, Nicole Kankam, Dan Malasky, Beth Meyer, Deanne Pownall, Mary Ryan, and Julia Walsh, who each contributed to the book's production in his or her own way.

At Abrams–a heartfelt thank you to Laura Dozier for her unfailingly wise and expert guidance throughout this journey. Steve Tager, with his boundless enthusiasm for this project, has been unmatched in supporting it. John Gall, Jordan Jacobson, and Mary O'Mara have all been aces as well. Kristina DiMatteo's design proved to be a true inspiration. A special debt of gratitude is served up to Michael Jacobs for getting the ball rolling.

This book would not have been possible without the assistance of Meredith Richards of the International Tennis Hall of Fame & Museum; Andre Christopher and Cheryl Lampert of H.O. Zimman, Inc.; Adam Motin of Triumph Books LLC; Warren Kimball, Geoff Felder, Bea Hunt, Janey Marks, Michael Powers, Marcio Torres, Courtenay Barrett, Kelly Bush Novak, and Michelle Proctor; and the astute input of Rozelle Rennert, Sara Rennert, and Julia Rennert, who have made the annual pilgrimage to Flushing Meadows for more than two decades.

The real stars of this book, besides the ones who display their athleticism on the courts, are the photographers who capture the sport with their glorious images–including Carrie Boretz, Manuela Davies, Jeff Davies, Melchior DiGiacomo, Corinne Dubreuil, Ray Giubilo, Ed Goldman, June Harrison, George Kalinsky, Bob Kenas, David Kenas, Louie Lu, Fred Mullane, Susan Mullane, Chris Nicholson, Art Seitz, Bob Straus, and Stephen Szurlej–and the contributors listed on page 269. Everyone was quick to get on board with this project, and for that my appreciation knows no bounds.

FROM TOP: Arthur Ashe Stadium, 2017; Slew Hester, 1982; Arthur Ashe Stadium roof unveiling ceremony with (left to right) Matt Rossetti, Daniel Zausner, Jeanne Moutoussamy-Ashe, Billie Jean King, Katrina M. Adams, and Gordon A. Smith, 2016; USTA Billie Jean King National Tennis Center, 2016.

Editor: Laura Dozier
Designer: Kristina DiMatteo
Production Manager: Kathleen Gaffney

Library of Congress Control Number:
2017956769

ISBN: 978-1-4197-3218-8
eISBN: 978-1-68335-315-7

Printed and bound in the United States
10 9 8 7 6 5 4 3 2 1

Abrams books are available at special
discounts when purchased in quantity
for premiums and promotions as
well as fundraising or educational use.
Special editions can also be created
to specification. For details, contact
specialsales@abramsbooks.com or
the address below.

ABRAMS The Art of Books
195 Broadway, New York, NY 10007
abramsbooks.com